QUEER HAPPENED HERE

QUEER HAPPENED HERE

100 YEARS OF NYC'S LANDMARK LGBTQ+ PLACES

MARC ZINAMAN

FOREWORD BY *PEPPERMINT*

Prestel
Munich · London · New York

CONTENTS

- 6 — FOREWORD
- 8 — INTRODUCTION AND EARLY QUEER LANDSCAPE

14 — 1920S-1930S: BATHHOUSES, BALLS, AND BOHEMIANS

- 18 — WEBSTER HALL
- 20 — EVERARD BATHS
- 22 — HARRY HANSBERRY'S CLAM HOUSE
- 24 — EVE'S HANGOUT
- 26 — CENTRAL PARK
- 30 — HAMILTON LODGE BALL @ ROCKLAND PALACE
- 32 — STEWART'S CAFETERIA
- 34 — HOWDY CLUB
- 36 — JIMMIE DANIELS' NIGHTCLUB

38 — 1940S-1950S: A LAVENDER LANDSCAPE

- 44 — SAN REMO CAFÉ
- 46 — WOMEN'S HOUSE OF DETENTION
- 50 — JEWEL BOX REVUE
- 54 — ST. MARKS BATHS
- 58 — CAFFE CINO
- 60 — CLUB 181
- 62 — CLUB 82
- 66 — THE MATTACHINE SOCIETY & DAUGHTERS OF BILITIS OFFICES

68 — 1960S: RAIDS, REBELS, AND RIOTS

- 74 — JULIUS'
- 76 — CRAZY HORSE CAFÉ
- 80 — OSCAR WILDE MEMORIAL BOOKSHOP
- 82 — STUDENT HOMOPHILE LEAGUE @ EARL HALL
- 84 — CHRISTOPHER'S END
- 86 — MAX'S KANSAS CITY
- 90 — THE SANCTUARY
- 92 — THE STONEWALL INN

96 — 1970S: A NEW DAWN

- 102 — FIRST PRIDE MARCH
- 108 — THE CONTINENTAL BATHS
- 110 — GAA FIREHOUSE
- 114 — CRISCO DISCO
- 116 — CHRISTOPHER STREET PIERS
- 122 — 12 WEST
- 124 — GG'S BARNUM ROOM
- 128 — THE MINESHAFT
- 132 — STUDIO 54

138	**1980S: DANCING THROUGH DARKNESS**	236	**2000S: MEET ME ONLINE**

- 144 PARADISE GARAGE
- 150 CLUB 57
- 154 DANCETERIA
- 158 THE SAINT
- 162 PYRAMID COCKTAIL LOUNGE
- 168 LIMELIGHT
- 174 BOYBAR
- 178 TRACKS
- 182 THE COPACABANA

188 1990S: STRIKE A POSE

- 194 ESCUELITA
- 198 PALLADIUM
- 204 CLIT CLUB @ BAR ROOM 432
- 208 THE ROXY
- 212 LUCKY CHENG'S
- 216 SOUND FACTORY & SOUND FACTORY BAR
- 220 NO DAY LIKE SUNDAY @ CAFÉ TABAC
- 224 EDELWEISS
- 228 THE LURE
- 232 CLUB CASANOVA @ CAKE

- 242 CUBBY HOLE & CUBBYHOLE
- 246 BEIGE @ B BAR
- 250 BARRACUDA
- 254 THE COCK
- 258 MR. BLACK
- 260 HENRIETTA HUDSON
- 262 NO PARKING

266 2010S: APP-ILY EVER AFTER

- 272 WESTGAY @ WESTWAY
- 276 XL
- 278 CHINA CHALET
- 282 BOOM BOOM ROOM & LE BAIN
- 288 FLAMING SADDLES
- 290 NO BAR
- 294 CLUB CUMMING

298 **MAP**

300 **BIBLIOGRAPHY AND RESOURCES**

302 **PICTURE CREDITS**

304 **AUTHOR BIOGRAPHY AND ACKNOWLEDGMENTS**

FOREWORD BY PEPPERMINT

I believe New York is one of the most unique and special cities on earth. To me, it represents vibrancy, success, community, and connection. And who am I? My name is Peppermint. I am an artist, actress, and drag entertainer who has lived and worked here since the early 2000s.

This book, and books like it, are increasingly essential in the attempt to redeem the once-lost stories of those in the queer community who have contributed to the tapestry of society. Throughout time, and even in recent years, queer culture and history have been successfully obscured and, in some cases, erased. This is part and parcel of why the New York City of today doesn't quite resemble the New York City I first laid eyes on.

Queer individuals have historically fled discrimination and persecution in small towns in search of community and support in larger cities like New York. They bring with them, of course, their imagination, panache, and artistic ambition.

One of my first jobs in the city was at the infamous Tunnel nightclub, where college students stood in line weekly to attend parties that featured as many types of music as they did so-called designer drugs. (At the time, Tunnel, Limelight, the Roxy, Palladium, and Twilo were the royal houses of clubland; the huge "anything goes" warehouse dance clubs.) The Tunnel building is now an office building. I remember standing with one of my drag queen friends, socializing in the bathroom, watching her wig burn on a sconce at Limelight while we were waiting to go into the H. R. Giger-decorated room (the creator of the Xenomorph monster in the movie *Alien*). Limelight is now some sort of shopping center.

I eventually went on to work at the original XL nightclub, where I once hosted the Pussycat Dolls in the weekly return of the game show *Faggot Feud*. Chelsea at the time was where most of the white middle-class gay men hung out, so naturally it was a good (albeit basic) starting point for a queer college kid to look for community. Even Big Cup, the gay internet café where folks would meet up and leave messages on the board for each other throughout the week, was buzzing.

In the '90s, a night of going out dancing could end in one of several ways for a young LGBTQ+ person: losing yourself at the dance club, losing your life on the way home from the dance club, or risking your life in a heated night of passion after the dance club. Which is not necessarily unique to New York or the '90s,

but the realization that so many of my friends were perfectly fine with any of those outcomes shows the mindset of many queer New Yorkers at the time.

It has been said that, ultimately, what we as individuals want to do is make a mark on the people, places, and institutions around us. If the cultures, customs, and attitudes of a particular city, state, or town are formed by its residents and citizens, then New York City has a lot to offer. I'm reminded of this every time I return after having been gone for a while. When I set foot back in New York, there is a vibration that is palpable. The city seems to have its own energy.

Historically, queer people in Western cultures have been forced to remain in the shadows for fear of retaliation or the threat of violence, under which circumstances our community developed not only our own enclaves, our own neighborhoods, our own "queer ghettos", but also our own languages to communicate with each other. While different ethnicities, nationalities, and cultures are able to pass traditions down while raising their families, the queer community must *manually* pass its traditions (and spoken and unspoken languages) from generation to generation while continuously adapting to ever-changing social and political pressures. In New York City, queer traditions have passed from the gay club, to the gay café, to the gay beach, to the gay bookstore, even to the gay sex club.

Yes, I am still very tickled knowing that the fancy designer shops and exclusive restaurants inside the triangular building on Hudson, near 14th Street in the Meatpacking District, were once home to some of the raunchiest sex clubs in the area—J's Hangout and Hellfire Club. Both were unceremoniously shuttered due to the "threat of unsafe sex" (which was more like moral judgment than concern for the health of LGBTQ New Yorkers) after a wave of family-friendly actions by the infamous Giuliani administration. If you visited these places in the 1980s, 1990s, and early 2000s, you would have probably witnessed one, two, or maybe ten people engaged in the sloppiest of moments situated somewhere between what is now the wine bar and the salad station in one of those pricey eateries.

This is what I mean by queer people really having a way of leaving their mark, even if it's no longer visible. In this book, we are taking a blacklight to the proverbial satin sheets that make up the fabric of our beautiful and diverse home. You already know: sex happened here, drugs happened here, rock and roll happened here, and yes, queer happened here.

Peppermint is a New York City-based actress, musician, and public speaker who made history in 2018 as the first out transgender woman to originate a principal role in a Broadway musical.

INTRODUCTION AND EARLY QUEER LANDSCAPE

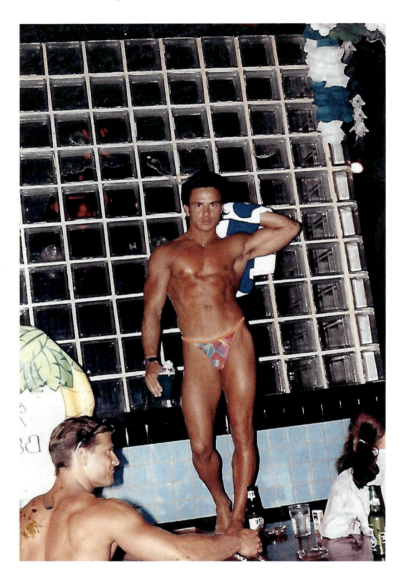

James Brace (Jimbo) bartending at Splash with dancer, circa 1990s.

Although I was born and raised in New York City in the 1990s, it would take nearly two decades for me to realize that LGBTQ+ people and their history had been around me all along. Instead, like many queer folks, I spent my youth—in New York City of all places—feeling like a freak, thinking no one else had ever endured the shame I was going through. How taken aback I was when, in my twenties, I discovered that queer author and Civil Rights activist James Baldwin once lived around the corner from me (and also

briefly in my grandmother's building ten blocks away); that my childhood bedroom window overlooked sex-positive, gay rights champion Mae West's mansion; and that every single day on my way to school, I passed the building that previously housed the Continental Baths, one of the most lavish, legendary gay bathhouses of all time.

When I finally did creep out of the closet in 2008, one of the first gay bars I snuck into was Splash, which was in its final years of operation. I knew nothing about the place's history. Instead, I turned my eighteen-year-old nose up at how dead it seemed, and how elderly its (probably thirty-something-year-old) clientele appeared. I never went back, and Splash would close shortly thereafter. It would take another decade before I found out that it had, in fact, revolutionized the gay bar experience when it opened.

As I got older, I began immersing myself in LGBTQ+ culture and history. Several books and documentary films I consumed mentioned nightlife spots like Paradise Garage, the Saint, and GG's Barnum Room, which I had previously never heard of, but which all sounded out of this world. Wanting to learn more about these places, I started researching various spots daily, building a simple map for myself with addresses, dates, facts, and photos. Each time I dug a little deeper, new spaces emerged, many of which had very little documentation. Hoping to fill in some of the historical gaps, I started reaching out to LGBTQ+ elders for interviews to capture their personal memories of these long-lost places. I relished connecting with older LGBTQ+ individuals—an opportunity that is all too rare—and realized there was no better way to commemorate queer bars and nightclubs than to record the stories of the people who created them, worked in them, or patronized them.

When the Covid-19 pandemic hit in 2020, I found myself with significantly more time on my hands. And, like so many LGBTQ+ people, I was affected by the indefinite closure of queer bars, clubs, and nightspots. I spent a lot of time ruminating on the sheer importance of these gathering spaces and the crucial role they've played for so many throughout our community's history. I immersed myself in even more research, map-building, and interviews, and eventually realized I had pinned nearly 1,000 LGBTQ+ spots on my New York map. I determined that more people my age needed to know about these places and began sharing them online with others via Instagram. Thus, Queer Happened Here was born.

I'd like to mention a few criteria that went into making this book. For one, it is a book after all, and therefore comes with physical constraints. *Queer Happened Here* only highlights spaces in Manhattan, though there have been many historically important LGBTQ+ places in Brooklyn, Queens, the Bronx, and Staten Island, which deserve their own books. Additionally, by no means are the spaces that *do* appear in this book the definitive or most important LGBTQ+ spots to have existed in New York City. In fact, they are but a small selection, aiming to represent diverse people and experiences across the queer spectrum. Some venues are very famous and feel impossible to leave out; others might be more obscure or only lasted a year. Taken together, I hope these paint a broad, vibrant picture of LGBTQ+ history and its ever-changing landscape in New York City.

Additionally, many of the spaces included in this book may have moved to different addresses over the years, closed and reopened, been renamed, or operated beyond the decade in which they are positioned in this book. Thus, attempts to provide them all with exact addresses or firmly ground them within a particular chapter by their dates of operation may be loose and imperfect. Some spaces have also been included in chapter introductions in order to provide additional breadth and flavor to the era in question.

Lastly, a comment on language. The vocabulary used by and against the LGBTQ+ community has constantly shifted over time and continues to do so today. We've been called, and have called ourselves, all sorts of names: inverts, homophiles, homosexuals, pansies, butches, faggots, trannies, dykes, friends of Dorothy, and so much more. Some of these have been empowering, others have been belittling, and several have managed to swing both ways. Many of these terms will appear throughout this book in their historical contexts, but for the most part, "LGBTQ+" and "queer" will be used as umbrella terms to refer to the broad spectrum of people whose sexual and gender expressions were anything but normative during their time. "LGBTQ+" and "queer" are thus not historically accurate, but intentionally used here for ease, inclusivity, and consistency.

With that, I welcome you to travel through my beloved city's LGBTQ+ history, and remind you that queer continues to happen here, and everywhere.

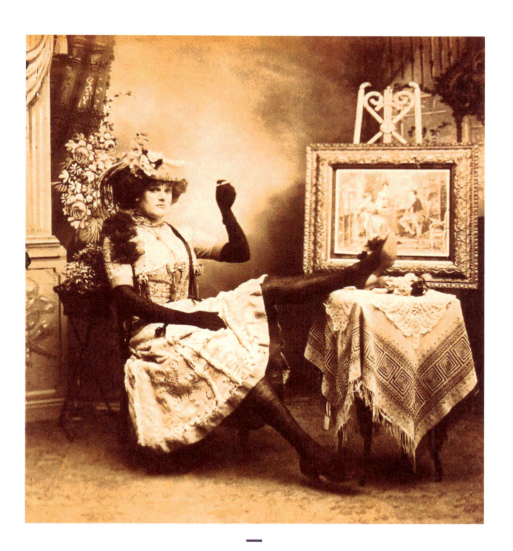

A member of the Cercle Hermaphroditos (likely at Paresis Hall), circa 1890s.

Before diving deeper into our story in the 1920s, let me briefly paint the scene as to what came before. Queerness certainly existed in the pre-colonial Americas, as many native and indigenous tribes used non-binary gender structures. The Diné (Navajo), for example, incorporated four gender identities, including the feminine and masculine Nádleehi. Similar concepts existed in other tribes, such as the Lhamana (Zuni) and Asegi (Cherokee). In more modern times, the term "two spirit" is sometimes used to describe these identities.

 Shortly after the first European settlers arrived in the 1600s to what would become New York City, the presence of LGBTQ+ individuals was already being documented. Unfortunately, this only occurred through reporting on criminal activities since, during the time of the American colonies, sodomy was considered a capital offense. The first documented sodomy trial in the New York area took place in 1646, when Jan Creoli was convicted

for his second offense and sentenced to death. Throughout the 1600s, several more individuals were convicted of sodomy—or "buggery"—and the punishment would remain the death penalty until 1796, when it was reduced to a sentence of fourteen years of either solitary confinement or hard labor.

During the 1800s, the area of present-day New York City nearly doubled its number of residents, becoming America's most populous urban center. In this period of immense growth, the city also saw an uptick in homosexual subculture. Much of the early urban development started at the southern tip of Manhattan, and by the 1840s, some of the first public green spaces (like City Hall Park and Washington Square Park) became cruising grounds for gay and sexually curious men. Meanwhile, places meant to provide housing and bathing facilities for young, single men, like YMCAs and bathhouses, became "major centers for the gay world and served to introduce men to gay life," according to historian George Chauncey in his book *Gay New York*. In 1903, police conducted the first recorded vice raid on the Ariston Hotel Baths, during which 26 men were arrested and 12 brought to trial on sodomy charges.

Other queer venues documented by vice squad raids included brothels like Paresis Hall, which rented out young men to paying male clients. Paresis Hall was also particularly notable for leasing one of its floors to the Cercle Hermaphroditos, a transgender organization whose members stored their women's clothing there due to the illegality of, and public hostility towards, dressing as the opposite sex.

The late 1800s and early 1900s saw saloons, dive bars, and tearooms downtown become notorious gathering spots for LGBTQ+ folk, whose "rowdy" behavior tended to attract the vice squad. During the early 1890s, for example, the Slide at 157 Bleecker Street was considered New York's "worst dive" because it was rampant with "fairies"—men who dressed as women and solicited other men. The Slide was shuttered by cops in 1892, its proprietor charged with keeping a "disorderly house."

Other spots included the Black Rabbit at 183 Bleecker, another "fairy" bar frequently subjected to raids, and the Mad Hatter at 150 West 4th Street, a space for queer women owned by Eliza Helen Criswell and her partner, Mathilda Spence. Venues like Webster and Walhalla Halls hosted masquerade balls where queer folk could dress in drag and dance with one another.

Much of early homosexual life in New York would be understood through the documentation created by several notable queer figures. These included photographer Alice Austen and her partner, Gertrude Tate, illustrator J. C. Leyendecker and his partner, Charles Beach, the gender-variant Murray Hall, and the celebrated poet Walt Whitman, who arrived in the city in 1841 and quietly wrote of his attractions to and affinities for the city's "robust, athletic" working-class men.

LGBTQ+ life in New York City would continue to grow but remain primarily underground until the onset of World War I in 1914, which would disrupt much of American life for the next four years. The war also disrupted traditional gender roles, brought together communities of same-sex individuals *en masse*, and accelerated the significant migration of people to major urban centers like New York City. All these elements would contribute to a post-war period in the 1920s that saw a massive boom in the expression of LGBTQ+ culture and the development of queer spaces.

- HAMILTON LODGE BALL @ ROCKLAND PALACE
- HARRY HANSBERRY'S CLAM HOUSE
- JIMMIE DANIELS' NIGHTCLUB
- CENTRAL PARK
- EVERARD BATHS
- STEWART'S CAFETERIA
- WEBSTER HALL
- EVE'S HANGOUT
- HOWDY CLUB

1920s–1930s
BATHHOUSES, BALLS, AND BOHEMIANS

1920s–1930s
POST-WORLD WAR I, PROHIBITION, AND THE HARLEM RENAISSANCE

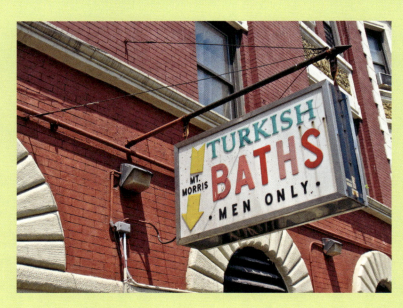

Mt. Morris Baths in Harlem was one of the longest-operating bathhouses in New York City. Through the 1920s and into the 1960s, it was the only gay bathhouse to admit Black men.

With World War I over and the Spanish Flu epidemic of 1918 subsiding, the start of the 1920s was a breath of fresh air. The Roaring Twenties marked the arrival of the Jazz Age, the Harlem Renaissance, and increased social tolerance for minorities and homosexuals. In New York in particular, nightlife venues emerged as spaces where people from diverse backgrounds could interact.

The Harlem Renaissance allowed queer artists and intellectuals of color to shine. Many queer-centric venues thrived during the "Pansy Craze" of the 1920s and early 1930s, which saw a growing appetite for LGBTQ+ entertainers and allowed for their greater visibility. The target audiences of these clubs were mostly straight, with queerness used for humor. Many female and male impersonators (the terms "drag queen" and "drag king" were not yet used) experienced surges in popularity. In addition, everyday people—both gay and straight—would partake in drag themselves, as drag balls at Webster Hall and Rockland Palace became all the rage.

While many were simply out to enjoy themselves after the war, conservative efforts were putting a damper on the experience. Prohibition went into effect in 1920, forbidding the manufacture and sale of alcohol nationwide. Perhaps no place in the country did a better job at skirting

Prohibition than New York, as underground speakeasies flourished throughout the city. Many were operated by organized crime syndicates. This configuration would also mark the Mafia's early role in the operation of LGBTQ+ nightspots, which became even more prevalent when Prohibition ended in 1933.

The New York State Liquor Authority, formed in 1934, forbade the employment in bars of anyone convicted of a felony or crime—a rule that specifically targeted homosexuals, who were more likely to have an arrest record than their heterosexual peers. With sly insinuation, the SLA also expected bars to keep out "disorderlies" or risk being raided and shut down, signaling that same-sex couples could not be caught together.

Several other laws greatly affected LGBTQ+ life. In 1923, the state passed the Schackno Bill, making it a misdemeanor for any man to proposition another man. Meanwhile, in 1927, the city's Cabaret Law came into effect, prohibiting "musical entertainment, singing, dancing or other form[s] of amusement" at any institution that also sold drinks or food, unless that venue obtained the proper license. These licenses were notoriously expensive and hard to come by, and targeted nightlife venues catering to LGBTQ+ folks, people of color, and other marginalized communities.

The year 1927 also saw the Wales Padlock Law, which barred theatrical performances from depicting "sexual perversion". The Hays Code went into effect in 1930, setting strict guidelines on what was morally acceptable in films and explicitly prohibiting homosexuality onscreen. In 1933, Mayor Fiorello La Guardia began cleaning up the city in preparation for 1939's World's Fair. His edicts included the increased entrapment of gay men, as well as the prohibition of any form of drag between 14th and 72nd Streets.

Since nightlife venues and cultural institutions came with such complicated baggage, LGBTQ+ people often gathered in other types of spaces like parks and bathhouses, which became important destinations where gay and bisexual men could socialize and have sex.

By the mid- to late-1930s, the Pansy Craze was over, and the effects of the Great Depression left their indelible mark. A shift towards conservative values began sweeping the country. As a result, many LGBTQ+ people felt compelled to conceal their sexual orientation once more. By the end of the decade, however, many were all too distracted by the nascent global war that would soon arrive on American shores.

1920s–1930s

WEBSTER HALL

125 EAST 11TH STREET
NEW YORK, NY 10003

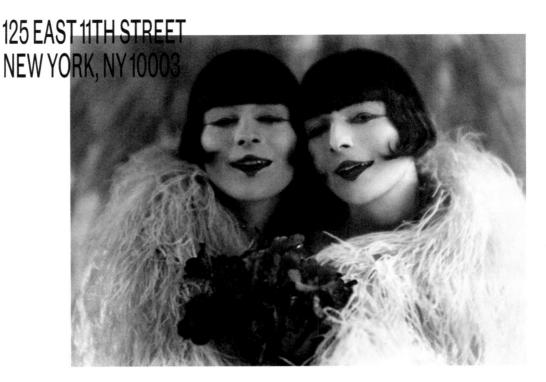

The Rocky Twins, Norwegian brothers who performed at Webster Hall, circa 1920s.

Considered by some to be America's first LGBTQ+ nightclub, Webster Hall was constructed in 1886 at 125 East 11th Street between Third and Fourth Avenues and quickly turned into an important gathering space for the city's queer community. Initially a "hall-for-hire" that served weddings and union rallies, it became a bohemian enclave when it started hosting masquerade balls that promoted gender-fluid drag and same-sex dancing, earning it the nickname "Devil's Playground." These events attracted many LGBTQ+ folks, who could feel at ease letting their hair down under its mansard roof.

One of the earliest documented masquerade balls at Webster Hall was a 1913 fundraiser for the socialist magazine *The Masses*. The event was so successful that, by the end of the decade, the venue was hosting balls at least twice a week, each of which became increasingly outlandish. According to historian George Chauncey, Webster Hall was the site of an annual gay and lesbian drag ball by the mid-1920s, along with numerous other mixed-crowd masquerades heavily attended by homosexuals. Chauncey also mentions an instance where a police investigator reported observing "phenomenal men" there made up to look like young women in rouge, wigs, and expensive gowns.

When Prohibition began in 1920, Webster Hall became a speakeasy, and as long as the police were properly paid off, its dances grew even more raucous. Among the many notable queer individuals who attended events during this time were artist Charles Demuth, poet Langston Hughes, and writer Djuna Barnes.

Over the decades, Webster Hall has undergone several renovations, changes in ownership, and temporary closures, but it remains open as one of New York's longest-running nightclubs that always holds space for LGBTQ+ events. Today, it is primarily a concert venue for indie bands that also hosts occasional dance parties. One of the most popular LGBTQ+ events there in recent years has been a recurring party by DJ Ty Sunderland and drag queen Aquaria which, in honor of the venue's queer history, is fittingly called Devil's Playground.

Webster Hall

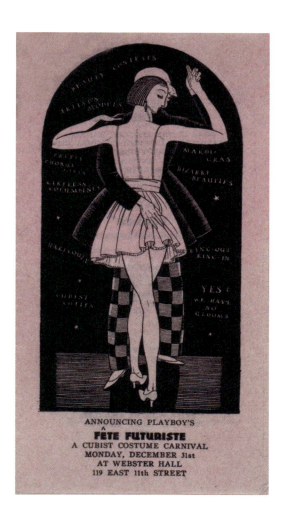

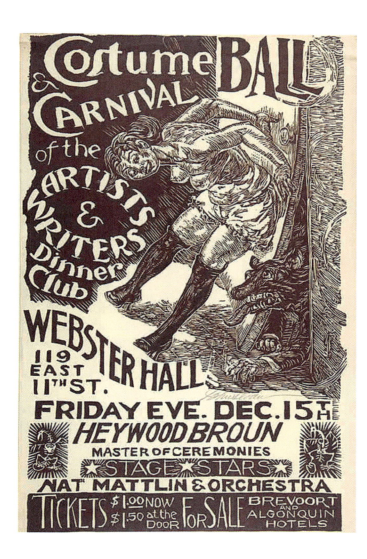

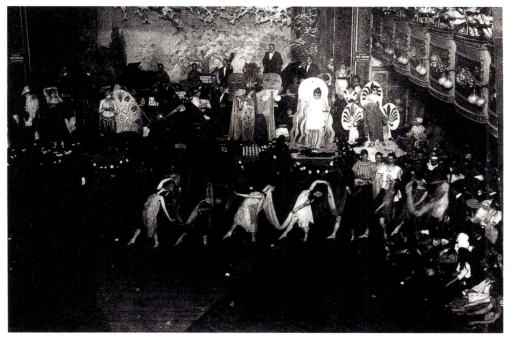

Top Left: 1924 invitation to the early arts and literary magazine *Playboy's* Fête Futuriste.

Top Right: Poster for Costume Ball and Carnival of the Artists and Writers Dinner Club, 1933.

Bottom: A 1920s drag ball at Webster Hall.

EVERARD BATHS

28 WEST 28TH STREET
NEW YORK, NY 10001

Founded by financier James Everard in 1888, the Everard Baths was a Turkish bathhouse located in a former church building at 28 West 28th Street between Sixth Avenue and Broadway. Like many bathhouses at the time, it was intended to promote general health and fitness—but as early as 1919, the Everard Baths was subject to documented police raids in which customers were arrested for "lewd behavior." By the 1920s, the Everard Baths was heavily patronized by homosexual men, and according to historian Neil Miller, was considered to be the "classiest, safest, and best known of the baths," earning it the cheeky nickname "Everhard."

In 1921, a new owner renovated the baths, and an ad from the following year declared "everything new but the location." The expanded venue now included a swimming pool, a huge dormitory on the second floor where "most of the activity takes place," as well as private cubicles on the higher floors.

The Everard Baths operated as a gay bathhouse for many decades, attracting prominent patrons along the way, including Truman Capote,

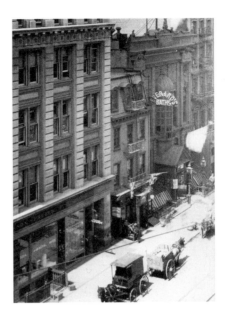

Everard Baths exterior, 1905.

Gore Vidal, Clifton Webb, Rudolf Nureyev, and Larry Kramer. In the book *Lavender Culture*, journalist and LGBTQ+ activist Arthur Bell recalled his time there: "It represented freedom to me—a place where I could have sex without plodding through the required conversation of a bar, where points are given for social status and artistic tastes...Everard's was a haven where I could stare at crotches in dimly lit hallways, wander the steam room, which smelled of sweat and Lysol, and screw with a cast of thousands who... were faceless and nameless."

In 1977, the Everard Baths would tragically make headlines when a fire killed nine men, injured nine more, and destroyed two upper floors. (While the venue was temporarily closed, many of its clientele migrated to St. Marks Baths (see p. 54)). Despite this, the baths reopened and remained a popular gay destination until 1986, when Mayor Ed Koch shut it down permanently during his campaign to close all bathhouses in response to the AIDS epidemic. Today, the unassuming building houses wholesale product distributors, with not even a whiff of what went down within its walls for nearly a century.

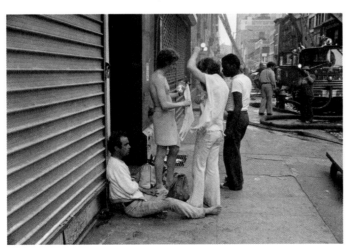

Survivors of the Everard fire, 1977.

Everard Baths

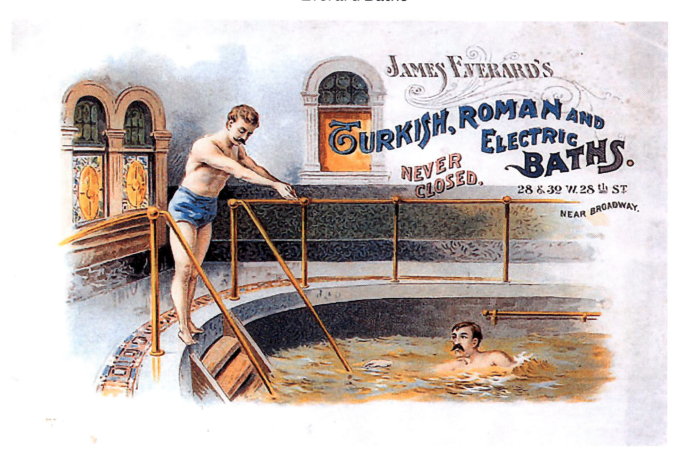

Cover of a booklet advertising the original Everard Baths, 1892.

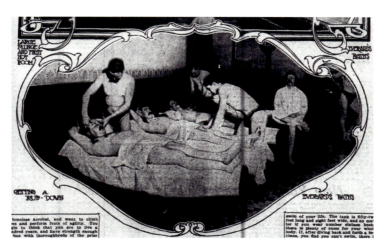

Getting a rub-down at the Everard Baths via the *New York Herald*, January 22, 1905.

> Thomas Von Foerster, patron: "I remember the Everard Baths had a very large, very beautiful Art Deco swimming pool. But it also had a very nice, very active steam room. It was always lovely to sit in that steam room and hear the grunts, the groans, and the moans, but not be able to see much of anything."

HARRY HANSBERRY'S CLAM HOUSE

**146 WEST 133RD STREET
NEW YORK, NY 10030**

As one of New York City's most notorious speakeasies, Harry Hansberry's Clam House was also one of Harlem's leading LGBTQ+ establishments during the Harlem Renaissance, thanks in part to its top-hat-wearing, tuxedo-donning performer, Gladys Bentley. Bentley, who got her start at the venue, made a name for herself singing raunchy revisions of popular songs and was so synonymous with the club that patrons at the time would even call the venue Gladys' Clam House.

Located at 146 West 133rd Street, Harry Hansberry's Clam House first opened circa 1920. At the age of 16, Gladys Bentley moved from Philadelphia to Harlem, and upon hearing that the Clam House was looking for a male pianist, applied for the job. According to Bentley herself, she wore "white full dress shirts, stiff collars, small bow ties, oxfords, short Eton jackets, and hair cut straight back." She was hired and began performing there regularly, perfecting her male impersonation act and ultimately skyrocketing her career. At the club's height, queer Hollywood stars like Tallulah Bankhead would often drop by to check out Bentley's racy shows.

Bentley was openly lesbian and often sang in a deep, snarling voice about "sissies" and "bulldaggers." She would mention female lovers in her lyrics and openly flirted with women in her audience. Her success at the Clam House led to her playing at other

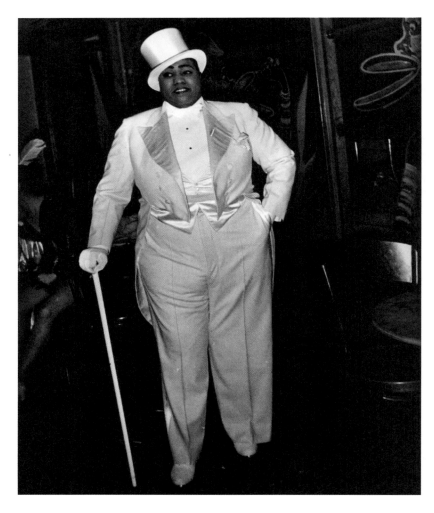

Gladys Bentley with cane, circa 1930s.

Harry Hansberry's Clam House

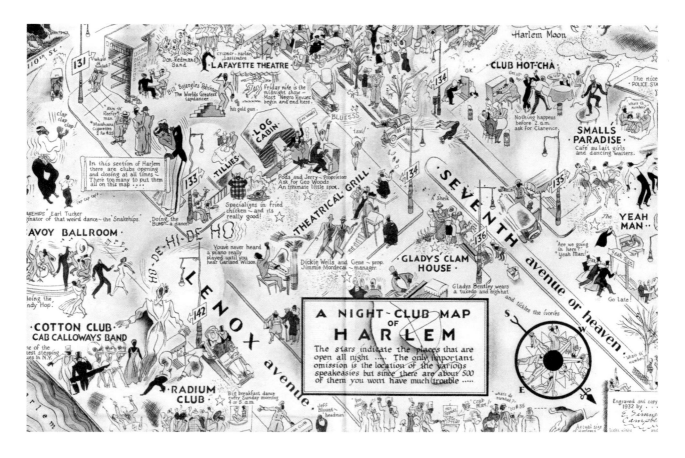

A Nightclub Map of Harlem indicating Gladys' Clam House by E. Simms Campbell, 1932.

popular venues during the Harlem Renaissance, including the Apollo Theatre, the Cotton Club, and the Ubangi Club, where her shows often included drag backup dancers. She also toured throughout the US and landed several recording contracts.

When Prohibition was repealed, Harlem speakeasies fell out of favor, which likely led to the Clam House's closing. Concurrently, Bentley's success waned. She relocated to California, where she tried to salvage her career but failed to achieve earlier levels of popularity. Further complicating matters, US law had veered more conservative, and Bentley was frequently harassed for wearing men's clothing, at one point needing to carry special permits to perform.

By the McCarthy Era, Bentley returned to wearing dresses and swiftly claimed to have married a man in 1952. Around this time, she also studied to be a minister and penned a devastating article for *Ebony* magazine entitled "I Am a Woman Again," in which she claimed to have been "cured" of homosexuality after taking female hormones and undergoing an operation. On January 18th, 1960, Bentley died unexpectedly of pneumonia at her home in Los Angeles, aged 52. Despite the tragic latter half of her life, she is now lionized by the LGBTQ+ community, seen as an early, visibly queer Black woman and a pioneer for drag kings.

EVE'S HANGOUT

129 MACDOUGAL STREET
NEW YORK, NY 10012

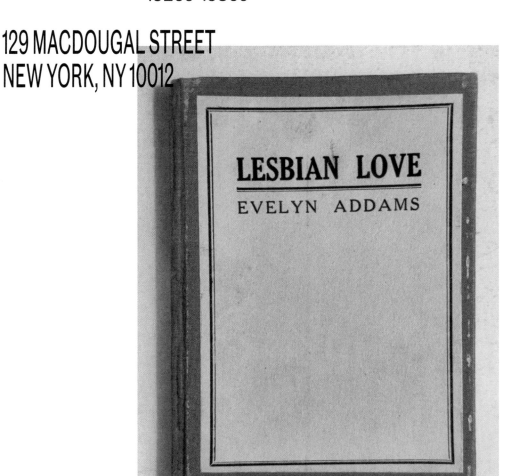

The only known original copy of Eve Adams' *Lesbian Love*, written under a stylized pseudonym.

In 1924, Polish-Jewish émigré and radical lesbian Eve Adams (born Chawa Złoczower) opened a tearoom in the basement of 129 MacDougal Street in Greenwich Village. Often cited as one of NYC's earliest lesbian bars (though it served no alcohol and allowed in other folks), the venue has over the years been referred to as Eve Adams' Tearoom, Eve and Ann's, Eve's Place, and most frequently, Eve's Hangout. In June 1926, Robert Edwards, a frequent Adams antagonist, described the Hangout in his conservative newspaper, the *Greenwich Village Quill*, as a place "where ladies prefer each other. Not very healthy for the she-adolescents nor comfortable for he-men."

Adams was born in 1891 in Mława, Poland, and arrived in America in 1912 as a politically fervent youth. She became known around Greenwich Village for wearing pantsuits and an androgynous bob. In 1924, she opened her small, dimly lit tearoom in the cellar of a row house that instantly became a popular destination for lesbians and gay men to meet. At the time, *Variety* magazine noted—possibly falsely—that the tearoom's entrance even displayed a sign that read "Men are admitted, but not welcome."

Early in 1925, Adams published the groundbreaking book *Lesbian Love*, one of the first works of American lesbian literature. The following year, she was arrested and convicted of obscenity for publishing the book, and on other morality charges. After a series of deportation hearings, she was sent back to Poland in 1927, and Eve's Hangout was forced to close. By 1930, Adams was living in Paris, hawking forbidden books and

erotic literature. In 1933, she met Hella Olstein Soldner, with whom she formed an incredibly close bond. When the Nazis ascended to power, Adams wrote to several US friends in the hopes of escaping Europe, but to no avail. In 1943, she and Soldner were arrested and shipped to Auschwitz. Neither would survive the war.

Over fifty years later, a college student found a green clothbound book in the lobby of her apartment building, discovered to be the only extant copy of *Lesbian Love*. In one section, entitled "How I Found Myself," Adams chronicles an early encounter with another woman: "She only smiled and drowned all my fears with her kisses and ardent caresses...I didn't know where I was or what happened to me—it was a thing too sublime to give an account of...All that I know is that it was one of the greatest and most significant events of my life, which will never be forgotten, and that the memories are always just beautiful."

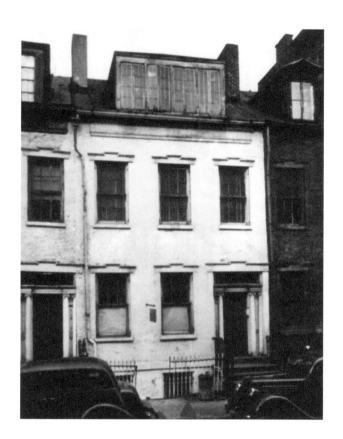

129 MacDougal Street, the basement of which housed Eve's Hangout, photographed in 1939.

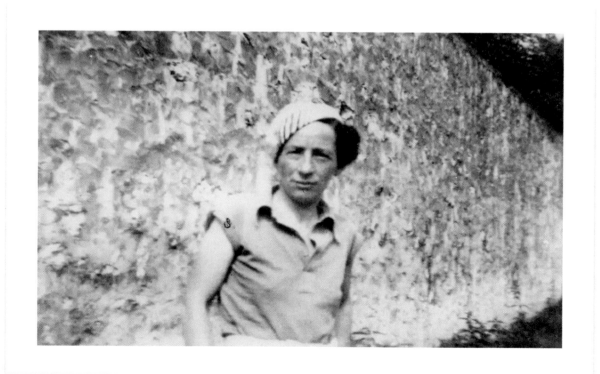

Eve Adams in Paris, 1934.

1920s–1930s

CENTRAL PARK

79TH STREET TRANSVERSE
NEW YORK, NY 10024

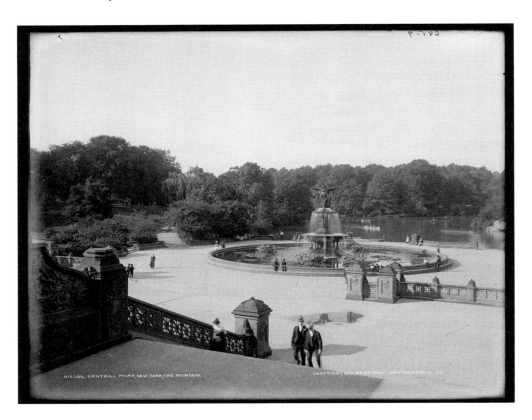

Bethesda Fountain, circa 1901.

Nearly since its creation in 1857, Central Park has had numerous vital affiliations with the LGBTQ+ community. One of the earliest came in 1873 with the commission of the Bethesda Fountain, a sculpture "dedicated to love," according to the Parks Department. Its designer, Emma Stebbins, took this quite literally and is said to have modeled the statue after her lover, actress Charlotte Cushman. Stebbins' statue is also notable for being the earliest public artwork by a woman in New York City.

With the turn of the 20th century, Central Park became a major social center and cruising ground for the queer community, particularly near Belvedere Castle and the benches by Columbus Circle. By the 1920s, the lawn at the upper end of the Ramble, an area north of The Lake, had become the primary homosexual hotspot, earning it the nickname "the Fruited Plain." Other spots in the park soon became popular with gay men too, including areas near the 72nd Street Transverse and the southeast walkway to the Mall, dubbed "Vaseline Alley" or "Bitches' Walk" due to its concentration of loitering homosexuals.

To counter the rise in homoerotic activities, police were sent into the park as early as 1921 to entrap and arrest gay men for "lewd activities," a practice which would continue for many decades. Over the years, a number of notable individuals would be caught cruising there, including future gay rights leader Harvey Milk in 1947. (Despite the numerous arrests and gay bashings, the Ramble remains a favored spot for cruising and outdoor sex to this day.)

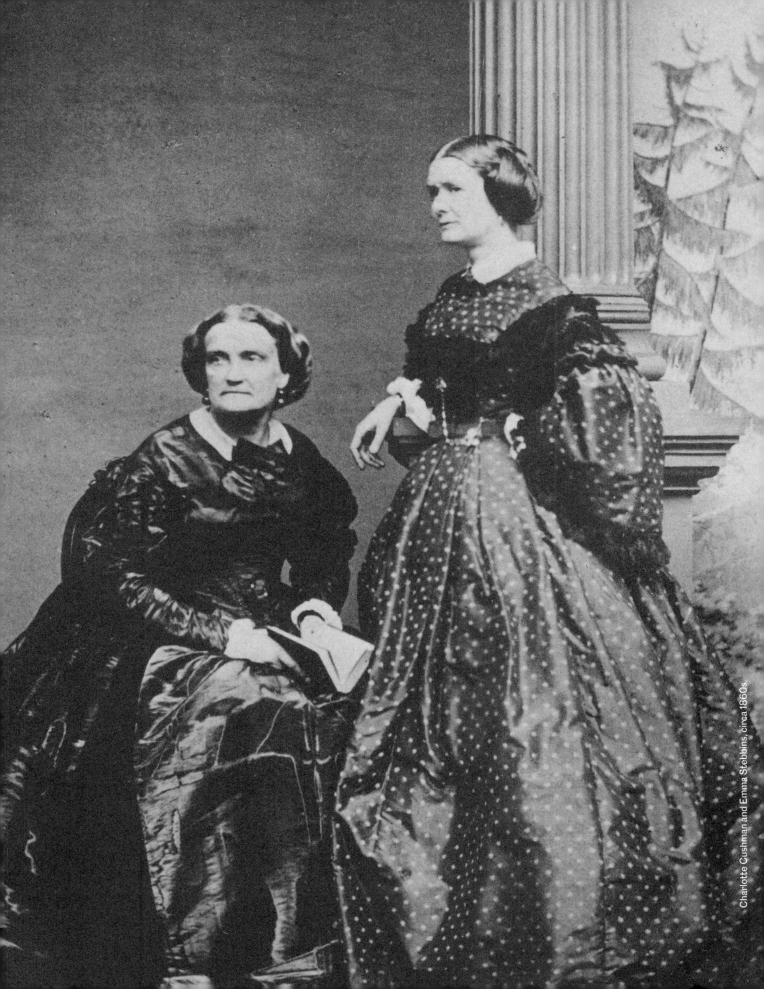
Charlotte Cushman and Emma Stebbins, circa 1860s.

1920s–1930s

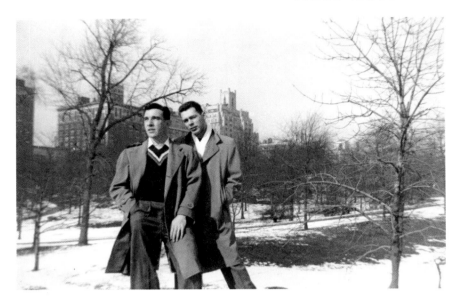

Couple Roger Pegram and Frank Bushong in Central Park, 1951.

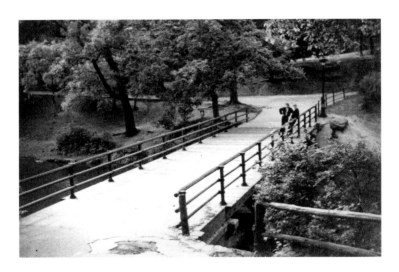

Two men stand flirtatiously on a bridge in the Ramble, circa 1950s.

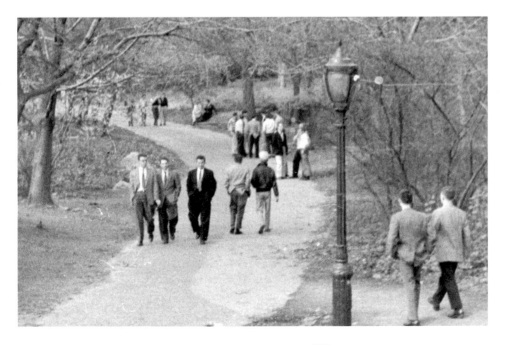

Cruising in the Ramble, circa 1950s.

Central Park

Central Park has also played other vital roles in LGBTQ+ history. In 1970, on the first anniversary of the Stonewall Uprising (see p. 92), a march celebrating Christopher Street Liberation Day set out from Greenwich Village, culminating in a "gay-in" held at the park's Sheep Meadow. This became an annual event, now known as the Pride March (see p. 102). For two decades, the parade routed through Central Park, before it was moved to end on Christopher Street in the West Village.

During the AIDS crisis, the park served as a stage for several important demonstrations. One landmark event occurred in 1989, when organizers unfurled 1,696 panels of the AIDS Memorial Quilt on the Great Lawn, reading out countless names of victims of the disease. The park's role in the fight against AIDS continues today with AIDS Walk New York, which is the world's largest single-day AIDS fundraiser and has been held since 1986.

In recent years, the legalization of same-sex marriage has made Central Park a destination for countless gay proposals and marriage ceremonies. The park's own website even highlights this fact: "Central Park welcomes all couples, including same-sex and gender neutral, to walk down the aisle in a quintessential New York City wedding ceremony!"

From servicing on both knees to proposing on just one, queer folks have used Central Park as a shelter, haven, and mecca for over a century. The park has been a firsthand witness to how far the LGBTQ+ movement and its history have come.

> Randy Wicker, LGBTQ+ activist: "When I first came to New York City, I had never heard of gay bars. Then I read a book in which a guy sees a sailor going into a gay bar. And so I went on a hunt. I sat in the park with bright red stockings on up to here, because I wanted to make sure I looked like an obvious homosexual. Sure enough, I got picked up and then that guy introduced me to the first gay bar I ever went to, called Lenny's Hideaway, one of the most transformative experiences of my life."

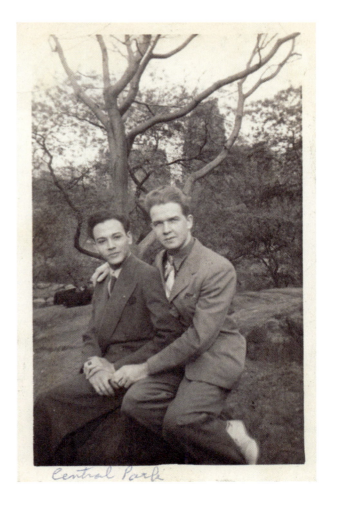

Two gay men in Central Park, circa 1940.

1920s–1930s

HAMILTON LODGE BALL @ ROCKLAND PALACE

280 WEST 155TH STREET
NEW YORK, NY 10039

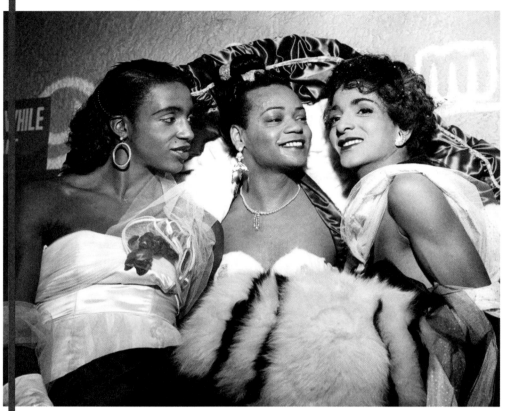

Funmakers' Ball participants Eddie Mcclennon, Bobbie Laney (first place winner for Best Costume), and Toni Evans, 1954.

Located at 280 West 155th Street, Harlem's Rockland Palace opened in 1844 as a venue for affluent Black people to hold political events and large social gatherings. In 1869, it made history when it hosted its first Masquerade and Civic Ball, considered the earliest documented drag ball in the United States. Originally organized by straight men, the Hamilton Lodge Ball was held annually and became an important space where queer individuals could parade publicly in drag. Informally called the Faggots Ball and the Dance of the Fairies, the event quickly grew in popularity (one newspaper article from 1886 described it as "the event of the season").

By the 1920s, the Hamilton Lodge Ball drew thousands of spectators. A 1939 essay by playwright Abram Hill detailing it mentions that the Faggots Ball attracted "effeminate men, sissies, 'wolves,' 'ferries,' 'faggots,' the third sex, 'ladies of the night,' and male prostitutes," who "got together for a grand jamboree of dancing, love making, display, rivalry, drinking and advertisement." Hill also noted that the lavish affair ended with the awarding of prizes for "the most beautiful gown and the most perfect feminine body displayed by an impersonator."

Hamilton Lodge Balls were also ahead of their time in that they were racially integrated, though Black participants still often felt discriminated against. (In 1936, however, a Black drag queen named Jean La Marr took home the top prize for the first time in the ball's nearly 70-year history.) The balls attracted a plethora of notable queer spectators, including actors, singers, artists, and writers like

Hamilton Lodge Ball @ Rockland Palace

Ethel Waters, Clifton Webb, Tallulah Bankhead, Max Ewing, and Langston Hughes, many of whom wrote about their experiences there.

Despite exhaustive efforts by the police and conservative reformers, the Hamilton Lodge Balls remained extremely popular throughout the 1920s. By the mid-1930s, backlash was gaining traction, and Rockland Palace held its final Hamilton Lodge Ball in 1937. A decade later, drag balls would resume once more at Rockland with the Funmakers' Ball, which occurred there annually for over ten years. By the 1960s, Rockland Palace transitioned into a concert venue for artists like James Brown and Aretha Franklin, and the building was ultimately demolished in the early 1970s. The formerly venerable space is now a parking lot.

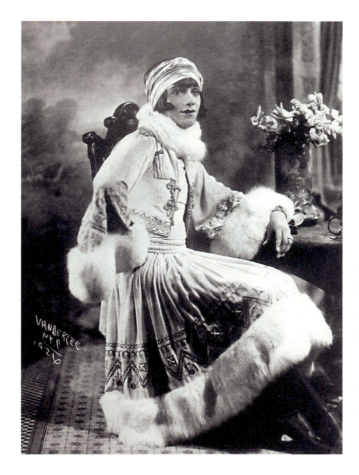

Top: Contestant/attendee at Hamilton Lodge's annual Masquerade & Civic Ball, 1926.

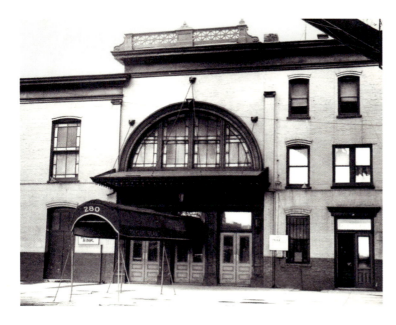

Bottom Left: Exterior of Rockland Palace, home to the annual Hamilton Lodge Ball, circa 1920.

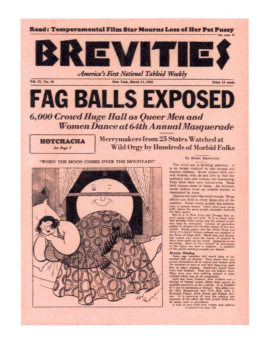

Bottom Right: *Broadway Brevities* coverage of Rockland Palace balls, 1932.

STEWART'S CAFETERIA

116 SEVENTH AVENUE SOUTH
NEW YORK, NY 10014

1920s–1930s

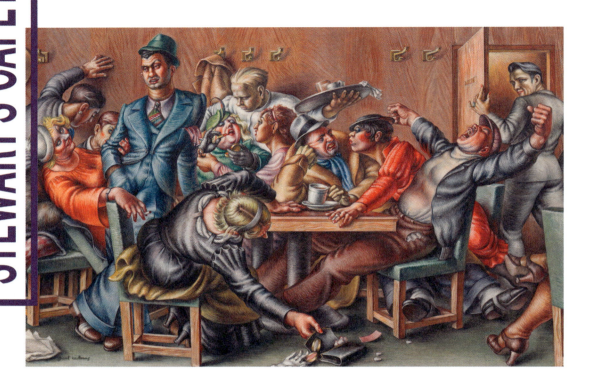

Paul Cadmus' *Greenwich Village Cafeteria*, 1934.

In 1933, a popular cafeteria chain named Stewart's opened a location on the ground floor of the Art Deco building at 116 Seventh Avenue South. Given its prime spot in the heart of Greenwich Village, the restaurant attracted a predominantly bohemian crowd, including many gay and lesbian customers. A 1934 *New Yorker* review of Stewart's made numerous sly references to the venue's queer crowd: "These people are not really of the proletariat. They come in swarms. They are all young. They are chorus men from the big musical shows further uptown…if you cannot be it, at least you can walk like it. Let the hair grow long. Wear a beard. If you are a woman, be mannish. Walk with a stride…here you may see, at first hand, a certain side of city life."

A 1933 edition of *Broadway Brevities* was far more explicit, calling Stewart's "a gathering spot for that nocturnal clan, the third sexers. Dykes, fags, pansies, lesbians, and others of that unfortunate ilk convene there nightly, parading their petty jealousies and affairs of the heart."

Open almost 24/7, Stewart's served as an ideal space for social gathering, offering reasonably priced food and ample opportunity for patrons to mingle, drink, and lounge around for extended periods of time. It also featured glass windows facing out onto busy Seventh Avenue, making clientele constantly visible to passersby. Stewart's was thus unique for its time in fostering an environment where gay social life was put on display, a stark contrast from covert LGBTQ+ spaces that were otherwise the norm.

Stewart's Cafeteria

In 1934, gay artist and Stewart's regular Paul Cadmus depicted the venue's debauched setting in his painting, *Greenwich Village Cafeteria*. One notable figure is a man in red nail polish and lipstick furtively glancing backwards as he enters the men's bathroom. In 1935, the manager of Stewart's was convicted of operating a "public nuisance" and "disorderly house" for allowing questionable behavior to take place inside the cafeteria. Accusations called Stewart's "a rendezvous for perverts, degenerates, homosexuals and other evil-disposed persons."

Although Stewart's closed after the conviction, it quickly reopened under the new name Life Cafeteria. It too attracted a queer crowd, including Tennessee Williams and Marlon Brando. After Life's closure, the venue was subdivided but continued to house several more institutions popular with the LGBTQ+ community, including the Sheridan Square Gym during the 1960s and Tiffany Diner from the 1970s until 2001. The space is now occupied by a branch of Bank of America, which at the very least sponsors a massive float each year at the Pride March.

Portrait of painter Paul Cadmus, 1938.

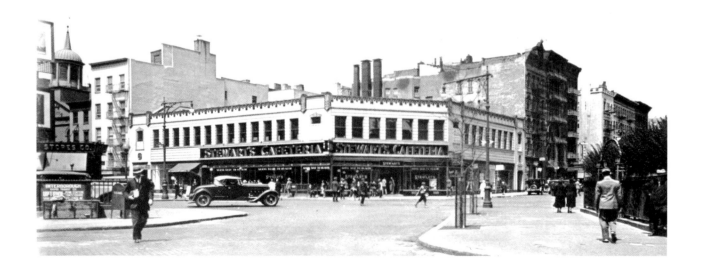

Stewart's Cafeteria exterior, 1933.

1920s–1930s

HOWDY CLUB

47 WEST 3RD STREET
NEW YORK, NY 10012

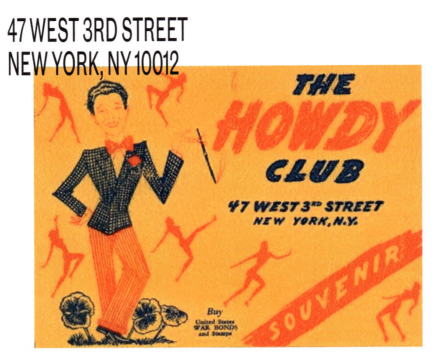

Howdy Club souvenir flyer, 1930s.

Opened in 1935, the Howdy Club, whose tagline read "Where the Village Begins and Ends," was owned and operated by the notorious Genovese crime family. Located at 47 West 3rd Street in Greenwich Village, the club quickly became a popular hangout for lesbian and queer women in particular, though it also attracted other LGBTQ+ folks and straight audiences.

The Howdy Club (also called Club Howdy or the Howdy Revue) staged three variety shows a night filled with male and female impersonators, while patrons were served by a primarily female waitstaff dressed in male uniforms. A 1940 postcard features some of these waitresses in male drag: collegiate-style football jerseys that spell out the word H-O-W-D-Y. In 1936, a *New York Post* article described the club as "the Village at its strangest—and not for the squeamish."

One of the leading performers at the Howdy Club was male impersonator Blackie Dennis, who would wear tuxedos or sharp suits while crooning to the audience, particularly to the ladies. Other distinguished performers included the "burlesque tease artist" Red Tova Halem, lesbian stripper Toni Bennett, Errol Flynn look-alike Gail Williams, and dancer/entertainer Clover Fern Mamone. Most of the male performers flaunted a combination of feathers, sequins, satin, and lace, and came out looking like Marlene Dietrich, Rita Hayworth, or other starlets of the time.

As a mob-owned venue, the Howdy Club was under frequent scrutiny, particularly by the city's watchful mayor Fiorello La Guardia, who was bent on closing spaces with "questionable values." In 1944, the club was the target of a sting and shut down on "morality charges" due to the presence of a "man with feminine characteristics." Despite its quick end, the Howdy Club served as a significant early venue in New York City specializing in drag performances. As a space where queer women congregated during a time when the law typically barred women from gathering at drinking establishments, the Howdy Club was a vital precursor to what today might be considered a lesbian bar.

Howdy Club

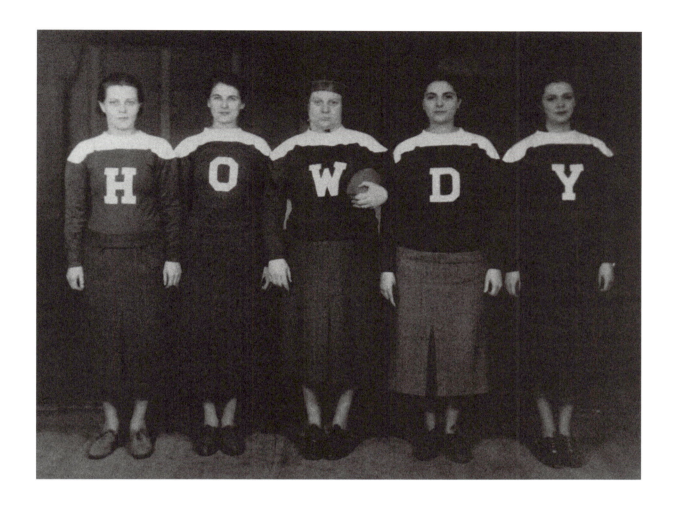

Top: Postcard with Howdy waitresses in male football drag, 1940.

Bottom Left: Howdy Club performer Blackie Dennis, 1937.

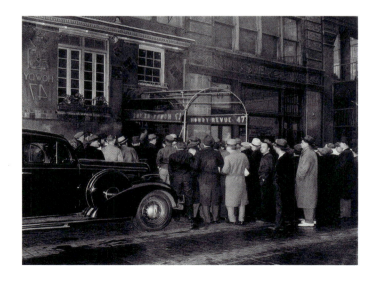

Bottom Right: The Howdy exterior, 1930s.

JIMMIE DANIELS' NIGHTCLUB

114 WEST 116TH STREET
NEW YORK, NY 10026

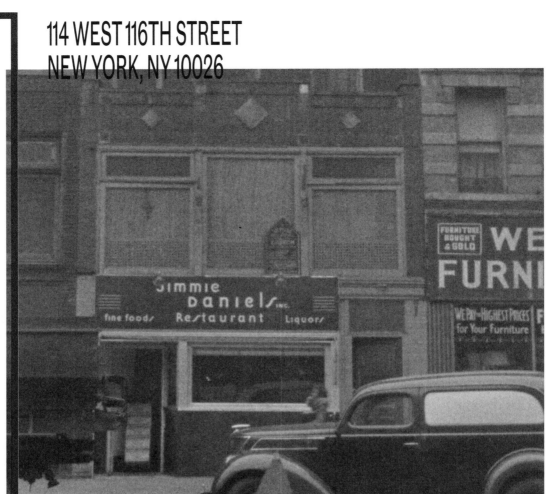

Jimmie Daniels' Nightclub exterior, 1939.

A key figure during the Harlem Renaissance, James "Jimmie" Lesley Daniels was a cabaret artist, actor, and model who performed across the world. In 1939, he opened a popular supper club named after himself at 114 West 116th Street in Harlem. The restaurant and nightclub hybrid was immediately successful thanks to his loyal fanbase as a performer and attracted Black, white, gay, and straight local celebrities, many of whom were members of high society or involved with the arts.

Daniels moved to NYC in the 1920s to pursue a career in theater and landed his first Broadway role in 1930. But parts for Black actors were limited, and he consequently started working as a cabaret singer at various nightclubs, including the famous Hot Cha Club in Harlem. He soon became a big name in Harlem nightlife and beyond, performing at nightclubs in Paris, London, and even Monaco.

When Daniels opened his club, it was considered a sophisticated establishment that attracted many well-known LGBTQ+ individuals, including poet Claude McKay, photographer Berenice Abbott, writer/photographer Carl Van Vechten, socialite Olivia Wyndham, and actress Edna Thomas. Daniels himself was quite open about his sexuality and was an icon in the neighborhood's vibrant gay scene. During his lifetime, he engaged in several public relationships with men, including architect Philip Johnson and filmmaker Kenneth Macpherson.

Jimmie Daniels' Nightclub could hold about 75 patrons and featured two grand pianos typically played

Jimmie Daniels' Nightclub

by jazz musicians. The *New York Amsterdam News*, a leading Black Harlem-based newspaper, called it "one of the most pleasant evening lounging spots in Harlem." Daniels managed the club until 1942, when he enlisted in the army. During World War II, he frequently performed for the troops.

When he returned to New York after the war, he became the lead performer at the Bon Soir in Greenwich Village, a refined nightclub that also attracted a mixed clientele, while sharing a home with his lover, fashion designer Rex Madsen. Daniels continued to organize parties, manage clubs, and perform throughout the '60s and '70s, including at the Blue Whale Bar in Fire Island Pines, New York's gay summer mecca, and the Tiffany Room (now Ice Palace) in Cherry Grove. He died on June 29, 1984, just days after performing at Carnegie Hall.

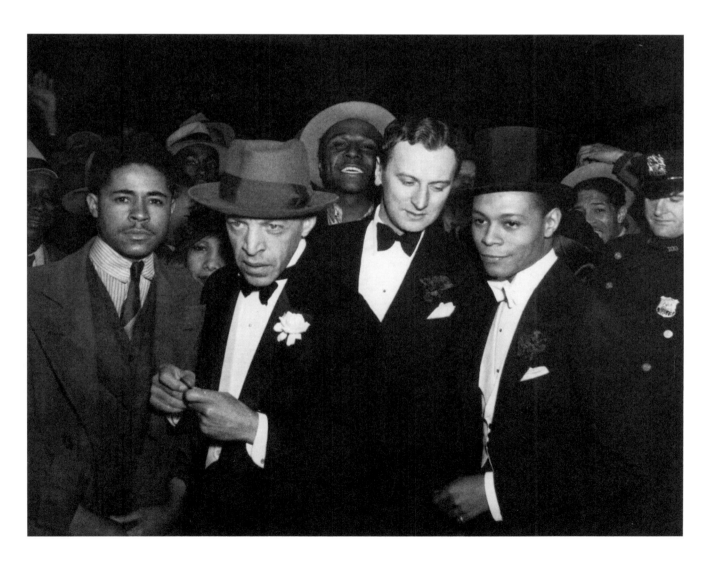

Kenneth Macpherson and Jimmie Daniels on the right, 1936.

- JEWEL BOX REVUE
- THE MATTACHINE SOCIETY & DAUGHTERS OF BILITIS OFFICES
- WOMEN'S HOUSE OF DETENTION
- CLUB 181
- ST. MARKS BATHS
- CAFFE CINO
- SAN REMO CAFÉ
- CLUB 82

1940s-1950s
A LAVENDER LANDSCAPE

1940s–1950s

BEATNIKS, CLASSIC DRAG REVUES, AND THE EARLY HOMOPHILE MOVEMENT

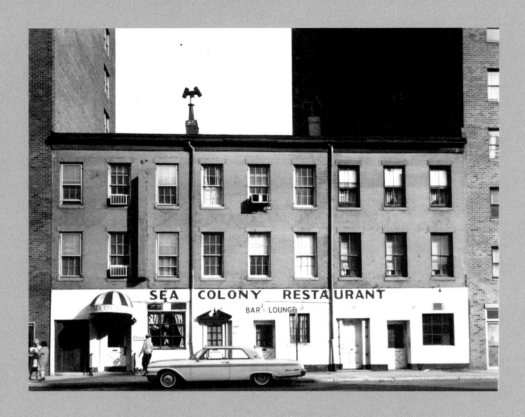

Sea Colony in Greenwich Village was one of the city's most popular lesbian hangouts in the 1950s.

By 1940, the threat of World War II loomed large over the US. As the war progressed, it had an indelible effect on all Americans, not least LGBTQ+ folks—for better and for worse. As early as May 1941, before the US had officially entered the war, the Army Surgeon General's office issued a circular that classified "homosexual proclivities" as grounds for exclusion from the military. As a result, many queer individuals would go to great lengths to conceal their same-sex attractions in order to serve their country, while some men intentionally turned on their "swishiness" to get out of it entirely. Of the 18 million men examined for military duty, nearly 5,000 were barred due to presumed homosexual orientation. While no official records were kept on the exclusion of lesbians from the Women's Army Corps, lesbianism was later determined to have been quite common. Many men after the war would also remark on their surprise at the prevalence of homosexuality they encountered while serving in the army.

World War II brought together a large concentration of men from different places and backgrounds, allowing more gay men to meet others like themselves than ever before. Meanwhile, women who volunteered to serve, or who worked together in factories, forged their own same-sex relationships. For those who had previously felt alone, the war fostered a sense of shared identity. This trend continued once the war was over, when many LGBTQ+ veterans chose to remain in major urban areas like San Francisco and New York to form enclaves where they could have greater freedom and face less discrimination.

During the war itself, however, military policies grew increasingly harsh against homosexuality, leading to investigations, dishonorable discharges, and other punitive measures. Anyone issued "blue tickets"—discharges for "undesirable habits and traits of character"—would be denied valuable G.I. Bill benefits once the war ended. To fight these injustices, a band of gay veterans in New York City formed the Veterans Benevolent Association, one of the earliest incorporated LGBTQ+ groups. Despite these and other protests, in 1949, the US Department of Defense proceeded to standardize anti-homosexual regulations across all branches of the military, stating that "prompt separation of known homosexuals from the Armed Forces is mandatory." Over the course of a few years, thousands of gay men and women were thus discharged.

Picture-perfect conformity reigned supreme in America during the late 1940s and early 1950s, when sexual deviation of any sort was demonized. Lucille Ball had to fight to show her real-life pregnancy bump on TV simply because the country was uncomfortable with the slightest implication of sexuality. For LGBTQ+ folks, the 1950s was an oppressive decade, when entrapment at gay bars was at an all-time high and the *New York Times* only mentioned homosexuals in crime reports, calling them "perverts."

During this period, the American Psychiatric Association listed homosexuality as a "sociopathic personality disturbance" in its first publication of the *Diagnostic and Statistical Manual of Mental Disorders*, which enflamed arguments that gays and lesbians were a major security risk to America. In 1953, President Eisenhower signed Executive Order 10450, establishing "sexual perversion" as legal grounds for the investigation and dismissal of federal employees. Over the next several years, Senator Joseph McCarthy and his associates set off on a ruthless campaign known as the Lavender

1940s–1950s

Scare and dismissed queer people from government service *en masse* for being national security threats. Hundreds of alleged homosexual men and women lost their jobs and livelihoods, while thousands more lived in fear of being outed. One of the most notable figures fired during the era was Frank Kameny, who was let go from the US Army Map Service in 1957. Kameny's firing incited him to become an important figure in the gay rights movement for decades to come.

Despite the rise in homophobic witch hunts, some progress did come out of this period, including several pivotal publications that would increase LGBTQ+ visibility. In 1948, Alfred Kinsey published *Sexual Behavior in the Human Male*, shocking the world by concluding that homosexual behavior was not restricted only to gay-identified men, and that at least 37 percent of males had reported engaging in homosexual activities at least once. In 1953, Kinsey followed up with his second groundbreaking report, *Sexual Behavior in the Human Female*.

Meanwhile, novelist Gore Vidal published *The City and the Pillar* in 1948, groundbreaking in its own right. According to a writeup in the *Hudson Review*: "Never before in American letters has there been such a revealing and frank discussion of the sexually maladjusted, of those of the submerged world which lives beneath the surface of normality."

Other seminal works published during this time included Donald Webster Cory's *The Homosexual in America: A Subjective Approach* (1950), hailed as one of the most important early works in the history of the gay rights movement, Evelyn Hooker's article "The Adjustment of the Male Overt Homosexual" (1956), which posited that heterosexuals and homosexuals did not significantly differ in any way, and James Baldwin's *Giovanni's Room* (1956), a controversial novel about masculinity, homosexuality, and social alienation. The Beat Movement also arose during the 1950s, with numerous writers celebrating non-conformity, homosexuality, and bisexuality. Prominent Beat writers included Allen Ginsberg, William S. Burroughs, Jack Kerouac, and Harold Norse, among others.

Alongside the Beats, notable gay, lesbian, and bisexual creatives hung around Greenwich Village at venues like the San Remo Café, Chumley's, and Minetta Tavern, including Paul Cadmus, Audre Lorde, Philip Johnson, Tennessee Williams, and countless more. In 1952, native New Yorker Christine Jorgensen became a celebrity when her highly publicized

transition brought transgender issues into the American consciousness for the first time.

The Mafia continued to play a key role in the "protection" of gay and lesbian bars in New York City, profiting off the marginalized community while paying cops to ignore the activities taking place inside its venues. This was especially true at drag-centric nightspots like Club 181, Moroccan Village, and Club 82, which employed female and male impersonators. For the most part, drag during this era was considered taboo, a form of entertainment to be ogled or laughed at. The practice of "slumming"—when well-off white New Yorkers would head downtown for entertainment by the gays—reached its peak. Most "respectable" LGBTQ+ city residents at the time would not patronize these "drag bars," and instead slyly found one another at upscale venues like the Metropolitan Opera House, the Oak Room, and the Plaza, or at more cruise-y bars near the shadowy Third Avenue elevated railway.

The hardships endured by queer people during the 1940s and 1950s contributed to the early rumblings of what became the gay rights movement. In 1950, Harry Hay co-founded the Mattachine Society, the first sustained LGBTQ+ rights group in the country. While Mattachine had some female members, the first organization specifically for lesbians was founded in 1955 under the name Daughters of Bilitis. In 1952, another key "homophile" group was formed called One, Inc., which would bring the first ever case relating to homosexuality in front of the US Supreme Court. In 1957's *One, Inc. v. Olesen,* the court ruled that One's monthly magazine was not an obscene publication and could be legally distributed. These organizations continued to grow throughout the late 1950s and would carry the movement into the next decade.

SAN REMO CAFÉ

189 BLEECKER STREET
NEW YORK, NY 10012

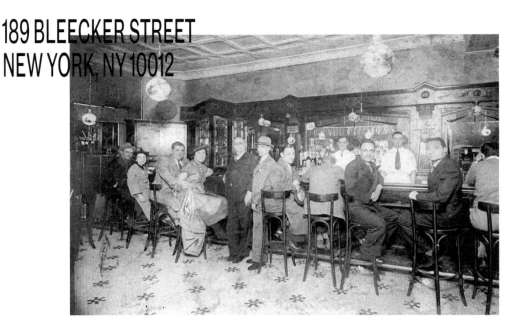

San Remo Café owner Joseph Santini Sr. and his son tend bar, circa 1930s.

Opened in 1925, the San Remo Café began as a working-class Italian restaurant and bar, but by the 1940s had evolved into a popular hangout for the bohemian and Beat crowds, many of whom were famous LGBTQ+ writers and artists. Located on the corner of Bleecker and MacDougal Streets, the mob-operated San Remo Café took up two storefronts and was sometimes listed at both 189 Bleecker and 93 MacDougal Street. Founded by Joe Santini to serve the local Italian community, the venue, which patrons affectionately dubbed "the Remo," morphed into one of the hippest hangouts in Greenwich Village for budding artists during the 1940s, alongside several other nearby businesses including the Minetta Tavern, Kettle of Fish, and the White Horse Tavern.

In its 42 years of operation, the San Remo Café served as a regular gathering space for many queer visionaries, including W. H. Auden, James Baldwin, Allen Ginsberg, William S. Burroughs, Tennessee Williams, Leonard Bernstein, Jasper Johns, Robert Rauschenberg, John Cage, and Merce Cunningham. It was also the site of several conflicting accounts regarding the relationship between two queer literary greats: Gore Vidal and Jack Kerouac. Some accounts say Vidal simply hit on Kerouac at the bar, while others state he picked him up there and took him to the Chelsea Hotel for sex. Still, other reports (including Vidal's own) say the San Remo Café itself was actually the site of a sexual encounter between the two men.

Regardless of what happened, the San Remo Café certainly affected Kerouac, who depicted the bar's crowd in *The Subterraneans*: "Hip without being slick, intelligent without being corny, they are intellectual as hell and know all about [Ezra] Pound without being pretentious or saying too much about it."

By the 1960s, the San Remo Café served a mostly gay clientele, even attracting hustlers from nearby Washington Square Park. By this time, Andy Warhol was a regular, using it as a place to ogle beautiful men and handpick several of them to join his Factory. The bar ultimately closed in 1967. On July 29, 2013, a plaque was unveiled at the site to commemorate its rich lifespan and deep ties to an extraordinary array of literary, musical, and social figureheads of the 20th century.

San Remo Café

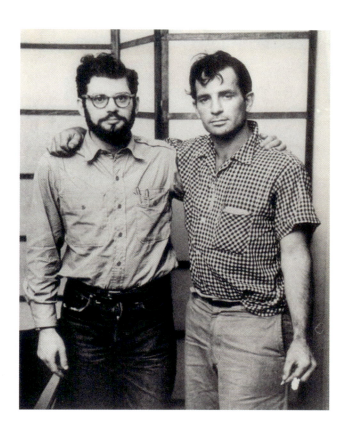

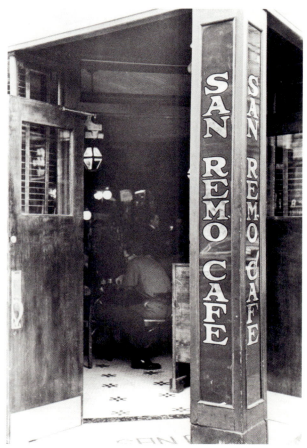

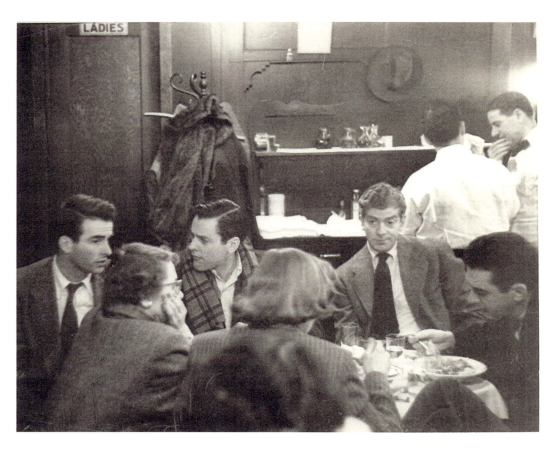

Top Left: San Remo regulars Allen Ginsberg and Jack Kerouac, 1959.

Top Right: San Remo Café exterior, 1960.

Bottom: Actor Montgomery Clift (far left) and Kevin McCarthy, along with several other unidentified diners, eat at the San Remo Café, circa 1940s.

1940s–1950s

WOMEN'S HOUSE OF DETENTION

**10 GREENWICH AVENUE
NEW YORK, NY 10011**

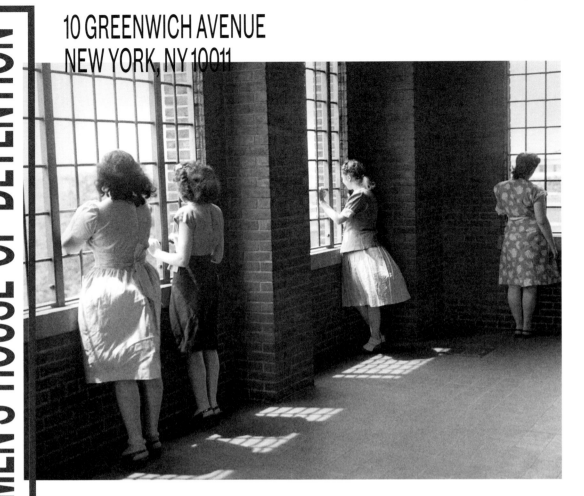

At the New York Women's House of Detention, four inmates stare out the windows, 1941.

In 1929, an eye-catching Art Deco building was constructed at 10 Greenwich Avenue and opened as the Women's House of Detention, or House of D for short, in 1932. For the next 40 years, this imposing prison in the heart of Greenwich Village incarcerated many queer women and transmasculine people. Early on, a number of the women detained at the House of D were arrested simply for being radical or non-conformist. Countless inmates were held for sexual promiscuity, sex work, or same-sex activity.

Hugh Ryan, author of *The Women's House of Detention*, estimates that by the early 1950s, 75 percent of those incarcerated in the House of D were queer in some capacity. By the 1960s, the prison began marking such prisoners with the letter "D" for "degenerate," often placing them into solitary confinement for being a "danger to other women."

While the House of D imprisoned many queer individuals, many more could be seen gathering outside the building, yelling up to their loved ones in captivity or waiting for a paramour to be released. Joan Nestle, cofounder of the Lesbian Herstory Archives, witnessed these dynamics, recalling in an *Outhistory* article: "The hot summer weekend nights that I stood and watched and listened to the pleas of lovers, butch women shouting up to the narrow-slitted windows, to hands waving handkerchiefs, to bodiless voices of love and despair…Here, my sense of a New York lesbian history began, not a closeted one, but right there on the streets."

The House of D detained many notable people over the years,

Women's House of Detention

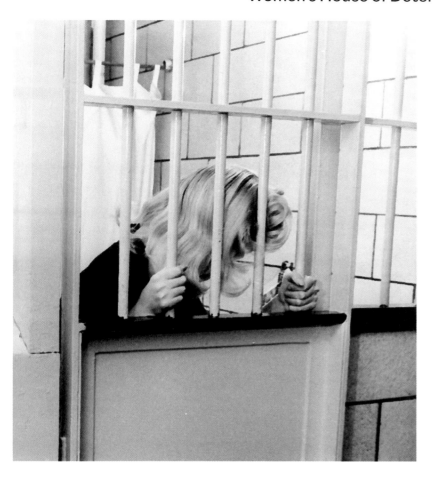

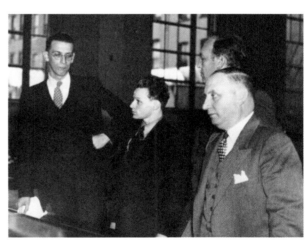

Top: A publicity still taken by the Department of Corrections at the House of Detention, 1956.

Bottom Right: Rare trial photo of a transgender person who was arrested for soliciting and sent to the House of D, 1937.

Bottom Left: Angela Davis arriving at the Women's House of Detention, 1970.

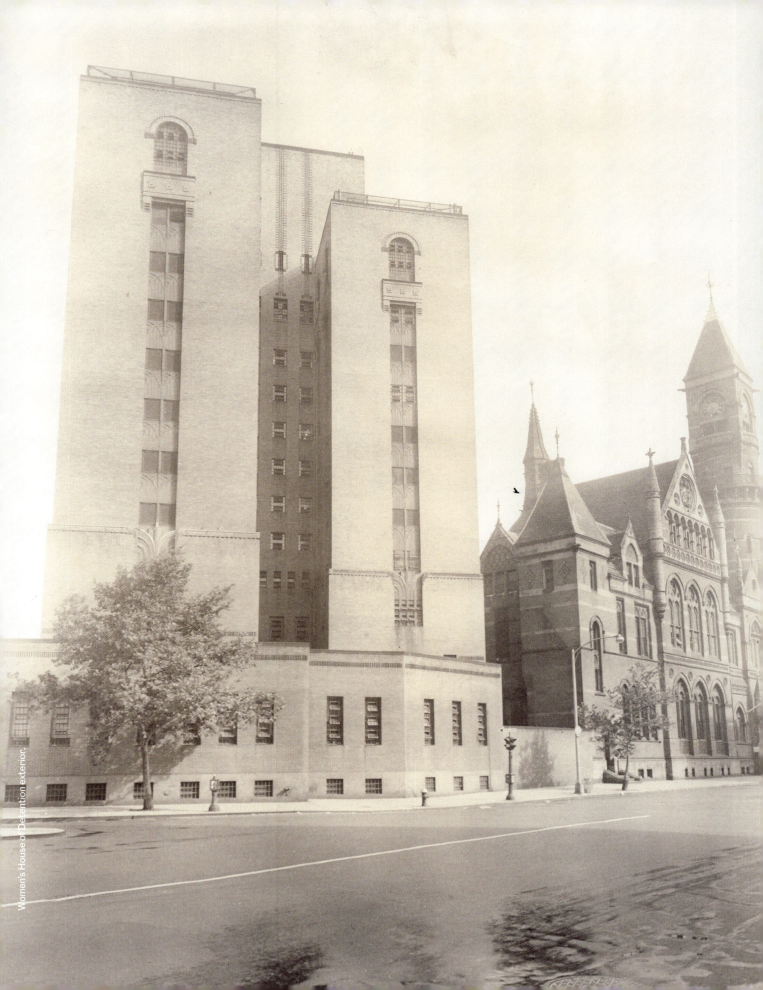

Women's House of Detention exterior.

including convicted Soviet Union spy Ethel Rosenberg, social activist and anarchist Dorothy Day, radical feminist and writer Valerie Solanas, Civil Rights activist and scholar Angela Davis, queer homeless rights activist Jay Toole, and Black Panther and activist Afeni Shakur. While many inmates were outspoken about their harsh experiences, it took one white middle-class woman named Andrea Dworkin to initiate the prison's downfall. After her detention in 1965 for protesting the Vietnam War, she publicized the violent pelvic exam she endured during her intake, shining a much-needed light on the prison's deplorable conditions.

Dworkin's testimony led to the House of D's closing in 1971, but not before the building and its prisoners were witness to the 1969 Stonewall Uprising, which took place just 500 feet [152 meters] away. Upon seeing the turmoil below, inmates ignited an uprising of their own, setting fire to belongings and throwing them into the street while chanting "Gay rights!"

Following its closure, the House of D was fully demolished in 1974. In its place, a committee of neighboring residents planted a community garden where visitors today can sit among roses and tulips. Lesbian author and activist Audre Lorde eulogized the House of Detention in her writing as "a defiant pocket of female resistance, ever-present as a reminder of possibility, as well as [of] punishment."

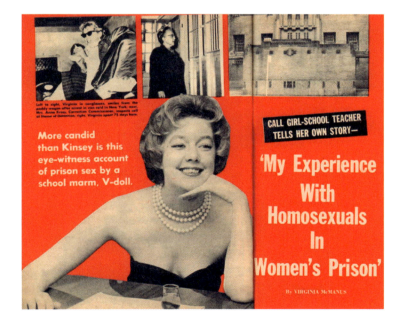

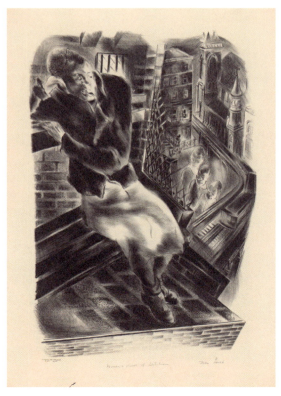

Left: Exposé on life in the House of D by Virginia McManus, who was arrested as a "call girl," for *Confidential Magazine*, 1958.

Right: Nan Lurie, *Women's House of Detention*, circa 1935–43.

JEWEL BOX REVUE

110 WEST 44TH STREET (HEADQUARTERS) NEW YORK, NY 10036

The Jewel Box Revue was a groundbreaking, racially inclusive traveling show of female impersonators (and one male impersonator) founded by gay lovers Danny Brown and Doc Benner in 1939. According to drag historian Elyssa Maxx Goodman in *Glitter and Concrete: A Cultural History of Drag in New York*, Brown and Benner cleverly positioned gender impersonation as a respectable art form when public queer gathering was considered illegal, and they "succeeded in reframing drag, allowing it to occupy an active space in mainstream culture while employing a large, rotating cast of queer performers."

Often referred to as "America's First Gay Community," the Jewel Box Revue debuted in a Miami nightclub called the Jewel Box as a small drag show featuring enchanting acts of female impersonation to primarily straight audiences. It included a live orchestra, singing, dancing, burlesque, comedy, and even magic. After early success, Brown and Benner took the revue on the road in 1941, dazzling crowds across the continent at a time when drag was often reduced to cheap punchlines in popular culture. Performing in venues as far as New Mexico and Ontario, the show was seminal in helping legitimize the art of female impersonation, and its performances were major hits with crowds otherwise less accepting of LGBTQ+ folks.

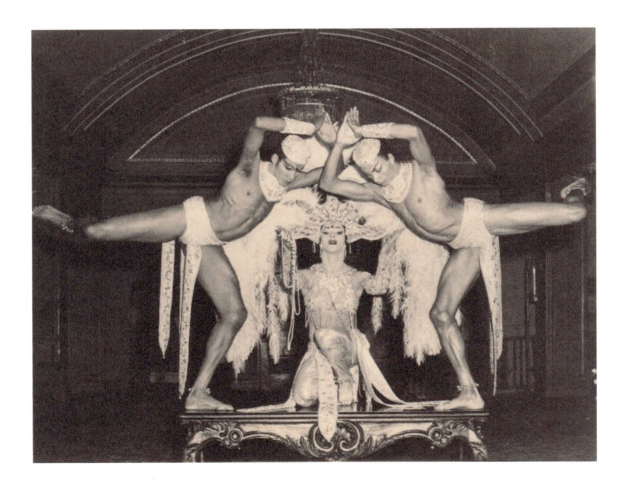

Jewel Box Revue performers Ted Duncan, Chunga Ochoa, and Ward Fleming, circa 1960.

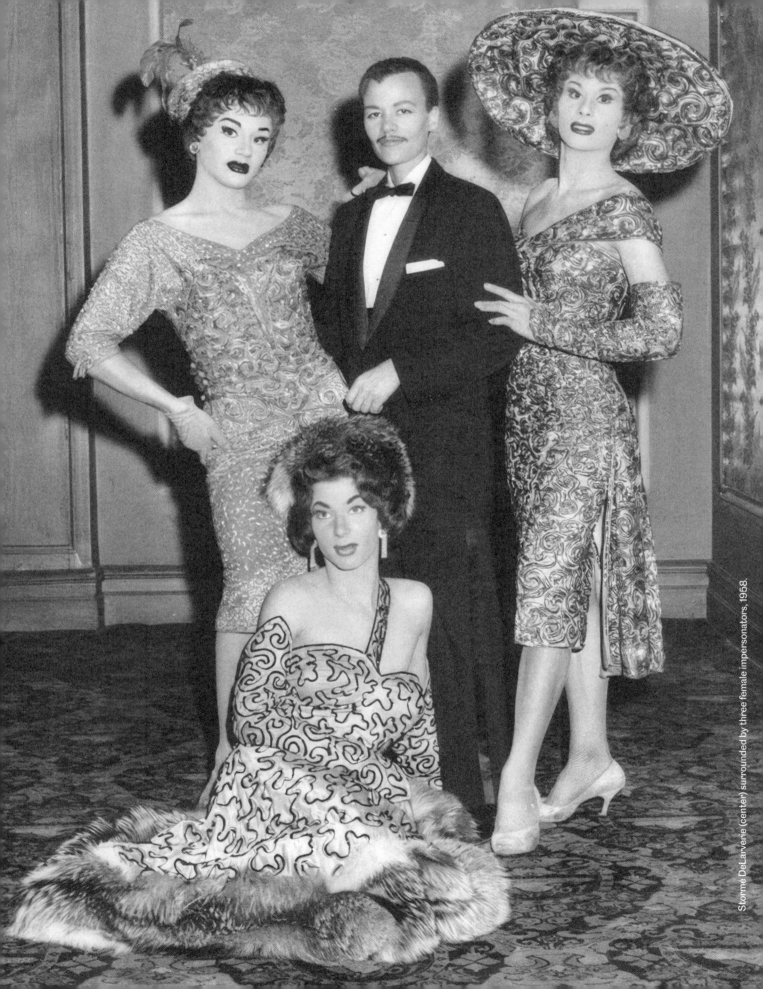

Stormé DeLarverie (center) surrounded by three female impersonators, 1958.

1940s–1950s

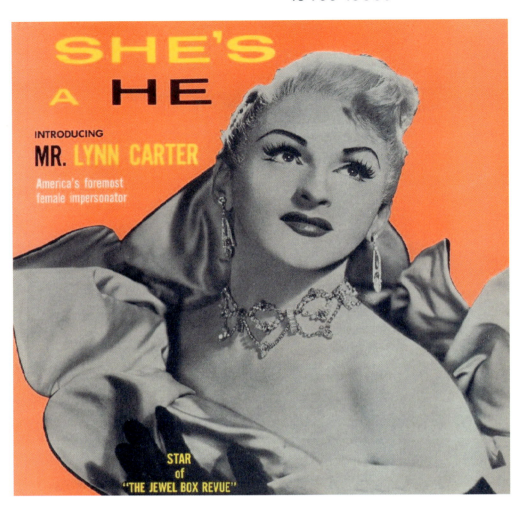

Lynn Carter, performer, 1957.

Despite some expected backlash, the company was able to travel and perform for more than three decades, exclusively employing gay men, some of whom would be considered transgender today, and at least one biracial butch lesbian named Stormé DeLarverie, one of the most well-known performers to come out of the revue. In New York City, the Jewel Box Revue performed at prominent venues including the Loew's State Theatre, Brooklyn's Town and Country, and even at the historic Apollo, where the show at one point had a long-term residency.

While the Jewel Box was not the only drag venture at the time, it was distinguished from its primarily mob-owned and heterosexual-run competitors by being both a gay-owned and gay-operated business. Brown and Benner were effeminate former lovers who even brought their own mothers on tour to serve as costume makers for the queens. One program for the Revue proudly touted its co-founders as "Boy-ological Experts!" who have "discovered and sponsored innumerable young men who have achieved stardom through their critical encouragement and interest."

The company continued putting on shows well into the 1970s, when prejudice against old-school gender impersonation began to grow. By that time its primary venue was the Apollo, and Civil Rights activists started boycotting performances there, stating the Jewel Box was promoting homosexuality in the Black community. After over 30 years as a successful traveling drag troupe, the Jewel Box Revue and its performers took their last bow in New York in 1975.

Jewel Box Revue

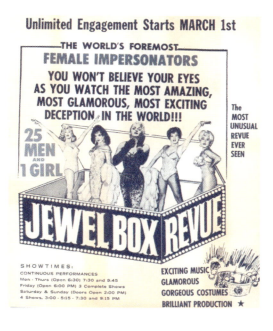

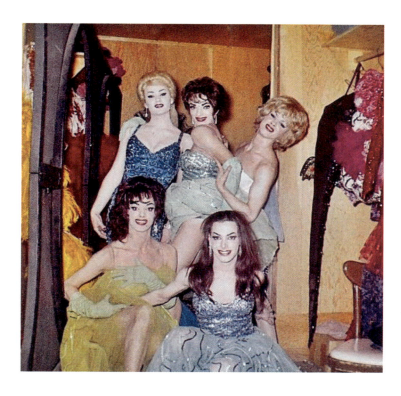

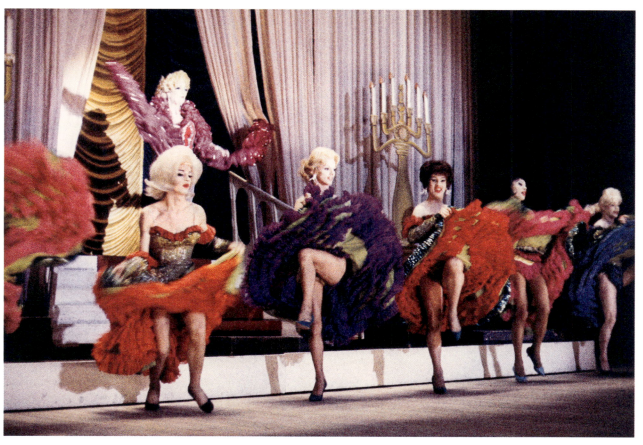

Top Left: Jewel Box Revue ad, circa 1967.

Top Right: Jewel Box Revue performers, circa 1960.

Bottom: Dancing onstage in drag at the Jewel Box Revue, 1962.

1940s–1950s

ST. MARKS BATHS

**6 ST. MARKS PLACE
NEW YORK, NY 10003**

Registration desk, circa 1983.

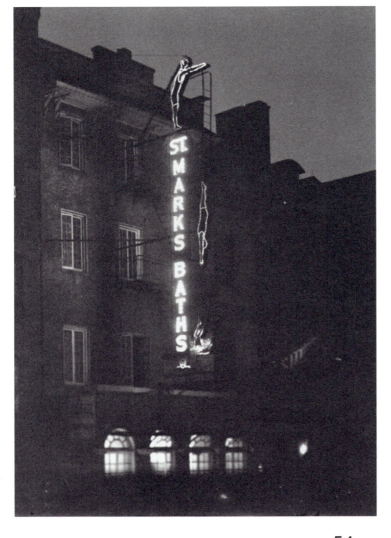

Original St. Marks Baths sign, 1917.

The St. Marks Baths first opened circa 1906 at 6 St. Marks Place in the East Village, intended as a center of hygiene for the local male immigrant population whose apartments lacked running hot water. Beginning in the 1950s, the bathhouse was taken over by gay men at night, though still used by the immigrant community during the day. By the early '60s, it had evolved into an exclusively gay venue, despite being rundown and considered unclean and uninviting.

In Ada Calhoun's book *St. Marks Is Dead*, a nearby resident recalls the bathhouse as a gay sex mecca: "It was before AIDS. Everything was different…[It] looked like a dorm room with iron beds—like fifty beds. I would look in the window and the guys would wave. It was always crowded."

In 1965, the historic, low-budget short film *Vapors*, directed by Andy Milligan and written by Hope Stanbury, portrayed a group of gay men over the course of one night at the St. Marks Baths. The set was made up to showcase the dilapidated aesthetic of the venue, including its scratched-up, graffitied walls.

St. Marks Baths

The St. Marks Baths began marketing exclusively to a gay clientele in 1979, when entrepreneur and off-Broadway theater founder Bruce Mailman purchased the building and completely refurbished the interior into a sleek and stylish destination. When it reopened, it was re-christened "the New St. Marks Baths" and promoted as the largest bathhouse in the country. Now open 24/7, the Baths included a café, pools and saunas, communal showers, and a dark barracks-style space intended for anonymous sex. Its upper floors contained 162 rentable cubicles, each with a platform bed.

After the massive overhaul, the Baths boomed in popularity, particularly among white, middle- and upper-class gay men, many of whom would pop in after a night of dancing at nearby gay discotheques like 12 West (see p. 122) or the Flamingo. Mailman observed this trend and opened his own gay megaclub just a few blocks away in 1980 called the Saint (see p. 158), which became one of the most popular nightclubs of the decade.

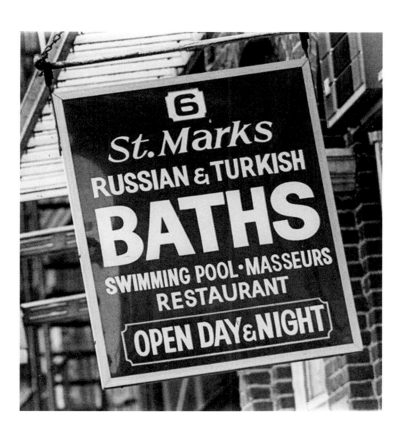
Exterior signage, 1976.

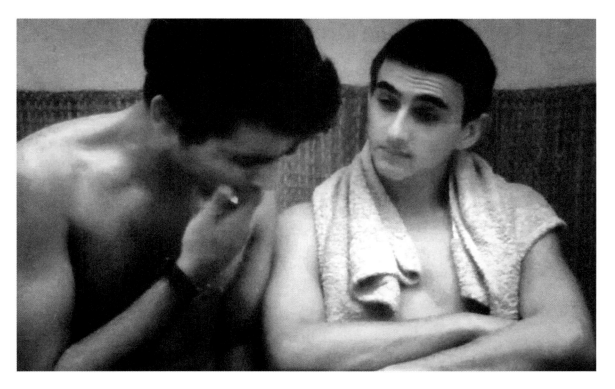
Men at the bathhouse, circa 1950s.

1940s–1950s

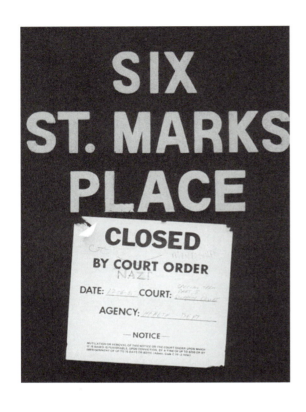

Left: Closed by court order sign on St. Marks Baths' door, 1985.

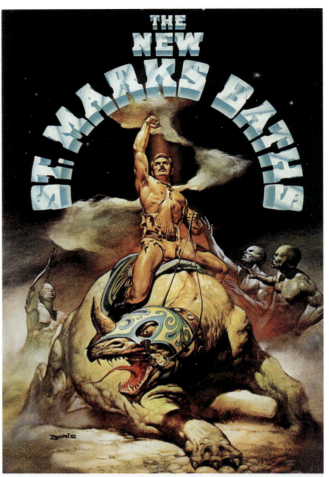

Right: Poster for the newly-reopened baths, circa 1978–80.

By 1982, AIDS began taking a grave toll among Mailman's patrons. As awareness grew, many argued that bathhouses encouraged unsafe sex, and pressure mounted to close the New St. Marks Baths. During these early years of the epidemic, Mailman became a central figure in the battle to keep bathhouses open, arguing that they were essential for safe-sex education and their closure would not stop unsafe practices elsewhere. The New St. Marks Baths began distributing safe-sex pamphlets and condoms in envelopes that read "This Could Save Your Life," as well as requiring signed safe-sex pledges upon entry.

The New York City Health Department ultimately ignored Mailman, ordering the closure of all bathhouses in 1985. Susan Tomkin, Mailman's longtime assistant, recalled in Patrick Moore's book *Beyond Shame* that Mailman "didn't want to close it. The community didn't want to close it…When they came to close the Baths down, there was no lock for the door. The Baths had never been shut since the day it opened."

After the Baths ultimately closed on December 7, 1985, the building stood vacant while Mailman spent years fighting in court to get it reopened. In 1994, he would die from complications related to AIDS, at age 55. Most gay bathhouses in New York would never reopen. Shortly after Mailman's death, 6 St. Marks Place turned into Kim's Video, a legendary movie rental store, and now houses an arcade game bar and a martial arts studio.

St. Marks Baths

Lockers, 1993.

Jay Blotcher, St. Marks Baths employee: "The first night I worked at the Baths I was a towel boy, which meant I stood at the third-floor entrance with a freshly laundered white towel over my left arm while in my right hand was a little paper cup that held a dollop of lube. Guys would come upstairs after checking in, give me their key, and I'd find their rented cubicle, open its door with great flourish, and hand them the lube and towel. Then I'd go back to my spot and wait for the next person to come up. But that was only half of it. When these lodgers had finished entertaining for the night, I'd have to go into their cubicle, strip their bed sheet—which usually had at least one, if not two or three, bodily fluids on it—and put that into the laundry."

1940s–1950s

CAFFE CINO

31 CORNELIA STREET
NEW YORK, NY 10014

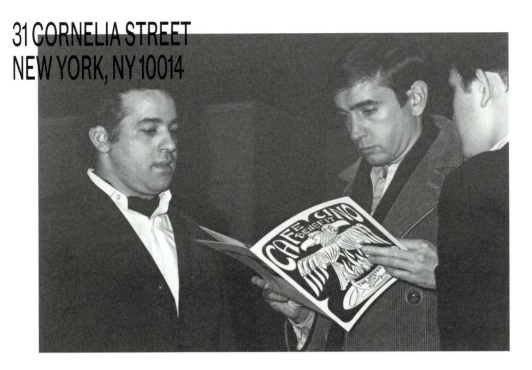

Joe Cino with Edward Albee at a Caffe Cino benefit, 1965.

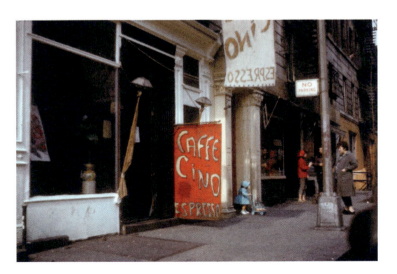

Caffe Cino exterior, 1962.

Founded in 1958 by Joe Cino, Caffe Cino began as a coffeehouse at 31 Cornelia Street in the West Village, occasionally showcasing poetry, folk music, and art exhibitions. Cino eventually started hosting short avant-garde theatrical plays, many of which included gay themes at a time when it was still illegal to depict homosexuality onstage. These performances became the venue's signature offering, and Caffe Cino would operate as a theater for the next decade, serving as an incubator and launchpad for budding artists. This included many people who identified as LGBTQ+, such as Doric Wilson, H. M. Koutoukas, María Irene Fornés, Tom Eyen, and Marshall W. Mason. Caffe Cino is now considered both the "birthplace of off-off Broadway" as well as a groundbreaking space in the development of gay theater.

Cino himself was a gay Italian American dancer who used the last $400 in his savings account to open what he initially called the Caffe Cino Art Gallery, encouraging friends to hang their artwork on its walls. The space soon hosted poetry readings and experimental performances on the café floor. Admission cost one dollar and included coffee and an Italian pastry. Cino later said that he aimed to create "a beautiful, intimate, warm, non-commercial, friendly atmosphere where people could come and not feel pressured or harassed."

Caffe Cino soon became a center for queer artists to share work with often overtly depicted homosexual themes, while its audience was

Caffe Cino

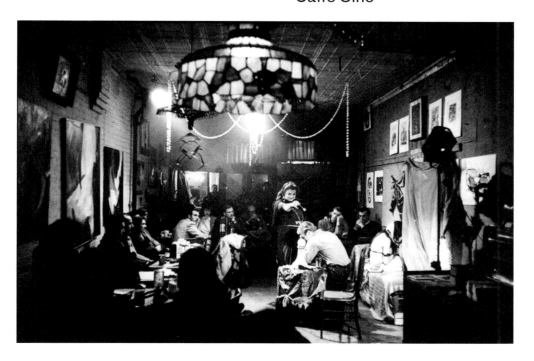

Shirley Stoler in Tennessee Williams' *Camino*, 1961.

teeming with notable queer figures like Marlene Dietrich, Andy Warhol, Edward Albee, and Agosto Machado. Many LGBTQ+ theater artists showcased work there over the years, including Roberta Sklar, Charles Stanley, and Jean-Claude van Itallie, among others.

In 1965, a fire destroyed the interior of the space. While the official cause was a gas leak, some have speculated that Cino's lover at the time was responsible. The neighboring community responded by raising money, and Ellen Stewart, founder of La MaMa Experimental Theatre Club, offered Joe a space at her theater to continue holding productions.

Caffe Cino eventually reopened but would not survive for long. In 1967, Cino committed suicide following the accidental death of his lover (and possible arsonist), and the venue shuttered within a year. Despite its sudden, tragic end, the venue's lasting impact on queer theater has remained. Fifty years later, through the efforts of the NYC LGBT Historic Sites Project, 31 Cornelia Street was listed on both the New York State Register of Historic Places and the National Register of Historic Places. Caffe Cino was also designated a New York City Landmark for its vital role in both theater and LGBTQ+ history.

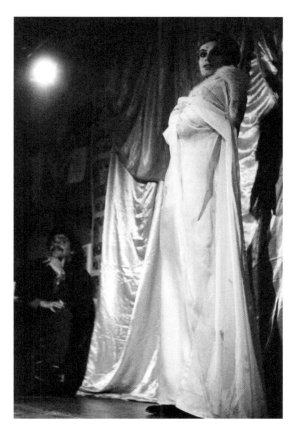

Poet H. M. Koutoukas watching Charles Stanley in *The Spring Horror Show*, 1968.

CLUB 181

181 SECOND AVENUE
NEW YORK, NY 10003

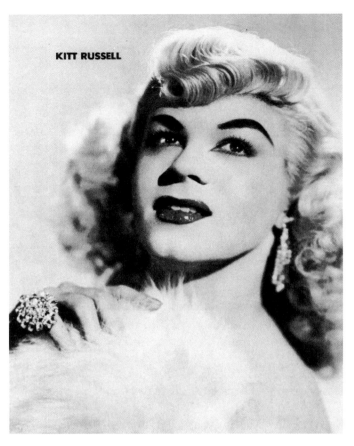

Right: Kitt Russell, performer at Club 181, circa 1940s.

Left: Club 181 ad, circa 1940s.

Advertised at the time as the "East Side's Gayest Spot," Club 181 was a popular Mafia-run nightclub in the East Village known for its extravagant shows featuring both female and male impersonators, as well as for its primarily drag king waitstaff. Located at 181 Second Avenue from 1945 to 1953, Club 181 (or the 181 Club) predominantly attracted straight audiences looking for niche entertainment, but employed many gays, lesbians, and individuals who would today be considered transgender, including Jackie Small, Toni Bennett, Gail Williams, Kitt Russell, Blackie Dennis, George "Titanic" Rogers, and Buddy "Bubbles" Kent.

Owned and operated by the Genoveses, a renowned Italian American Mafia family, Club 181 was situated in the downstairs area of what was originally built as a Yiddish live performance venue. Riding the wave of the Pansy Craze of the 1930s, Club 181 was extremely popular from its inception, with patrons lining up around the block, excited by the prospect of experiencing entertainment otherwise considered taboo.

Entering the luxurious venue, one would descend a palatial spiral staircase into a red carpeted theater with blue and white walls. The club's tuxedoed female waitstaff would often refer to the venue as "the homosexual Copacabana," (see p. 182) comparing it to another popular nightclub at the time on East 60th Street. Club 181 was so successful that it typically raked in over $500,000 a year, a considerable sum for the era.

By 1952, Club 181 was named "the most famous fag joint in town" by Jack

Club 181

Lait and Lee Mortimer in their book *U.S.A. Confidential*. Around that same time, however, the club had its liquor license revoked after being surveilled by undercover police, eventually receiving citations for numerous violations, including the sale of alcohol after hours, "indecent" acts by patrons onsite, and the presence of homosexuals, lesbians, and other "undesirables." The *New York Daily News* then reported on the club, calling it "a hangout for perverts of both sexes," and Club 181 was subsequently shut down in 1953. Given their incredible success, however, the Genoveses opened a nearly identical venue around the corner the same year. The new location, called Club 82 (see p. 62), would continue to operate until 1973 and employ a whole new generation of drag performers during its reign.

> Lisa E. Davis, LGBTQ+ historian: "[The] whole circle of 181 gals…had maintained a community which lasted 20, 30 years after their brief careers there. But working at 181 was the most fun thing they ever did in their lives, to dress up…serve drinks, and perform in the opening numbers and grand finales. Eventually, they all moved to Florida together."

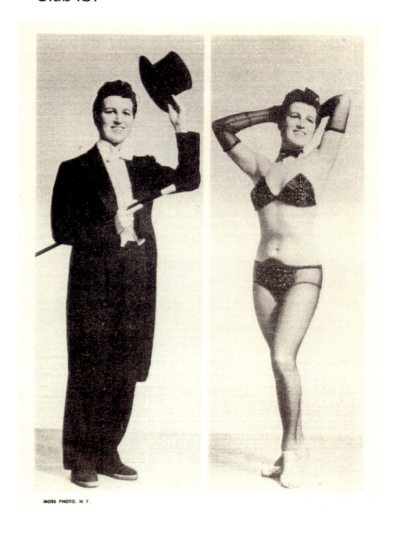

Buddy "Bubbles" Kent's two looks, circa 1940s.

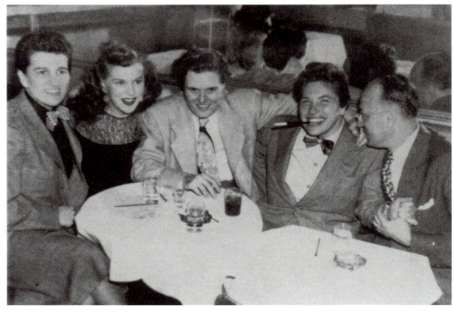

Buddy "Bubbles" Kent, Jacquie Howe, Kicky Hall, and friends, circa 1940s.

1940s–1950s

82 EAST 4TH STREET
NEW YORK, NY 10003

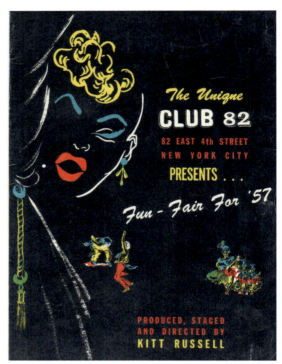

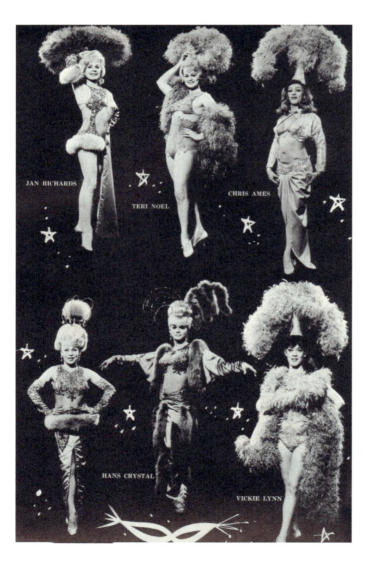

Top Left: Joe College aka Miss Jo Vaughn, circa 1950s.

Top Right: Club 82 Revue drag show program, 1957.

Bottom: Jan Richards, Teri Noel, Chris Ames, Sandy Rogers, Hans Crystal, and Vickie Lynn, 1965.

After Club 181 (see p. 60) was branded "a hangout for perverts of both sexes" in 1951, its liquor license was revoked, and the business was shut down. The club's owners, the Genovese mob family, began searching for a new venue to host their successful female impersonator-fronted club, landing on a spot around the corner in the basement of 82 East 4th Street. The new nightclub was simply called Club 82 and opened in 1953. For the next two decades, it would operate as New York City's premier drag venue, putting on lavish shows that prominently featured female impersonators, employing a waitstaff of male impersonators, and advertising itself with the tagline "Who's No Lady."

Throughout the 1950s, Club 82 became known as "New York's Most Unique Nite Spot" and "East Side's

62

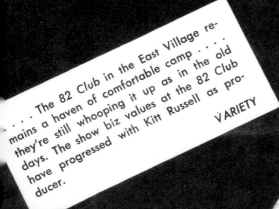

... The 82 Club in the East Village remains a haven of comfortable camp.... they're still whooping it up as in the old days. The show biz values at the 82 Club have progressed with Kitt Russell as producer.
VARIETY

The best Pearl Bailey imitation in town at the 82 Club. The femmeitator is Mel Michaels.
Walter Winchell
VARIETY

Those femme impersonators at the 82 Club look more like girls than the kids in the Copa chorus line, and those Copa ponies are for real — I think!
Charles McHarry
DAILY NEWS

Mel Michaels, 1969.

Mel Michaels

1940s–1950s

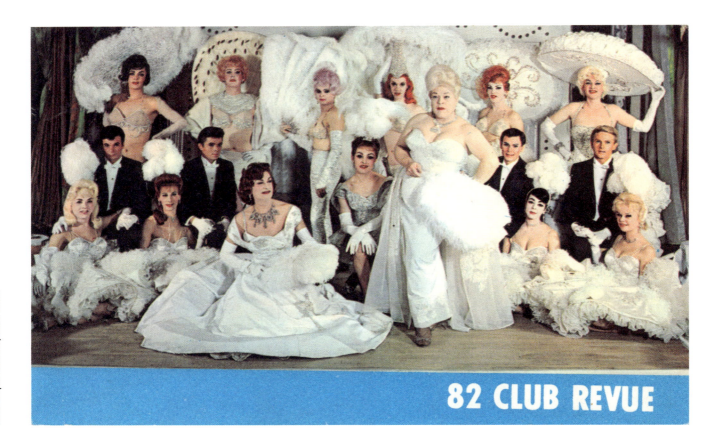

Club 82 performers, circa 1956.

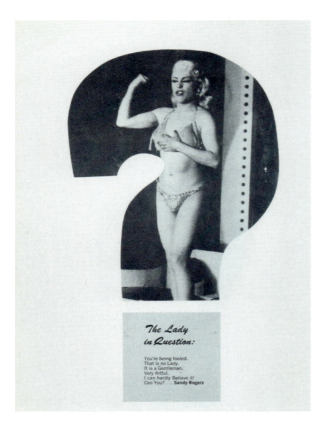

"The Lady In Question" from a Club 82 program, circa 1961.

Gayest Rendezvous." Despite this reputation, it mainly attracted straight audiences, who partook in "slumming" by traveling to queer venues in search of outré entertainment.

To get into Club 82, one would descend a long flight of stairs into a room decorated with fake palm trees, mirrored columns, and tables covered in white tablecloths. While the crowd skewed straight, many notable gay patrons also visited, including Liberace, Tennessee Williams, and Harvey Fierstein, often in the company of non-LGBTQ+ icons like Judy Garland, Elizabeth Taylor, and Errol Flynn (who once reportedly played the piano there with his penis).

The venue was an essential employer of many LGBTQ+ folks, who worked both onstage and behind the scenes, and top female impersonators

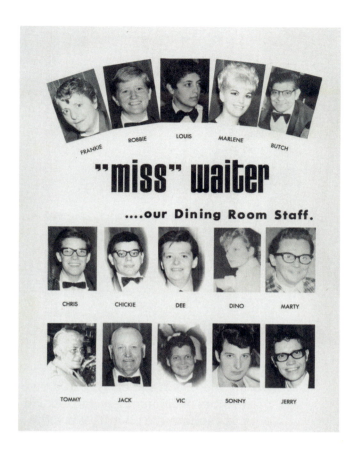

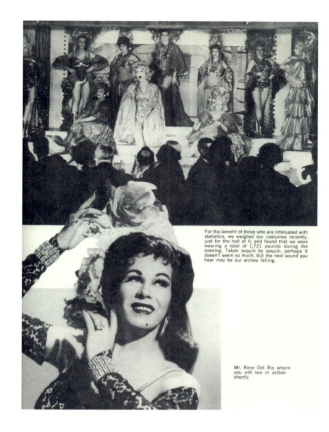

Left: "Miss" Waiter Dining Room Staff, 1969.

Right: Mr. Rene Del Rio, circa 1961.

from around the country vied for a chance to perform there. Its productions were also unbelievably extravagant and could cost up to $25,000 to put on, a vast sum for the time period. While most of the onstage performers were gay men in drag or transgender women, the waitstaff was largely composed of butch lesbians, drag kings, and trans men. On occasion, the venue's mob family manager Anna Genovese would have affairs with her female staff performers, even keeping a long-term girlfriend named Jackie, who worked in drag as a waiter.

After the Stonewall Uprising, Club 82's style of entertainment lost its popular appeal, and by the mid-'70s, the venue had morphed into one of New York's premier rock clubs. After several more changes throughout the '80s, in the '90s it became the Bijou, a gay porn theater with a popular back room. Remarkably, the Bijou stayed open until 2019, far beyond the lifespan of most gay porn theaters in the city. In 2023, a restaurant called Ella Funt, named after one of Club 82's most popular queens, opened on the ground floor of 78–80 East 4th Street, while the venue's original downstairs area is being renovated to become a queer performance space that will operate under the name Club 82.

1940s–1950s

THE MATTACHINE SOCIETY & DAUGHTERS OF BILITIS OFFICES

Dick Leitsch at his desk in the Mattachine Society office, circa 1960s.

1133 BROADWAY
NEW YORK, NY 10010

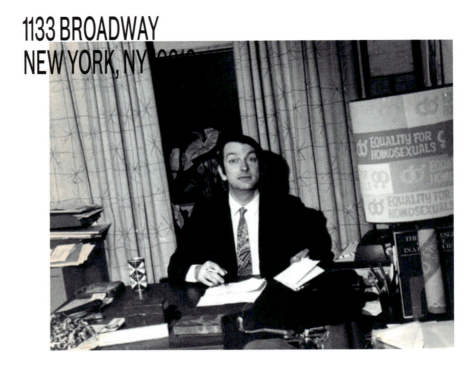

During the 1950s and early 1960s, two of the most prominent gay and lesbian organizations in the country were the Mattachine Society, founded in 1951 and catering primarily to gay men, and the lesbian-centric Daughters of Bilitis, founded in 1955. The organizations—called "homophile groups" at the time—were founded in California, but soon spread nationally. Beginning in 1958, New York chapters of both groups began sharing an office space at 1133 Broadway between West 25th and 26th Streets.

About ten years prior, political activist Harry Hay first conceived of a gay advocacy group, and on November 11, 1950, secretly gathered a handful of gay men in Los Angeles under the name Society of Fools. Within a year, the group changed its name to the Mattachine Society, after medieval French secret societies of masked men who were empowered by their anonymity to criticize ruling monarchs without risk of punishment. Hay told Charles Kaiser in *The Gay Metropolis*: "We didn't know at that point that there had ever been a gay organization of any sort, anywhere in the world

"Homosexuals are Different" ad, circa 1960.

before…if we made a mistake, and got into the papers the wrong way, we could hurt the idea of a movement for years to come. And we were terrified of doing that."

When the New York chapter was established, it was formally called the Mattachine Society of New York, Inc., or MSNY for short. Early MSNY members included Tony Segura, Dorr Jones, Art Maule, and Sam Morford, and the group often met at members' apartments before moving into the office space in 1958.

In San Francisco, meanwhile, the Daughters of Bilitis (DOB) was started by Del Martin and Phyllis Lyon and is regarded as the country's first lesbian civil and political rights organization. Like Mattachine, the group also began meeting at one another's homes, and in their second gathering landed on a name. Bilitis was drawn from *The Songs of Bilitis*, a work by French writer Pierre Louÿ, and referred to a fictional lesbian contemporary of Greek poet Sappho. The women chose the name specifically for its obscurity.

In 1958, Barbara Gittings and Marion Glass established a New York chapter of DOB, and soon began sharing Mattachine's office space. The organizations would remain at this location until 1961, when prominent Mattachine member Dick Leitsch terminated the lease due to rent increases and worsening office conditions.

Both Mattachine and DOB remained the leading LGBTQ+ rights groups in the United States until the 1969 Stonewall Uprising. By the '70s, they were perceived as too traditional and non-confrontational. The new decade gave birth to other more militant organizations, including the Gay Liberation Front, Radicalesbians, Gay Activists Alliance, and Street Transvestite Action Revolutionaries. While Mattachine and DOB's memberships dwindled and both groups folded within the decade, their legacy in LGBTQ+ history has lived on.

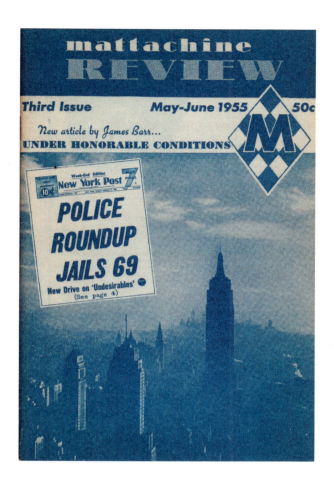

Mattachine Review, 1955.

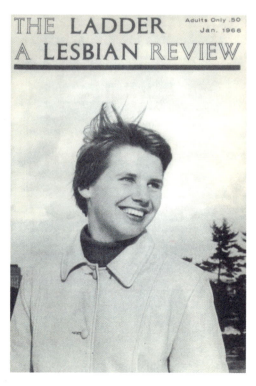

The Ladder: A Lesbian Review, 1956.

STUDENT HOMOPHILE LEAGUE @ EARL HALL

THE SANCTUARY

CHRISTOPHER'S END

MAX'S KANSAS CITY

JULIUS'

OSCAR WILDE MEMORIAL BOOKSHOP

THE STONEWALL INN

CRAZY HORSE CAFÉ

1960s RAIDS, REBELS, AND RIOTS

1960s

COMING OUT OF THE SHADOWS

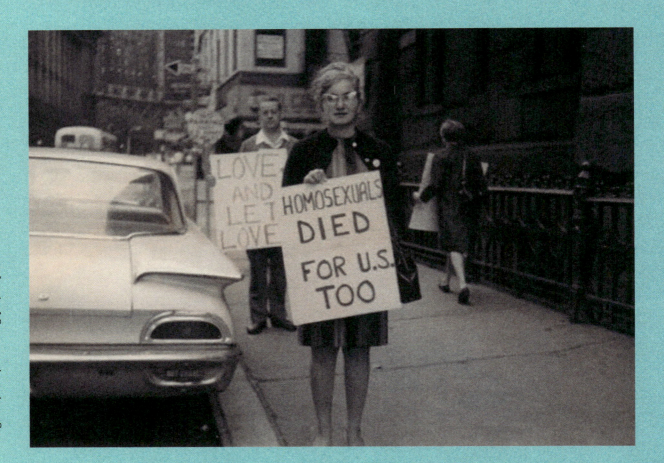

On September 19, 1964, ten demonstrators gathered in front of the US Army Building in lower Manhattan to protest the military's discrimination against queer people. It was the first officially recognized public protest for gay equality in the US. Renée Cafiero (front); Jack Diether (behind).

The 1960s was a watershed decade for many concurrent social movements, including the Civil Rights movement, women's liberation, and of course, gay rights. Each one influenced the others, while many of their participants found themselves at intersectional crossroads, torn between agendas that were not always aligned. Bayard Rustin, for example, was the principal organizer of 1963's historic March on Washington but was also shunned by many Civil Rights activists because of his homosexuality. Meanwhile, many queer women were fighting for both equality of the sexes and of sexual orientations at a time when the birth control pill was shifting attitudes towards sex. The conservatism of earlier generations gave way to looser, freer, and more experimental views, forever linking the '60s with its "peace and love" messaging.

All in all, it was a frenzied decade. JFK, MLK, and Malcolm X were assassinated, America landed on the moon, and massive protests swept the

nation. Counterculture reigned supreme, and queer organizing efforts that began in the '50s would continue to gain traction, reaching a boiling point in 1969 when the Stonewall Uprising gave birth to a new wave of gay liberation.

Throughout the '60s, court decisions sent mixed signals to the LGBTQ+ community. In 1962, the Supreme Court ruled that nude photographs designed to appeal to homosexuals were in fact not obscene and could now be legally sent by mail. In 1965, the Court decided that the US Civil Service Commission couldn't disqualify someone from federal employment just because they were labeled as homosexual. One year later, however, the country's first transgender rights case ruled against a trans person in New York City who wanted to change the name and sex on their birth certificate after undergoing gender-affirming surgery. Then Illinois became the first state to legalize homosexual intercourse in 1967, which New York would not do until 1980.

Meanwhile, mass media in America was openly hostile towards the LGBTQ+ community. In 1963, the *New York Times* published a landmark article on its front page entitled "Growth of Homosexuality in City Provokes Wide Concern." In 1966, *TIME* magazine printed an anonymously written feature called "The Homosexual in America," claiming that "homosexuality is a pathetic little second-rate substitute for reality…a pernicious sickness." Soon after, CBS aired "The Homosexuals," the first national broadcast concerning homosexuality, which was watched by forty million viewers and has been described as the country's "single most destructive hour of antigay propaganda."

This barrage of attacks pushed activists to begin staging public demonstrations. In September 1964, a small group of gays and lesbians picketed in lower Manhattan, an event since identified as the first documented gay rights demonstration in the US. Such actions continued throughout the decade, growing slowly but surely in size and frequency.

One of the decade's most famous protests took place in New York City in 1966 when activists staged a "Sip-In" at Julius' bar, challenging a longstanding regulation that allowed establishments to deny alcohol to homosexuals for being "disorderly." The momentous event, which involved Dick Leitsch, Craig Rodwell, John Timmons, and Randy Wicker, led to changes in the law, introducing new protections for legally licensed gay bars and their LGBTQ+ patrons.

1960s

In terms of nightlife, both the Mafia and police maintained a strong presence in New York City's queer spaces, while Mayor Robert F. Wagner made a push to shutter such "indecent" bars and venues. Popular Mafia-run spots included Kooky's, Gianni's, Lenny's Hideaway, and the Stonewall Inn, where patrons reported overpriced and watered-down drinks, as well as frequent entrapment by plainclothes officers.

Throughout the decade, LGBTQ+ folks gathered in other important spaces besides Mafia-run bars. In 1966, the first gay and lesbian college student group formed at Columbia University, which became known for its monthly dances at Earl Hall. In 1967, Craig Rodwell opened the Oscar Wilde Memorial Bookshop, the first gay and lesbian bookstore on the East Coast. In the late '60s, the Labyrinth Foundation Counseling Service was started, the first transgender community-based organization to specifically support female-to-male trans people.

When it came to drag, the classic style popular in the 1950s—old Hollywood glamor and female impersonation—spilled into the new decade, but earlier traditions were chipped away as less formal bars and nightclubs replaced fancy venues with dinner service. Live bands became less common, too, and real singing gave way to the newest drag routine: lip synching to recorded tracks, a practice that would become most drag performers' go-to talent. The new breed of queens were also less concerned with "passing," and slowly opened the door for messier, gender-bending types of drag. This confluence of elements lowered the barriers for drag and led to ever more performers on the scene.

Still, many queens continued the art form's classic traditions. Old-fashioned pageant balls reached a new peak in 1968 with the release of *The Queen*, a documentary following a drag beauty contest in New York City that gave Americans a close-up view of the topic like never before. The film featured several future stars, including International Chrysis, who became a popular trans entertainer and Salvador Dalí's protégé, as well as Crystal LaBeija, who would create the famous ballroom house system still in place today.

In addition to *The Queen*, several other pivotal cultural works helped shed a positive light on homosexuality. In 1967, the book *Homosexual Behavior Among Males* by Wainwright Churchill broke ground amidst scientific studies that treated homosexuality as a fact of life rather than

a sin, crime, or disease. It also introduced people to "homoerotophobia," a precursor to today's term "homophobia." Other notable books of the decade included James Baldwin's *Another Country* (1962), which featured prominent bisexual themes, John Rechy's *City of Night* (1963), about gay hustling in New York, and Gore Vidal's *Myra Breckinridge* (1968), the first novel whose main character undergoes a clinical sex change. Mart Crowley's play *The Boys in the Band* debuted off-Broadway in 1968; it humanized gay men and provided many theatergoers with their first unabashed look at New York City gay life. Stephen Sondheim would later refer to the play as "the shot heard round the world," and it went on to have multiple revivals and two film adaptations. The late 1960s also saw early signs of the discotheque at clubs like Regine's, Arthur, and the Sanctuary, which attracted both gays and straights and would pave the way for more gay-centric venues in the 1970s like the Flamingo, the Loft, and 12 West.

On June 28, 1969, one day after Judy Garland's funeral, police raided the Stonewall Inn in Greenwich Village. According to legend, a butch lesbian began resisting arrest, and soon a large-scale uprising broke out, marking one of the first times that the LGBTQ+ community fought back in New York. The event fueled a new political energy, and before the decade's end, several more radicalized LGBTQ+ rights groups formed, including the Gay Liberation Front and the Gay Activists Alliance. While the growing gay rights movement had many factions, several groups would come together to commemorate the Stonewall Uprising with the Christopher Street Liberation Day March in June 1970, the predecessor to today's annual Pride March. A new era was on the horizon.

1960s

JULIUS'

159 WEST 10TH STREET
NEW YORK, NY 10014

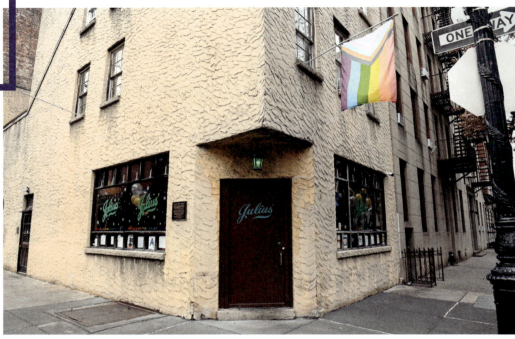

Julius' distinctive exterior.

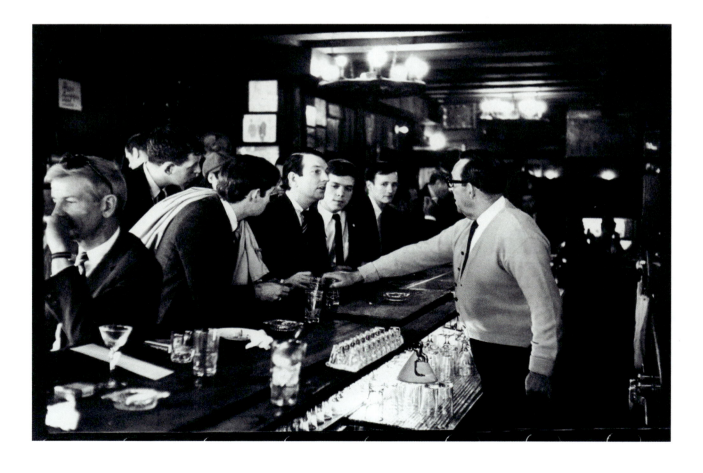

A bartender at Julius' refuses to serve members of the Mattachine Society, who were protesting New York liquor laws that prevented serving gay customers, April 21, 1966.

Julius'

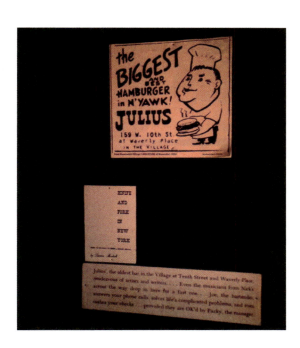

Vintage burger signage on Julius' wall.

> Helen Buford, Julius' owner: "One time, I planned to have some repair work done at Julius' and was supposed to meet the contractor there at 7 a.m.…so I brought a lawn chair and pillow and decided I was gonna sleep over. As I'm laying there, I feel something playing with my hair. I started whispering, 'OK, I'm a friend, I'm no threat to anyone.' And it stopped. At some point, I fell asleep, when suddenly the jukebox went on by itself. And then I went, 'OK, that's it, I'm done.' I think the ghosts of the bar were coming out. Maybe the spirit of a hairstylist."

Located at 159 West 10th Street in Greenwich Village, Julius'—considered the oldest continuously operating gay bar in New York City—was first established circa 1864, though its current name only dates back to around 1930. Though not initially a gay bar, it began attracting gay patrons by the 1950s, including Truman Capote, Tennessee Williams, and Edward Albee, whose play *Who's Afraid of Virginia Woolf?* was reportedly inspired by a young lover he met at the bar.

Still, Julius' bartenders often denied service to anyone they deemed "disorderly," coded to mean homosexual. The bar was catapulted into the spotlight on April 21, 1966, when activists organized a "Sip-In," a highly publicized event in which they intentionally revealed themselves to be homosexuals in order to be refused service. The event challenged the State Liquor Authority, whose regulations had allowed bartenders to refuse serving anyone they deemed gay or lesbian.

Stringing along a handful of reporters, the group landed at Julius', where a clergyman had recently been arrested for soliciting sex from another man. A sign in the bar's window consequently read "This is a raided premises." Upon hearing their declaration of queerness, Julius' bartender put his hand over a glass, a moment that was famously photographed. The *New York Times* and the *Village Voice* both ran headlines the next day, and the "Sip-In" action ultimately led to major policy changes and the emergence of a more liberated gay bar culture in New York City.

Now a historic landmark, Julius' has remained a popular destination for visitors from near and far. The neighborhood bar is currently owned by Helen Buford, who purchased it in 1999. After learning about Julius' history from a regular, Buford made it her mission to help preserve the space and keep it within the LGBTQ+ community. Over the years, she has turned the walls into a museum that documents the venue's notable patrons and the countless landmark events and parties that have taken place inside its dark environs.

CRAZY HORSE CAFÉ

**149 BLEECKER STREET
NEW YORK, NY 10012**

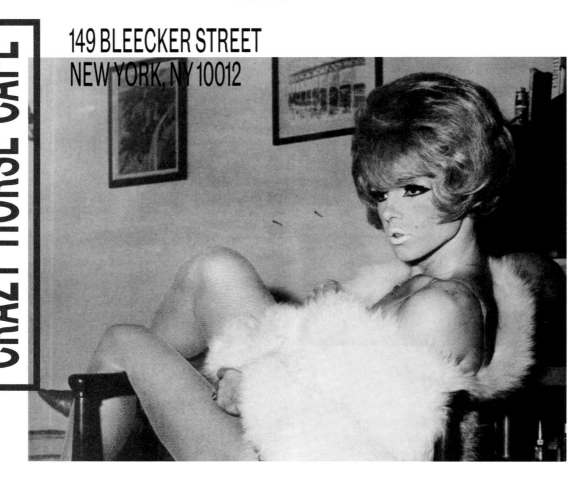

Tammy in furs, *Female Mimics Magazine* Volume 1, Number 9, 1967.

Located upstairs at 149 Bleecker Street in Greenwich Village, Crazy Horse Café operated circa 1965 to 1968 as a café that also doubled as a drag bar, with popular female impersonation revues. Joseph Touchette, who performed in drag as Tish throughout the 1950s and 1960s, staged his popular "French Box Revue" there, alongside other drag headliners like Kicks Wilde, Billie Kamp, and Dena Grevis (whose appearance was frequently compared to Elizabeth Taylor's).

One of the biggest stars to pack audiences into Crazy Horse Café was Pudgy Roberts, who billed himself as "the world's funniest comic stripper." Ahead of his time and predating the likes of Divine, Pudgy was known for his garish makeup, with extremely dark high-arched brows and comically overdrawn lips.

Other performers listed in Crazy Horse's revue included the "exotic Joey Baker," who hailed from the West Indies and performed a sophisticated strip-tease, the "dulcet-voiced Leslie Caroll," who would do impressions of Eartha Kitt, Lena Horne, and Pearl Bailey, and the "talented and famous Tony Del Rey," who came from Spain and showcased authentic Spanish dancing.

Like many drag-revue-based venues before it, Crazy Horse Café sold queerness as entertainment and attracted primarily straight audiences. Still, it served as an important gathering space for many queer people, providing an opportunity to bring joy to others and explore gender identities. When it closed, the building changed identities several times itself, becoming the Rock 'n' Roll Café, a goth club, and most recently, a pirate-themed restaurant with a blues saloon upstairs.

Crazy Horse Café

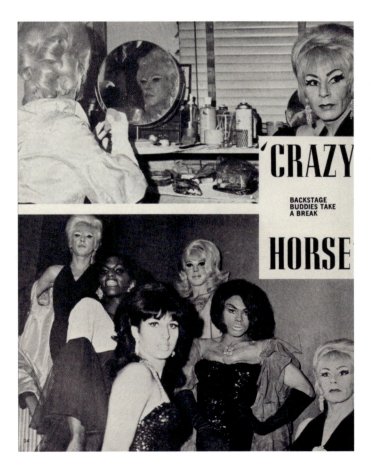

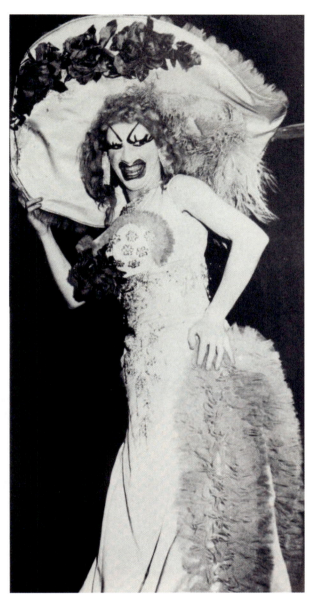

Top Left: Headliners at the Crazy Horse, *Female Mimics Magazine* Volume 1, Number 10, 1967.

Bottom Left: "Backstage Buddies," *Female Mimics Magazine* Volume 1, Number 9, 1967.

Right: Pudgy Roberts at the Crazy Horse, *Female Mimics Magazine* Volume 1, Number 5, 1965.

Femmes Fatales

For those of you who can't make it to the Crazy Horse in person (and for those who have, and have bombarded us with requests!) here are the first photos to appear in print of this remarkable nitery. That is, we *think* they're the first—unless some other genius has beat us to it!

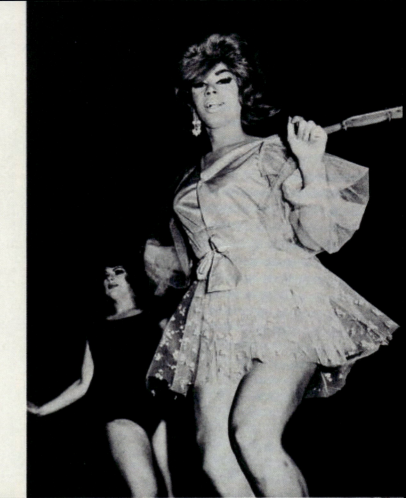

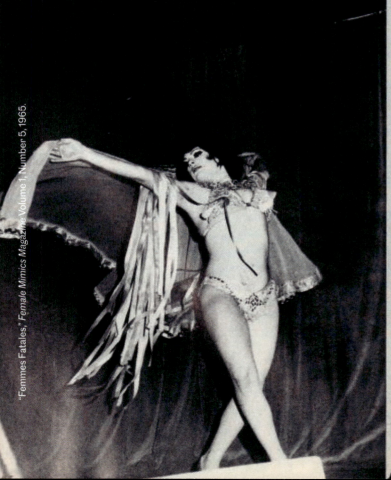

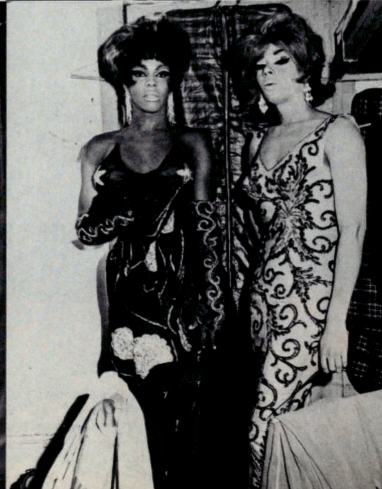

Crazy Horse Café

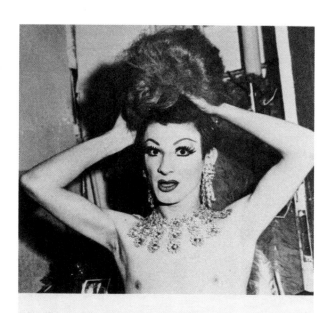

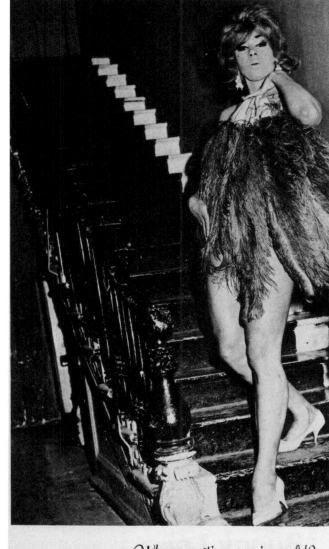

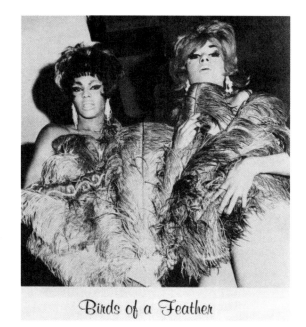

Top Left: "Topless bathing suits? Why Not?" *Female Mimics Magazine* Volume 1, Number 5, 1965.

Bottom Left: "Birds of a Feather," *Female Mimics Magazine* Volume 1, Number 5, 1965.

Right: "Who says it's a man's world?" *Female Mimics Magazine* Volume 1, Number 5, 1965.

OSCAR WILDE MEMORIAL BOOKSHOP

**291 MERCER STREET
NEW YORK, NY 10003**

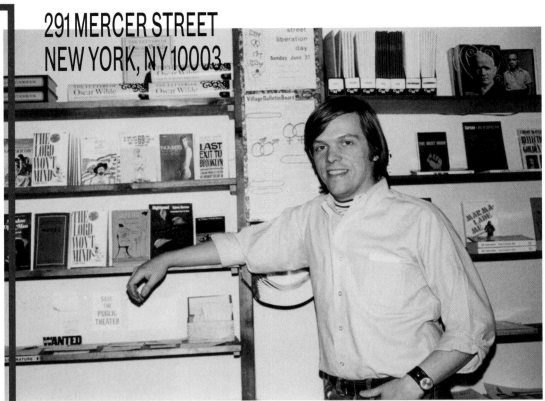

Craig Rodwell at the Oscar Wilde Memorial Bookshop, 1971.

On November 24, 1967, gay rights activist Craig Rodwell opened the Oscar Wilde Memorial Bookshop in his apartment building's storefront at 291 Mercer Street. As one of the first LGBTQ+ bookstores in the US, it was a key hub for community gatherings and activism. Rodwell named the store after Oscar Wilde, whom he admired as "the first homosexual in modern times to defend publicly the homosexual way of life."

For years, Rodwell had been a member of the Mattachine Society (see p. 66) but felt the group needed to improve its public engagement. He suggested opening a bookstore with a community space, but when the idea was vetoed, he took matters into his own hands. Rodwell set up the store using his savings from cleaning Fire Island hotel rooms and began stocking it with literature by gay and lesbian authors, though he staunchly refused to carry pornography.

The shop struggled in its early years but grew into an important fixture in the LGBTQ+ community, stocking an ever-increasing number of queer publications and hosting readings with the likes of Tennessee Williams, Rita Mae Brown, and Harvey Fierstein. In his book *Stand By Me*, historian Jim Downs notes that the shop was one of the city's few places where gay people could meet and "relate to each other on something other than a sexual level."

In 1973, Rodwell opened a second bookstore at 15 Christopher Street, closer to the city's center of gay life, and shuttered the original location a few months later. In 1992, he received a Lambda Literary Award for his pioneering efforts, though he would die one year later of stomach cancer. The store then changed owners multiple times but struggled to stay afloat. Despite numerous attempts to preserve the bookshop, it ultimately ceased operations in 2009, after over 35 years of welcoming visitors from all over the world to its historic storefront.

Oscar Wilde Memorial Bookshop

Martin Belk, patron: "The Oscar Wilde [Memorial] Bookshop came into being right after other significant counterculture projects, such as Ellen Stewart's La MaMa, and Better Books in London. While they did earn money and were supported by people, they were not strictly commercial ventures. The point? Every genuine effort, every coffee, every book, every 'talk,' every event for people to gather mattered!"

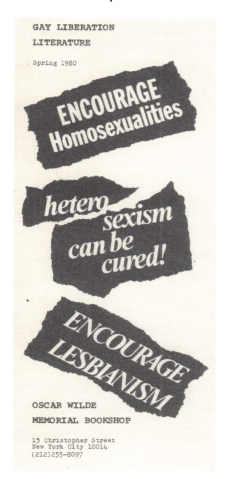

Bookshop ad, 1980.

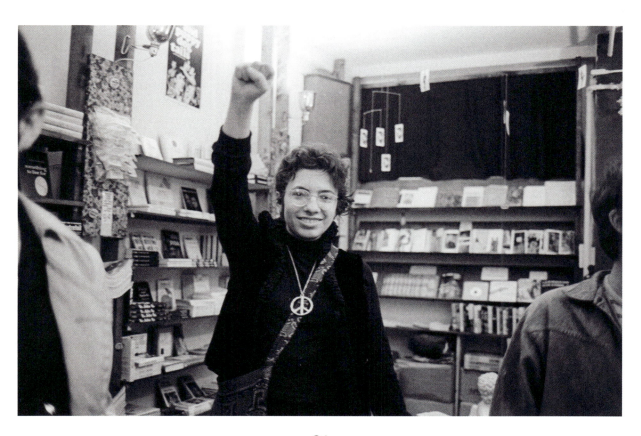

Martha Shelley at the bookshop, 1969.

1960s

STUDENT HOMOPHILE LEAGUE @ EARL HALL

**2980 BROADWAY
NEW YORK, NY 10027**

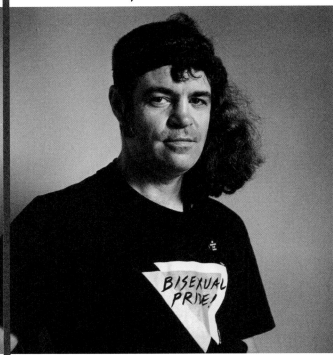

Left: Portrait of Robert Martin (Stephen Donaldson), 1992.

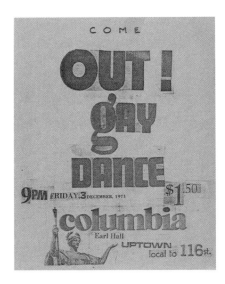

Right: Gay Dance flyer, 1971.

Located at 2980 Broadway, Earl Hall was constructed on Columbia University's campus in 1902. Sixty-five years later, it became the home base for the Student Homophile League, regarded as America's first LGBTQ+ student group, who used the building for popular dances, activist meetings, and more.

Beginning in 1966, ten individuals, including bisexual activist Stephen Donaldson, forged the League at Columbia, spending over a year battling for official recognition and insisting that its members list be kept confidential. Once the university agreed to keep names private, a charter was finally granted in 1967, making Columbia the country's first university to recognize an LGBTQ+ student group.

The League received support from the university's chaplain, who established Earl Hall as a safe space in which to hold meetings and events. The success of the group inspired student activists to form similar leagues at their own universities. Within four years, more than 150 such LGBTQ+ student organizations had been documented.

In 1970, the group was renamed Gay People at Columbia-Barnard and began sponsoring First Friday Dances at Earl Hall. These were open to the greater LGBTQ+ population of the city and grew into some of the most important queer social events in New York, offering a safer and more casual alternative to gay bars at the time. Parties often drew attendance of over 1,000 people and would peak in popularity during the 1980s.

Columbia's group is still in operation today, now called the Columbia Queer Alliance (CQA), and Earl Hall has been named a historic landmark for its role in hosting its meetings and dances.

Student Homophile League @ Earl Hall

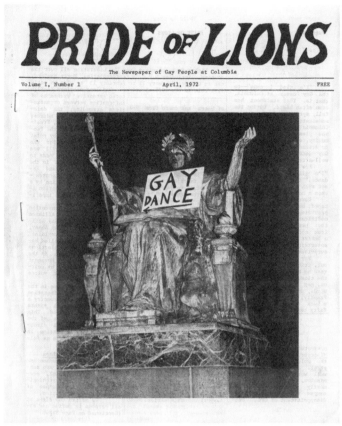

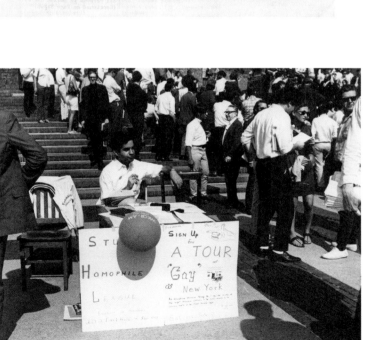

Kathy Wakeham, early Student Homophile League member: "I saw an ad for a gay dance in the *Daily Spectator*, Columbia's newspaper, which said it would be mixed—men and women. When I went, it was mostly men; at least, it was in those early days. But I met a woman there named Eileen who came up to me and said, 'Let's get outta here, there's too many men.' So she and I then went down together to a lesbian bar on Christopher Street called the Checkerboard, where we met up with some other women, including one who invited me to go home with her even though she lived in Astoria, Queens."

Top Right: Earl Hall, Columbia University, 1949.

Top Left: *Pride of Lions* front page featuring a photo of the Alma Mater statue with a sign for a party at Earl Hall, 1972.

Bottom: Recruiting members on campus, circa 1970s.

1960s

CHRISTOPHER'S END

180 CHRISTOPHER STREET
NEW YORK, NY 10014

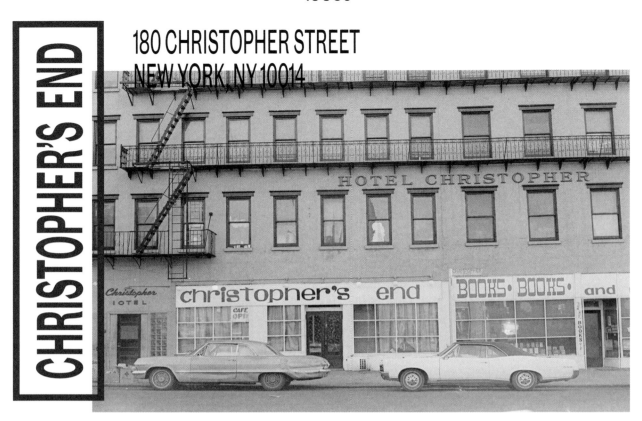

Christopher's End exterior, 1969.

The building at 180 Christopher Street in the West Village has a long, complicated queer history. In the late 1960s it housed Christopher's End, a coffee shop turned gay-male after-hours club that featured dancing, a back room, go-go boys, and even male sex shows. Like many LGBTQ+ spaces at the time, it was Mafia-controlled and managed by Mike Umbers, an associate of the Gambino crime family who called himself the "Emperor of Christopher Street."

According to a *Village Voice* article from 1971, Umbers ran three separate operations on Christopher—a cruising spot called Gay Dogs, the Studio Book Store for "paper flesh," and Christopher's End, which Umbers declared as "climax flesh." According to Daniel Hurewitz in *Stepping Out: Nine Walks Through New York City's Gay and Lesbian Past*, Christopher's End was particularly memorable for its "busy as bees" back room and for a waitress named Linda who introduced shy gay boys to one another.

In 1971, the venue made headlines when police raided it twice in one week, completely smashing up its interior. The location reopened with a sign posted outside: "Open Again. Weirdo Sex Inside." The raids prompted a spontaneous demonstration organized by the Gay Activists Alliance. Held on July 24, 1971, nearly a thousand individuals walked the length of Christopher Street and picketed two police precincts in the area.

Christopher's End would close permanently soon thereafter, but the building at 180 Christopher Street continued to serve the gay community. In the late '70s, it became the Cock Ring, a dark, cruise-y gay discotheque, and in the mid-'80s, it briefly held Uncle Charlie's Village, described in a 1984 *New York Times* article as "a new disco that attracts homosexuals." In 1986, the building became the Bailey-Holt House, the nation's first permanent home for people living with AIDS.

Christopher's End

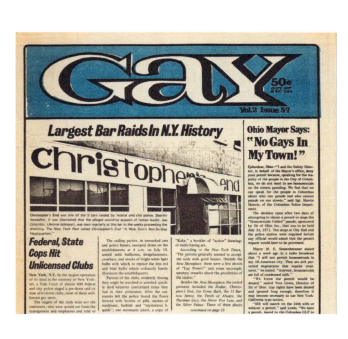

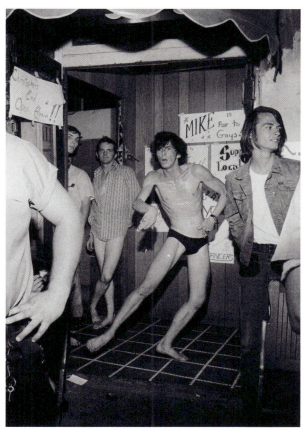

Top: Gay Activists Alliance protest at Christopher's End, 1971.

Bottom Left: GAY Newspaper front page headline, 1971.

Bottom Right: Half-dressed patrons in front of Christopher's End during Gay Activists Alliance protest, 1971.

1960s

MAX'S KANSAS CITY

**213 PARK AVENUE SOUTH
NEW YORK, NY 10003**

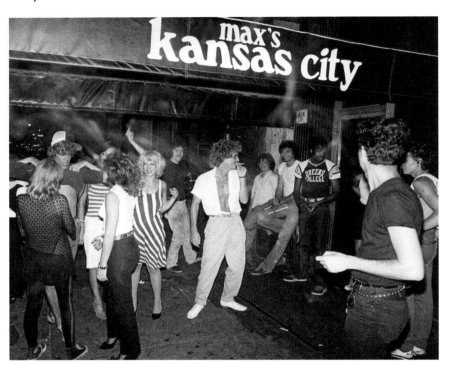

Max's Kansas City, 1980.

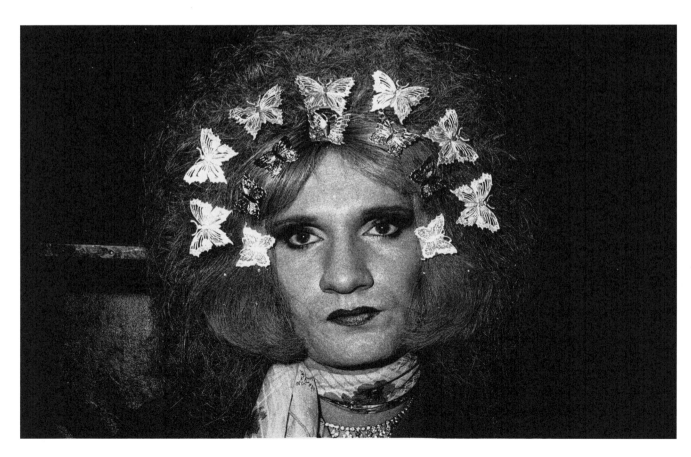

Jayne/Wayne County at Max's, circa 1973.

Max's Kansas City

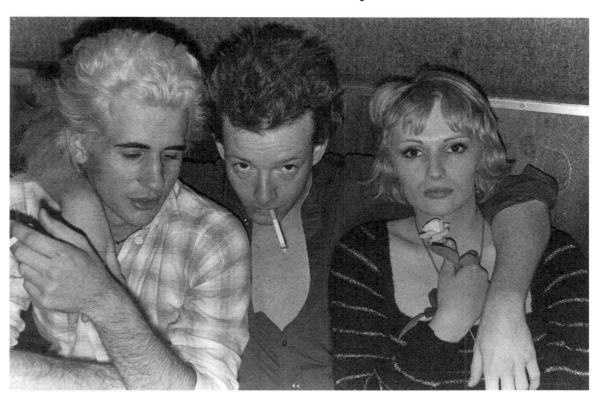

Rocco, Jackie Curtis, and Candy Darling at Max's, circa 1973.

Opened in December 1965 at 213 Park Avenue South, Max's Kansas City was a nightclub and restaurant that became a magnet for many notable musicians and artists, fostering the city's rock, glam, punk, and new wave scenes. It also attracted a mixed crowd of patrons mingling in a welcoming, queer-friendly environment.

Max's acted as an early sanctuary for the city's LGBTQ+ community and regularly drew notable queer people like Robert Rauschenberg, William S. Burroughs, Annie Leibovitz, Allen Ginsberg, Robert Mapplethorpe, and more. It was also a favorite hangout of Andy Warhol, who would often take over the club's back room, flanked by his Factory entourage of trans superstars Holly Woodlawn, Jackie Curtis, and Candy Darling. Frequently presiding over the club was DJ Jayne County (then Wayne County), a gender-non-conforming proto-punk singer known for outlandish stage antics and costumes.

By the end of 1974, Max's popularity had waned, and the venue closed shortly after. The owner then opened another space called the Ninth Circle Steakhouse, which would morph into an important gay venue in its own right. In 1975, Max's reopened under new ownership, booking many notable queer bands including the B-52's, the Runaways, the Mumps, and Klaus Nomi. Max's II, as it was called, ran until 1981, before closing and reopening one final time. Max's third and last location, at 240 West 52nd Street, was short-lived.

Warhol summed up the creative melting pot that was Max's in his intro to the book *High On Rebellion*: "Max's Kansas City was the exact spot where Pop Art and Pop Life came together in the sixties—teenyboppers and sculptors, rock stars and poets from St. Marks Place, Hollywood actors checking out what the underground actors were all about…everybody went to Max's and everything got homogenized there."

1960s

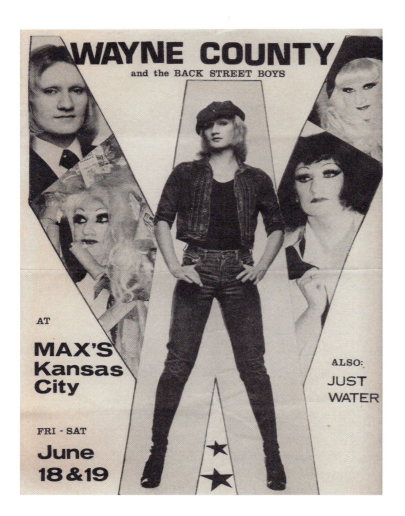

Poster for Wayne County (with the Back Street Boys) at Max's Kansas City, circa 1970s.

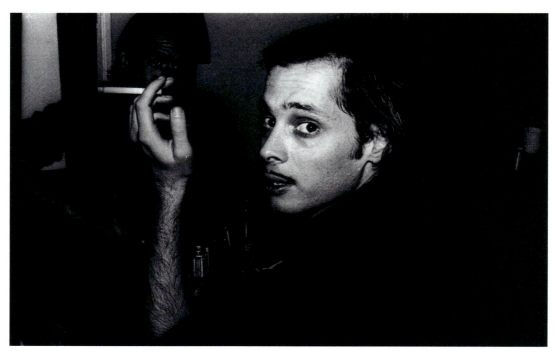

John Waters, circa 1973.

Max's Kansas City

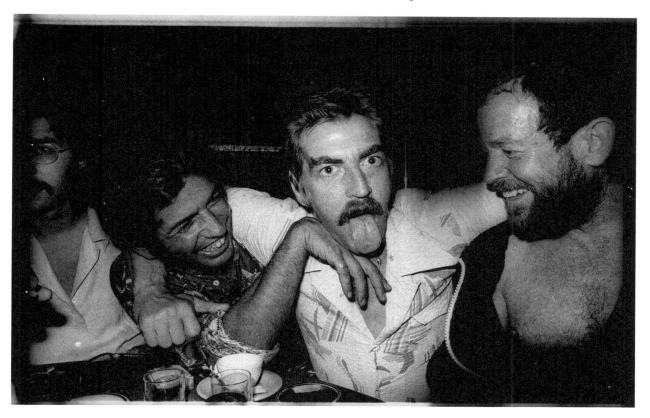

Tony Masaccio, Forrest Myers, and David Budd, circa 1973.

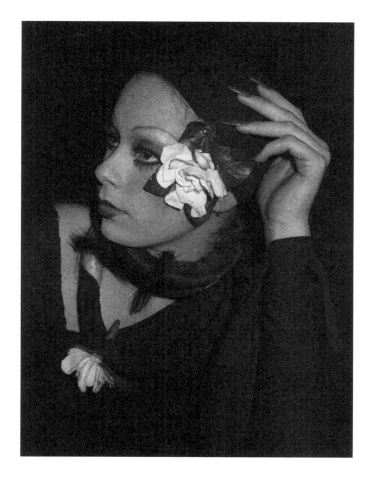

Cockette Bobby Cameron, circa 1973.

1960s

THE SANCTUARY

407 WEST 43RD STREET
NEW YORK, NY 10036

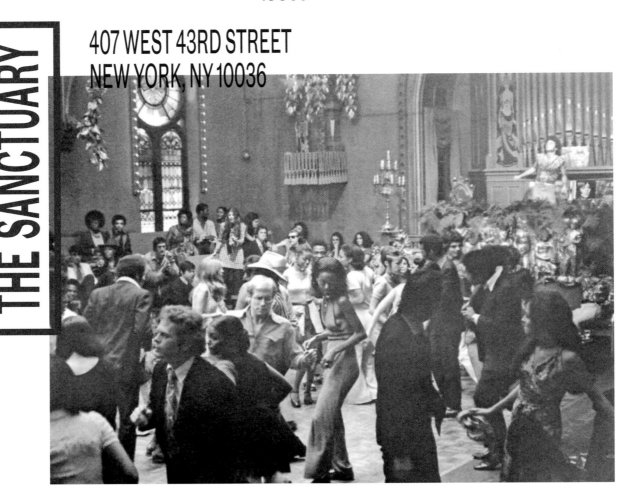

The Sanctuary dancefloor, circa 1960s.

An ad for the Sanctuary, circa 1960s.

Located at 407 West 43rd Street in Hell's Kitchen, the Sanctuary was once described as "the first totally uninhibited gay discotheque in America." Opened in 1969 in a former church, it evolved from a "straight disco for white celebrities to a bacchanalian palace populated almost entirely by gay men," according to Jan-Willem Geerinck in his culture blog *Jahsonic*. Leigh Lee, a Robert Mapplethorpe model who visited the Sanctuary, told Geerinck: "It was supposed to be a secret. But I don't know how secret it could have been when faggots and lesbians come out of a church from midnight till sunrise."

When the building was first purchased and converted into a nightclub, its owners planned on calling it the Church. But the Department of Buildings refused to grant permits

The Sanctuary

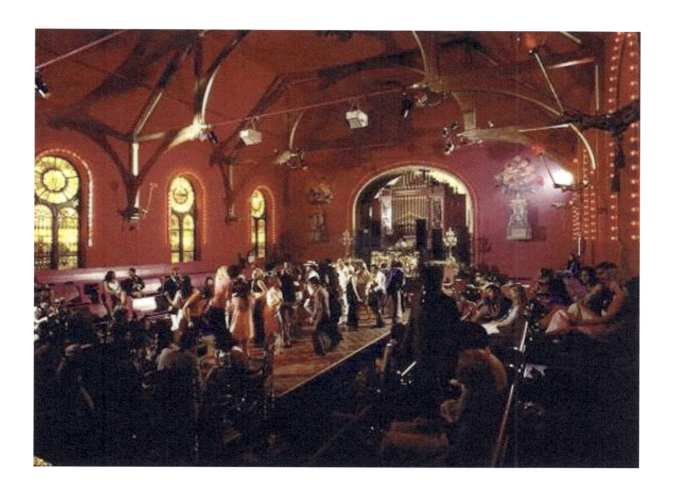

The dancefloor, circa 1960s.

unless the misleading name was changed, and the discotheque was renamed in 1969. While the club's official capacity was 350 people, it soon packed in over 1,000 bodies on any given night. After two gay entrepreneurs named Shelley Bloom and Seymour Seiden took over the Sanctuary's ownership, its LGBTQ+ patronage only increased.

The club's interior featured several satanic elements, including a wall mural of demons making love to angels, and a large purple statue of Satan by the entrance. The DJ booth, meanwhile, was in the church's old altar. The Sanctuary's uniqueness and extravagance led to its appearance in several films, including the Jane Fonda movie *Klute* (1971) and the gay romantic drama *A Very Natural Thing* (1974).

The Sanctuary itself only lasted until 1973, when its popularity waned and newer, even flashier discotheques were opening. The building briefly became a methadone clinic before turning into an off-Broadway performance space that continues to operate there today.

While the Sanctuary was not solely for gay patrons, it would inspire countless new LGBTQ+-only nightclubs over the next decade, including the Flamingo in 1974, which officially holds the title of New York City's first exclusively gay discotheque.

THE STONEWALL INN

51-53 CHRISTOPHER STREET
NEW YORK, NY 10014

1960s

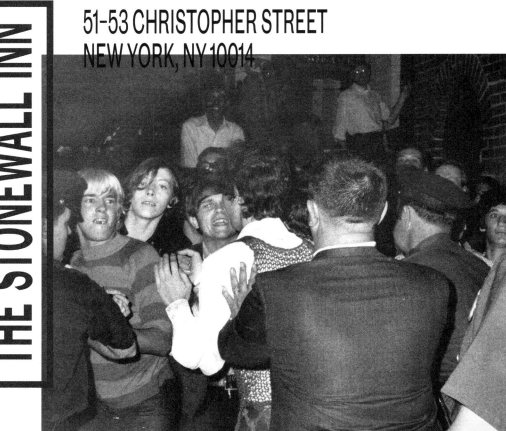

The Stonewall Inn nightclub raid as the crowd attempts to impede police, 1969.

The Stonewall Inn, initially located at 51–53 Christopher Street in Greenwich Village, has been etched into history as the site of the Stonewall Uprising, a series of clashes that took place between June 28 and July 3, 1969. Ignited when a group of gay men, lesbians, and transvestites fought back against a police raid, the uprising is widely regarded as the birth of the modern LGBTQ+ rights movement in the United States. Over time, the exact history and details of the events have become contentious and debated, but one certainty is that the Stonewall Inn that exists today is not the same Stonewall Inn of 1969, which in fact closed down just months after the uprising.

The two buildings which would house the Stonewall Inn were initially built as stables in the mid-1800s. By 1930, they were combined and became Bonnie's Stonewall Inn, a popular restaurant and bar that operated until 1964, when a fire destroyed its interior. In 1966, three members of the Mafia turned the Stonewall Inn into a gay bar, hoping to make an easy profit by serving overpriced alcohol to the ostracized community and demanding regular payoffs. Painted black inside to conceal the fire damage, the Stonewall Inn had no running water, and as Jerry Hoose recalled in *Stonewall Inn: Through the Years*: "The bar itself was a toilet, but it was a refuge, it was a temporary refuge from the street."

The Stonewall Inn boasted two small dancefloors and a jukebox, making it a rare gay bar in Greenwich Village where patrons could slow dance together. It quickly became popular, attracting young gay men

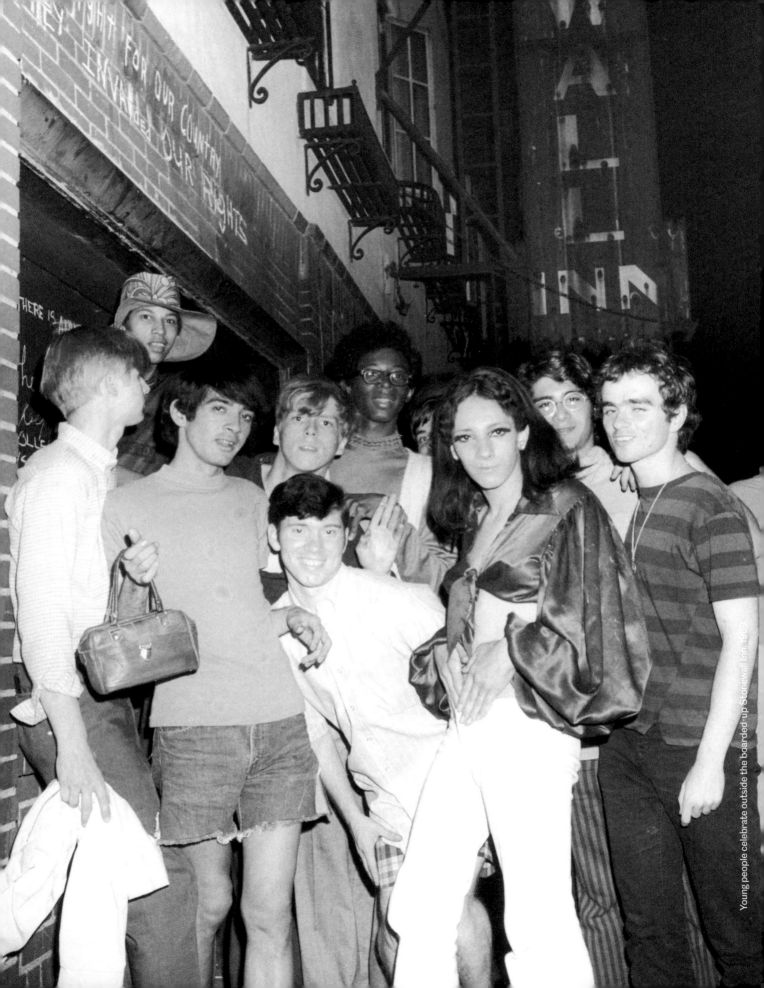

Young people celebrate outside the boarded-up Stonewall Inn, 1969.

> Tyler Evertsen, drag performer: "I used to perform at Stonewall which, back in the day, was a decrepit, seedy little hole in the wall. You only really went there to do drugs and get lucky. But then, little by little, it brought itself up the ranks and became more reputable."

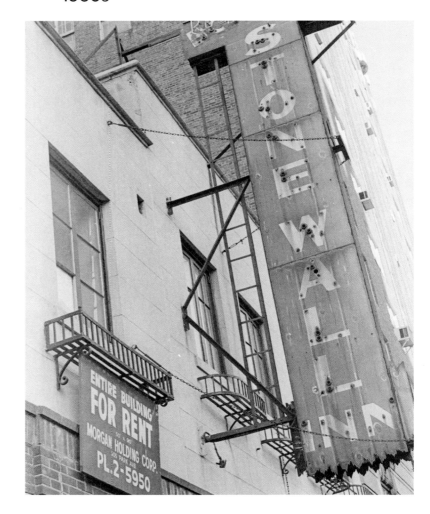

Stonewall for rent, 1969.

and some lesbians. Patron Robert Bryan recalled his first time at Stonewall, where "everybody was dancing and having a fun time. And this was different from most of the other gay bars at the time, where people would pretty much be sitting or just standing around."

The Stonewall Inn was frequently raided, and a white light bulb would flash to warn patrons to avoid arrest for "lewd conduct." During the early hours of June 28, 1969, one such raid got out of hand when patrons decided to take a stand. Most reports indicate that a butch lesbian in handcuffs was seen fighting back, at which point the crowd outside the bar turned into a mob, igniting a multi-night uprising throughout Greenwich Village.

The Stonewall Uprising sparked a mass movement that led to the formation of some of the first radical gay activist groups, including the Gay Liberation Front, Radicalesbians, and Gay Activists Alliance. According to David Carter in his seminal book *Stonewall*, there is no single reason for how the uprising unfolded, but rather "a number of reasons having to do with timing, social history, cultural changes, and local history and geography, as well as political events...with some of the underlying causes occurring decades prior to the event while others were as fresh as that week's headlines."

Just a few months after the uprising, gay rights groups boycotted all Mafia-run establishments, and the Stonewall Inn closed in October 1969. The space was split in two and leased to various businesses over the next decades, including a Chinese

restaurant, bagel shop, and shoe store. In 1987, a new bar called Stonewall opened again at 51 Christopher Street but closed two years later.

In 1990, a man named Jimmy Pisano opened a new gay bar called New Jimmy's at 53 Christopher Street, with signs reading "New Jimmy's at Stonewall Place: Where It All Began." Pisano's bar lost money every year, but he stubbornly kept it open, refusing to give up its legacy. In 1994, he died from complications of AIDS, but Stonewall remained open with the help of numerous people who shared his vision to preserve it. The location became the first LGBTQ+ site in the country to be listed on the National Register of Historic Places and was declared a National Historic Landmark in 2000, as well as a National Monument by President Barack Obama.

In 2006, the Stonewall Inn's current management, which includes lesbian co-owner Stacy Lentz, bought the bar and has been operating it at 53 Christopher Street ever since. On Pride weekend in 2024, the new Stonewall National Monument Visitor Center opened at 51 Christopher Street, uniting the two addresses where the original bar once stood. Now globally recognized as a foundational symbol for LGBTQ+ rights, the Stonewall Inn continues to maintain its feel as a local pub, while attracting queer tourists from around the world who come for a drink and to bask in its far-reaching history.

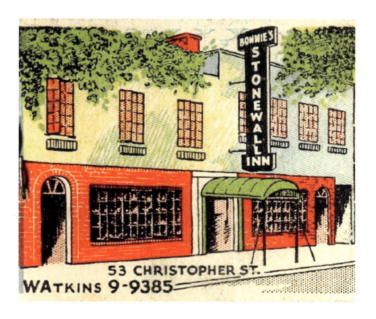

Matchbook cover from Bonnie's Stonewall Inn, circa 1940s.

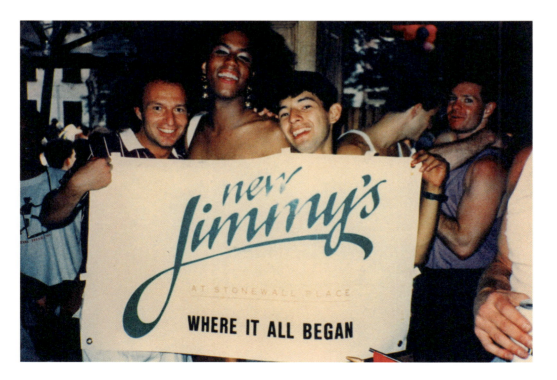

Jimmy Pisano (left), Darryl Brantley (center), and Xavier Mendoza (right) at Stonewall Revival, 1990.

THE CONTINENTAL BATHS

STUDIO 54

GG'S BARNUM ROOM

CRISCO DISCO

THE MINESHAFT

12 WEST

FIRST PRIDE MARCH

CHRISTOPHER STREET PIERS

GAA FIREHOUSE

1970s

POST-STONEWALL: PRIDE, DISCO, AND SEXUAL LIBERATION

Ice Palace 57 staff photo, 1970s. The club was known for its state-of-the-art sound and lighting systems, with pulsating neon strips that provided an icy feel.

In the wake of the Stonewall Uprising, the 1970s promised a new dawn for the gay movement—a fresh sense of liberation, pride, and visibility for many who had long felt ashamed, fearful, and closeted. The early '70s saw large numbers of homosexuals moving to major urban centers like New York City, which became known as the "gay migration." This shift was spurred by a desire in queer people to meet others just like them, but also to join the newly emboldened gay rights movement.

At the end of the '60s, only two major organizations, the Mattachine Society and the Daughters of Bilitis, had any significant public clout. But within just four years, the landscape erupted with all types of newly formed organizations, including increasingly radical and diverse groups like the

Gay Liberation Front, Radicalesbians, National Gay Task Force, Salsa Soul Sisters, and Gay Activists Alliance.

To commemorate Stonewall's first anniversary, a march was held on Sunday, June 28, 1970, with thousands walking along Manhattan's Sixth Avenue towards a "Gay-In" held in Central Park's Sheep Meadow. This Christopher Street Liberation Day March drew national publicity, cemented Stonewall's significance in history, and served as the inaugural event that would become New York City's annual Pride March.

But with increased LGBTQ+ visibility came increased ostracism, and Stonewall was certainly not the last police raid on a queer institution in New York. Less than one year later, for example, police raided the Snake Pit bar at 215 West 10th Street, where at least 167 people were arrested. That same year, therapist George Weinberg coined the term "homophobia" after witnessing the mistreatment of a lesbian friend. Raids on LGBTQ+ venues continued throughout the decade, albeit less frequently, with one of the last documented raids transpiring as late as 1982 at Blue's, a bar in Times Square catering primarily to gay Black men.

Parallel to the gay rights movement, the 1970s would also prove pivotal for women's liberation, peaking with the Supreme Court's landmark 1973 decision in *Roe V. Wade* recognizing the right to abortion. A year prior, Congress passed Title IX, prohibiting sex discrimination in educational programs that receive federal funds, forcing all-male schools to accept women and athletic programs to bolster female teams. Numerous feminist-led spaces, such as Mother Courage, Womanbooks, and the Women's Liberation Center, began popping up across New York City, often run by or catering specifically to queer women. During this time, the Lesbian Herstory Archives was founded, which remains a vital city institution to this day.

While public LGBTQ+ visibility became more prevalent in the '70s, not everyone was made to feel welcome. The leather community, drag queens, and gender-non-conforming individuals were initially discouraged from participating in the Pride March, deemed scandalizing eyesores who would set back the cause. In 1973, march organizers banned drag queens outright. In response, Sylvia Rivera and Marsha P. Johnson, two tireless activists, defiantly marched at the front of the parade anyway. Three years prior, the pair had formed S.T.A.R.—Street Transvestite Action Revolutionaries—to better support trans folks, homeless youths, and other

marginalized queers, who they felt were neglected by the leading gay groups in operation at the time.

There was still plenty of exclusion and setbacks for trans people in the '70s. In 1976, New York implemented an anti-prostitution law, which became known as the "walking while trans law" due to the disproportionate number of trans folks it would target and affect. The decade did, however, see some breakthroughs for trans and gender-non-conforming people who could find refuge in emerging nightlife spaces catering specifically to them, such as the Gilded Grape, the 220 Club, and GG's Barnum Room. In becoming celebrities, several trans and gender-non-conforming people also helped boost acceptance and visibility, including Warhol superstars Candy Darling, Holly Woodlawn, and Jackie Curtis, as well as tennis player Renée Richards, who was the first trans woman to compete in a professional tennis tournament at the 1977 US Open.

Drag, meanwhile, would begin to unwind from its tightly coiled restraints, becoming more experimental, playful, and raunchy. In the downtown scene, pageant balls that previously centered around luxurious gowns and "passing" female impersonations began to dwindle, and a new generation of performers broke out at more alternative venues like the Anvil and La MaMa. Uptown, new drag balls of a different sort, created by and for queer people of color, took shape, with Crystal LaBeija and Dorian Corey both founding their respective "houses" in 1972. Houses functioned as alternative families and refuges throughout the '80s, '90s, and beyond, becoming an integral part of Ballroom culture led by experienced members of the scene called "mothers" and "fathers."

Drag queens in the '70s often found themselves at odds with another newly formed tribe: the Clones. The turn of the decade's rise in gay liberation also sparked a sexual revolution, and many gay men began repudiating the effeminate aesthetics that had dominated previous decades. During this time, Tom of Finland's highly masculinized homoerotic drawings surged in popularity, emphasizing a macho image that many would emulate. Men began donning a full mustache, sideburns, tight T-shirts, snug denim, leather, and uniforms. To accommodate this new breed, sex clubs, leather clubs, and bars with back rooms became more prevalent. The Mineshaft, Ramrod, and the International Stud offered alternatives to bathhouses for men to meet and have sex. In response, bathhouses such as the Continental

Baths grew more elaborate in their own right, with live entertainment and dancing alongside the typical steam room and sauna offerings.

Perhaps most famously, the 1970s was also the decade of disco, a musical genre that originated in underground Black, Latino, and LGBTQ+ clubs. 1974 saw New York's first exclusively gay discotheque with the debut of the Flamingo, which was soon joined by many more, including 12 West, Crisco Disco, and the Cock Ring. Two of the most popular emerging discotheques were Paradise Garage and Studio 54, both of which catered specifically to homosexuals on certain nights. In many ways, the popularity of disco and its culture helped make society more accepting of LGBTQ+ folks, allowing them to dance carefree among their heterosexual peers.

Indeed, greater societal acceptance of the LGBTQ+ community began to take shape in the '70s. In 1971, the first version of the Sexual Orientation Non-Discrimination Act was introduced into both houses of the state legislature. In New York City specifically, gay liberation activists pushed Mayor John Lindsay to enact a law prohibiting job discrimination based on sexual orientation. Most importantly, in 1973, homosexuality was officially removed from the American Psychiatric Association's list of mental disorders, a landmark decision that was covered nationwide and paved the way for many gays and lesbians to grow more accepting of themselves.

Towards the late 1970s, however, a new wave of religious revival ushered in a backlash of conservatism that would make life more difficult once again for LGBTQ+ people in the next decade. This included campaigns like the highly publicized anti-gay crusade Save Our Children. On the flipside, the first national gay rights march took place on October 14, 1979 in Washington, DC, in response to both Ronald Reagan's imminent presidency and the recent assassination of gay Californian politician Harvey Milk. The march involved approximately 100,000 people and marked a new chapter in the nation's fight for gay rights, which would evolve into a grueling battle in the decade to come.

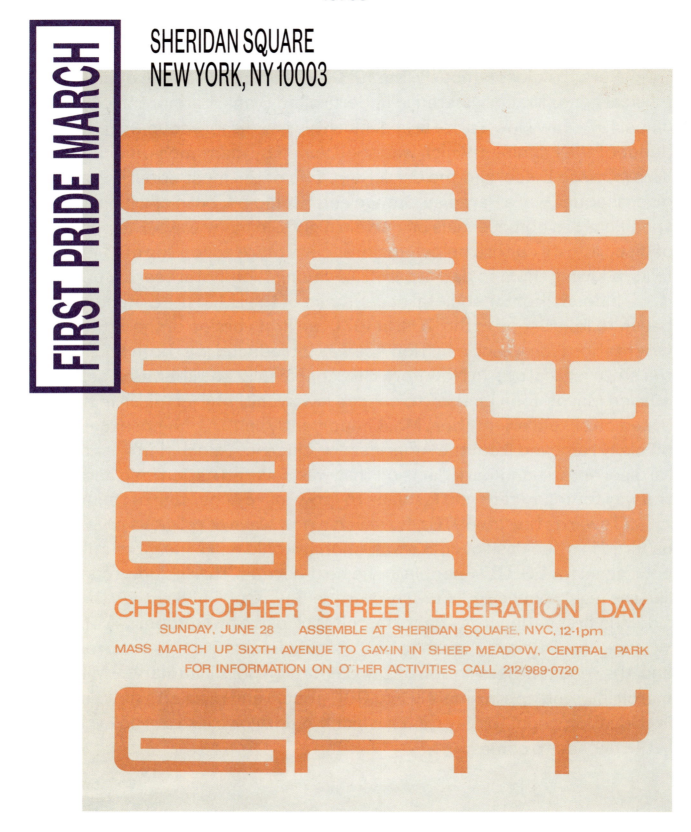

Poster for the first Christopher Street Liberation Day, 1970.

First Pride March

New York City's inaugural pride parade, initially called the Christopher Street Liberation Day March, was held on Sunday, June 28, 1970, to mark the one-year anniversary of the Stonewall Uprising. Organized by a group led by Craig Rodwell, owner of the gay and lesbian Oscar Wilde Memorial Bookshop (see p. 80) in Greenwich Village, the route began at Washington Place between Sheridan Square and Sixth Avenue and ended with a "Gay-In" in Central Park's Sheep Meadow.

Plans for the original march began in November 1969 when Rodwell, alongside other activists, proposed the anniversary event at a gay rights conference in Philadelphia. Their proposal suggested that homophile groups throughout the country hold similar demonstrations that day.

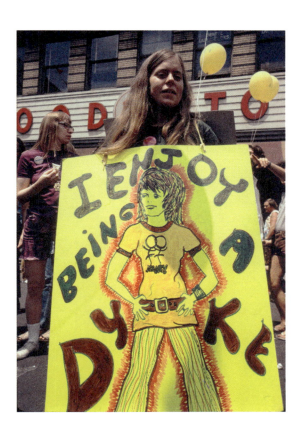

"I Enjoy Being A Dyke," 1971.

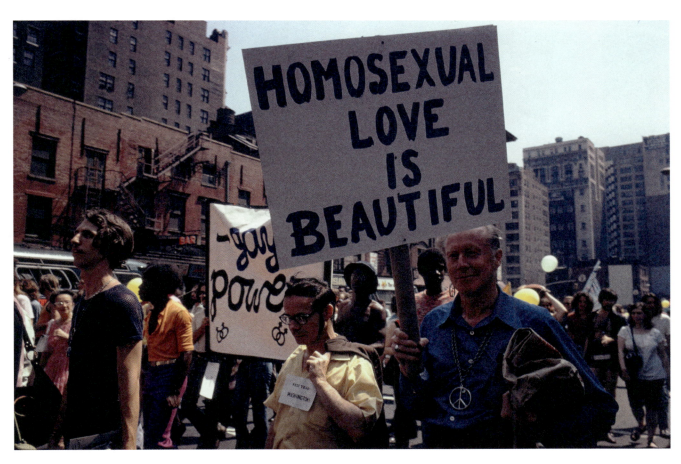

"Homosexual Love Is Beautiful," 1971.

"I Am Your Worst Fear I Am Your Best Fantasy," 1970.

First Pride March

The organizing group came to be called the Christopher Street Liberation Day Committee and it continued to host the annual event until 1984, when the non-profit Heritage of Pride (HOP) took over.

Much to the organizers' own surprise, the first Christopher Street Liberation Day March attracted thousands of participants, with various reports citing wildly differing numbers from 3,000 to 20,000 people, probably because many passersby spontaneously joined the free-for-all procession. In her book *The Gay Revolution*, historian Lillian Faderman points out the sheer significance of the march: "Never in history had so many gay and lesbian people come together in one place and for a common endeavor."

The 1970 march garnered significant media attention, even making the front page of the *New York Times* under the headline: "Thousands of Homosexuals Hold A Protest Rally in Central Park," noting that it "serves notice on every politician in the state and nation that homosexuals are not going to hide anymore."

The march's success made it an annual event in New York City and spawned several other local marches, including the annual Dyke March, Drag March, and Queer Liberation March. It also inspired pride marches across the country and all over the globe. Now officially called the NYC Pride March, it has grown into the largest pride parade in North America and is among the largest pride events in the world. In 2019, 50 years after Stonewall, the event attracted between four to five million people, the largest parade of any kind in New York City's history.

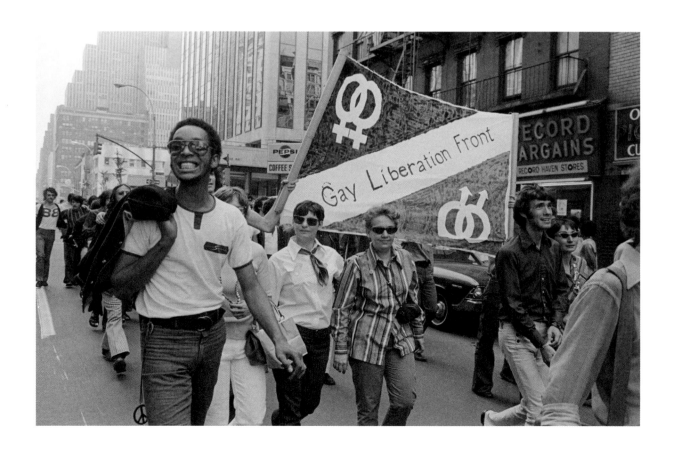

"Gay Liberation Front," 1970.

1970s

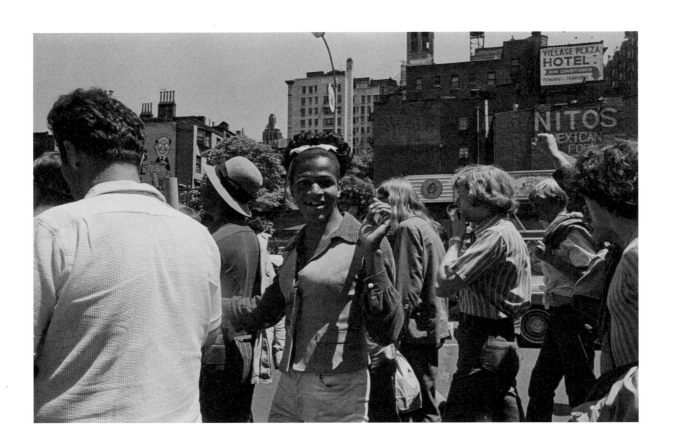

Marsha P. Johnson at Christopher Street Liberation Day, 1970.

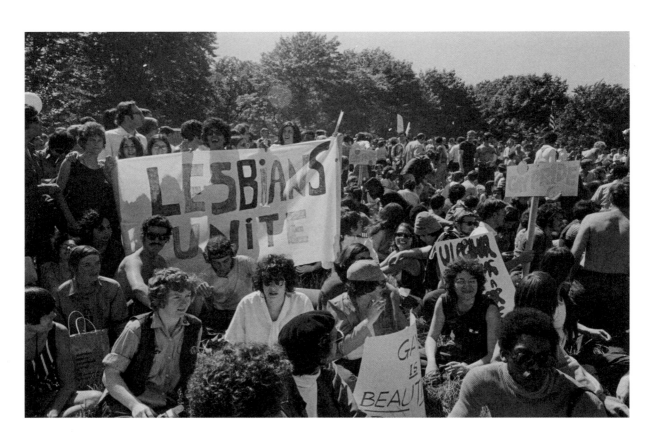

"Lesbians Unite" at the "Gay-In" at Sheep Meadow, 1970.

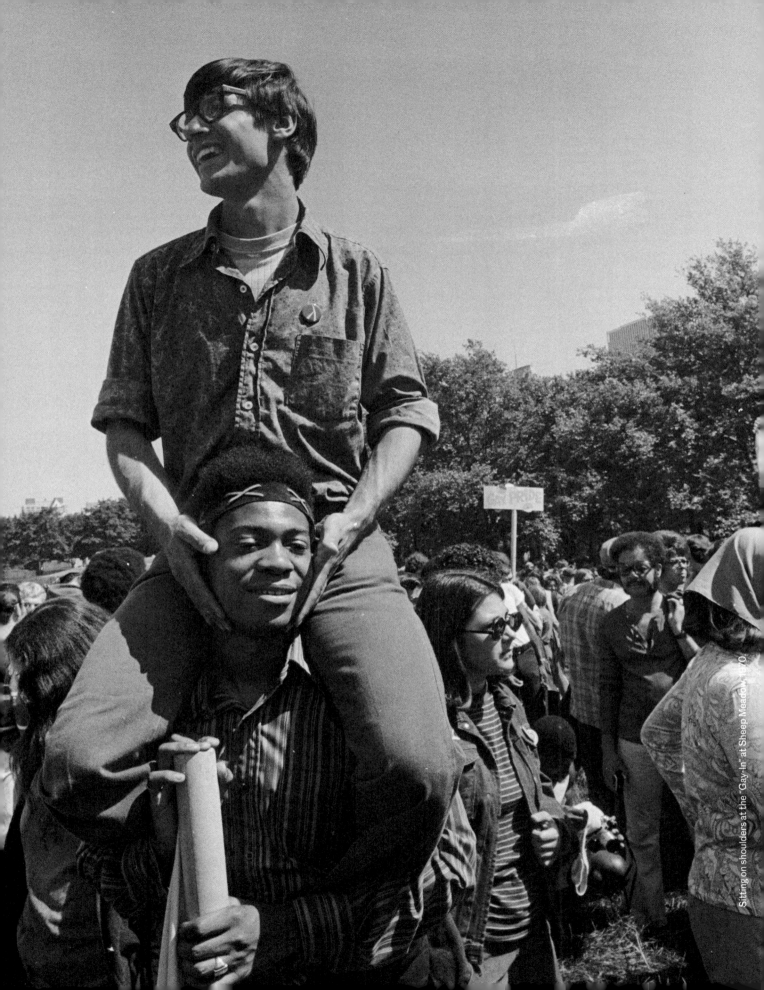

Sitting on shoulders at the "Gay-In" at Sheep Meadow, 1970.

THE CONTINENTAL BATHS

230 WEST 74TH STREET
NEW YORK, NY 10023

1970s

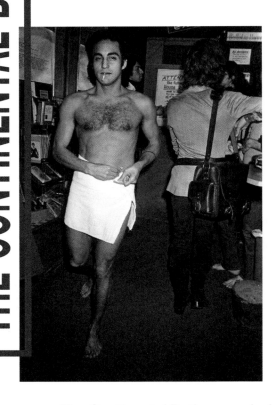

Left: Smoking baths patron in towel next to fully dressed concertgoer, 1972.

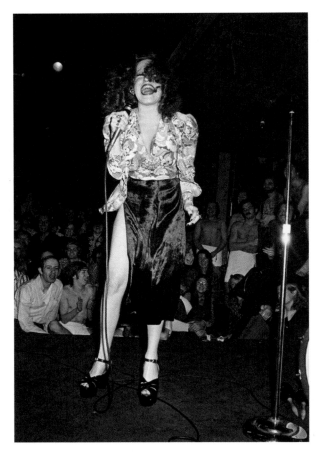

Right: Bette Midler performing at the Continental Baths, 1972.

The Continental Baths was a lavish gay bathhouse, discotheque, and live entertainment venue inside the Ansonia Hotel at 230 West 74th Street on Manhattan's Upper West Side. It was opened in 1968 by opera singer Steve Ostrow as a luxurious alternative for gay men, rivaling the seedier, dilapidated bathhouse options of the time.

Advertised as reminiscent of "the glory of ancient Rome," the Continental Baths occupied the 40,000-square-foot [12,000-meter] basement of the Ansonia and integrated its extravagant Gilded Age décor. It initially boasted private rooms, saunas, a swimming pool with a cascading waterfall, and bunk beds in a public area. Over time, many more amenities were added, including a dancefloor, restaurant, gym, STD clinic, and most importantly, a stage. Up-and-coming DJs like Frankie Knuckles and Larry Levan began spinning there, while many live performers launched their careers at the venue, most notably Bette Midler, who earned her nickname "Bathhouse Betty" and forged her onstage persona "the Divine Miss M" there.

In his book *Saturday Night At the Baths*, Ostrow recalls that the Continental Baths were "a rebirth of Cabaret in the city of New York," with artists like Patti LaBelle, Barry Manilow, and countless others getting their first break there. "It was the first gay establishment to treat gay people as equals and not exploit them," Ostrow wrote.

At its peak, the Continental Baths, open 24 hours, had 400 private rooms and served up to a thousand

men every day. It was repeatedly subject to police harassment and endured over 200 raids, in part because it was not Mafia-affiliated and lacked "protection." Despite this, it remained incredibly busy and was so iconic that it inspired films and plays to tell its story, including *Saturday Night at the Baths* (1975, filmed on location), *The Ritz* (1975)—for which Rita Moreno won a Tony Award—and the documentary *Continental* (2013).

By 1974, attendance by the Continental Baths' core crowd sharply declined, with many gay patrons complaining that too many fully clothed straight people were now attending the shows. Unable to reverse this trend, Ostrow closed the Continental Baths for good in the same year. The location reopened as Plato's Retreat, a members-only swingers' club for heterosexual and bisexual couples, which would ultimately shutter during the AIDS epidemic.

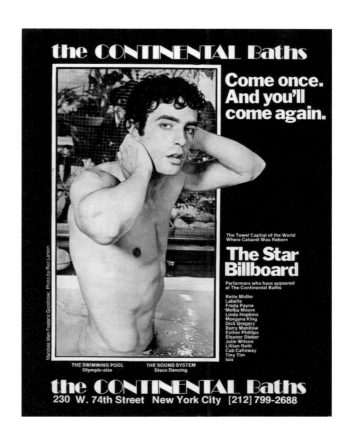

Advertisement for the Continental Baths from *Mandate*, a gay porn magazine, 1975.

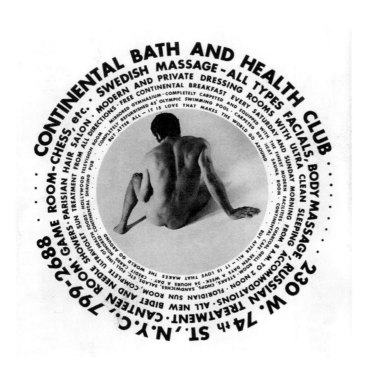

Ad for the Continental Baths, 1970.

Robert Bryan, patron: "Most people wore only towels, but I guess for the shows some would come fully dressed just to see Bette Midler or whoever else was performing. I got to see Bette there two or three times and it was always so fun. But we all hated Barry Manilow, of course, and whenever Bette would say, 'Oh now my accompanist Barry is going to do something HE wrote,' everybody would groan out loud."

1970s

GAA FIREHOUSE

**99 WOOSTER STREET
NEW YORK, NY 10012**

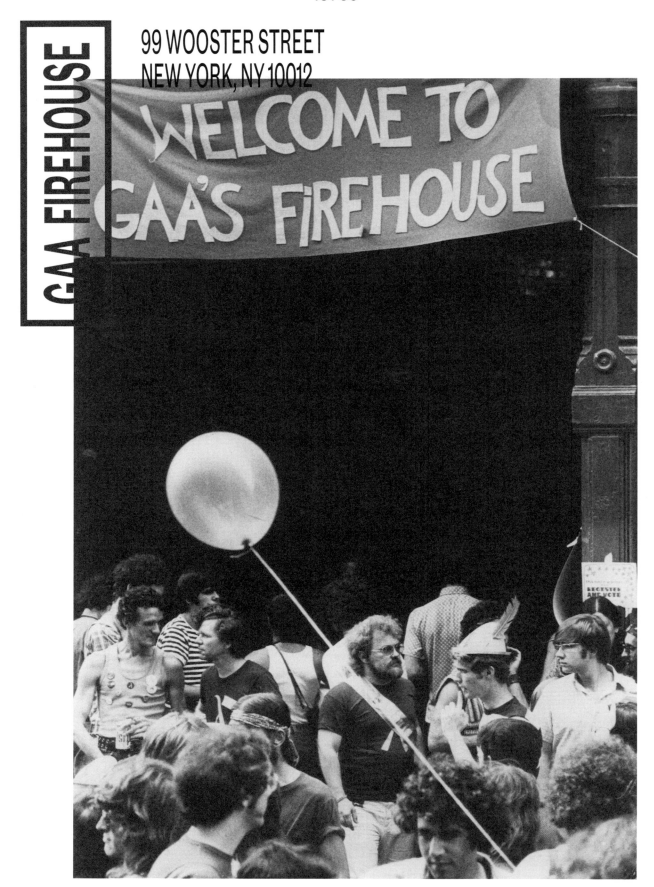

Welcome to GAA's Firehouse street fair, 1971.

GAA Firehouse

The Gay Activists Alliance, a leading gay liberation organization, was established in December 1969, six months after the Stonewall Uprising. From 1971 to 1974, the GAA used a former firehouse at 99 Wooster Street in SoHo as its headquarters, which became one of New York's most important queer political and cultural hubs and served as the city's first unofficial LGBTQ+ center.

The building dates back to the turn of the century, but in the spring of 1971, GAA members completely overhauled the space's interior. Volunteers painted a dramatic mural featuring women holding hands, men embracing, and the likenesses of Walt Whitman, Gertrude Stein, and Allen Ginsberg, along with slogans like "Gay Power" and "An Army of Lovers Cannot Lose." GAA was also the first group to adopt the lambda as a gay symbol in 1970, which became a prominent portion of their logo and was publicly displayed on a banner outside the Firehouse.

GAA's focus was to advance LGBTQ+ civil and social rights, and many of the group's activities were planned at the Firehouse, including sit-ins, protests, and picket lines. Perhaps GAA's most famous tactic was the "zap," a direct, public confrontation designed to gain media attention, such as a kiss-in at a straight bar that had ejected gays.

In addition to its role as a political forum, GAA also ensured that the Firehouse served as a center for visible, proud gay social life. It used the space for large events, including weekend dances that drew 1,500 people and fundraised for the group. According to Wallace Hamilton in the

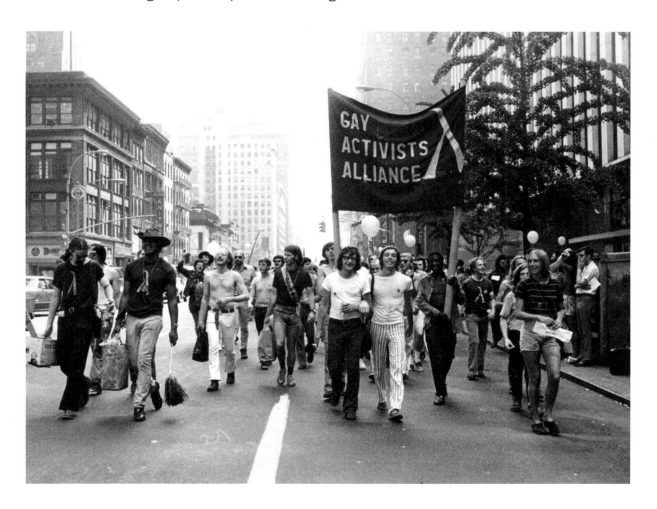

GAA marching during Gay Liberation Day, 1971.

1970s

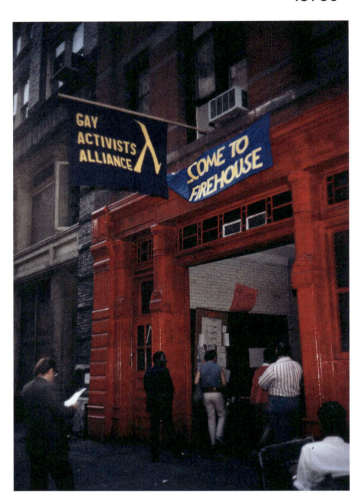

Gay Activists Alliance Firehouse exterior, 1971.

book *Stepping Out*, "This wasn't the same kind of dancing as was happening at bars on Christopher Street. These dances…were a celebration of post-Stonewall identity."

By late 1972, however, GAA faced criticism for being too white, too middle class, and too male. As time wore on, members defected to other more disparate, specialized groups, many of which used the Firehouse as a meeting space, including the Lesbian Feminist Liberation, Gay Youth, and the Gay Men's Health Project.

Tragically, in October 1974, arsonists destroyed the Firehouse and the GAA was subsequently evicted from the space. The group then jumped around, meeting at various locations for the rest of the decade, but ultimately could not recapture the magic and officially disbanded in 1981.

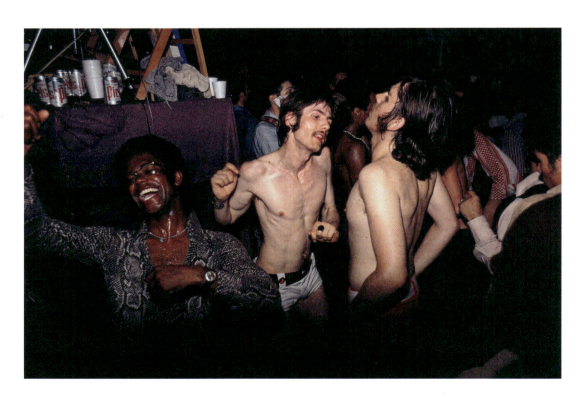

Sweaty dancers in ecstasy at a GAA Firehouse dance, 1971.

GAA Firehouse

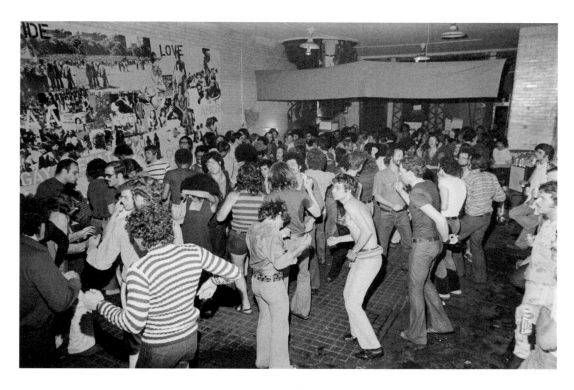

Bustling dancefloor at a Gay Activists Alliance Firehouse dance, 1971.

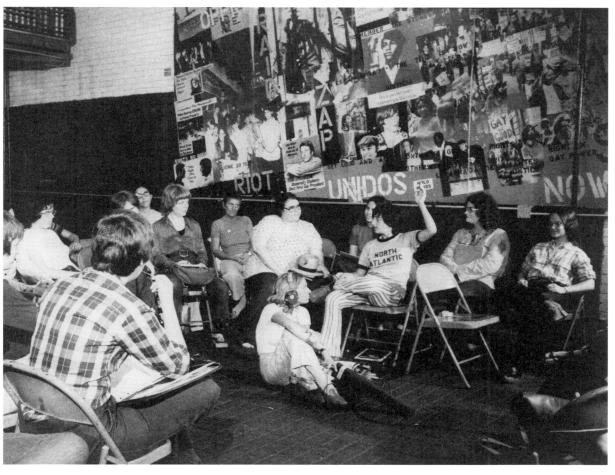

Lesbian Lifestyle Interview at GAA Firehouse, 1974.

CRISCO DISCO

408 WEST 15TH STREET
NEW YORK, NY 10011

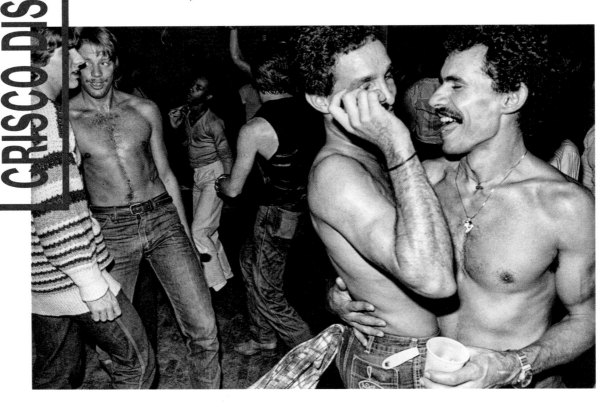

Crisco dancers, 1979.

Located at 408 West 15th Street, Crisco Disco was an after-hours discotheque known for its humorous name, referring to the brand of vegetable shortening that had become synonymous with gay sex and was used by many as a personal lubricant. Its DJ booth was the club's most iconic feature, built as a giant can of Crisco shortening, with painted phrases like "It's digestible."

Open throughout the 1970s, Crisco Disco hosted some of the finest DJs at the time, including Danny Rodriguez, Frankie Corr, Michael "Copa" Haynes, and John Rossi. Called Crisco's for short, it was a multi-floor club in a converted warehouse in the Meatpacking District, which was still highly industrialized at the time. It did not have a liquor license, so patrons would either buy special tickets to exchange for drinks indirectly or bring their own booze if they knew the owner, Hank Pagani. Pagani was notorious for inviting attractive people into the club's VIP room, where a huge pile of cocaine would often be waiting.

Elton John reminisced about being turned away from Crisco Disco in his memoir *Me*: "I was with Divine, too, the legendary drag queen...He was wearing a kaftan, I had on a brightly coloured jacket and they said we were overdressed: 'Whaddaya think this is? Fuckin' Halloween?'"

In 2015, nightlife journalist Michael Musto listed Crisco Disco as one of the city's edgiest venues "that shall never be recaptured." Crisco's ultimately closed circa 1982. Its warehouse sat unoccupied for over 30 years, until it was finally bought and renovated into an upscale restaurant during the Meatpacking District's major revitalization in the 2010s.

Crisco Disco

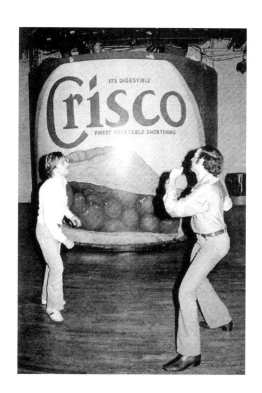

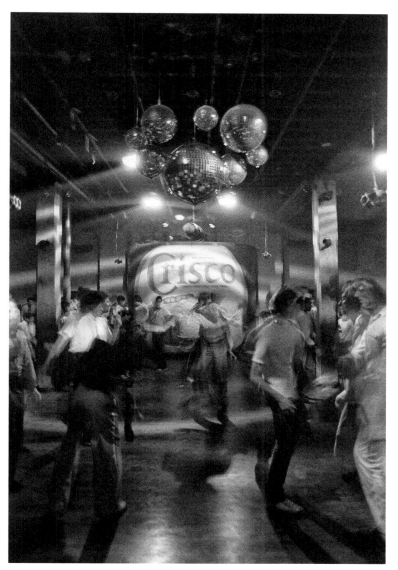

Left: Dancers in front of the DJ booth, circa 1978.

Right: Crisco Disco dancefloor, 1979.

> Danny Rodriguez, DJ at Crisco Disco: "The DJ booth was a massive Crisco Can, and on the lower left-hand side was a door cut out that was flush. You couldn't see it unless you knew about it, and couldn't get in unless you were let in. But a lot of people that Hank knew got let in, including his side lover, a 20-year-old kid he called Super-Toy, who was 6'2", blonde, good-looking. One night, I went downstairs for a drink, came back to go up into the Can, but when I opened the door, Super-Toy was laying on the floor with a girl riding on him. And I said to myself, 'Ah, THAT's why they call him Super-Toy. He had like, 12 inches that he was working with."

1970s

CHRISTOPHER STREET PIERS

393 WEST STREET
NEW YORK, NY 10014

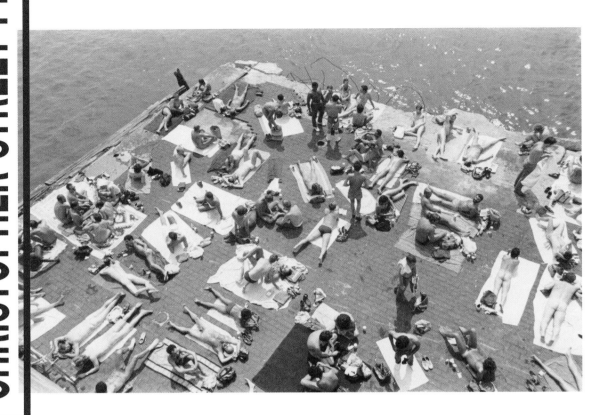

Pier 48, 1980.

Once a working part of the city's industrial waterfront, the Christopher Street Piers along Manhattan's west side have long been a vibrant gathering site for the LGBTQ+ community. Now a section of the polished Hudson River Park, the piers previously served as living quarters for queer homeless youth, a blank canvas for many artists, and a destination for nude sunbathing, cruising, and sexual intercourse for gay men.

During the early 1900s, Greenwich Village's Hudson River waterfront was the city's busiest port. As early as WWI, the area was a cruising ground for sexually curious men, and by WWII the confluence of unmarried, working-class men in close quarters, the waterfront's relative isolation, and a smattering of seedy dive bars forged this early hub for gay city life.

By the 1960s, industrial shipping and its workforce were moved out of the neighborhood, leaving the abandoned piers behind. A community of gay men now trickled into the region, seeking both isolation and refuge. By the end of the decade, the gay community had all but fully claimed the piers as their own, meeting one another for cruising and sex there, particularly late at night.

In the 1970s, when nearby Christopher Street had become the center of NYC's gay life, the piers grew into a primary daytime destination as well, attracting sunbathers and more publicly visible sex acts. Numerous explicitly gay bars and clubs began opening in the vicinity, such as Badlands, Sneakers, Keller's, Ramrod, and Peter Rabbit's.

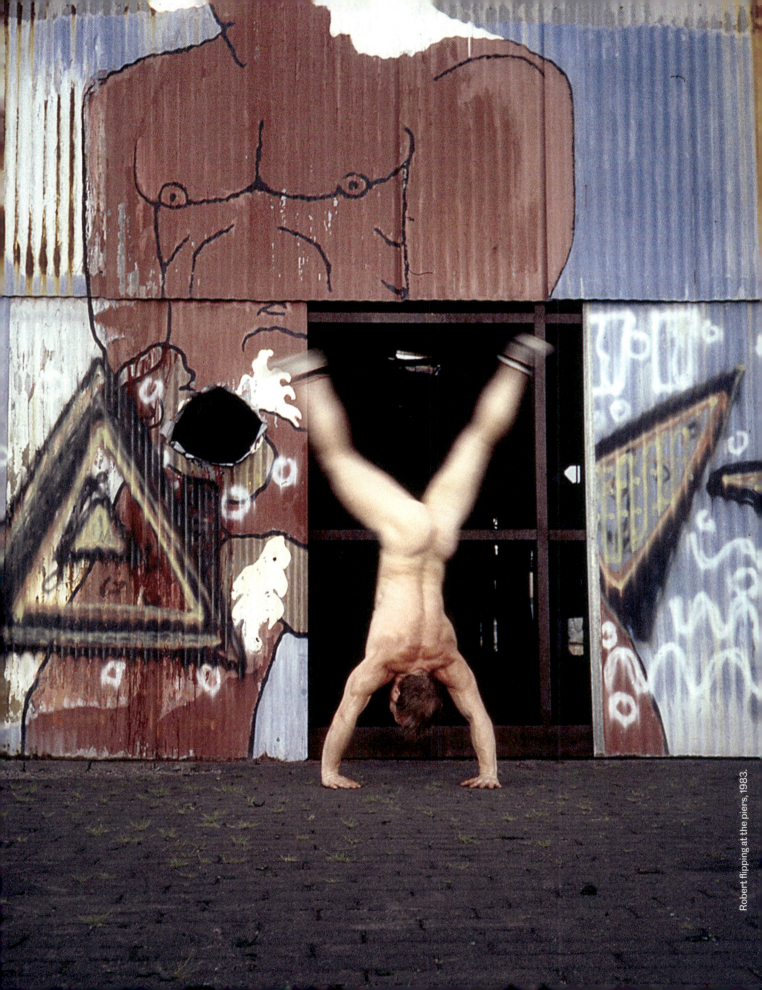

Robert flipping at the piers, 1983.

1970s

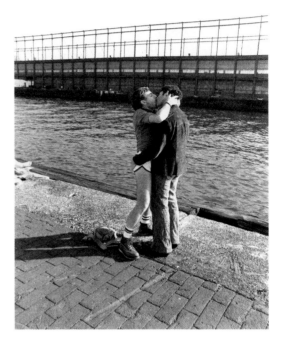

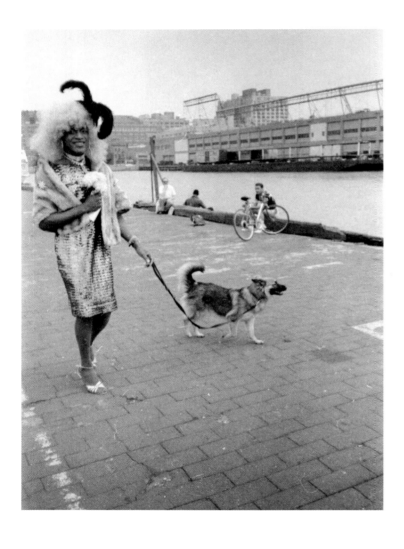

Left: Activist Marsha P. Johnson walking a dog on the piers, 1982.

Right: Kissing at the piers, 1970s.

The piers' ramshackle structures also became important spaces for artists, including photographers like Alvin Baltrop, Peter Hujar, and David Wojnarowicz, who took countless photos of the decrepit environments and their colorful inhabitants in various stages of undress. The enormous interiors hosted site-based installations by artists like Wojnarowicz, Keith Haring, and Gordon Matta-Clark, who famously created *Day's End* by cutting out giant holes in the walls of Pier 52.

By the '80s, the piers were affected by both the AIDS epidemic as well as by the city's early waterfront development plans. At this time, the piers became a haven for marginalized queer youths of color and trans folks. Two in particular, activists Marsha P. Johnson and Sylvia Rivera, established a strong presence in the area, giving out food and clothing to needy

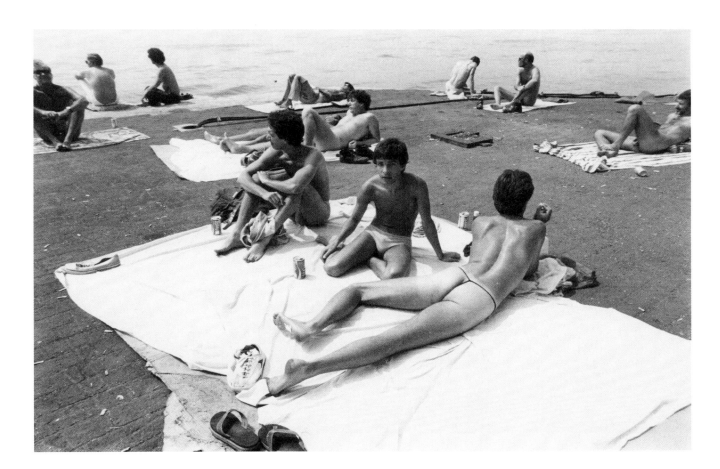

Pier 46, 1979.

recipients. Rivera made the piers her home in the mid-'80s, where she struggled with homelessness, only to be heartlessly evicted by the city.

Johnson, meanwhile, would be found dead in the Hudson River just off the piers in July 1992. Though police called it a suicide, her friends insisted they had seen her being harassed shortly before her death, a case which remains unsolved. Despite such troubles, the piers continued to be a vital refuge. Many scenes from the seminal 1990 documentary about ballroom culture *Paris is Burning* were shot in the area.

Plans to rebuild the entire waterfront began in the early '90s, a process which disregarded the presence and needs of its queer community. This sparked a grassroots LGBTQ+ effort that endured for years, including 1998's "Queer Pier" campaign, which hoped to salvage the piers. The city, however, officially closed the piers in 2001, which were then completely renovated throughout the early 2000s, slowly developing into the clean, gentrified waterfront of today. In 2014, the Whitney Museum commissioned artist David Hammons to develop a permanent public art piece along the pier, which he entitled *Day's End*, directly referencing Matta-Clark's work from 1975.

Given the proximity to both Greenwich Village and the West Village, the Christopher Street Piers continue to be a central gathering place for the city's LGBTQ+ community today. A visit there can still feel cruise-y at the right times, but nudity and public sex are no longer present for the most part. The region remains a vital queer space whose LGBTQ+ history can never be washed away.

1970s

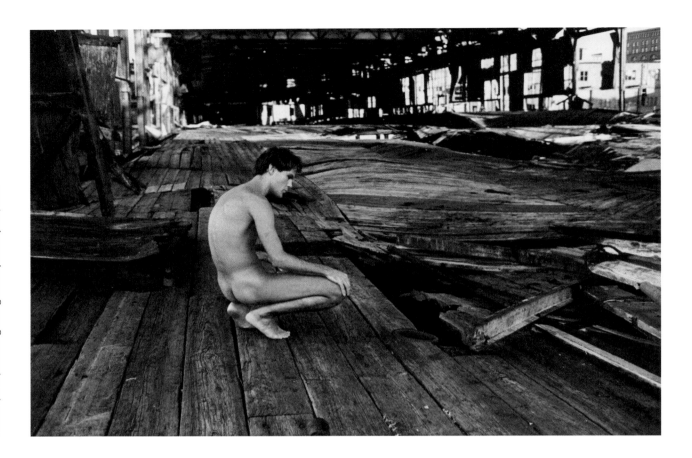

Kenneth, nude, reflecting among the dilapidated piers, 1977.

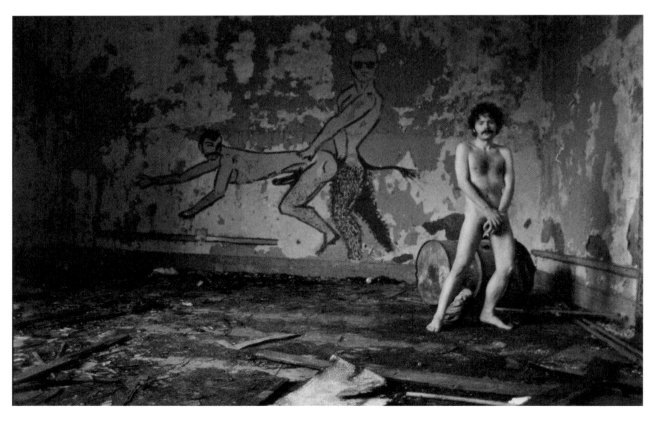

Pier 46, circa 1980.

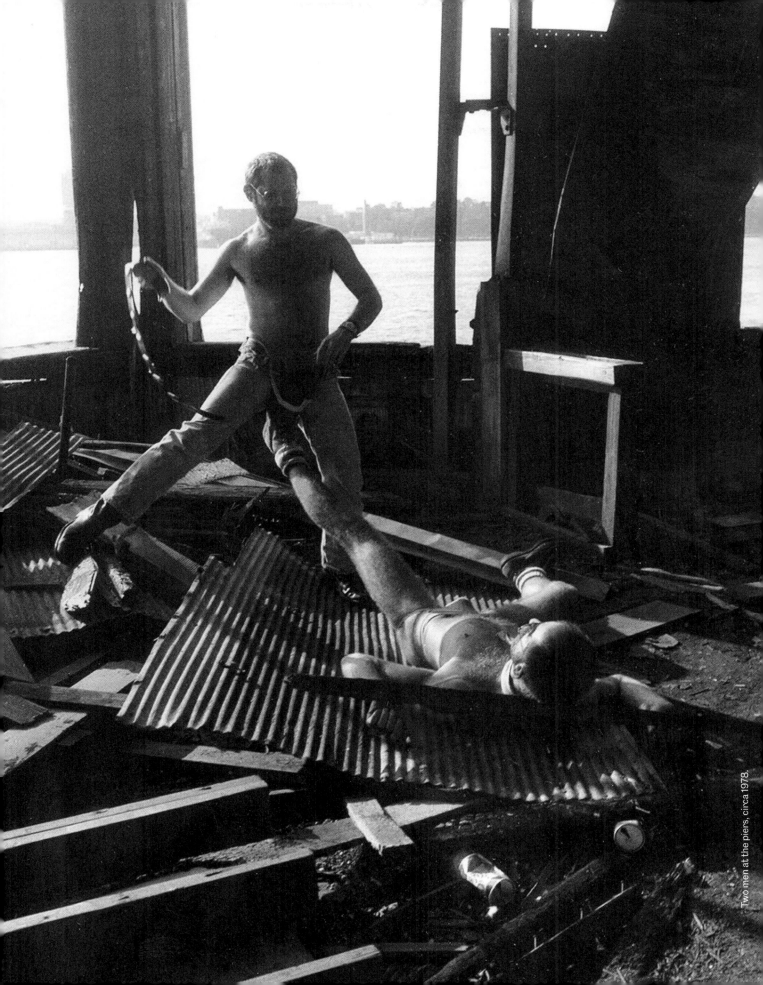

Two men at the piers, circa 1978.

12 WEST

491 WEST STREET
NEW YORK, NY 10014

Located at 491 West Street between West 12th and Jane Streets, 12 West was one of the most popular membership-based discotheques catering to a predominantly gay clientele. Operating between 1975 and 1980, the club was exclusively a "juice bar," meaning no alcohol was ever served. Instead, patrons could order coffee, cookies, and of course, juice.

Previously a flower factory, 12 West was laid out like an amphitheater, with three raised banquettes surrounding the dancefloor. The club's sound system was highly advanced for its time and many of the hottest DJs spun there, including Tom Savarese, Jim Burgess, Alan Dodd, Robbie Leslie, and Jimmy Stuard, among others.

The combination of 12 West's state-of-the-art sound and alcohol-free environment meant the club was primarily patronized by people who were devoted to music, often fueled by drugs and dancing into the early hours. Regular Teddy Pecora recalled that 12 West became a testing ground for record companies to gauge the popularity of unreleased tracks. One night, record label agents came to test Donna Summer's "Last Dance"; Pecora recounted seeing them with clipboards, observing how dancers reacted. Initially confused by the song's unusual downtempo intro, everyone soon went wild when the beat dropped, and the song became one of Summer's biggest hits.

When Bruce Mailman opened his membership-based gay megaclub the Saint in September 1980, men who were 12 West diehards began flocking there and transferring their memberships. 12 West's owners struggled to keep the club afloat, and it closed that same year. Trying to salvage the space, they rebranded as the River Club in 1981, but failed to reclaim the peak of 12 West's popularity. After the River Club closed in 1985, the building was torn down.

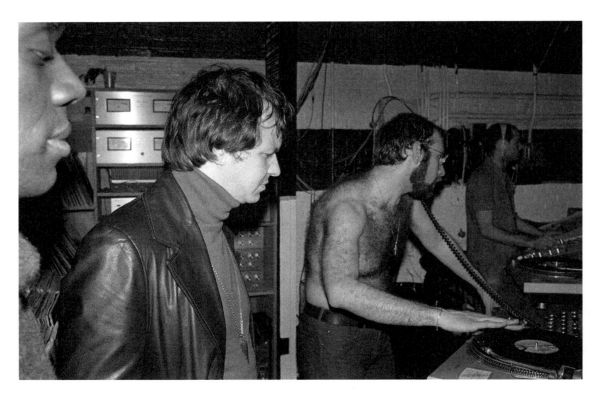

Producer Michael Zaeger with DJ Jimmy Stuard, circa 1970s.

Teddy Pecora, fan dancer at 12 West: "Originally, there was no sign outside 12 West. It was just a locked black door and when you got there you knocked and the doorman would open it and say, 'Welcome to Oz!' When you walked in, you entered your gay world, with no straight people, because straights were the enemy at the time. Back then, we didn't want to be with people who tortured us, and 12 West was very private in that sense. There was a membership to join, and you had to have two members bring you in. So even though you were gay, you couldn't just show up at the door. Of course, guys did show up and say, 'We don't have a membership,' and the doorman would reply, 'So go see if somebody on this line thinks you're cute, find a member and he'll bring you in.' And that's often how people joined."

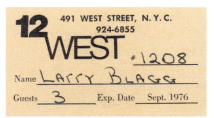

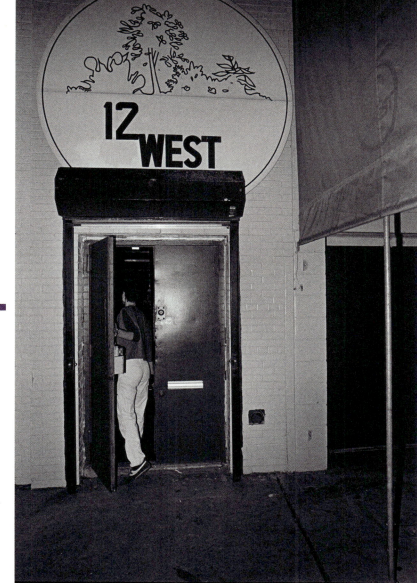

Left: 12 West membership card (front and back), 1976.

Right: 12 West entrance, 1978.

GG'S BARNUM ROOM

**128 WEST 45TH STREET
NEW YORK, NY 10036**

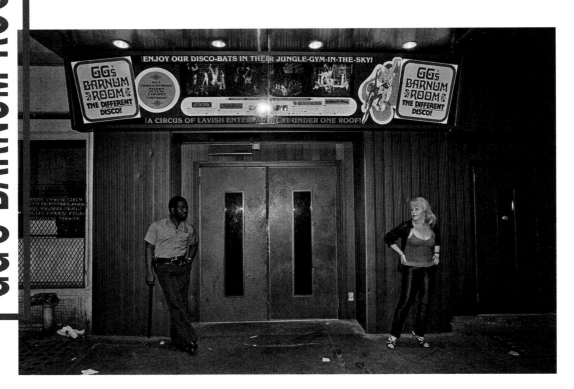

GG's Barnum Room entrance, 1979.

In 1978, the former location of the original Peppermint Lounge, a popular discotheque and birthplace of the Twist craze in the '60s, reopened as GG's Barnum Room at 128 West 45th Street, a frequent hangout for transgender people and drag queens in particular. It was owned by mob associates of the Genovese crime family, who managed numerous other queer-oriented bars in Manhattan.

Initially, the club's full name was quite a mouthful: GG Knickerbocker's PT Barnum Room. It was partly named after the famous founder of the Barnum and Bailey Circus, and partly referred to the Knickerbocker Hotel, which housed the club. "GG" stood for "Gilded Grape," the name of an earlier club that also attracted drag performers, as well as trans and gay people, serving as an important signal that the same crowd would be welcome here too.

GG's Barnum Room was an incredibly vivid experience, notable for its "Jungle Gym in the Sky," where a troupe of male and transfeminine trapeze artists performed above the dancefloor. The acrobats, often called the "Disco-Bats," infused the club with a sexualized, gravity-defying floor-to-ceiling energy. In a 1979 issue of *New York* magazine, Orde Coombs recalled how "half-naked men swing spread-eagle through the air. They freeze for fifteen seconds, and as the music goes into its rhythm break, they drop into the net, the only thing that stands between them and the bodies of the revelers below."

Following in the Gilded Grape's footsteps, GG's was also a notable haven for trans folks. Coombs

GG's Barnum Room

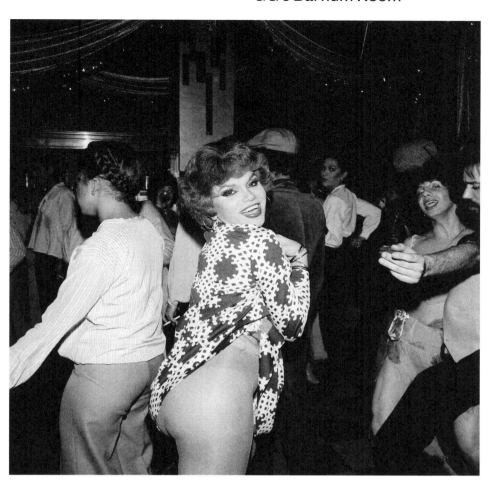

Patron hiking up her dress on the dancefloor, 1978.

documented overhearing a trans patron saying, "This place is like the new heaven. All the people doing all their things without condemnation," and another retorting, "It's just lovely. It must have been like this in Nero's Rome."

GG's liquor license was eventually revoked after steady neighborhood complaints and a pair of murders. The club closed for good in November 1980. The space was later revived as the Peppermint Lounge and became a rock music nightclub. In 1982 it moved downtown, where it remained until 1985, while the building at 128 West 45th Street was torn down in the mid-1980s.

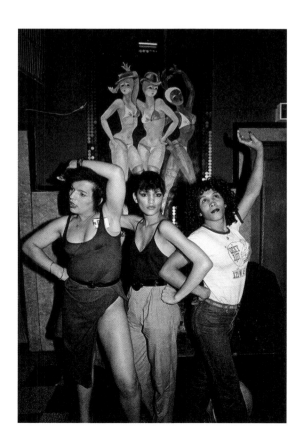

Partying at GG's Barnum Room, 1979.

1970s

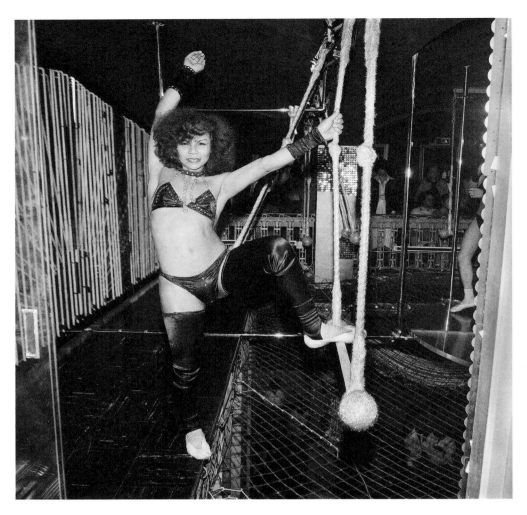

Trapeze artist Michelle Castillo hanging above GG's Barnum Room, 1978.

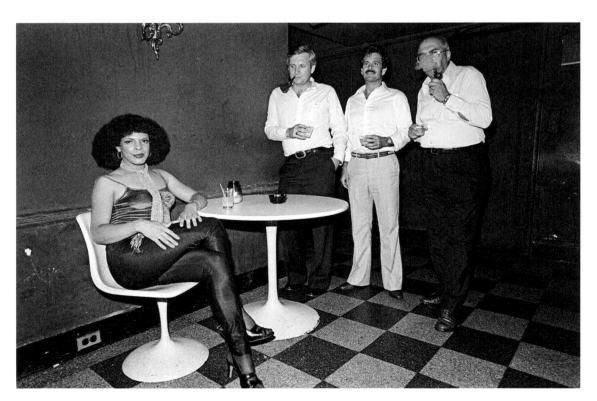

Patrons at GG's, 1979.

Norell Gardner, performer at GG's: "The toast of New York back then was a drag queen named Brandy Alexander who was famous for her strip act...she gave me a reference, and I got to put together a one-woman show for Barnum. I remember going in to audition wearing a purple silk Diane Von Furstenberg dress with a green silk duster. On my way there, I got stopped in Times Square by a couple of people asking if I was Lynda Carter [TV's Wonder Woman]. I kept saying no, but they would say, 'Oh yes you are.' So I signed an autograph just to get rid of them, and then they said, 'Oh you're not Lynda Carter! You spelled 'Lynda' wrong!'"

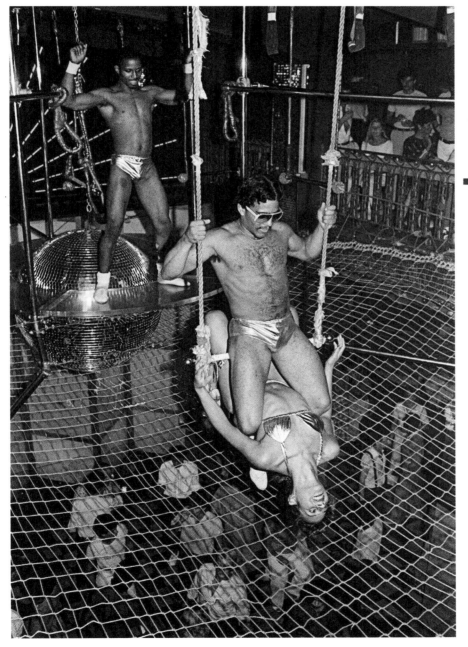

Disco Bats, 1979.

1970s

THE MINESHAFT

**835 WASHINGTON STREET
NEW YORK, NY 10014**

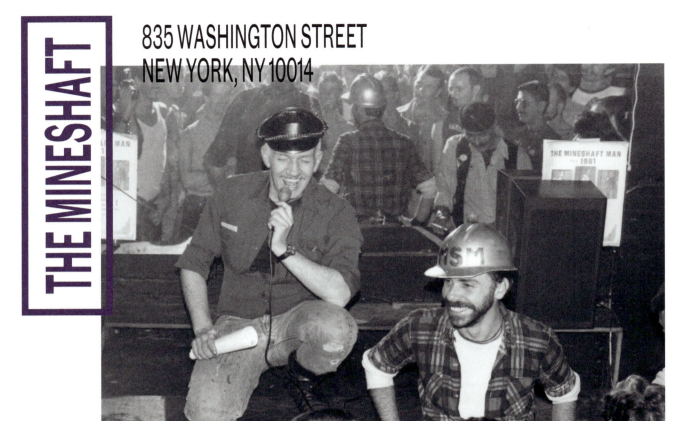

Top: The Mineshaft Man, 1981.

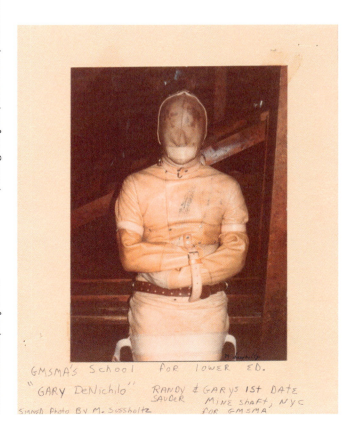

Bottom left: A Gay-Male-S/M Activists' event at Mineshaft, early 1980s.

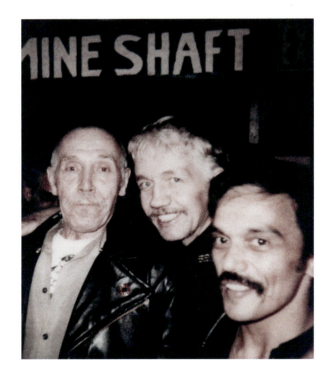

Bottom Right: Tom of Finland, Wally Wallace, and Etienne (Domingo Orejudos) at Mineshaft, circa 1970s.

The Mineshaft

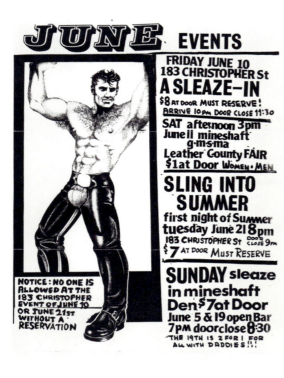

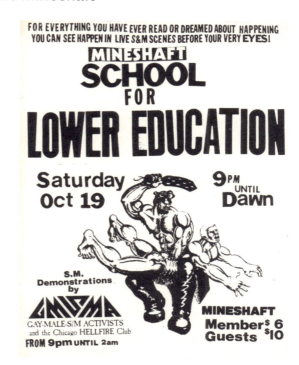

Left: Mineshaft flyer, circa 1980s.

Right: Mineshaft School for Lower Education flyer, 1985.

Located at 835 Washington Street in the heart of the Meatpacking District, the Mineshaft was a members-only BDSM gay leather bar and sex club christened by many as the "temple" of nontraditional sex. Operating from 1976 to 1985, the Mineshaft's entrance was nondescript, marked by a white arrow pointing to a red door, the words "Private Club," and the building number. Inside, a completely black staircase was guarded by a bouncer who would ensure that all patrons adhered to the strict dress code, listed on a sign detailing many of the rejected items: "No colognes or perfumes; no suits, ties, dress pants; no rugby shirts, designer sweaters, or tuxedos; no disco drag or dresses." Instead, customers typically donned leather, cowboy attire, motorcycle gear, blue-collar uniforms, or not much at all.

Nudity or minimal clothing was in fact encouraged. Promiscuity was celebrated, and the club offered a wall of glory holes, several dungeons, slings, and cans of Crisco for use as lubricant. The venue served no alcohol, though drugs were common.

Long rumored to have been Mafia-owned, the Mineshaft was managed by the much-beloved Wally Wallace, called the "godfather of leather sensibility." In a touching obituary, he was remembered in 1999 by Arnie Kantrowitz as "the set designer for exposing the beautiful, darker side of our sexuality."

The club was frequented by several famous patrons who helped shape the perception of BDSM culture within the public sphere. Among those were Robert Mapplethorpe, who took many pictures there, at one point becoming its official photographer. Jacques Morali took inspiration from the Mineshaft's dress code to create the Village People's Leatherman character, portrayed by musician Glenn Hughes, another club regular. Other visitors included philosopher Michel Foucault and Freddie Mercury, who wore a Mineshaft T-shirt in Queen's music video for "Don't Stop Me Now." Al Pacino visited to research his role for the controversial 1980 movie *Cruising*, though the bar refused to let the film be shot there. (The movie's scenes were instead recreated at the

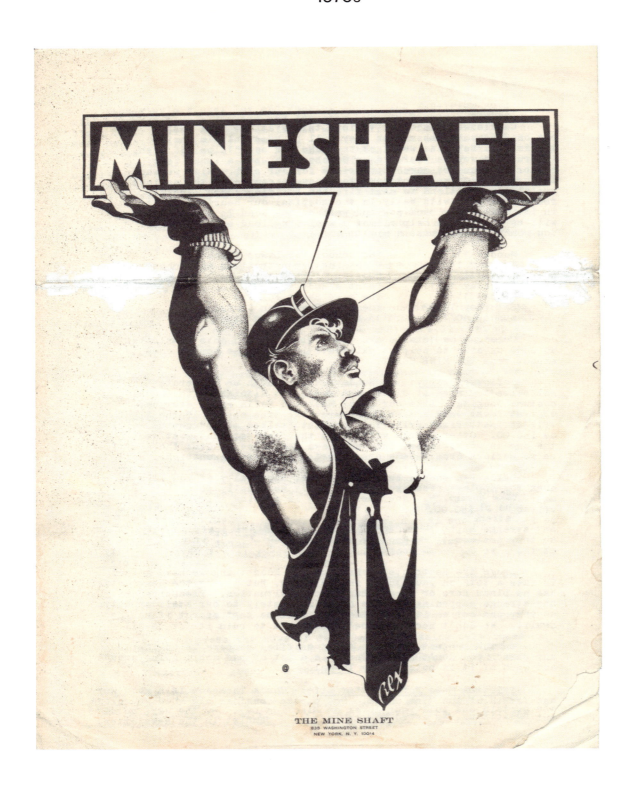

A drawing by the artist Rex, circa 1970s.

nearby Hellfire Club, styled to resemble the Mineshaft.)

The AIDS epidemic ultimately led to the Mineshaft's demise when authorities began closing any venue where high-risk homosexual activities were taking place. On November 7, 1985, it became the Health Department's very first target, the exterior pasted with neon-orange "Closed" signs. It would be the first of many, as New York shuttered countless gay bathhouses and sex clubs, the effects of which can still be felt today.

Thor Stockman, patron and GMSMA (Gay Male Sadism Masochism Activist): "I remember a friend of mine who was not into leather, but who was, like so many other gay men, curious. He was a little drunk one night, coming back from some other function wearing a tux. Clearly, he was not dressed appropriately and was immediately turned away at [the] Mineshaft's door. But before leaving, he clapped back, purposely using a squeaky, feminine voice, and said, 'Whaaat, don't you want some variety in there?' And I just thought that was so funny."

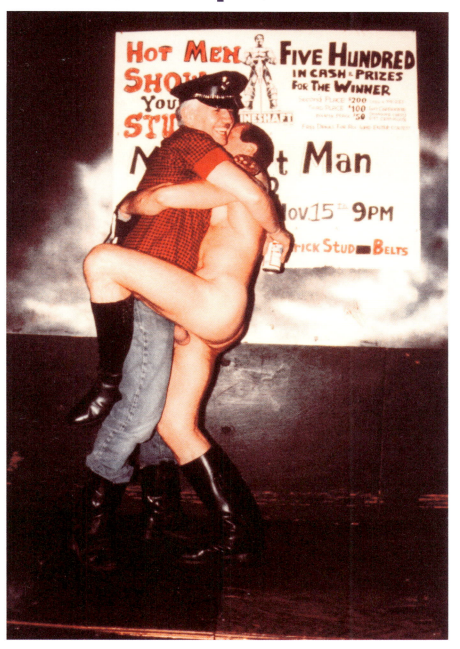

Men embracing onstage, the Mineshaft Man competition, 1981.

1970s

STUDIO 54

254 WEST 54TH STREET
NEW YORK, NY 10019

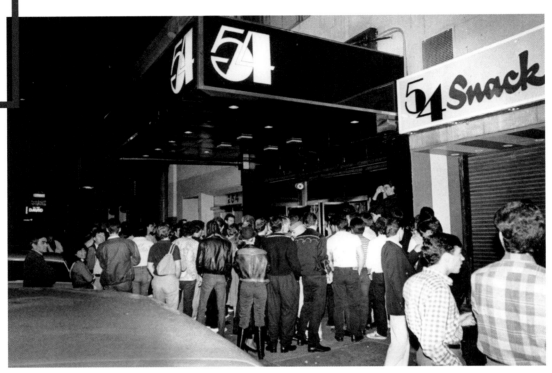

Studio 54 exterior, 1975.

Perhaps no nightclub burned brighter in such a short time than the fabled discotheque Studio 54, the place to be for gays, straights, and everyone in between during its three energetic years. Located at 254 West 54th Street, it was the brainchild of college friends Steve Rubell, who was gay, and Ian Schrager, who was straight. Studio 54 opened on April 26, 1977, when disco was peaking in popularity, and quickly became known around the world for its lavish parties that fused extensive celebrity guest lists, door policies based on appearance and style, rampant drug use, and open sexual activity to create one of the most famous night spots of all time.

The building itself first opened in 1927 and housed multiple live entertainment venues until 1942, when CBS took it over as a broadcast studio called Studio 52. When the station moved out and put it up for sale in 1976, German-born male model Uva Harden and Israeli entrepreneur Yoram Polany swooped in with plans to open a nightclub. After encountering difficulties, they were introduced to Rubell and Schrager, who agreed to partner in the club's operation. Both Harden and Polany eventually left the deal, while Rubell and Schrager brought in a third partner named Jack Dushey to create Studio 54.

Using a modest budget, the team enlisted a design team of several gay men to transform the space in just six weeks, taking advantage of the preexisting theatrical infrastructure. Studio 54 became known for integrating large-scale set pieces into the nightlife experience, such as a wall-mounted mural of an Aztec sun god that spewed

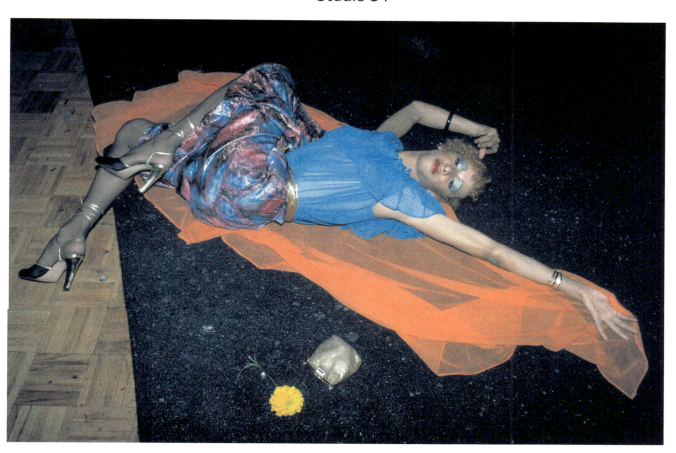

Colorful queen splayed out on Studio 54's dancefloor, 1977.

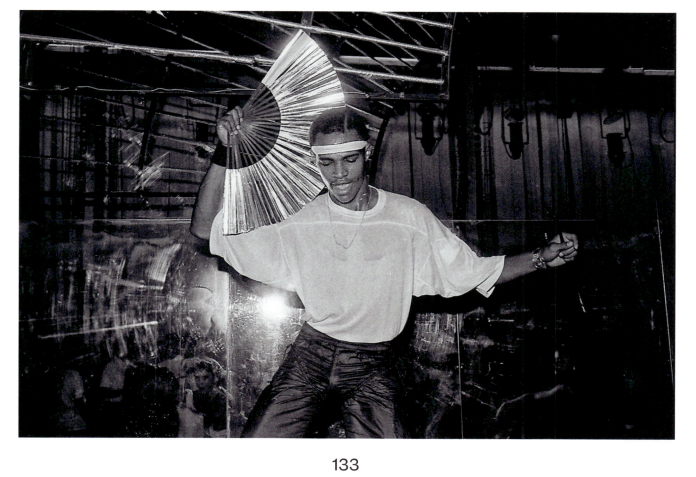

Fan dancer, 1979.

1970s

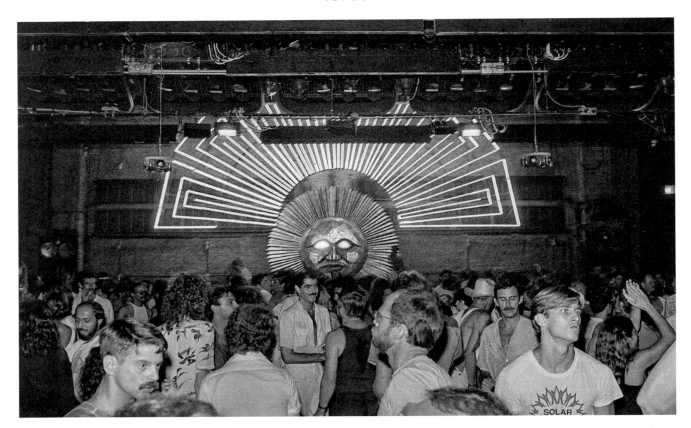

Studio 54 Sun God dancefloor, 1979.

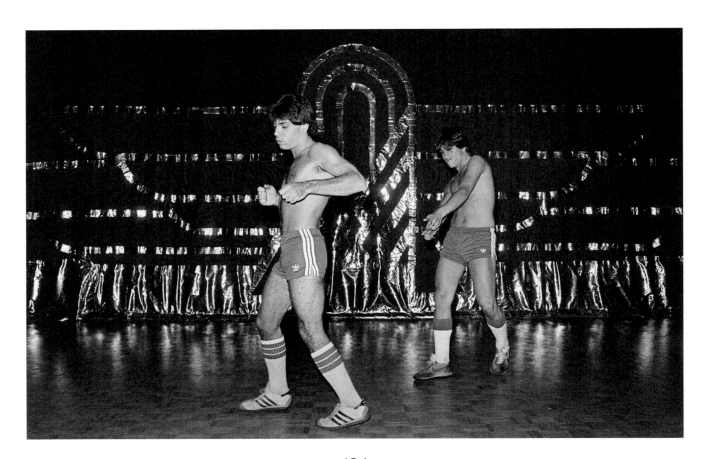

Studio 54 busboys, 1979.

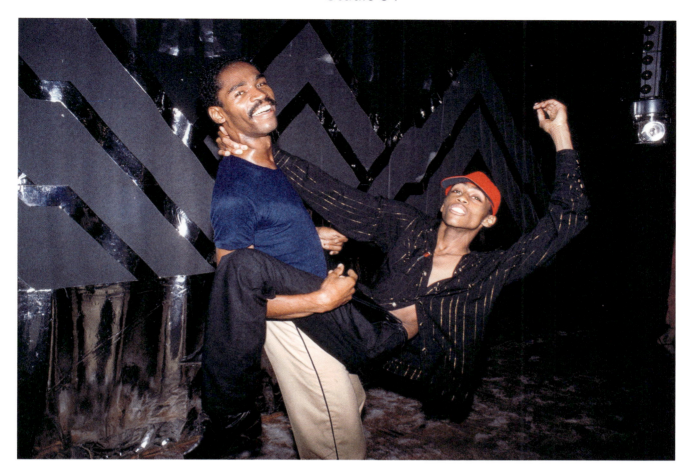

Two men dancing intimately, 1977.

smoke, or the highly photographed cocaine-snorting moon, which swung above the dancefloor and became the emblem of the era.

While Studio 54 was not exclusively gay, it attracted people from every walk of life, and counted many LGBTQ+ folks as regulars. Famous queer celebrities who visited the venue included Halston, Victor Hugo, Lily Tomlin, André Leon Talley, Truman Capote, Divine, and Andy Warhol, while LGBTQ+ performers and icons like Grace Jones, Donna Summer, Sylvester, Gloria Gaynor, and the Village People put on extravagant shows there.

Opening night at Studio 54 was an absolute mob scene, and the discotheque's unbridled popularity continued for the next three years, with swarming crowds waiting outside, hoping to be hand-selected for admission. Many patrons engaged heavily in drugs, while others frequently had sex on the balcony. The club was constantly written up in newspapers and gossip columns, documenting the countless shenanigans, such as Bianca Jagger's legendary ride on a white horse led by a naked, gold-glittered hunk.

With all eyes on Studio 54, trouble was soon afoot when a disgruntled ex-employee tipped off the IRS in 1978, alleging that Rubell and Schrager were skimming profits and storing large amounts of cocaine in the basement. The club was raided and the duo arrested, though Studio 54 continued to operate as usual until 1980, when both men were sentenced to three-and-a-half years in prison. They were permitted to attend the club's farewell party, which lasted from

1970s

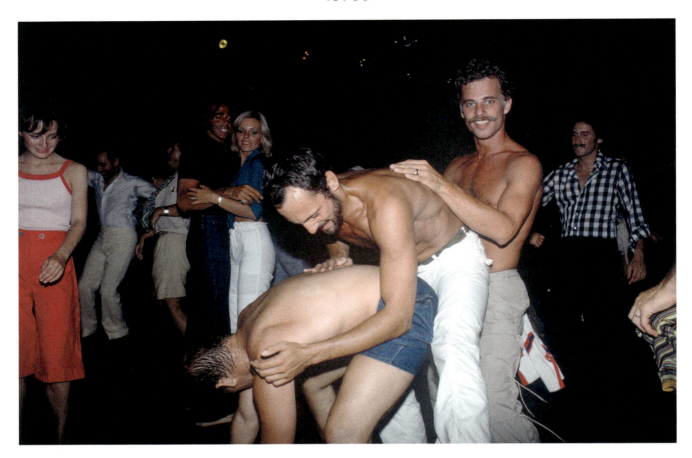

Three shirtless men grinding on one another, 1977.

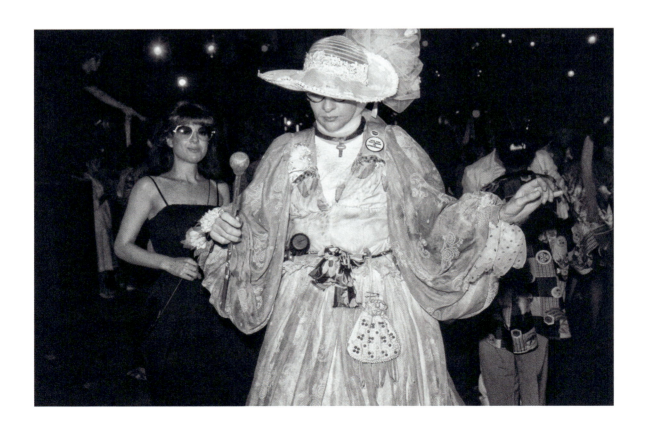

Rollerena with a button reading "How dare you presume I'm heterosexual", 1979.

Studio 54

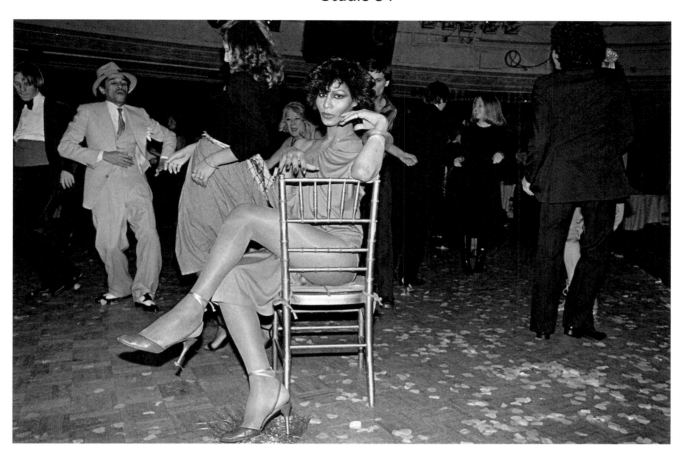

Potassa De La Fayette, 1977.

February 2 to February 3, 1980, and featured both Diana Ross and Liza Minnelli serenading guests.

With Rubell and Schrager out of the picture, many tried to capitalize on Studio 54's namesake and keep the club going past the '70s. The duo sold the business to Mark Fleischman, who reopened it in 1981. Though it remained popular, he would file for bankruptcy in 1986. The club changed owners and lasted another decade, going through several iterations and hosting a variety of parties. In 1996, Studio 54 held its final party as a nightclub, featuring performances by Gloria Gaynor, Crystal Waters, and RuPaul. Two years later, the venue returned to its roots when the Roundabout Theatre Company took it over.

Although the space and the club's name lived on for much longer, it was those first three years, from 1977 to 1980, that cemented Studio 54 as one of the greatest nightclubs to ever exist.

> Peter McGough, patron: "Studio 54 was a mixture of high, low, gay, straight, whatever. Potassa was a famous trans woman who would dance there, hanging out with Halston, snorting coke with him and his friends. And then you'd have sex up top, men or women. Then later they had a gay night. When all the gays who couldn't get in with Liza Minelli and Halston could have their own night."

THE COPACABANA

TRACKS
LIMELIGHT
DANCETERIA

BOYBAR

THE SAINT
CLUB 57

PYRAMID COCKTAIL LOUNGE

PARADISE GARAGE

1980s
DANCING THROUGH DARKNESS

1980s

THE EMERGENCE OF AIDS, ALTERNATIVE DRAG, AND THE DOWNTOWN ART SCENE

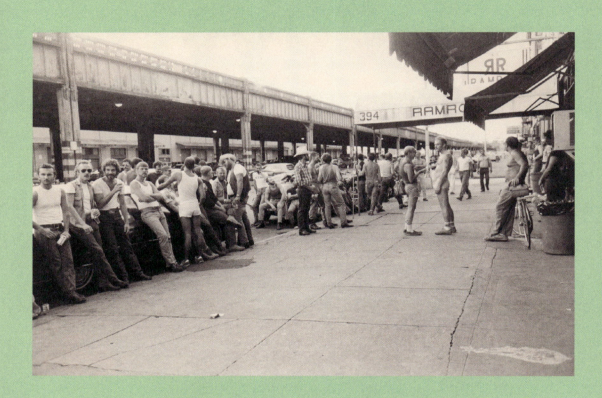

Outside Ramrod in the West Village. Throughout the 1970s it was one of New York's most beloved leather bars and in 1980 was subject to an act of anti-gay gun violence when an ex-transit cop fired at patrons, killing two people and wounding three others.

On July 12, 1979, a crowd of angry, homophobic rock-and-roll fans blew up crates of disco records at a Major League Baseball event in Chicago, now known as Disco Demolition Night. At the time, disco had started to fall out of style, and newer music genres including new wave, house, and synth pop made their way onto the radio. Though Studio 54 was shut down in February 1980, many other nightclubs in the city, like Paradise Garage, Xenon, Hurrah, and Danceteria, kept the party going. The early 1980s also saw the arrival of the Saint and Limelight, both considered among the greatest nightclubs of all time, as well as the elimination of New York's last anti-sodomy laws. The decade was on track to be the most raucous yet for the LGBTQ+ community but would ultimately take a very different turn.

Trouble began in November 1980 with the landslide victory of Ronald Reagan and his Republican party. This conservative backlash was an incredible blow to queer people and would soon prove devastating given the government's response—or lack thereof—to the crisis about to unfold. On July 3, 1981, a *New York Times* headline on page 20 read, "Rare Cancer Seen in 41 Homosexuals." It documented an unusual skin cancer and pneumonia running among gay men in New York and California, a disorder which the Centers for Disease Control and Prevention (CDC) first referred to as Gay-Related Immune Deficiency (GRID), and later, AIDS (Acquired Immune Deficiency Syndrome).

As early as September 1982, about two cases of AIDS were diagnosed daily in America, according to the CDC. But these early alarm bells were faint, and little changed in people's behaviors, all while the Saint, Paradise Garage, bathhouses, and sex clubs were as popular as ever. Still, some early activists had the foresight to react. In 1982, playwright and novelist Larry Kramer was galvanized by the lack of response and gathered 80 men in his apartment, establishing the Gay Men's Health Crisis (GMHC).

Because HIV primarily affected gay people and other ostracized communities, the political response was slow. In April 1983, New York City Mayor Ed Koch—himself a deeply closeted gay man—agreed to meet with activists about AIDS for the first time. President Ronald Reagan, however, would not publicly mention the topic for another two years. As deaths from AIDS-related causes continued to skyrocket, the LGBTQ+ community became increasingly weary and more radical. Larry Kramer helped form a new organization in 1987 called the AIDS Coalition to Unleash Power (ACT UP), which staged demonstrations and disruptions to bring more urgent attention to the crisis. ACT UP's in-your-face model of resistance would play a critical role in delivering experimental drugs to people more quickly and prolonging thousands of lives.

In parallel, homophobia and anti-gay violence were starkly on the rise following the conservative backlash that spurred Reagan's election. The Moral Majority was formed in 1981, a political movement that would wage an anti-homosexual crusade throughout the decade. In the same year, tennis superstar Billie Jean King was outed for her lesbian relationship and subsequently lost all endorsements. These early attacks on the queer community would only be exacerbated once AIDS struck and was labeled a "gay disease."

1980s

Despite all this, LGBTQ+ people found many ways to come together and stand up for their rights. In 1983, the Lesbian, Gay, Bisexual & Transgender Community Center was established in New York City, creating a vital hub of support for hundreds of thousands of people. In addition to GMHC and ACT UP, many other notable organizations were formed throughout the '80s, including the influential Human Rights Campaign (HRC), the Gay & Lesbian Alliance Against Defamation (GLAAD), and the New York Area Bisexual Network (NYABN).

The decade also saw hotbeds of creativity, with many LGBTQ+ artists pushing boundaries across all mediums. Around the mid-to-late '80s, a new form of dance called voguing developed in the uptown ballroom scene, while ballroom competitions began appearing at downtown venues like Tracks, Paradise Garage, and the Roseland Ballroom. This would soon lead to an international explosion of ballroom in the 1990s.

The East Village—dilapidated and graffiti-covered at the time— became an essential gathering space for artists looking to squat or find cheap rent. The area was a breeding ground for creative experimentation, particularly at venues like Club 57, the Pyramid Cocktail Lounge, the World, and Boybar, where many queer artists assembled and left their mark, including Keith Haring, Klaus Nomi, John Sex, Alexis del Lago, Tseng Kwong Chi, Peggy Shaw, Lois Weaver, Deb Margolin, and Joey Arias. These venues also fostered new levels of DIY, androgynous, and eccentric drag, with performers like Ethyl Eichelberger, Hattie Hathaway, Lypsinka, RuPaul, and Lady Bunny emerging onto the scene. Lady Bunny and other Pyramid performers started Wigstock in 1984, an annual drag festival first held in Tompkins Square Park that became an international sensation over the next decade.

Many of these creatives were motivated by the devastation happening all around them, or within themselves. On August 6, 1983, Klaus Nomi died of complications from AIDS, becoming one of the earliest known figures from the downtown arts community to perish from the illness. Many more—like Haring, Eichelberger, Sex, and Chi—would soon follow. By the end of the '80s, a number of spaces frequented by the queer community would fail due to their dwindling populations. The city administration directly shuttered bathhouses and sex clubs, deemed hotspots for transmission of the disease. Many of the remaining venues hosted numerous

AIDS fundraisers and became spaces of refuge, where LGBTQ+ folks might dance the pain away.

In 1987, journalist Randy Shilts published *And the Band Played On*, the first major book on AIDS, which was both critically acclaimed and a bestseller. That same year, motivated by the AIDS crisis and the need for more visibility, Representative Barney Frank came out of the closet, becoming the first US congressman to do so voluntarily. In the summer of 1988, the CDC mailed out over 100 million AIDS brochures to every household in the country, and six months later, the World Health Organization (WHO) organized the first World AIDS Day.

Closing out the decade, ACT UP held its most impactful protest yet on December 10, 1989, when thousands of activists disrupted a Mass ceremony at St. Patrick's Cathedral in Midtown, deemed the largest demonstration against a religious organization in US history. More people began paying attention, but by 1990, nearly 70,000 Americans had already lost their lives to AIDS, with tens of thousands more dying and no end in sight. The fight was far from over.

1980s

PARADISE GARAGE

84 KING STREET
NEW YORK, NY 10014

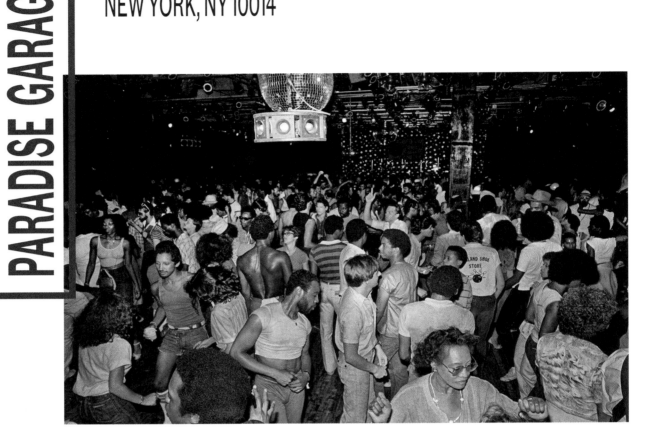

The Paradise Garage dancefloor, 1979.

One of the most celebrated, musically significant clubs of all time, Paradise Garage was a 10,000-square-foot [3,050-meter] membership-based venue located at 84 King Street in West SoHo. Unlike other major nightclubs during its time, it welcomed patrons of all races, economic backgrounds, and sexualities, and served as a haven for queer communities of color, particularly Black gay men. With resident DJ Larry Levan at its helm, renowned for his nightlong, musically diverse explorations into sound, it is heavily credited with influencing the development of the modern nightclub.

Paradise Garage, whose name derived from its building's origin as a parking structure, was opened by Michael Brody and initially called the 84 King Street Garage. Mel Cheren, co-founder of influential disco label West End Records and Brody's former boyfriend, backed the club financially. Paradise Garage underwent a year-long renovation, during which Levan collaborated with sound designer Richard Long to redesign the club's layout and dancefloor, centering them around a custom-built sound system then considered to be the best in New York City. The club officially reopened as Paradise Garage on January 28, 1978.

With its main dancefloor and a separate lounge area, Paradise Garage could accommodate over 2,000 revelers. In 1984, a rooftop lounge was added, modeled after the beachside villas of Fire Island Pines. The club served no alcohol and operated as an after-hours space, bypassing laws that would require it to close at 4 a.m., an hour when many patrons would

Paradise Garage

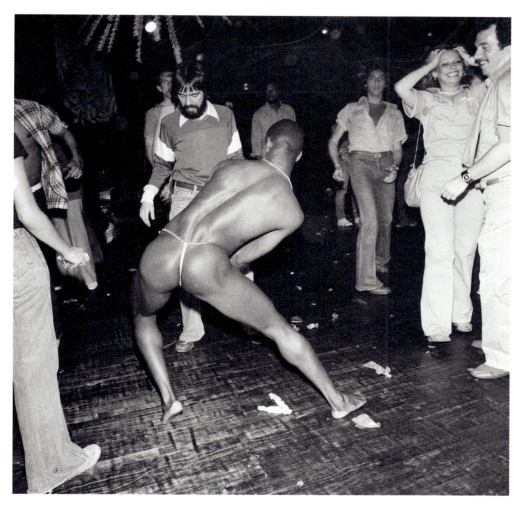

Paradise Garage dancer in white G-string, 1978.

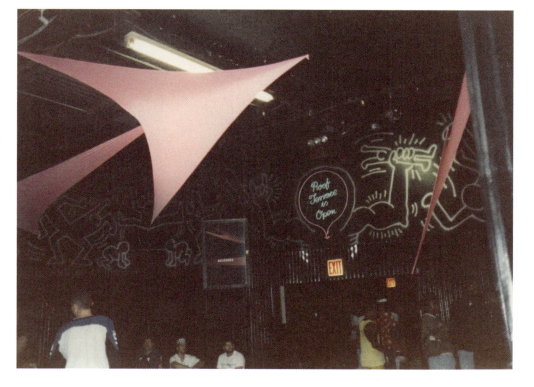

Paradise Garage's interior on closing night, with decor by Keith Haring, 1987.

1980s

Exterior sign, 1979.

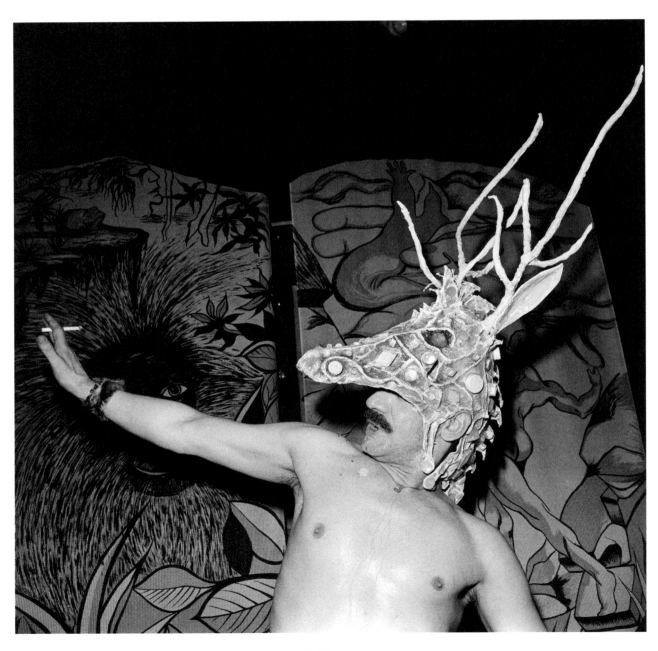

Patron in jungle party headdress, 1978.

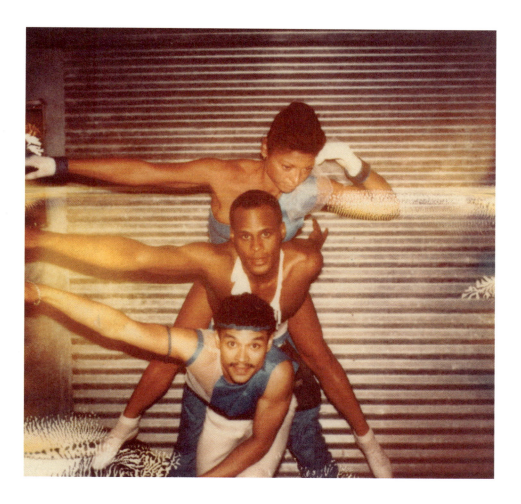

Puma (bottom), Michele (top), and friend at Paradise Garage, 1982.

typically just arrive. It was open on weekends only—Friday nights were technically straight, while Saturday nights were reserved for the gays—though both nights were often packed with mixed crowds.

As one of the club's primary DJs, Levan put Paradise Garage at the forefront of dance music, taking party goers on magical journeys via marathon sets. He wove together myriad records by artists ranging from The Clash to Whitney Houston, The Police to Sylvester, and Yoko Ono to Gwen Guthrie—anything he deemed danceable. He had an unmatched ear for talent, regularly breaking new songs and artists during his sets. He also brought in many legendary acts for live performances, such as Diana Ross, Patti Labelle, the Pointer Sisters, the Weather Girls, and a young Madonna, who filmed her very first music video ("Everybody") there.

According to Garage regular Michele Saunders in *i-D* magazine: "Everyone danced well together, but they had their own style. We were responding to the music. Larry was the maestro...It was spiritual, but it was physical, too. The music touched your body, your energy, your brains. It was a hell of a trip." Today, Levan's style is widely acknowledged as a major influence on many notable DJs who came after him.

During his time at the club, Levan also wielded influence on the music industry as a whole. According to Andy Beta in *Pitchfork*, "There was a conduit between Levan's sets at the converted parking garage...and the national Billboard charts. What the DJ spun on a Friday night could wind up

1980s

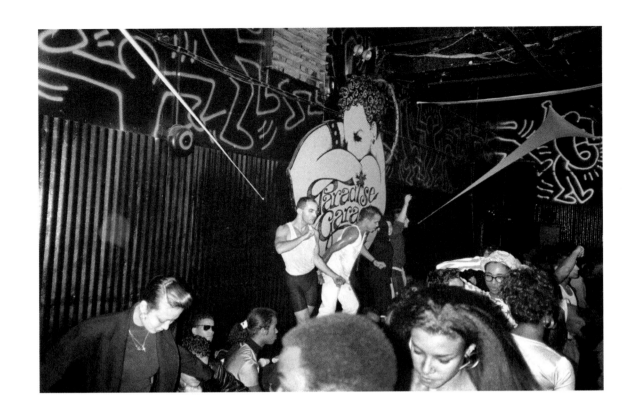

Dancing at the closing party of Paradise Garage in front of logo and Keith Haring graffiti, 1987.

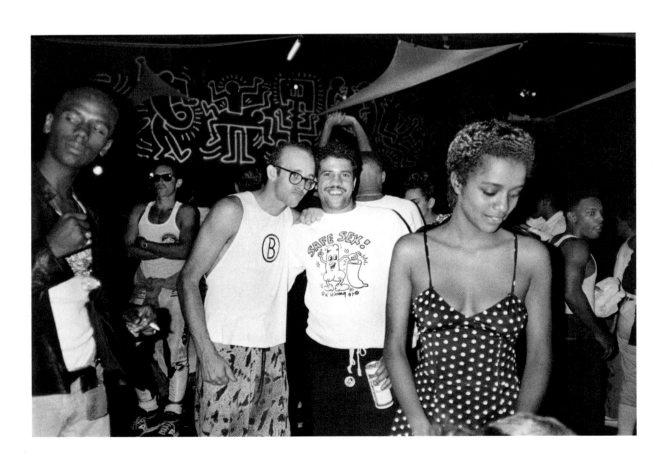

Keith Haring, LA2, and Lysa Cooper at Paradise Garage, 1987.

on the radio by Monday morning, and such demand in NYC often foretold what the rest of the country would want to hear."

As with many queer spaces in the '80s, AIDS began taking its toll on Paradise Garage as the decade wore on. In April 1982, the recently formed Gay Men's Health Crisis held its very first fundraiser there. In 1985, Brody, having tested HIV-positive himself, announced he would shut the club down at the end of its ten-year lease. In September 1987, Paradise Garage held its closing party which lasted three days, officially ending its run on October 1. Brody would succumb to the disease just two months later. Levan himself died in 1992, and Cheren passed away in 2007 from AIDS-related complications.

After the closure, 84 King Street reverted back to its original use, serving as a truck depot. In April 2018, the building was demolished to make way for luxury condos. Though the physical space is no more, Paradise Garage's legacy has continued to live on. In 2014, a massive tribute event was held on King Street, drawing thousands of people in front of the club's former site. Garage reunion parties are still thrown annually, bringing together young, club-loving queers and devoted Garage veterans, including some who attend with their wheelchairs, canes, and walkers. Before his untimely passing, Cheren summed up Paradise Garage's legacy in the *New York Times*, calling it "the ultimate expression of the whole fabric" of gay nightlife.

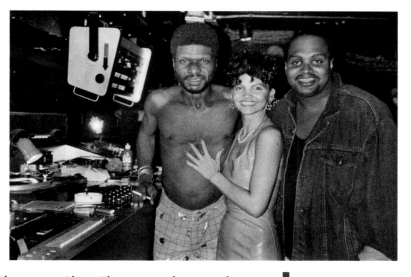

DJ Larry Levan, Liz Torres, and Jessie Jones at Paradise Garage, 1987.

Darryl Hobson, patron: "Nothing can touch the Garage. You could go there and be gay even if you weren't. I once took my mother there, and even she was hooked. One night, Larry was playing, and he must have been in love. You could tell his moods sometimes. He kept playing, 'You Stepped Into My Life' by Melba Moore. He'd have you grabbing someone by the hips in ecstasy, then cut into that song, and he did it over and over all night long. People went frantic. He was the only jock who could get away with that kind of thing."

CLUB 57

57 ST. MARKS PLACE
NEW YORK, NY 10003

1980s

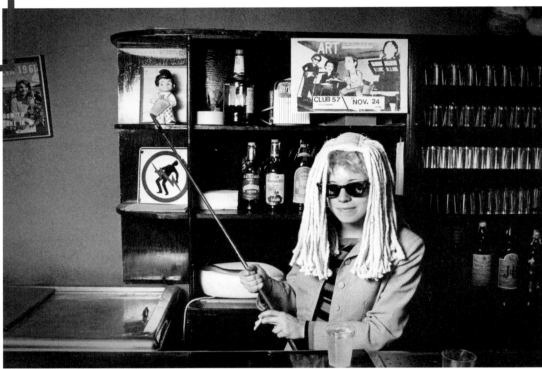

Dany Johnson, Club 57's DJ, 1980.

Located in the basement of a Catholic church at 57 St. Marks Place in the East Village, Club 57 was a nightclub and performance space that served as an influential incubator for the city's downtown avant-garde art scene from 1978 to 1983. It was particularly known for its punk, homemade, and do-it-yourself aesthetic, and became a regular hangout for countless artists and performers—many of whom were LGBTQ+—including Keith Haring, Klaus Nomi, Jean-Michel Basquiat, Kenny Scharf, and John Sex.

In 1978, bishops from the church asked Stanley Strychacki, a Polish immigrant known in the neighborhood for organizing social and cultural events, if he could find a use for their empty basement to help raise funds for the institution. He initially tried using the venue for punk and garage band concerts, but soon handed the space over to Susan Hannaford and Tom Scully, whom Strychacki knew from their New Wave Vaudeville revues at Irving Plaza.

Hannaford and Scully began hosting Monster Movie Club at Club 57 and brought in Ann Magnuson to curate performance-based works. Along with Frank Holliday and Andy Rees, they organized a wide variety of experimental events featuring fledgling artists and entertainers from the East Village, including Ethyl Eichelberger, Lance Loud, Holly Hughes, Tseng Kwong Chi, Holly Woodlawn, and countless others. Many of the avant-garde performances had strong LGBTQ+ affiliations, such as New Year's is a Drag and John Sex's Burlesk Show (Live and uncensored!).

Club 57

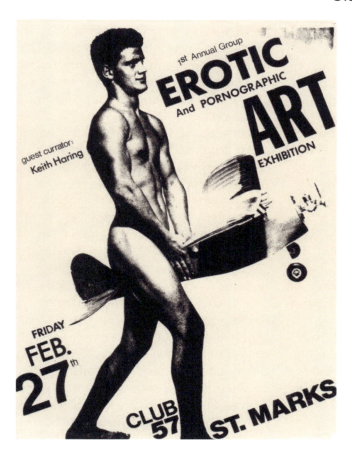

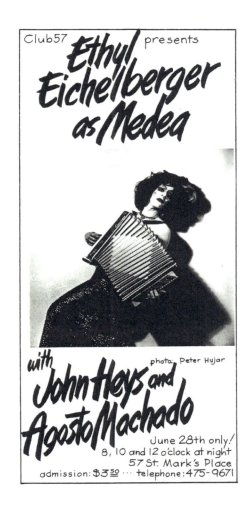

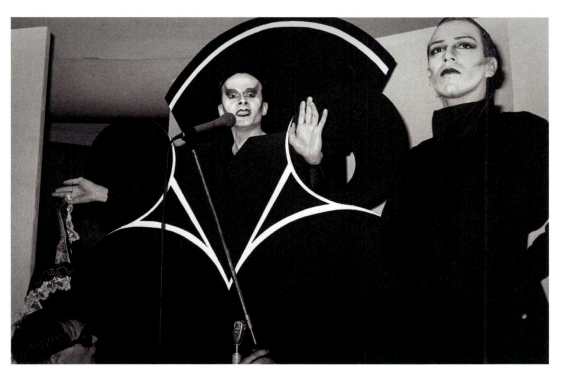

Top Left: Flyer made by John Sex for Keith Haring's 1st Annual Group Erotic and Pornographic Art Exhibition, 1981.

Top Right: *Ethyl Eichelberger as Medea* flyer designed by John Heys, featuring a photo by Peter Hujar, circa 1980s.

Bottom: Klaus Nomi performing with Joey Arias, 1980.

1980s

In the summer of 1979, both Keith Haring and Kenny Scharf, already Club 57 regulars, began organizing video screenings and art exhibitions in the space. Haring read poetry, performed inside a fake TV set, debuted his famous "radiant baby" motif, and hosted an art-making Club 57 Invitational. One of his most famous Club 57 events was the Erotic Art Show in February 1981, a particularly graphic group exhibition that was promoted by a flier of a nude man with an airplane between his legs.

During this time, Club 57 became part of a growing number of downtown venues heavily influencing one another, which included Mudd Club, the Pyramid Cocktail Lounge (see p. 162), Limbo Lounge, and S.N.A.F.U., among others. But after a few years, artists who were founding members of Club 57 were moving on to showcase work at larger, more prominent venues. As with many other nightlife spaces, it was also heavily impacted by the AIDS epidemic and rampant drug use, both of which claimed many of its regulars.

In Tim Lawrence's book *Life and Death on the New York Dance Floor*, Scharf recalled that "at Club 57 there were drugs and promiscuity—it was one big orgy family...and it was before AIDS. Everybody there was either living together or sleeping together." Alarmed by the scene unfolding around him, Strychacki closed Club 57 in February 1983. The church later sold 57 St. Marks, and the building became a non-profit health clinic.

In 2017, the Museum of Modern Art honored Club 57's massive creative influence with a major retrospective. And in August of 2020, Strychacki was able to install a plaque on the building's exterior, honoring the club and thirteen of the key individuals who contributed to its foundation.

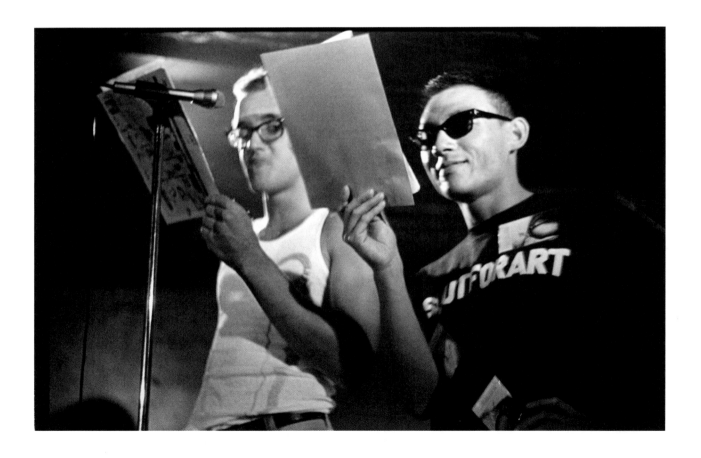

Keith Haring and Tseng Kwong Chi performing at Club 57, 1980.

Club 57

The entrance to Club 57, 1980.

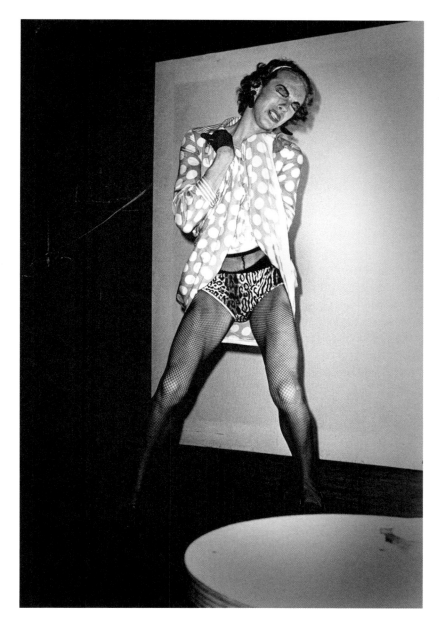

Lypsinka (John Epperson) performing in *Acts of Live Art*, 1980.

> Susan Hannaford, Club 57 manager: "There were events six nights a week at Club 57. Ann Magnuson and I would sit down and free-associate to make up crazy themes, like I'd say, how about the Model World of Glue? Not knowing what that meant. Well, we'll teach people how to sniff glue and make model airplanes. Putt-Putt Reggae was another one, which was mini-golf played on a course designed to look like a Jamaican shantytown."

1980s

DANCETERIA

30 WEST 21ST STREET
NEW YORK, NY 10010

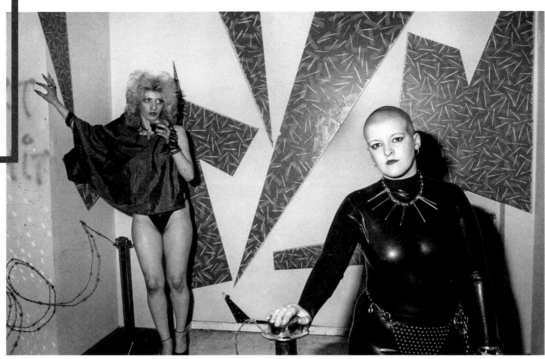

Two patrons at Danceteria, 1980s.

As both a nightclub and performance space, Danceteria was an incubator for New York City's musicians, artists, DJs, activists, and LGBTQ+ folks throughout the 1980s. It operated in several locations, moving to three different addresses in Manhattan as well as a roaming space in the Hamptons. The most famous Danceteria location was its second iteration in the city, a four-story venue at 30 West 21st Street. Many famous queer artists, like the B-52's, the Smiths, R.E.M., Wham!, and RuPaul often visited and performed there, making it an important hub for new wave and post-punk music.

The first Danceteria opened in 1979 at 252 West 37th Street, run by nightclub entrepreneur Rudolf Piper, who would later be involved with other venues like Palladium (see p. 198), the Underground, and Tunnel. His cofounder was gay rights activist Jim Fouratt, who would book the club's talent. Being an illegal after-hours venue with no liquor license, it was raided and shut down within a year of opening.

A few years later, the second and most well-known Danceteria opened in 1982 on the lower floors of an industrial building. This iteration was run by John Argento, who brought on Fouratt and Piper to continue booking and promoting talent. Live bands mainly performed on the first floor, while the second floor held the club's main dancefloor. The third floor was the so-called Video Lounge, which pioneered the concept of the video DJ (or VJ), showcasing ongoing visuals made by artists like Keith Haring and Kenneth Anger.

Danceteria

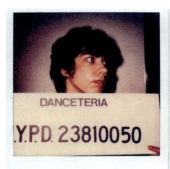 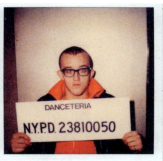 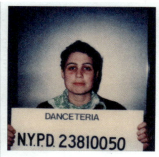 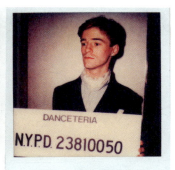
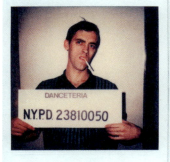 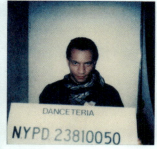 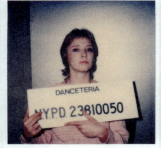 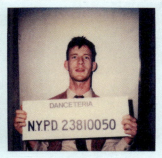
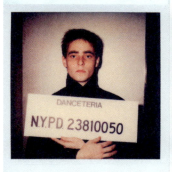 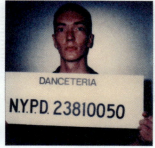 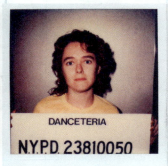 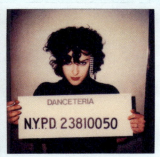
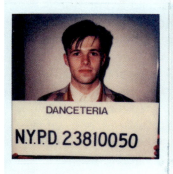 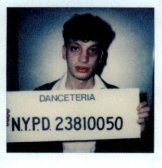 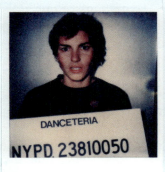 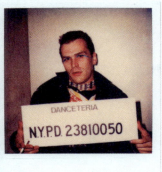

Danceteria employees mugshot collage: [left to right] Pat Ivers, Keith Haring, Debra Miller, Peter McGough, David Wojnarowicz, Taylor Henry Ford III, Carol Skelski, Tim McCormack, Jesse Hultberg, Brian Butterick, Emily Armstrong, Zoe Leonard, Chuck Nanney, Haoui Montaug, Kate Stafford, Kenneth O'Brian, circa 1980s.

1980s

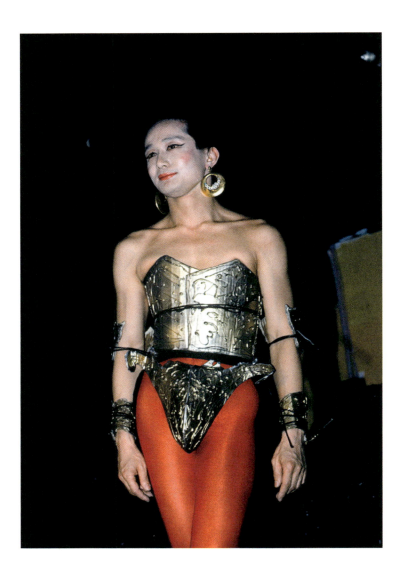

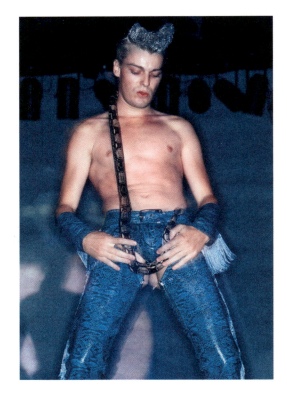

Left: Miss Ming Vauze in *Mermaids on Heroin*, 1985.

Right: John Sex performing, 1983.

Three months after the second Danceteria opened, Argento dismissed Fouratt and hired Ruth Polsky to manage talent. Polsky, a rare female in the music promotion business, took an inclusive approach when booking artists, and made the club an epicenter for new wave and post-punk music. A wide range of the performers that took the stage during this time would become famous throughout the decade, spanning from Klaus Nomi to LL Cool J, Cyndi Lauper to Philip Glass, John Sex to Run DMC, Madonna to New Order, and countless others.

Danceteria also regularly hosted avant-garde performances, art exhibits, film screenings, comedy shows, fashion runways, cabaret acts, and dance parties, many with a queer sensibility. As a result, it uniquely attracted an incredibly diverse, gender-and-sexuality-bending crowd.

The second Danceteria location closed in 1986, but a third and final version opened in 1989 in the former ballroom of the Martha Washington Hotel at 29 East 29th Street, which continued to host many queer-centric events as well. As the new decade wore on, Danceteria lost its appeal, as many newer and more popular venues had entered the fray. It had its final dance in 1992.

Danceteria

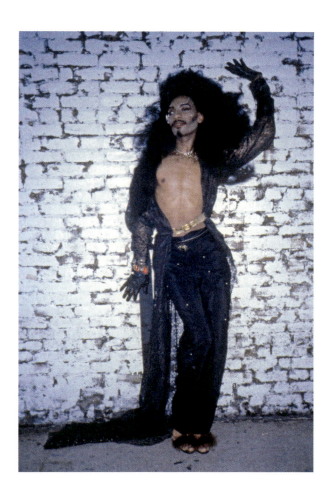

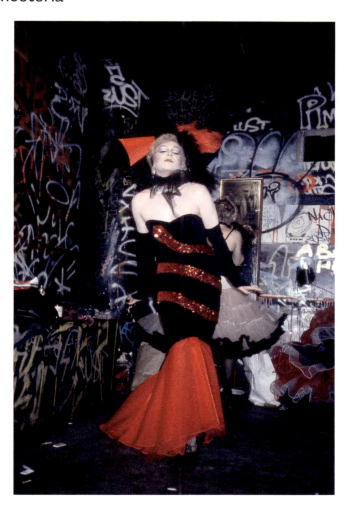

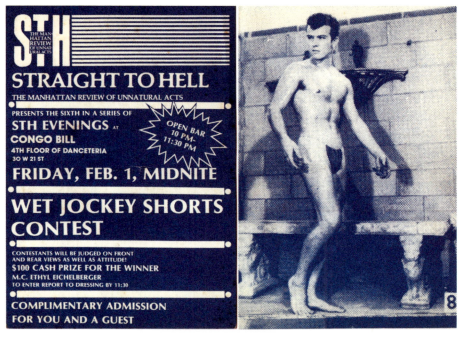

Top Left: Gerard Little a.k.a. Mr. Fashion at Danceteria, 1980s.

Top Right: Alexis Del Lago at Danceteria, 1980s.

Bottom: Straight To Hell flyer, 1980s.

1980s

THE SAINT

105 SECOND AVENUE
NEW YORK, NY 10003

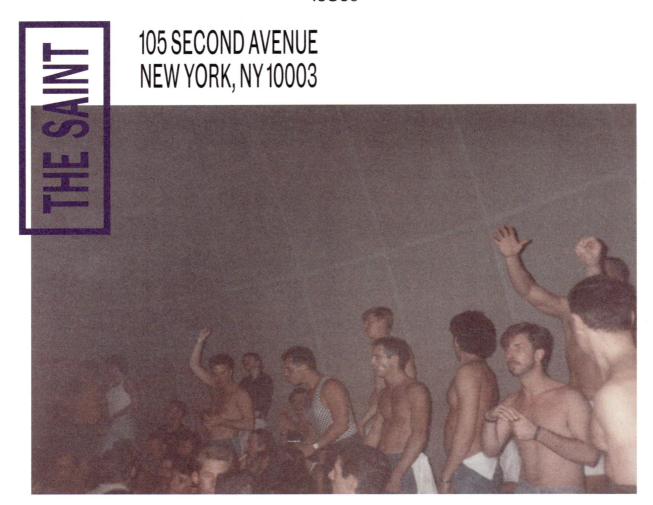

The Saint dancers and dome, circa 1980s.

Sometimes referred to as the "Vatican of disco," the Saint was a gay superclub that debuted at 105 Second Avenue in the East Village on September 20, 1980. The membership-based venue was revered for its majestic light shows, state-of-the-art sound system, and roster of stellar DJs that included Jim Burgess, Roy Thode, Michael Fierman, Sharon White, Alan Dodd, and Robbie Leslie. In addition to its DJs, the club often featured live performances from celebrated musicians, including Grace Jones, Natalie Cole, Gloria Gaynor, Loleatta Holloway, and Thelma Houston.

The Saint was located in what was once the Fillmore East, a legendary rock-and-roll venue during the '60s and '70s. After it sat dormant for several years, entrepreneur Bruce Mailman purchased the building in the late '70s and spent millions on renovations. He also owned the nearby New St. Marks Baths, a popular and highly lucrative gay bathhouse, which he used to finance the extravagant nightspot.

Together with business partner and architectural designer James Terrell, Mailman created a distinguished and futuristic megaclub, boasting a 4,800-square-foot [1,500-meter] circular dancefloor beneath an impressive planetarium-like dome. In its center stood a tower, known as the Tree of Light, which held a star projector and over 1,500 lighting fixtures that would cast spellbinding light shows upon the rounded ceiling, creating impressions of sunrises and twinkling celestial scenes. The club's first-rate sound system contained over 500 speakers while its original balcony hung above, favored by party

The Saint

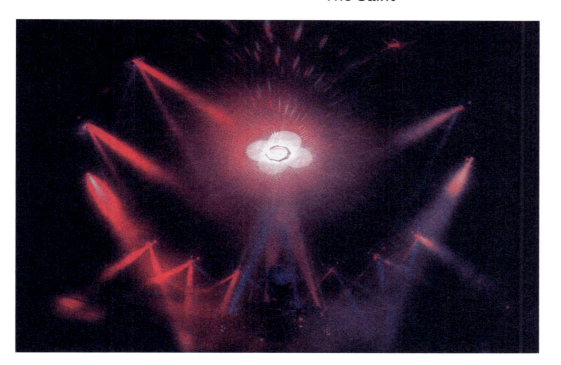

The Saint lighting effects, circa 1980s.

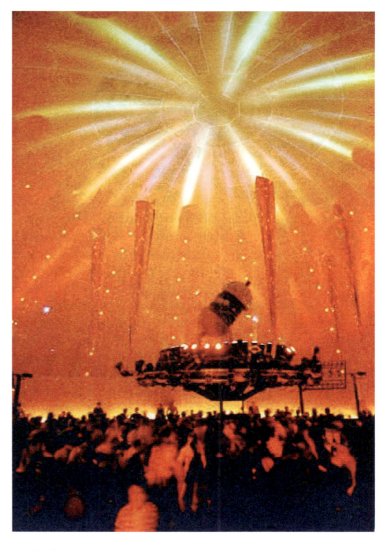

Dancefloor, circa 1980s.

goers as a viewing deck and spot for sexual activity.

The Saint was initially open only on Saturday and Sunday nights, from Labor Day weekend through mid-June. It operated as a private, membership-only club for gay men (and a select few women, such as DJ Sharon White) and almost exclusively attracted an affluent, white crowd. Despite its selective exclusivity, The Saint sold 2,500 memberships before it even opened.

By the mid-1980s, the AIDS epidemic had severely impacted the Saint's membership, and AIDS was even referred to as "the Saint's disease" by many. With attendance rapidly dwindling, the club lowered membership costs, extended its season to year-round, and loosened its male-only policy, even

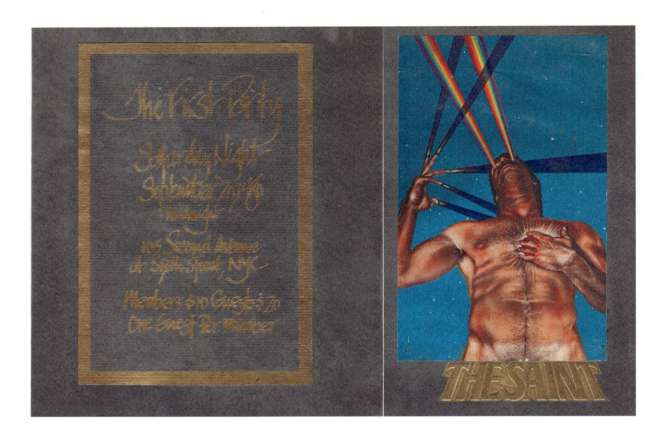

The Saint opening party flyer (front and back), 1980.

hosting women-only events. But these changes failed to reverse the club's decline, and on April 30, 1988, Mailman closed out the Saint with a bang, hosting a massive farewell party that lasted three days and pushed the venue to its limit.

The club's legacy lived on, however, via the Saint At Large parties, which Mailman began throwing in 1989. Held several times a year, the events became particularly famous for their annual White Party and Black Party, and served as the template for what would become circuit parties. To date, the Black Party is the longest-running gay men's circuit event worldwide.

In 1994, Mailman himself died of complications from AIDS. Two years later, the interior space of 105 Second Avenue was replaced by a residential building, though the original façade and lobby of the structure remain.

"I always feel terrible when I talk to young guys who have no idea what the Saint was like," Susan Tomkin, Mailman's long-term assistant, told Barry Walters in an article for *Red Bull Music Academy*: "They go to dance clubs that are just little tiny places. The Saint was so spectacular. I can remember the first time I went upstairs into the dome. The star machine was on, and the lights were going. I felt like somebody had sliced off the top of my head and poured acid in my brain. It was absolutely like another world."

The Saint

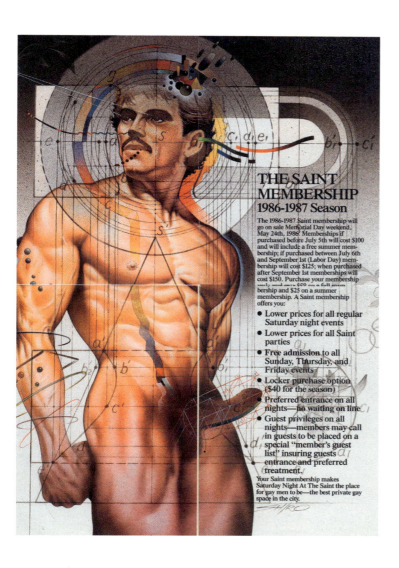

1986/1987 membership poster.

Robbie Leslie, DJ at the Saint: "At the Saint's opening, the line to get in was literally around a whole city block. At two in the morning that night, DJ Alan Dodd put on a choral selection from *Close Encounters of the Third Kind*, a very surreal instrumental piece that went from very quiet to a loud crescendo, an unforgettable five seconds when the entire lighting horizon was pulled out. The room went pitch black and all that was left were the stars. The whole Milky Way was right above you, and the crowd collectively gasped. I get gooseflesh still thinking about it."

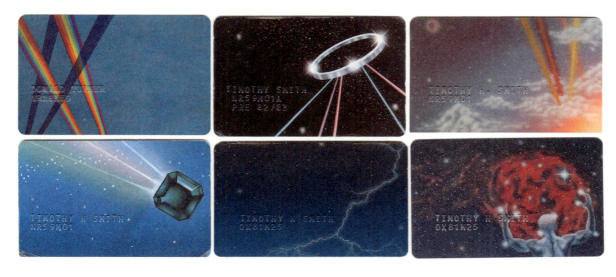

Membership cards, circa 1980s.

1980s

PYRAMID COCKTAIL LOUNGE

101 AVENUE A
NEW YORK, NY 10009

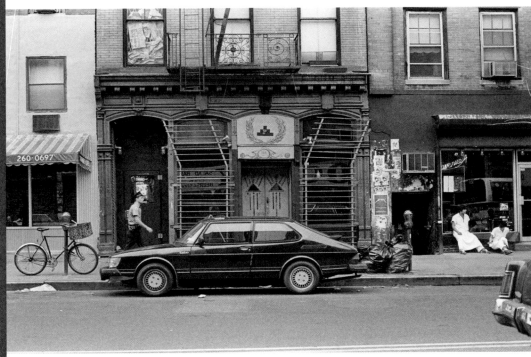

Pyramid Club exterior, 1984.

In 1979, the ground floor space at 101 Avenue A in the East Village opened as the Pyramid Cocktail Lounge (also called Pyramid Club, Pyramid Bar, or simply Pyramid), billing itself as New York City's hottest new cruising bar. Pyramid, whose name stemmed from the designs on the building's tiles, struggled to gain traction until the night of December 10, 1981, when nearby resident Bobby Bradley, his boyfriend Alan Mace, and pal Victor Sapienza convinced owner Richie Hajguchik to let them throw a party in the typically empty venue. Called Home on the Range, the event was so successful that the owner suggested they expand to a daily schedule. Thus Pyramid was reborn, and over the next several decades it would develop into a primary hub for the East Village drag, gay, punk, and art scenes, launching the careers of many drag legends and performers.

Bradley, Mace, and Sapienza began regularly hosting events there, creating an unconventional nightclub experience that combined the experimental performances known from Club 57 (see p. 150) and Mudd Club, the seedy drag shows and go-go dancers from the Anvil, and the bizarre installations from the Club With No Name. Many performers migrated to Pyramid from Club 57, whose popularity waned with Pyramid's rise. During its peak in the '80s, it shifted earlier forms of drag into more avant-garde and politicized performances. The club played a central role in expanding the art of drag to new audiences and attracted many forward-thinking performers, including International Chrysis, Lypsinka, Flotilla DeBarge,

Pyramid Cocktail Lounge

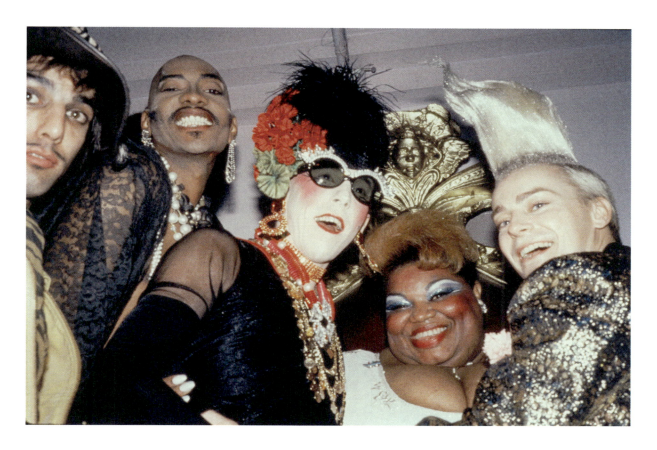

Tabboo!, Gerard Little, unknown performer, Jean Hill, and John Sex, 1983.

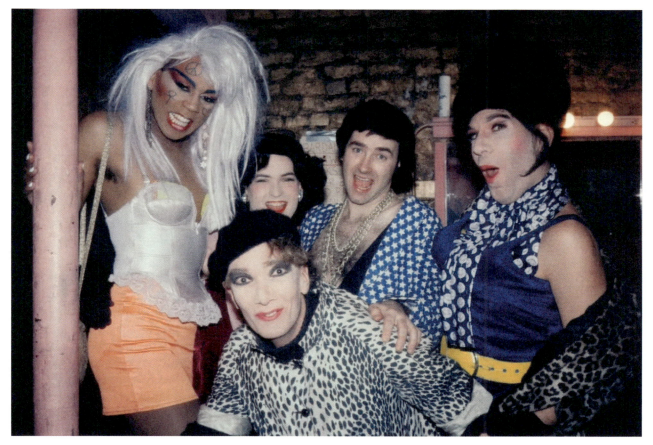

RuPaul, Billy Beyond, Larry Tee, Hapi Phace, and Hattie Hathaway (front) at the Pyramid, circa 1980s.

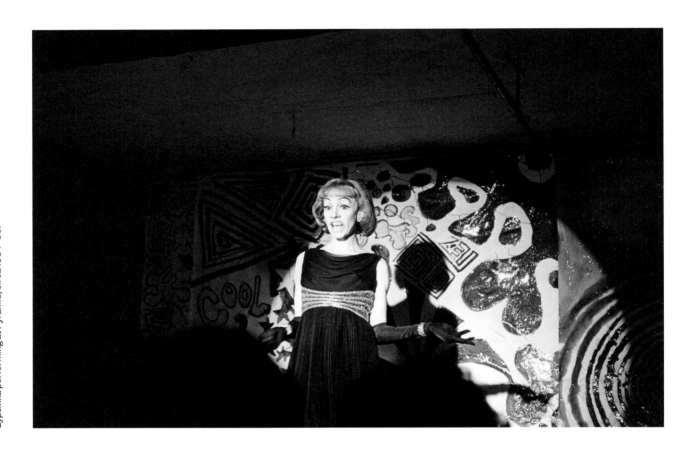

Lypsinka performing at Pyramid, circa 1984–85.

Ethyl Eichelberger, Dean Johnson, Hapi Phace, and Tabboo!.

One of the biggest drag artists of all time to emerge from the Pyramid was RuPaul herself, whose first show was held there in 1982. Then mostly unknown, Ru even lived in the venue's basement for a time. Another crucial figure was Lady Bunny, who hosted the first Wigstock Drag Festival in 1984 with support from the club and would go on to run the famous festival for the next twenty years.

Pyramid thrived throughout the decade, hosting many queer events and artists like Keith Haring, Andy Warhol, John Waters, David Wojnarowicz, Joey Arias, and Holly Hughes. But by the end of the '80s, both the AIDS epidemic and rampant drug use had taken a toll on its performers and patrons alike. Then, in 1990, drag queen Linda Simpson and DJ Dany Johnson launched Channel 69, a weekly bash that helped revive Pyramid and nurture a new lineup of parties and of queens, including Sweetie, Mistress Formika, Afrodite, Miss Understood, and Mona Foot.

Pyramid continued to operate, albeit attracting straighter crowds each year, until March 2020, when the Covid-19 pandemic forced it to close. In 2022, a new rock club named Baker Falls opened in its place, preserving many elements from the original space.

Though Pyramid itself is gone, its mark on history will never be forgotten. As Tricia Romano explained in an article for *Red Bull Music Academy*, "The Pyramid Club came along at the right time—just before the AIDS crisis shook the city and gentrification pushed artists out of the East Village. It served as a safe haven for freaks, geeks, weirdos, queers, and dreamers to come together and create. Sometimes it was bad; sometimes it was beautiful. But it was never boring."

Pyramid Cocktail Lounge

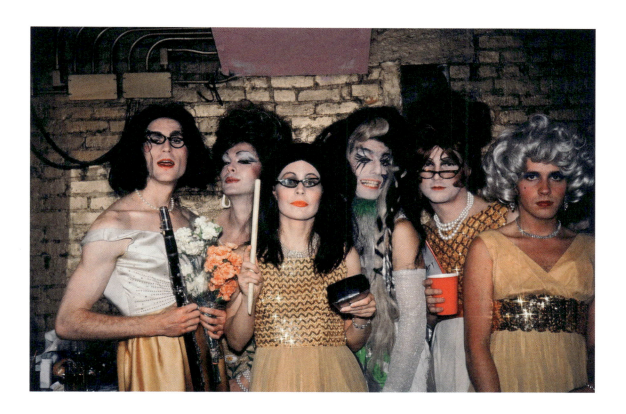

Ladies Auxiliary of Avenue A with Tabboo! as a guest, circa 1980s.

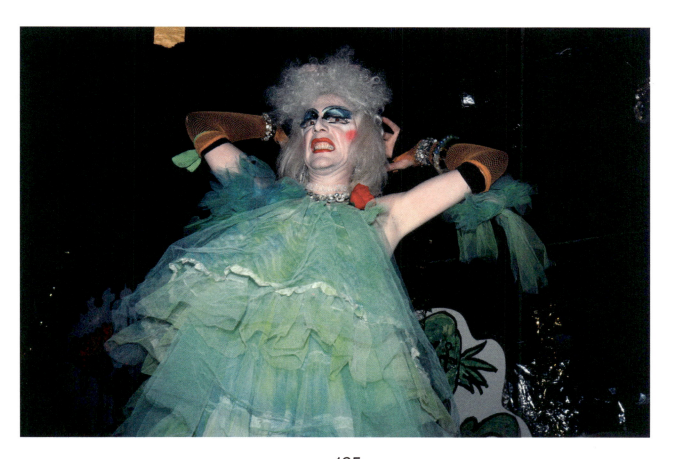

Ethyl Eichelberger, circa 1980s.

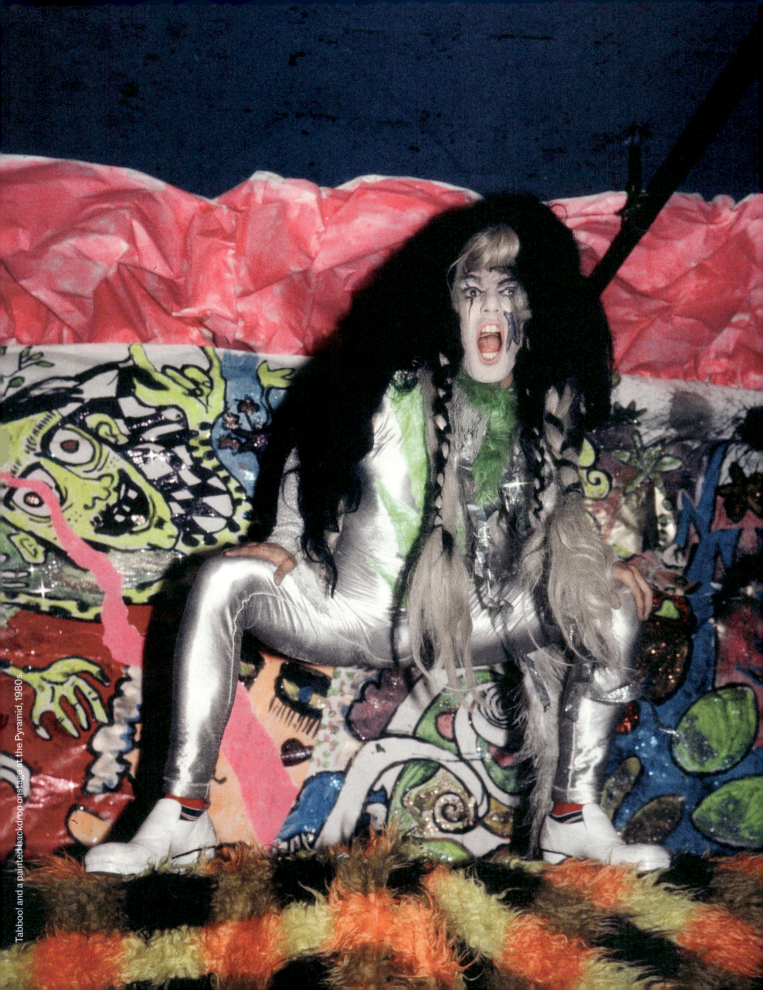
Tabboo! and a painted backdrop onstage at the Pyramid, 1980s.

Gene Fedorko, patron: "Pyramid made a huge impression on me in the '80s, the way the drag queens were presenting themselves. The paradigm was changing from the manicured, meticulous, feminized, nails and makeup girls. Like Tabboo!, who would get onstage with fishnet stockings that showed off his hairy legs and shoes that looked like Minnie Mouse rejects. There was this anarchy at the time in the whole East Village, which spanned from visual art to drag performance."

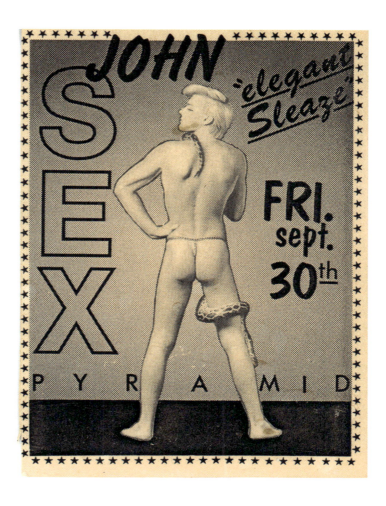

Flyer for Elegant Sleaze, a night hosted by John Sex at the Pyramid Club, circa 1980s.

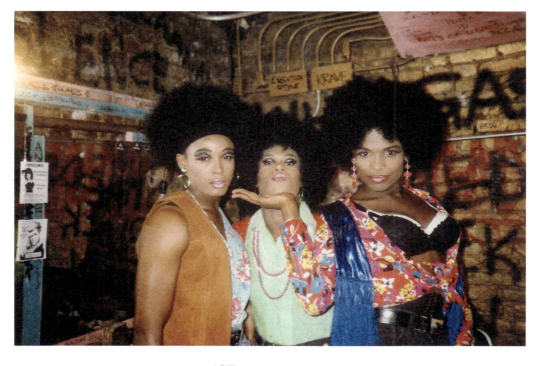

Afrodite, London Broil, and Ebony Jet in Pyramid Club's dressing room, 1992.

LIMELIGHT

47 WEST 20TH STREET
NEW YORK, NY 10011

1980s

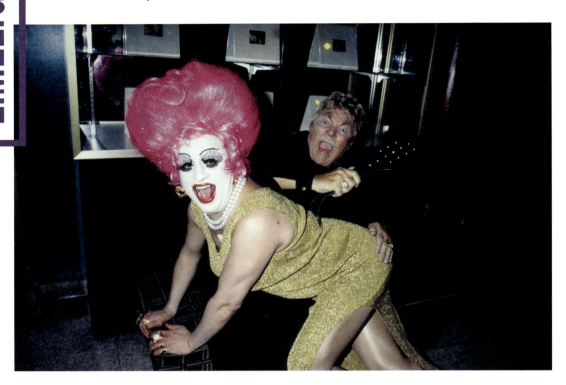

Brandywine being spanked by Rip Taylor at Limelight, 1995.

Alongside Studio 54 (see p. 132) and Paradise Garage (see p. 144), Limelight is seen as one of the greatest nightclubs to have ever existed, especially due to its 12,000-square-foot [3,700-meter] space inside a Gothic-style church from 1845. The club kept many of the venue's original features, including its stained-glass windows and religious iconography, and became notorious for the less-than-holy activities that took place inside. It attracted the full gamut of New York subcultures and LGBTQ+ communities, from outlandishly costumed Club Kids to shirtless Chelsea gays, barely dressed lesbians to dolled-up drag queens, and everyone in between.

Peter Gatien opened Limelight at 47 West 20th Street in 1983, but it was not his first venue to bear that name. Gatien previously opened a Limelight in Florida in the late '70s, then another in Atlanta, which attracted celebrities and publicity, before he relocated to New York. (Unrelated to Gatien, there was also a Limelight Discotheque near Christopher Street during the early '70s.) In photographer Steve Eichner's book *In the Limelight*, Gatien reflected that "I would have just been another Studio 54 wannabe if I had just gotten a bigger theater and more spinning wheels. So the church architecture of the Limelight was an opportunity that came from heaven, quite frankly."

The church had been deconsecrated and sold in the late 1970s to a drug rehab institution, but following financial hardship, the new owner sold the building to Gatien in 1982. He worked with designer Ari Bahat and spent nearly five million dollars to renovate the space, which included ceilings that soared four stories over the main dancefloor, five sets of staircases that led to various VIP

Limelight

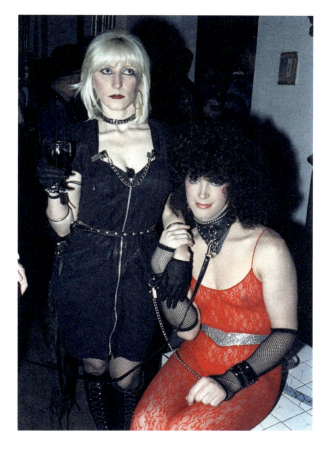

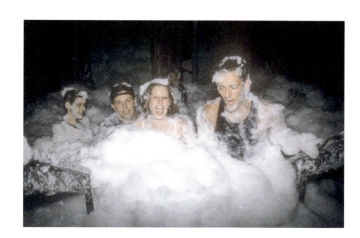

Top Right: Shampoo Room at Limelight, 1995.

Top Left: Leashed patrons, 1983.

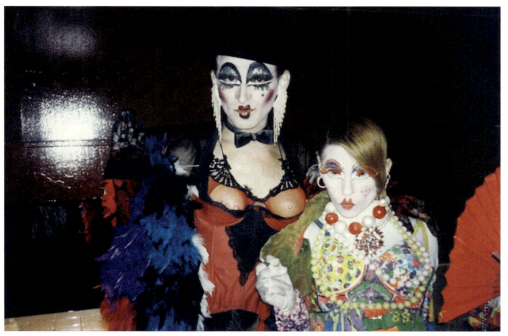

Bottom: Club Kids at Limelight, circa 1980s/'90s.

1980s

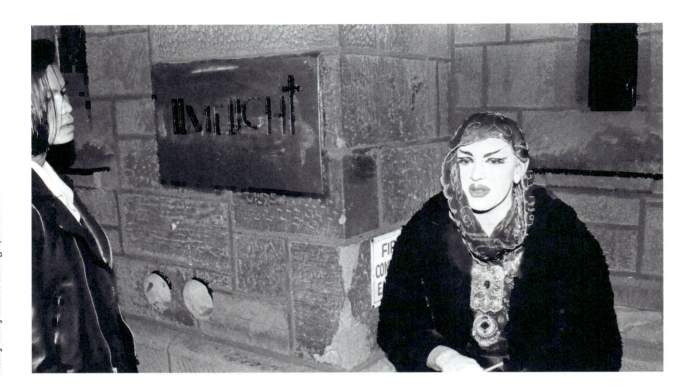

Kenny Kenny outside Limelight, circa 1994.

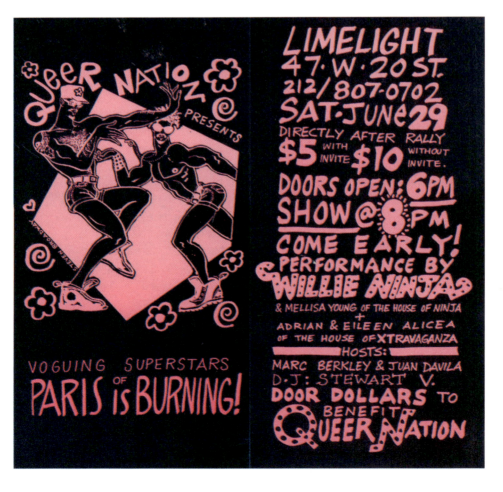

Queer Nation flyer (front and back) with artwork by Steven Broadway, 1991.

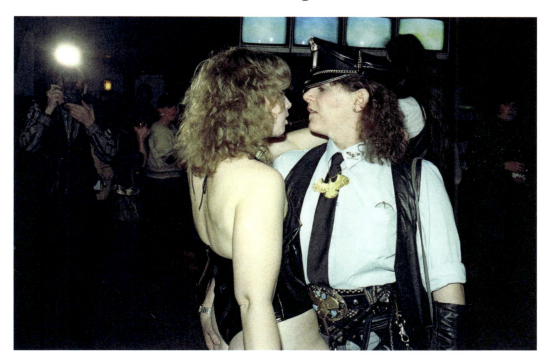

Leather-clad women embracing at Limelight, 1983.

rooms, lounges for different crowds, and even a chapel area where more experimental parties would be tested out on a smaller scale.

Early on, Limelight was primarily a rock and disco club, but eventually became prominent for techno, goth, and industrial music. Though it assembled a wide array of folks, many of its most popular parties were hosted by or heavily attracted LGBTQ+ people, such as Michael Alig's Disco 2000, Marc Berkley's Lick It!, and John Blair's Drama. Many other queer-centric events took advantage of Limelight's church in name and theme, such as the regular Heaven, or the sexier Res-Erection.

Gatien became involved with more of New York's most popular megaclubs, including Palladium, Tunnel, and Club USA, though Limelight would remain his favorite. However, the club began drawing more negative attention starting in 1996, when Alig, a prominent Limelight promoter and Club Kid, was convicted for killing and dismembering Angel Melendez, a fellow scenester and drug dealer.

Mayor Rudy Giuliani then went after Gatien as part of his campaign to "clean up the city," and the police frequently raided Limelight, forcing it to close and reopen several times throughout the '90s. Gatien spent the latter half of the decade fighting legal battles related to tax evasion and the selling of party drugs. Although he was acquitted of most charges, he was nevertheless deported to his native Canada in 2003.

Party promoter John Blair then purchased Limelight from Gatien, rebranding it first as Estate and then as Avalon. By that time, however, the religious ecstasy of the club was in steep decline, and the church's run as a nightclub came to an end in 2007. Since then, the structure has struggled to find a new use. It was first transformed into a high-end shopping mall, then a series of gyms and restaurants. In 2023, it was announced that the venue would become an off-Broadway theater, which perhaps will one day stage a play about what went down at Limelight.

1980s

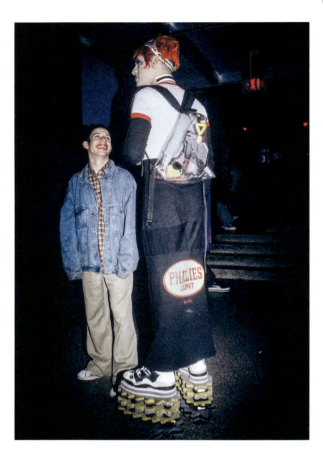

Limelight looks, 1994.

David Kennerley, patron: "One night at Limelight, at a Michael Alig party, they had these punch bowls they claimed were ecstasy punch. They got everyone's attention and said, 'Okay, it's time to come to the Altar of Love' and everyone started crowding around these punch bowls. I was like, 'They can't really be doing this. It's got to be illegal, right?' But of course, I too was pushing my way in, I'm willing to take the risk, who knows what's in it? But by the time I got there, it was all gone. So I never got to know what was really in that punch."

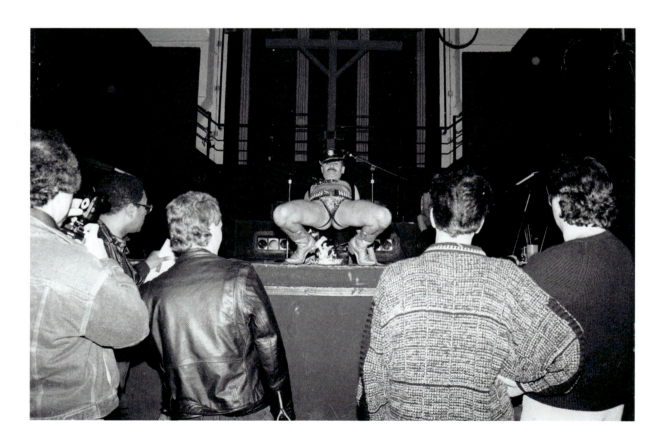

Leather Pride at Limelight, 1989.

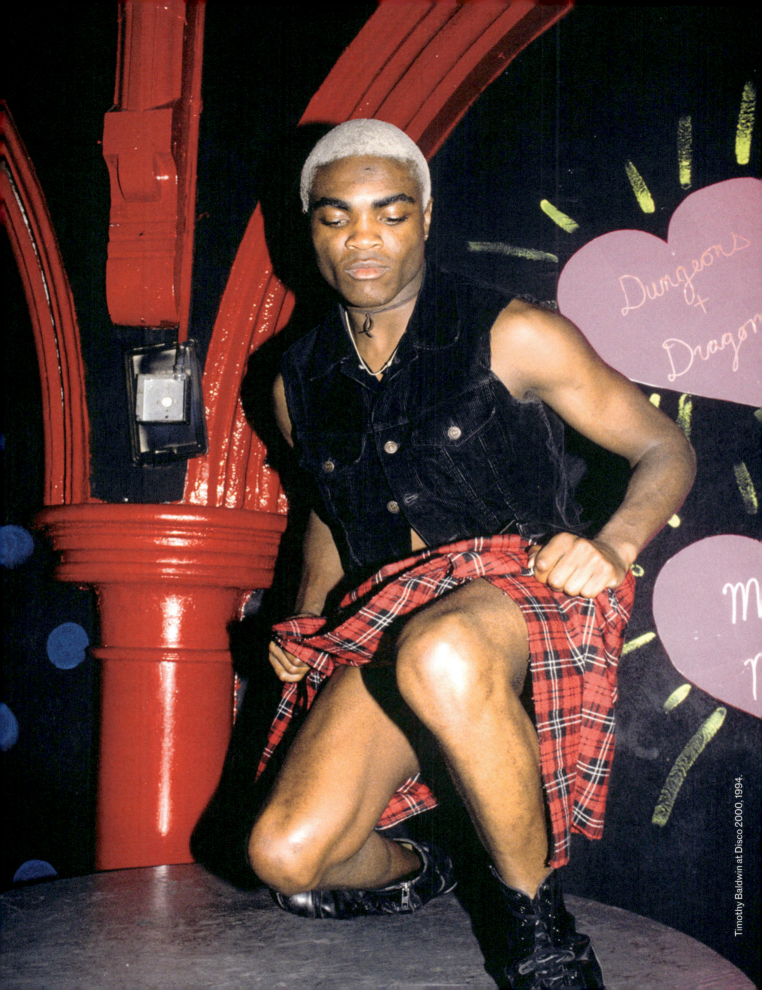

Timothy Baldwin at Disco 2000, 1994.

1980s

BOYBAR

15½ ST. MARKS PLACE
NEW YORK, NY 10003

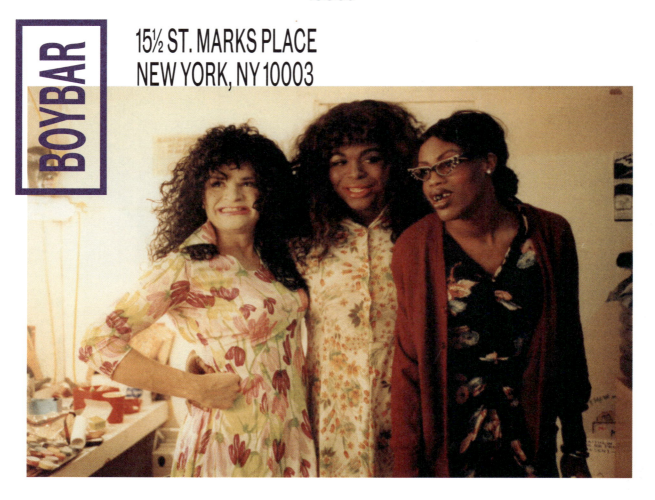

Glamamore, Mona Foot, and Connie Girl backstage, circa 1980s.

It was hairdresser Matthew Kasten who encouraged Paul McGregor to turn his bar, located at 15½ St. Marks Place in the East Village, into a gay one. McGregor was previously an esteemed hairdresser, who had invented the shag haircut worn by Jane Fonda in *Klute*. In the late '70s, McGregor converted his salon into a tiny roller-skating disco, and later, a regular dive bar, but complained that the heterosexual crowd was too "quarrelsome." Soon Kasten came along, and the spot turned gay and was rechristened as Boybar in 1984.

With a strong desire to showcase drag, Kasten became Boybar's creative director. He and a small team would help put on spectacular, innovative shows. He even developed an in-house troupe known as the Boybar Beauties, modeled after the Radio City Rockettes. An unspoken drag rivalry with the Pyramid girls soon developed, the only other downtown venue at the time known for highlighting innovative drag. Prominent Boybar regulars included Lady Bunny, Flotilla DeBarge, International Chrysis, and Hattie Hathaway, alongside newer queens like Afrodite, Candis Cayne, Connie Girl, Codie Ravioli, HRH Princess Diandra, Miss Lulu, and Sherry Vine.

Drag performances at Boybar were often incredibly elaborate and scripted, sometimes running like serialized soap operas that made patrons return each week to see what happened next. Popular shows included Mona Foot's Space Cunt, and the annual Miss Boybar Pageant, with winners including the likes of Kevin Aviance, Nickie Nicole, and Perfidia.

Boybar also started hosting a weekly women's night, appropriately

Boybar

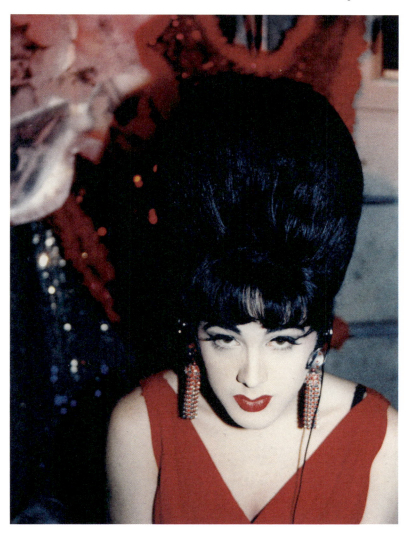

Perfidia at Boybar, circa 1985–87.

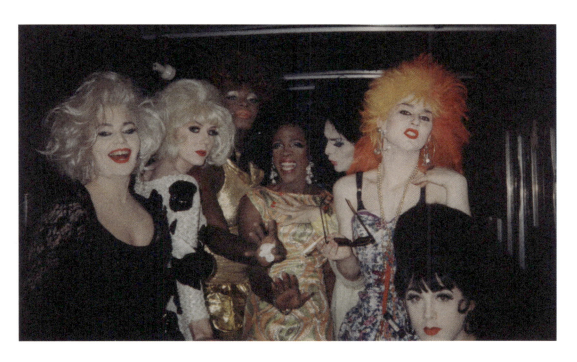

Ms. Shannon, Miss Guy, Mona Foot, Princess Diandra, Glamamore, Codie, and Perfidia, 1988.

175

1980s

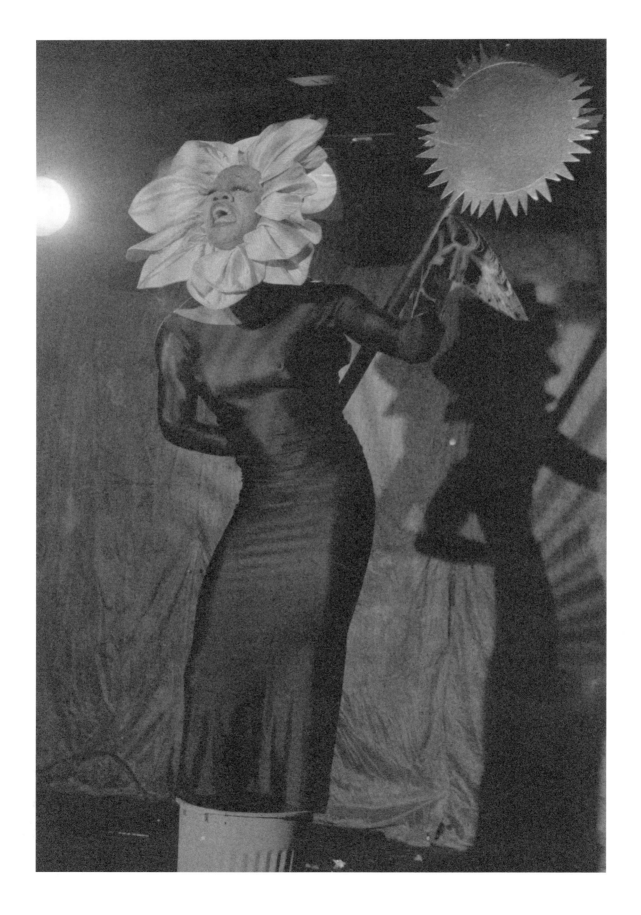

Kevin Aviance performing at Boybar, 1994.

called Girlbar. Artist Kate Huh recalled being hired to work the door for those parties, which were held on slower nights: "At the time, bathrooms at gay male clubs didn't have doors on the stalls, and I remember on Girlbar nights we'd have to hang industrial-sized trash bags in front of each stall."

Like Pyramid and the annual Wigstock festival, Boybar helped nurture downtown's subversive drag culture and bring it into the mainstream. The bar itself closed in 1995, but many of its Beauties went on to even greater success. Aviance has worked with Janet Jackson and Whitney Houston, Perfidia is an Emmy-nominated wig stylist, and Cayne became the first transgender actress to play a recurring trans character on primetime TV in *Dirty Sexy Money*. As Connie Girl noted in the book *Glitter and Concrete: A Cultural History of Drag in New York City*, Kasten wanted the Boybar Beauties to know that "we were professional performers, and that we could take our craft anywhere and have it be perceived as entertainment, which it is."

Boybar Beauty Contest flyer (front and back), circa 1987.

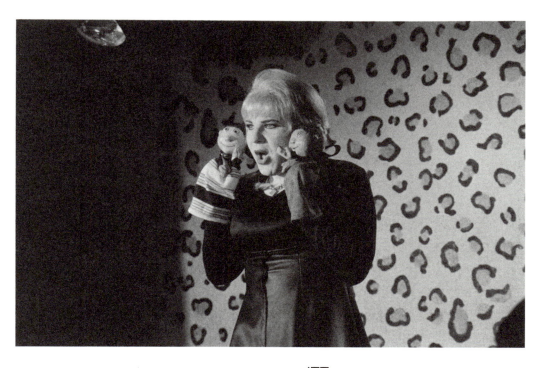

Randella performing at Boybar, 1994.

1980s

TRACKS

531 WEST 19TH STREET
NEW YORK, NY 10011

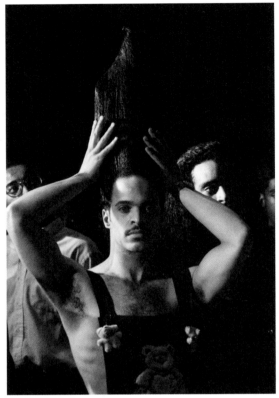

Right: Cesar Valentino at House of Omni Ball, 1989.

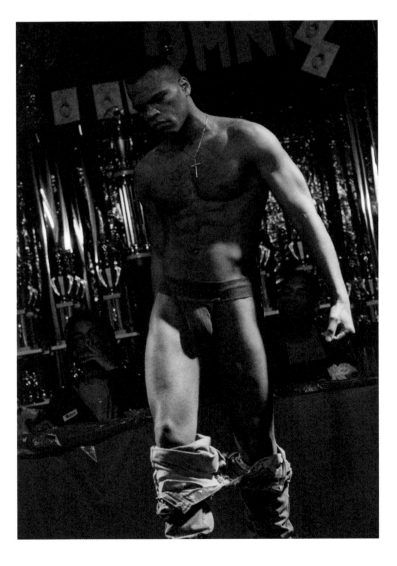

Left: Kevin Afrika, House of Omni Ball, 1989.

Opened in 1985 at 531 West 19th Street in Chelsea, Tracks was one of several pivotal clubs that brought voguing from Harlem's ballrooms downtown. Michael Fesco was hired to run the space, after previously creating the Ice Palace on Fire Island and the Flamingo in New York City, two major '70s gay discotheques. David DePino, a frequent DJ at Paradise Garage, started playing at Tracks on Tuesdays, initially attracting only 40 attendees in a venue that could hold 2,000. But DePino's events soon became a hit, making Tracks one of the first midweek club nights at that scale to be successful in the city.

Several years prior, at Paradise Garage, DePino connected with the House of Xtravaganza, one of the biggest houses in the ballroom scene

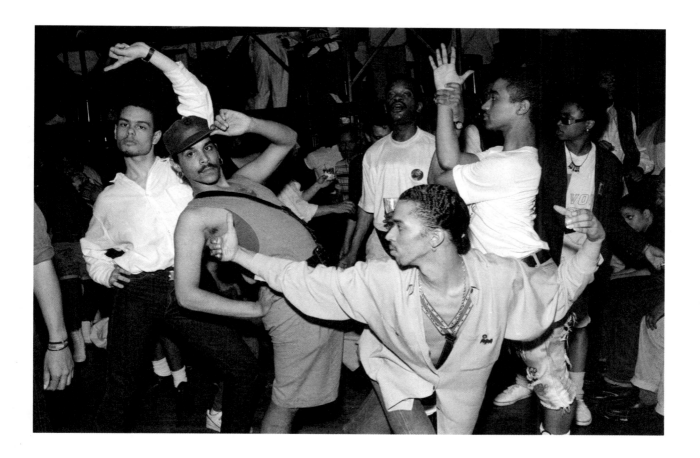

House of Xtravaganza voguing (Luis, Dany, Jose, David Ian), 1989.

at the time. They asked him to DJ at their first ball at Elks Lodge in Harlem, and soon made him an honorary Xtravaganza member. It was DePino who then convinced Tracks to hold its own ball, leading to its first House of Xtravaganza's Black & White Ball in 1988. Many more legendary balls followed there, including the House of Omni Ball (1989) and the House of LaBeija Ball (1990). Tracks also hosted Paris is Burning IX, part of a series of balls that lent its name to the 1990 documentary by Jennie Livingston, which catapulted ball culture into the international spotlight. When producer Susanne Bartsch witnessed a moment of silence at a Tracks ball in 1989, she was inspired to create the Love Ball at Roseland Ballroom, which would raise millions of dollars to fight AIDS.

In 1991, however, voguing at Tracks ended abruptly when the owner's declining health made him give up the mega-popular location. DePino recalled that the closing party fell on Halloween: "On the same night, Sound Factory had Grace Jones, and we destroyed them. We had thousands of people in a line wrapped around the corner and Sound Factory was empty." Sound Factory (see p. 216), however, lived on, and many of the voguing regulars from Tracks would make it their new home throughout the '90s.

Denise Pendavis, House of Omni Ball at Tracks, 1989.

Tracks

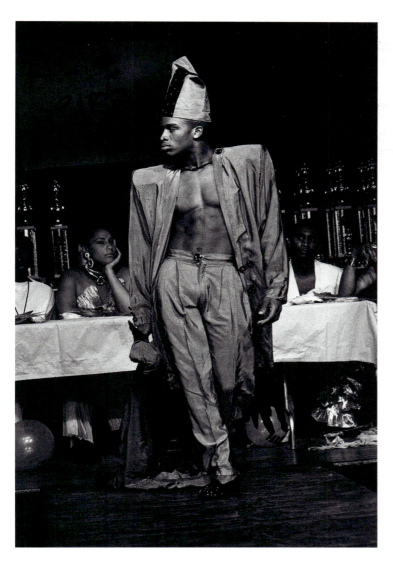

Abraham Mitchell Jr., patron: "I remember the Paris Is Burning Ball at Tracks being so ovah! Avis Pendavis was a scandal when she came out as a Vegas showgirl and needed two sticks to balance her headpiece. So legendary!"

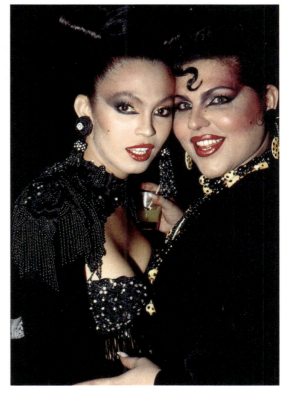

Left: Dee Legacy, House of LaBeija Ball, 1990.

Right: Carmen Xtravaganza and Lady Katiria Continental at House of LaBeija Ball, 1990.

1980s

THE COPACABANA

**10 EAST 60TH STREET
NEW YORK, NY 10022**

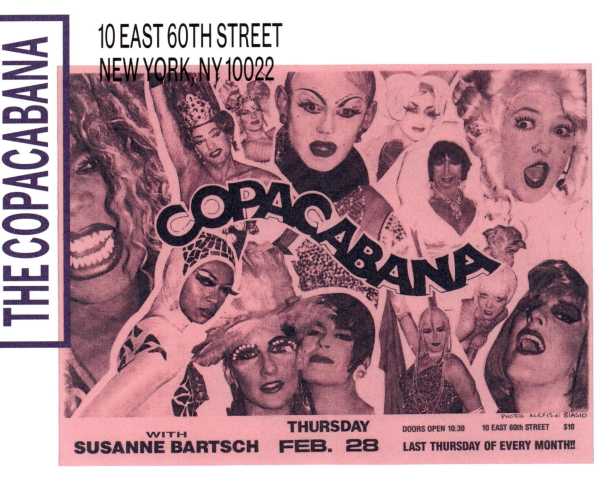

Susanne Bartsch at Copacabana flyer with photos by Alexis di Biasio, 1991.

Named after the beach in Rio de Janeiro, the Copacabana is one of the fabled New York City clubs with a long, winding past that spanned multiple addresses and decades and meshed together many diverse communities. First opened in 1940 at 10 East 60th Street, the club intersected in numerous ways with LGBTQ+ history over the years and is famed for launching the nightlife career of the iconic event producer Susanne Bartsch.

Copa, as it was called for short, initially opened with the backing of the mob as a Latin-themed live music venue. It changed ownership and was reborn in the '70s as a discotheque during the height of the disco era. In 1978, Barry Manilow (who would come out several decades later) released his hit song "Copacabana (At the Copa)" as a direct reference.

In the late '80s, Swiss-born Bartsch began organizing nightlife events at short-lived venues like Savage and Bentley's. She learned that the Bentley's owners also ran Copacabana, a space she found ultra-elegant, with the upscale Pierre Hotel being just across the street. Back then, nobody went partying that far uptown, but she decided to try, and began hosting a monthly bash there. Thousands of people flocked to it almost immediately.

Copa soirees were "incredibly glamorous and decadent," Bartsch recalled in *The Advocate*, with "people calling to see if they could land with a helicopter on the roof to come to the party." Journalist Michael Musto noted in the *New York Times* that, at Copa, Bartsch "pioneered the mixed crowd, where you'd see someone with

The Copacabana

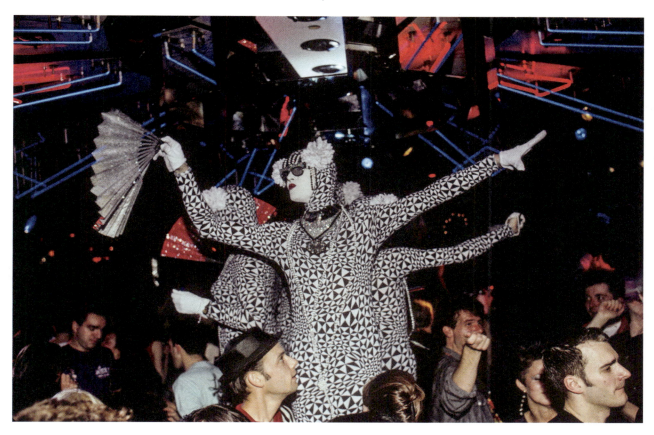

Copa Halloween party, 1995.

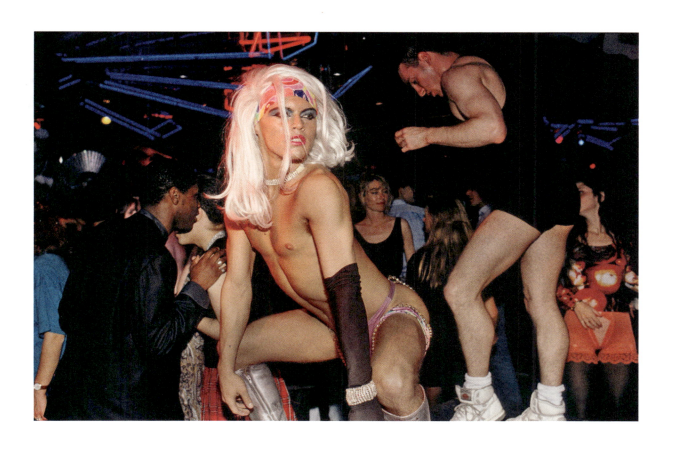

Copa dancers, 1995.

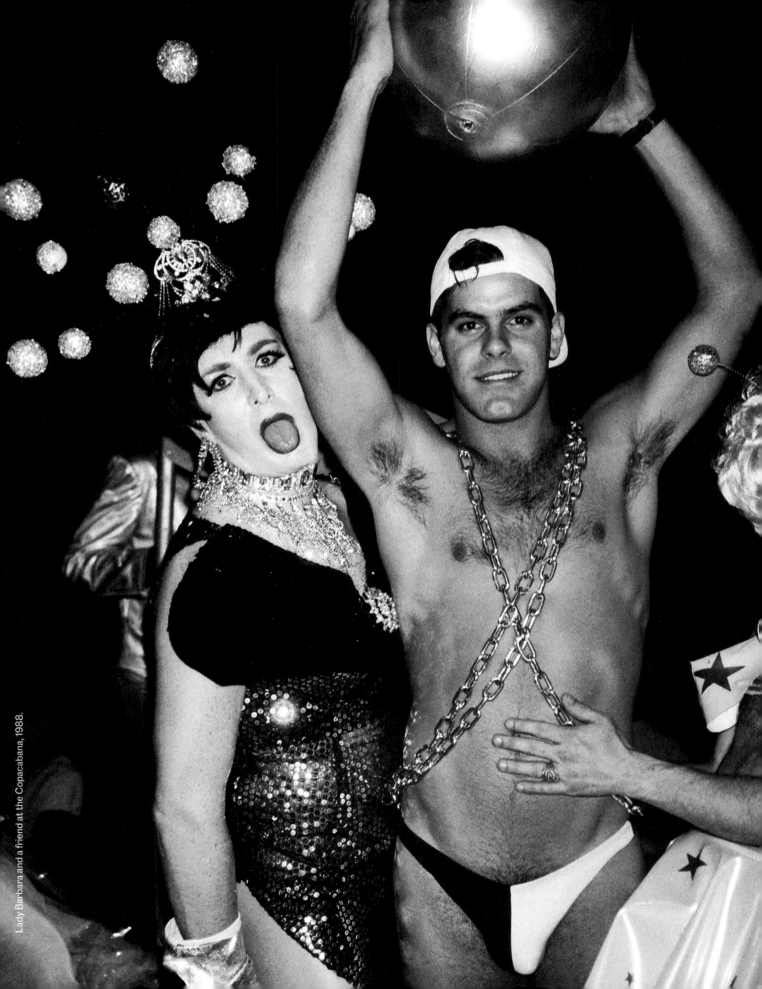

Lady Barbara and a friend at the Copacabana, 1988.

The Copacabana

a fruit basket on their head next to a Wall Street banker next to a lesbian couple."

During this era, Bartsch was also a frontline witness to the AIDS crisis and later recalled that half of her address book was crossed out by the time of her Copa parties. In 1989, she created the highly impactful Love Ball, held at Roseland Ballroom, which helped introduce Harlem vogue ball culture to a wider audience and raised $400,000 in its first year to combat AIDS. Bartsch also continued throwing parties at Copa until 1992, when the venue's owner closed and relocated it to 617 West 57th Street.

In more recent years, Copa has become a club with nine lives. In 2001 it was forced to close but relocated and opened again at 560 West 34th Street. In 2007, the club closed yet again due to the extension of the 7 line subway, and for the next four years, it operated in a shared nightclub space at 246 Columbus Avenue. In 2011, a new Copacabana opened at 268 West 47th Street until the Covid-19 pandemic shut down its operations. The owners brought Copa back to life once more in February 2022 at 625 West 51st Street, where it remains. Throughout these many iterations, it has continued to host a variety of regular and one-off LGBTQ+ events.

Bartsch, meanwhile, could also be said to have nine lives, as she continues to be a leading party promoter in New York City today at venues like Le Bain (see p. 282), while many of her nightlife comrades have faded from the scene. As her friend and former Studio 54 owner Ian Schrager noted in *New York* magazine, "Throwing parties is in [Susanne's] DNA. She is a true icon of the night, someone who goes down in the nightlife hall of fame."

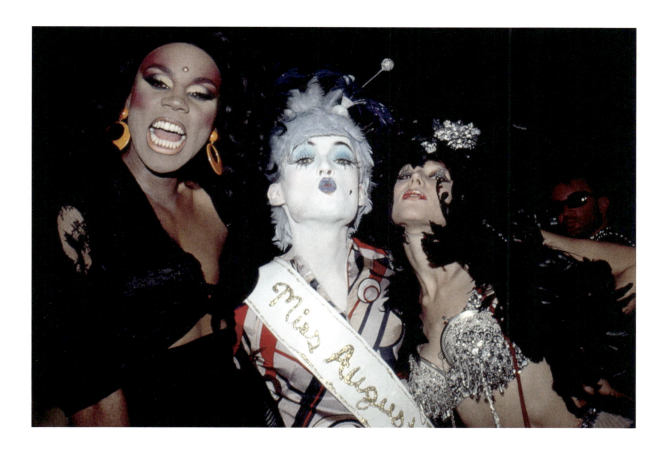

RuPaul, Billy Beyond, and Susanne Bartsch at Copa, 1990.

1980s

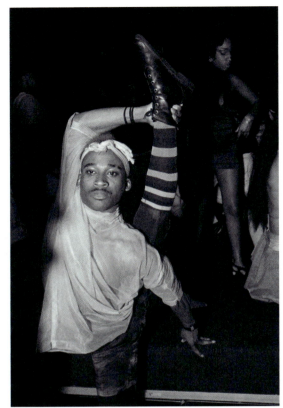

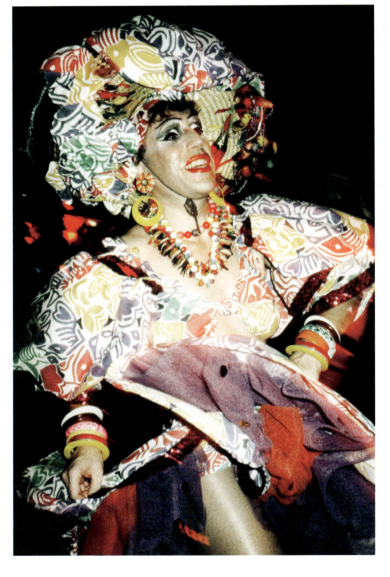

Right: Jerome Pendavis voguing at Copa, 1990.

Left: Sun PK at Copa, 1988.

Susanne Bartsch, party promoter: "At my Copa parties I had all kinds of entertainment mixing together. Upstairs I had the voguers, downstairs I had Brazilian Samba girls and boys. It was Rio de Janeiro-meets-hooker-meets-drag-queen-meets-muscle-boy."

The Copacabana

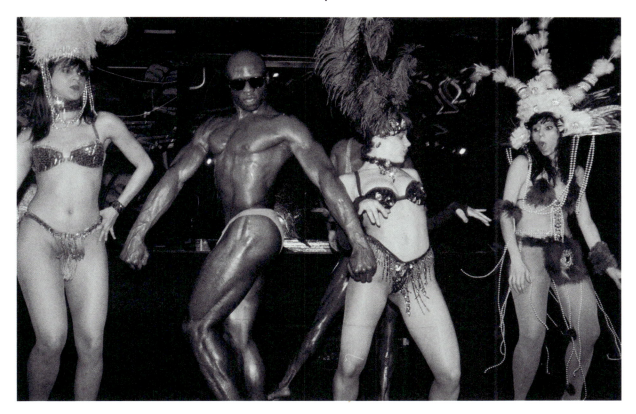

Muscle god posing with Samba dancers during a Susanne Bartsch party at Copa, 1989.

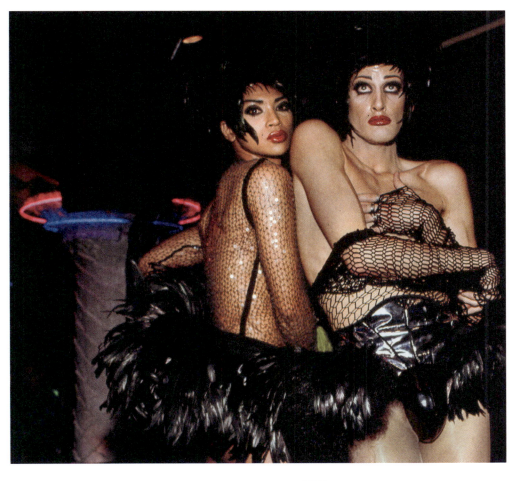

Zaldy and Mathu Andersen at Copa, 1995.

ESCUELITA

EDELWEISS

THE ROXY

SOUND FACTORY & SOUND FACTORY BAR

CLIT CLUB @ BAR ROOM 432

THE LURE

PALLADIUM

NO DAY LIKE SUNDAY @ CAFÉ TABAC

CLUB CASANOVA @ CAKE

LUCKY CHENG'S

1990s STRIKE A POSE

1990s
MEGACLUBS, THE BALLROOM BOOM, AND CIRCUIT PARTIES

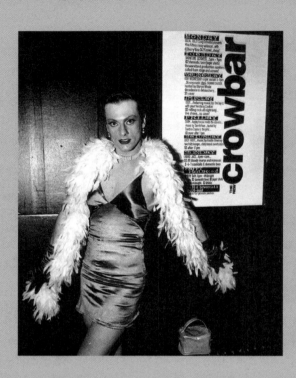

A patron at Crowbar. Opened in 1991, the tiny spot in the East Village was beloved for its quirky drag performances and raucous parties.

The 1990s roared in with the LGBTQ+ community reeling from a decade of being devastated by AIDS, with no end in sight. By 1990, the death count in the US alone had surpassed 100,000, with almost one third of those reported specifically that year. President George H. W. Bush continued Reagan's reign of apathy, even blaming the victims themselves and calling for abstinence rather than boosting federal funding for research. In response, even more radical activist organizations sprung up alongside ACT UP, such as Queer Nation and The Lesbian Avengers.

With AIDS killing more people than ever, New York lost countless notable artists, DJs, drag performers, and nightlife luminaries throughout the decade. 1990 alone took the lives of performance artist John Sex, fashion designer Roy Halston, visual artist Keith Haring, photographer Tseng Kwong Chi, drag performer Ethyl Eichelberger, and film historian Vito Russo, among others. As the decade wore on, they would be joined by DJ Larry Levan, club owner Bruce Mailman, drag performer Dorian Corey, artist David Wojnarowicz, ballroom icon Angie Xtravaganza, and many more.

Hope and progress would finally arrive in 1995, when the FDA approved an HIV-curbing drug cocktail composed of AZT, 3TC, and protease inhibitors, which would finally start saving lives. But by the end of the '90s, another 60,000 people in New York City alone would perish from AIDS-related causes.

Paradoxically, the increased visibility of the LGBTQ+ community in the media due to AIDS ultimately led to greater acceptance and compassion for queer folks, inspiring numerous prominent cultural figures to publicly come out and lend their voices to the cause. In 1992, musicians Elton John and k.d. lang both announced they were gay, followed by Grammy Award-winning musician Melissa Etheridge in 1993 and Olympic diving gold medalist Greg Louganis in 1994 (who would follow up a year later by also coming out as HIV-positive). Perhaps most famously, Ellen DeGeneres came out in 1997 on the cover of *TIME* magazine with the iconic headline "Yep, I'm Gay," while her fictional TV character on ABC's sitcom *Ellen* came out one week later, a first for American network TV.

In addition to *Ellen*, LGBTQ+ representation in the media improved steadily. The back-to-back successes of 1990's hit dance track "Vogue" by Madonna, followed by Jennie Livingston's 1991 documentary film *Paris Is Burning*, helped propel New York City's previously underground ballroom scene into the national spotlight and made stars out of several of its queer and colorful denizens. In 1992, another queer, Black New Yorker would achieve international acclaim, when downtown drag artist RuPaul released the hit song "Supermodel," providing a whole new level of visibility for drag queens. Its success ultimately led Ru to host her own talk show in 1996 and helped propel her into the international superstar she is today.

1993 saw the release of the film *Philadelphia*, the first mainstream movie to address AIDS, as well as the debut of Tony Kushner's AIDS epic *Angels In America* on Broadway, which won the Tony Award for Best Play. Just three years later, a different show addressing the topic debuted on Broadway called *Rent*, a rock musical set in New York City that won the Pulitzer Prize and became one of the longest-running shows of all time.

On a lighter note, 1995 saw the cinematic release of *To Wong Foo, Thanks for Everything! Julie Newmar*, a road comedy starring Wesley Snipes, Patrick Swayze, and John Leguizamo as three New York City drag queens, while two years later, Hollywood started releasing mainstream

movies with purely positive gay narratives, including *In & Out* starring Kevin Kline and Tom Selleck. On the small screen, *Will & Grace* became the first primetime TV comedy featuring openly gay lead characters, debuting its pilot episode in 1998.

On the political front, progress was also made. 1990 saw Deborah Glick become the first openly LGBTQ+ member elected to the NY State House of Representatives, and by 1998, the country had its first openly gay candidate in the US House of Representatives with the election of Tammy Baldwin. Though the decade began with Bush leading the country, the LGBTQ+ community rallied hard behind 1992 presidential hopeful Bill Clinton, who promised to increase funds for AIDS research and end the ban on gays openly serving in the military.

Across NYC, gay clubs like the Roxy and Sound Factory Bar threw parties to help encourage and register voters, and in 1993 Clinton officially took office, receiving an estimated 75 percent of the gay vote. That same year, the third March on Washington for Lesbian, Gay, and Bi Equal Rights would take place and be the largest in scale by far, drawing approximately 1,000,000 participants.

For the duration of the '90s, the Clinton administration implemented numerous pieces of legislation impacting the LGBTQ+ community, some of which were deemed progressive, but many of which fell short on the politician's promises. On December 21, 1993, the infamous "Don't Ask, Don't Tell" policy went into effect, which prohibited military personnel from discriminating against or harassing closeted homosexual or bisexual service members or applicants, but also barred openly gay, lesbian, or bisexual persons from military service. Two years later, however, Clinton signed into effect Executive Order 12968, which for the first time banned discrimination based on "sexual orientation" with regards to granting classified information access to federal government employees. Perhaps most dismaying, however, was 1996's passage of the Defense of Marriage Act, which allowed individual states to refuse to recognize same-sex marriages performed in other jurisdictions, and which would not be officially repealed until 2022's Respect for Marriage Act.

With the election of Mayor Rudolph Giuliani, 1993 also saw the ascent of another political figure who drastically affected LGBTQ+ life in New York City specifically. Giuliani quickly embarked on a mission to clean up the city

in what would come to be known as his "Quality of Life" campaign, acutely changing the local nightlife landscape and especially targeting queer spaces. He reinvigorated NYC's controversial Cabaret Law, which was first enacted in 1926 but hadn't been put to use since the '60s. It restricted any venue that didn't have a cabaret license from allowing more than three people to dance; if caught, they would be fined or shuttered temporarily. Most venues did not have these licenses since they were perceived as unnecessary and obtaining them was both time-consuming and costly. Two years later, Giuliani established a task force specifically formed to infiltrate clubs and bars to issue tickets and warnings. Once again, raids and inspections on queer nightlife venues became a common occurrence, and refuges for trans folks and LGBTQ+ people of color in particular, such as Edelweiss and Sally's Hideaway, would be permanently put out of business. This citywide sanitation incited rapid gentrification across several neighborhoods central to the queer community, ultimately leading to the "Disneyfication" of Times Square and the Meatpacking District's glossy revamp.

City nightlife underwent numerous other ups and downs throughout the decade as well. The '90s embarked with the rise of the Club Kids who, born out of the late '80s, transitioned beyond being mere nightlife celebrities to become leaders of an international artistic and fashion-conscious youth culture. They even appeared on daytime TV talk shows, shocking the greater world with their flamboyant behavior and outlandish appearances. The phenomenon would peak, however, in 1996, when the movement's de facto leader, Michael Alig, made headlines after being arrested for the killing and dismembering of fellow Club Kid Andre "Angel" Melendez.

Meanwhile, in response to the city's flourishing nightlife scene, *Homo Xtra* (*HX*), a weekly gay party and entertainment guide, launched in 1991, quickly growing from a foldable pamphlet into a full-fledged glossy magazine. Started by Matthew Bank and Marc Berkley, it was followed by the more nationally focused *Out Magazine* and direct competitor *Next Magazine*. Even more NYC-centric and national publications followed, including *Genre*, *LGNY*, *XY*, and the *New York Blade*. As these print publications proliferated, however, a new form of communication would slowly emerge towards the decade's end, with the internet's rise in popularity. By 1999, AOL chat rooms and other internet forums became a leading source for queer people to find each other, a trend that would continue to flourish well into the new millennium.

ESCUELITA

1990s
301 WEST 39TH STREET
NEW YORK, NY 10018

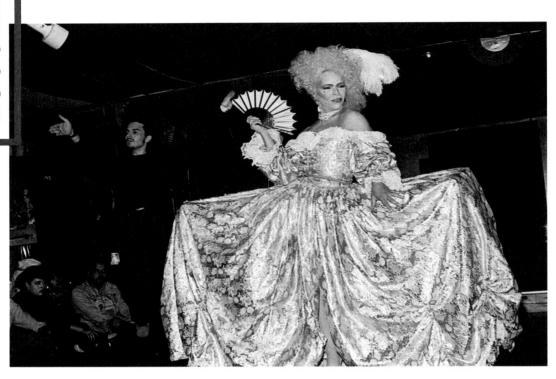

Iconic Mother Paris Dupree performing at Escuelita, 1990.

Escuelita, also known as La Escuelita or Esco's for short, was a pivotal LGBTQ+ nightclub in Manhattan that primarily catered to the Latino and Black communities, prominently showcasing drag and trans performers of color for over 50 years. Seen as a major New York institution, the club had several locations since first opening in the late 1960s, each on Manhattan's West Side. Its longest-running address was 301 West 39th Street between Eighth and Ninth Avenues.

In the late '60s, a group of gay Latinos opened a social club across the street from Lincoln Center to create a nightclub that would be welcoming to their community. Called Escuelita, the venue took its name from being in the basement of a language school, as Spanish-speaking patrons would describe the location as under "the little school."

The first Escuelita was closed by police after just a few years and the club moved further uptown, to the Hotel Lucerne on 79th and Amsterdam. The owners obtained a proper liquor license, and Escuelita soon began hosting its iconic drag shows that would make it famous. In the late '70s it relocated to Hell's Kitchen, at 607 Eighth Avenue, in a former downstairs bowling alley. Go-go boys typically performed on raised platforms to a mixture of salsa, merengue, Latin house, and hip-hop. During renovations in 1996, the entrance moved around the corner, changing its address to 301 West 39th Street; people began calling the location "La Nueva Escuelita."

Escuelita

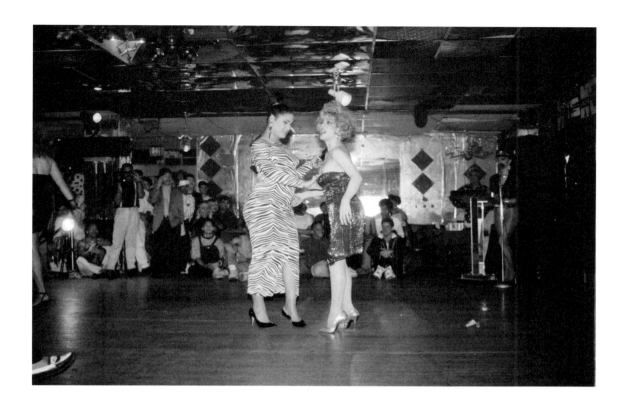

Performer pulling down the top of another, 1990.

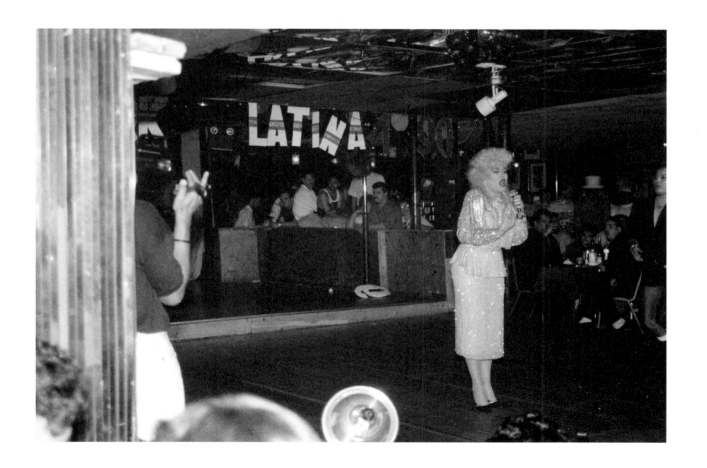

Singing performer in front of Latina 1990 sign at Escuelita, 1990.

1990s

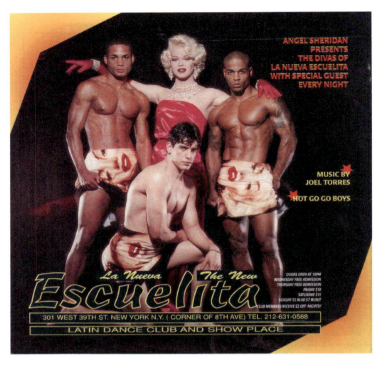

La Nueva Escuelita, circa 1990s.

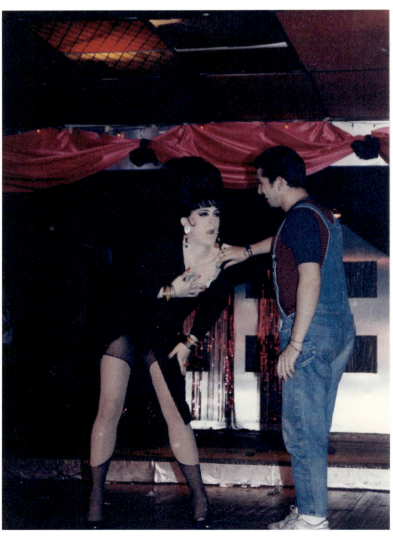

Perfidia performing at Escuelita, circa 1985–87.

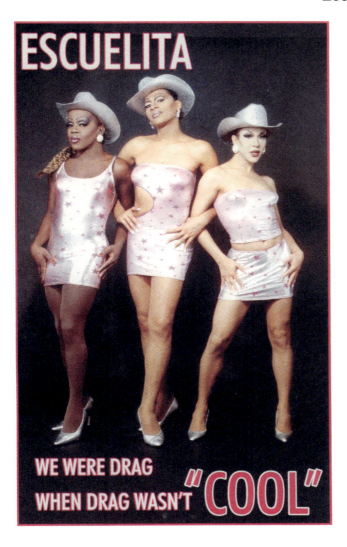

Escuelita ad, circa 1980s/'90s.

> Alphonso King Jr. (Jade Elektra), DJ/drag performer at Escuelita: "At Escuelita, I had to referee the queens and the go-go boys, someone always trying to blow one of the go-go boys or something. It was a hot mess back then, because the boys would be backstage, fluffing themselves up to fill out their G-strings, and the queens had to walk through that room to get to their own dressing room. And some of those boys were on the covers of [porn magazines] *Latin Inches* or *Black Inches*, so there was a lot going on."

At a time when drag was changing, Escuelita was known in particular for its traditional drag revue hosted by Angel Sheridan, described by Michael Musto in the *Village Voice* as "an old-school diva who's so vital and well-rehearsed she can even breathe life into Bette Midler's version of *Gypsy*." Many Escuelita performers were larger-than-life showgirls who would lip sync lavishly to anything from old-style Latin divas to pop hits.

In its later years, the club brought in more varied types of promoters to host events there. It became the original location for the iconic Vogue Knights parties—DJ'ed by scene stalwart MikeQ—which later moved to John Blair's XL bar (see p. 276) and has continued shifting around to various venues. As a haven for queer people of color, however, Escuelita was frequently targeted by the police and State Liquor Authority. In 2012, the SLA declined to renew the club's license due to minor incidents, which owner Savyon Zabar called a pretext for gentrification, and stated in an affidavit that "we are no longer welcome on West 39th Street, as minorities scare the mostly white tourists who patronize the newly built and expensive boutique hotels on the block." Escuelita remained open, but continued to be harassed, finally closing for good in 2016 after decades of serving as a refuge for LGBTQ+ people of color in central Manhattan.

1990s

PALLADIUM

126 EAST 14TH STREET
NEW YORK, NY 10003

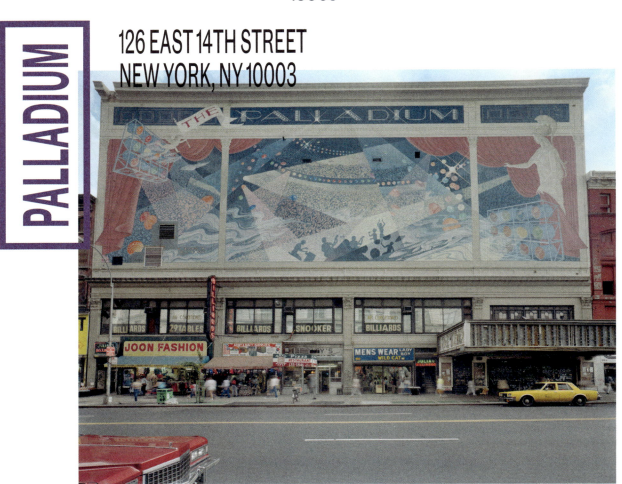

Palladium's exterior, 1985.

Located at 126 East 14th Street between Third Avenue and Irving Place, Palladium was a massive nightclub that was opened in 1985 by Steve Rubell and Ian Schrager of Studio 54 fame, four years after being released from prison. Bringing in celebrated Japanese architect Arata Isozaki to redesign the building's interior, the duo took over the colossal structure that was originally built in 1927 as a deluxe movie palace and had later housed a historic rock concert hall.

The visually enrapturing redesign featured large-scale murals by artists Keith Haring, Jean Michel Basquiat, and Francesco Clemente, as well as custom-built banks of television monitors that would traverse the space, flashing various music videos. In 1986, artist Kenny Scharf got his very own self-named room in the club's basement, which he swathed in floor-to-ceiling psychedelic extravagance. Palladium also contained the Michael Todd Room, its famous upstairs VIP lounge which held a 40-foot-long [12-meter] Basquiat painting as well as crystal-beaded dark mirrors, floating candelabra, and white-lace-covered café tables with lace-draped banquettes.

From its star-studded opening in May 1985 through the end of the 1980s, Palladium virtually dominated the New York club scene, with DJs Richard Sweret, Patrick Anastasi, and Luis Martinez turning it into a new wave, Euro, and house music-oriented club. In 1992, Peter Gatien, owner of Limelight (see p. 168), Tunnel, and Club USA, took over the reins, and throughout the '90s, the club began hosting designated weekly gay nights

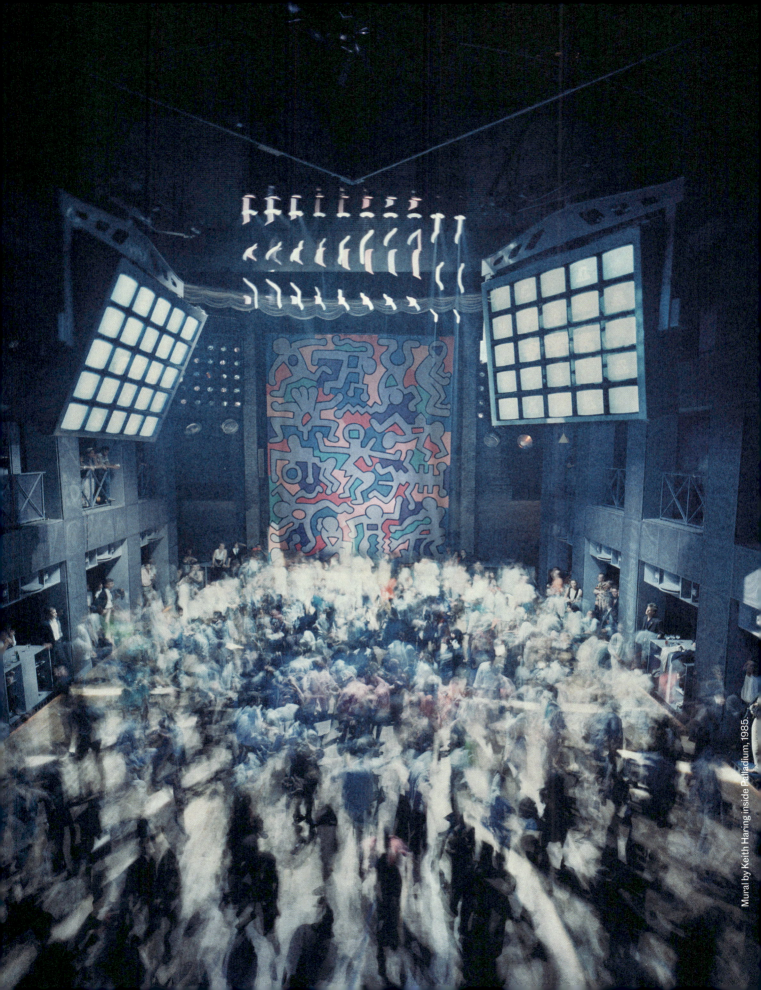

Mural by Keith Haring inside Palladium, 1985.

1990s

which attracted a varied mix of Club Kids, drag queens, celebrities, muscle boys, and more.

Tuesday nights at Palladium, for example, were often hosted by DJ Larry Tee, who threw his Club Kid-fueled party Love Machine. When Club USA closed in 1995, party promoter Marc Berkley moved his mega-popular weekly bash Bump! over to Palladium, which continued to pack in the crowds. Beginning in September 1996, Junior Vasquez's Arena party, held Saturday nights into Sunday mornings, became arguably the most popular party in the New York club scene at the time (and although promoters billed it as "The Gay Man's Pleasure Dome," the party drew an eclectic mix of gays, lesbians, and straights from all over). Other popular recurring parties over the years included Lee Chappell's Locomotion, Kenny Kenny, Sister Dimension, and Bella Bolski's Panty Girdles, and the It Twins' Combustion.

Lighting engineer Marsha Stern remarked on Palladium's innovative contributions to the nightlife scene: "As a club, it offered a huge jump technologically. We were dealing with computerized lighting, digitized lighting, lighting that was only previously available on major music tours. And it was famous for its custom-built video arrays and the integration of playing videos. MTV had just begun a few years earlier. So you had all these technologies converging. Palladium was at the forefront of that, and I think that changed clubs a lot afterwards."

Palladium ultimately closed in August 1997 following the building's purchase by New York University. In August 1998, the historic structure was demolished to build a twelve-story residence hall that was named, of all things, Palladium Hall, and which remains today.

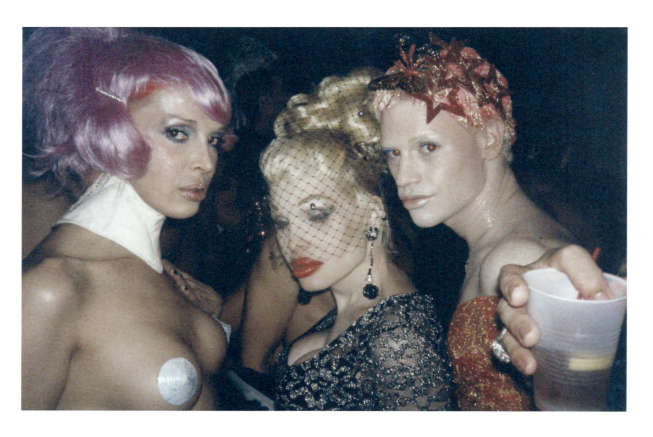

Sophia Lamar, Amanda Lepore, and Richie Rich, circa 1990s.

Palladium

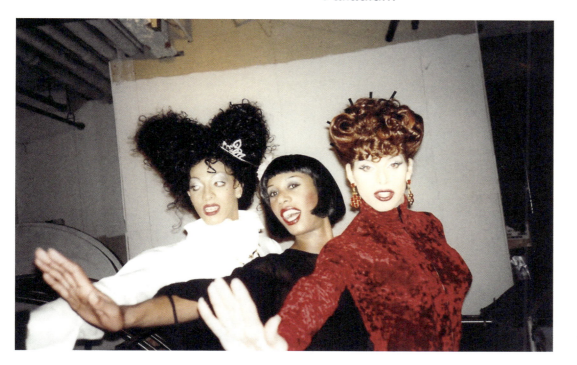

Girlina, Honey Dijon, and Candis Cayne at Palladium, circa 1990s.

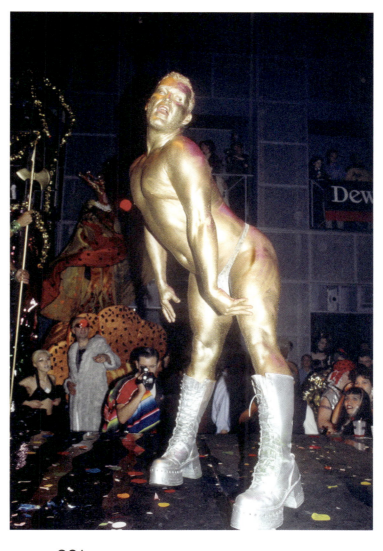

Gold dancer at a Susanne Bartsch party at Palladium, 1995.

1990s

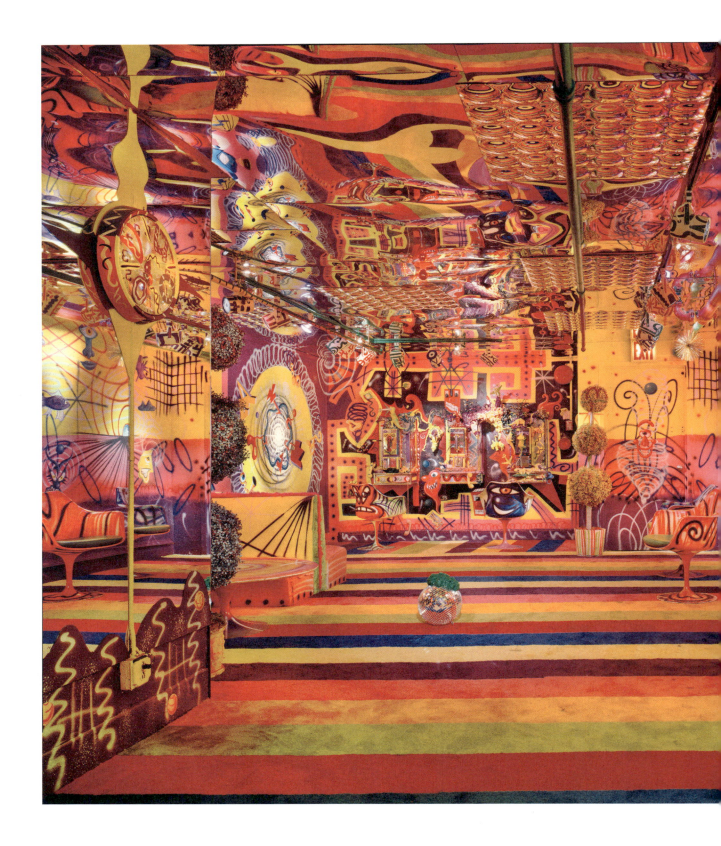

Kenny Scharf room at Palladium, 1986.

202

Palladium

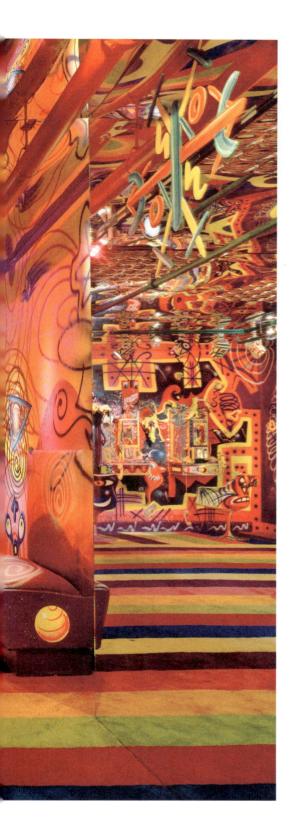

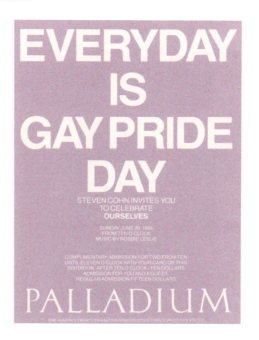

Gay pride party invitation, 1986.

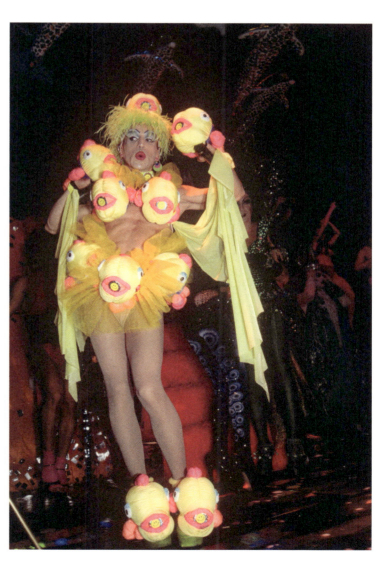

Fishy queen, 1986.

1990s

CLIT CLUB @ BAR ROOM 432

432 WEST 14TH STREET
NEW YORK, NY 10014

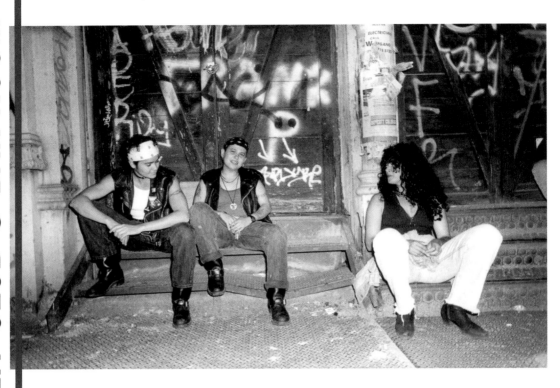

Patrons lounging outside, circa 1990s.

Clit Club was a brazenly named lesbian and queer party founded in 1990 by two activists and artists of color, Julie Tolentino and Jocelyn Taylor (aka Jaguar Mary). It was the first queer event to occupy what was then called Bar Room 432, located at 432 West 14th Street in Manhattan's Meatpacking District. In 1990, contemporary dancer Tolentino was introduced to the space by a downtown choreographer whose husband co-owned it. Tolentino and Taylor threw the inaugural Clit Club party at the space on July 27 of that year, which quickly morphed into a mega-popular event held every Friday night.

Clit Club was conceived as a sex-positive, racially, generationally, and economically mixed space for lesbians, trans people, gays, and everyone in between. Tolentino and Taylor themselves had both been members of House of Color, an ACT UP affinity group focused on the lack of representation for LGBTQ+ people of color, and the pair brought this activist sense of inclusivity to Clit Club.

The party offered a unique feeling of sexual freedom, a radical departure from the more conservative women's bars of previous decades. In the '90s, in part due to spaces like Clit Club, lesbian sexuality grew increasingly bolder and became reflected in the explicitly sexual names and advertising used for new parties and clubs. What was once perceived as exploitative, many lesbians in the '90s now began embracing as part of their power. DJ Susan Morabito reflected on Clit Club's success: "Part of that was the rawness, the coldness, the dinginess, the underground vibe of the space as

Clit Club @ Bar Room 432

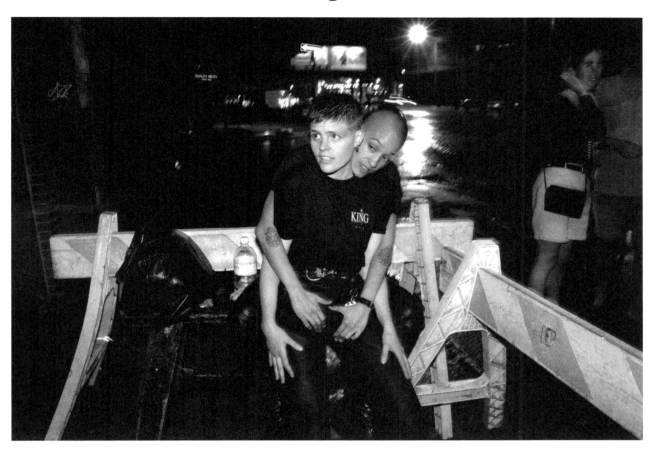

Julie Tolentino and Jet Clark outside of Clit Club, 1995.

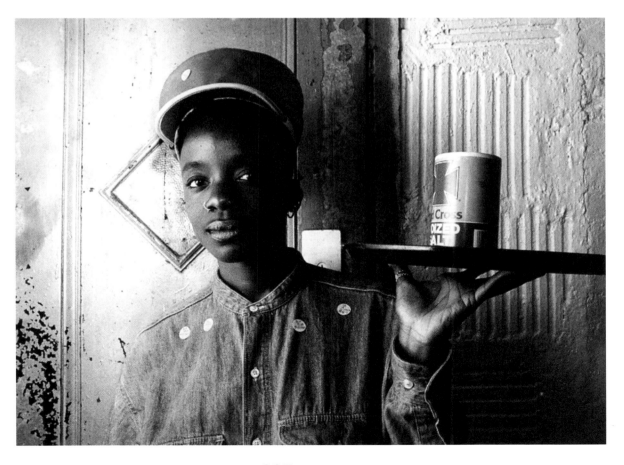

Melanie Hope at Clit Club, circa 1990s.

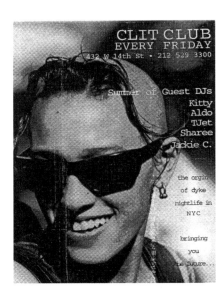

Left: The Origin of Dyke Nightlife in NYC flyer, circa 1990s.

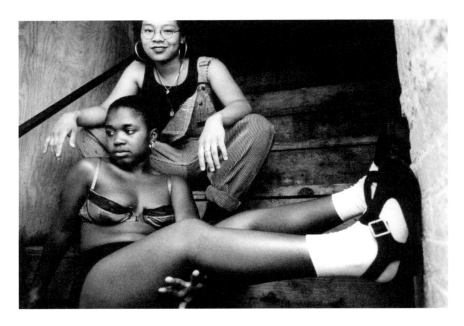

Right: Shigi and Andrea at Clit Club, circa 1990s.

soon as you walked in. It was almost like you'd be at Henrietta Hudson [see p. 260], and then all those girls would run over to the Clit Club come 12:30–1 o'clock in the morning and would behave differently…A little more promiscuous, a little more adventurous. Flirtatious, I should say, really. And I think that had everything to do with the vibe. It gave you permission."

Clit Club made a lasting impact on lesbian and queer life in New York City. It also sparked other weekly LGBTQ+ parties which shared the 14th Street space throughout the '90s, helping keep it afloat. One of those was MEAT, operated by Aldo Hernandez, Clit Club's very first DJ, which became its own weekly party. Another was Jackie 60, an underground, performance-oriented party founded and produced by promoter Chi Chi Valenti, DJ Johnny Dynell, fashion designer Kitty Boots, and dancer/choreographer Richard Move that took place on Tuesday nights starting in March 1991.

In 1996, Valenti and Dynell took over Bar Room 432's lease and management, renaming the venue Mother. More recurring LGBTQ+ events began popping up, including Click + Drag, a weekly "cyber/fetish/Gothic/gender hacking" party, and Martha@Mother, a monthly dance party thrown in tribute to choreographer Martha Graham. Mother ultimately closed in 2000 when the building was sold and redeveloped during the Meatpacking District's rapid gentrification. Clit Club then bounced around other venues before finally fizzling out in 2002.

Nina Kennedy, patron/performer at Clit Club: "Clit Club had several dancers, but I remember one very sexy one named Otter who danced on a platform. In the summer it would get very hot there, so clothes would come off right and left. One night, I was drinking scotch on the rocks and Otter was on one of these lower platforms. I started putting my glass on her body, you know the condensation, and licking some of the drippage off her, so she and I had a real rapport going on. Some people started watching, and soon we had a little circle forming around us. I looked away for one second and the next thing I knew, she had jumped spread eagle off the platform and right onto me, without any warning. Luckily, I somehow stayed on my feet and didn't hit the floor. That's a moment I won't ever forget."

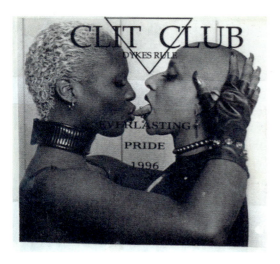

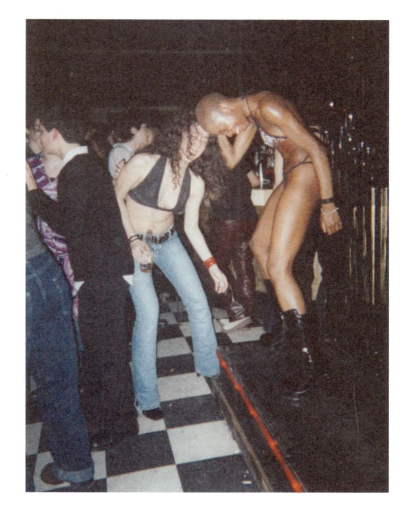

Top Left: Clit Club logo, 1998.
Bottom Left: Dykes Rule flyer, 1996.
Right: Dancers at Clit Club, circa 1990s.

THE ROXY

1990s

515 WEST 18TH STREET
NEW YORK, NY 10011

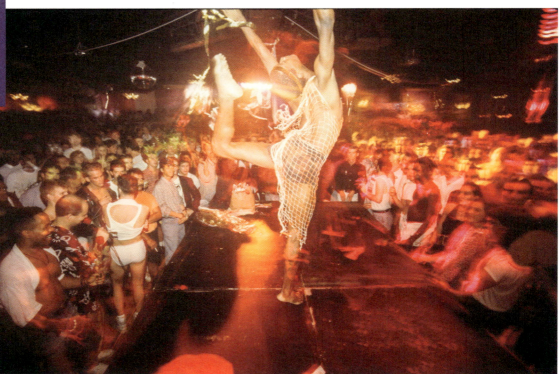

Stage dancing at the Roxy, circa 1990s.

Located at 515 West 18th Street between Tenth and Eleventh Avenues, the Roxy was a popular megaclub that first opened as a roller disco in 1978. In the early '80s, its owners began hosting extravagant private parties there, which gave it its reputation as the "Studio 54 of roller rinks." By 1982, the space was revamped into a nightclub, featuring a large dancefloor for over 2,300 patrons. It then briefly became a buzzing hip-hop venue but would close in the late '80s after legal and financial troubles.

In 1990, the Roxy was reborn by its latest owner, Gene DiNino, this time catering to gay clientele and hiring promoters and DJs like David Leigh, Lee Chappell, and Larry Tee to host weekly dance parties such as Locomotion Saturdays, which brought in a mixture of downtown drag queens, Club Kids, and performance artists.

The Roxy's quirky queer vibe shifted in 1991 with the launch of Saturdays at Roxy, which became one of the city's largest weekly gay dance nights and attracted a more muscular, often shirtless male crowd. In a *New York Times* interview, the party's promoter recounted: "Your Chelsea boy was born…Everyone was taking steroids and had big upper bodies and small legs." Club fliers for these events began promoting this aesthetic, frequently featuring black-and-white photos of half-naked, hyper-muscular men.

Throughout the '90s, the reinvigorated Roxy featured countless world-renowned DJs, including Junior Vasquez, Hex Hector, Victor Calderone, Frankie Knuckles, and more. The club

The Roxy

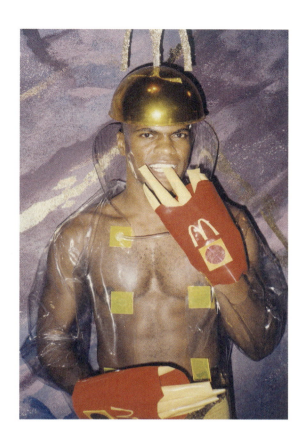

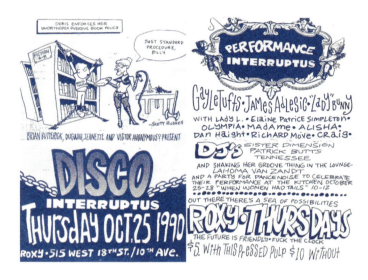

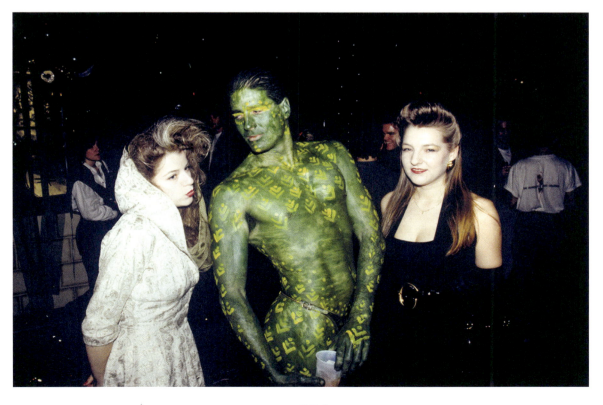

Top Left: Kevin Africa at the House of Field Ball, 1990.

Top Right: Disco Interruptus flyer (front and back), 1990.

Bottom: Really Denise and clubgoers, 1990.

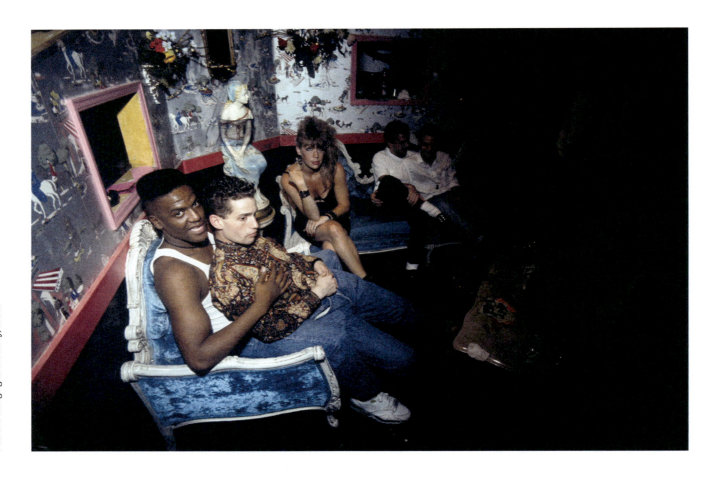

Patrons lounging at the Roxy, 1990.

also became a hotspot for top-billing artists, including Madonna, Grace Jones, Cher, and Whitney Houston. Additionally, it returned to its earliest roots and began throwing gay roller-skating parties, often billed as Rollerballs or Muscle On Wheels.

Unlike most megaclubs of the time, the Roxy managed to hang on the longest, but closed for good in March 2007 after the building's owner sold it to developers. The final night brought in over 4,000 people and kept going until noon the next day. Its final DJ, Peter Rauhofer, played a remix of Donna Summer's "Last Dance" twice back-to-back to close out the venue.

The Roxy left a major mark on the city's gay nightlife, seeing it through multiple decades, musical genres, and historic events. Its closure was greatly mourned, and in 2008, a documentary about the club's final party premiered on the LOGO TV network. The space itself was briefly replaced with a high-end art gallery before the building was demolished in 2017 to make way for luxury residential condos.

The Roxy

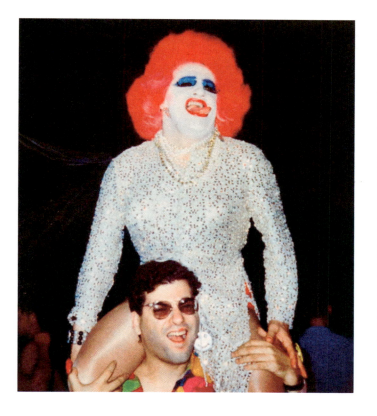

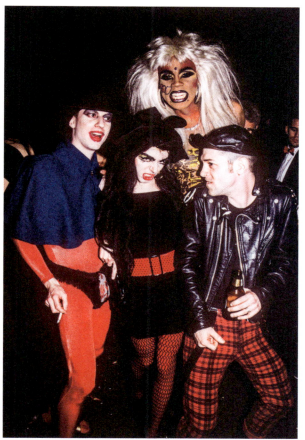

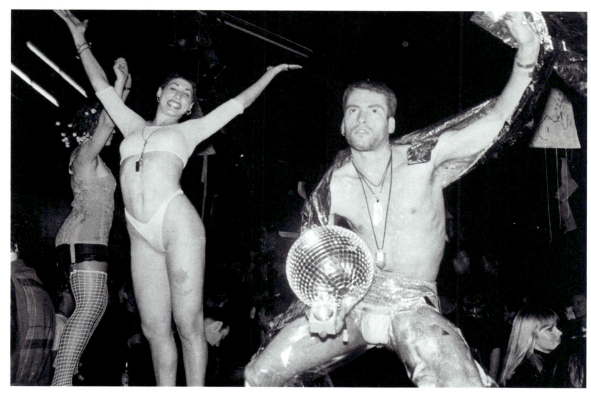

Top Left: Brandy Wine atop Michael Musto, 1993.

Top Right: RuPaul and friends, circa 1990s.

Bottom: Rebecca "YoYo" Weinberg and David Leigh at Saturday Night at Roxy, 1990.

LUCKY CHENG'S

24 FIRST AVENUE
NEW YORK, NY 10009

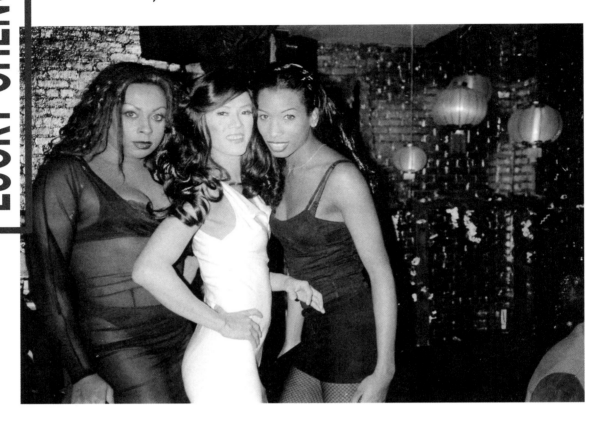

Performers at Lucky Cheng's (Daisy Ang, center), circa 1990s/'00s.

In 1993, a new kind of queer venue debuted at 24 First Avenue in the East Village: Lucky Cheng's, a "California Asian"-style restaurant, where the servers were also the performers and were all Asian drag queens and transgender women. Prior to Lucky Cheng's, the space had housed the Club Baths from 1971 to 1983, the first openly gay-owned bathhouse, where Keith Haring was a regular. When the bathhouse shut down during the AIDS crisis, quirky East Village resident Hayne Suthon bought the building, turning it into a restaurant named Cave Canem that kept many of the bathhouse's original features and became a popular hangout for hip lesbians.

In 1993, Suthon closed Canem and partnered with producer Robert Jason to open a new restaurant in the space. Noting the neighborhood's dearth of Asian cuisine at the time, Suthon also wanted to make a big splash by opening one of the city's first-ever drag queen restaurants. On a whim, Suthon named the venue Lucky Cheng's, after a former busboy at Canem named Mi Ching Cheng, who became part owner of the business. According to Jason in a *Thrillist* interview, the business was "revolutionary and very taboo," but also "a raging success."

Lucky Cheng's became a sanctuary and community hub for queer Asians who felt rejected from society. Tora Dress, who worked there since its inception, noted that since many Asian cultures expect men to get married and adhere to strict gender guidelines, the mere existence of Lucky Cheng's was a big deal. Daisy Ang, another original employee, noted:

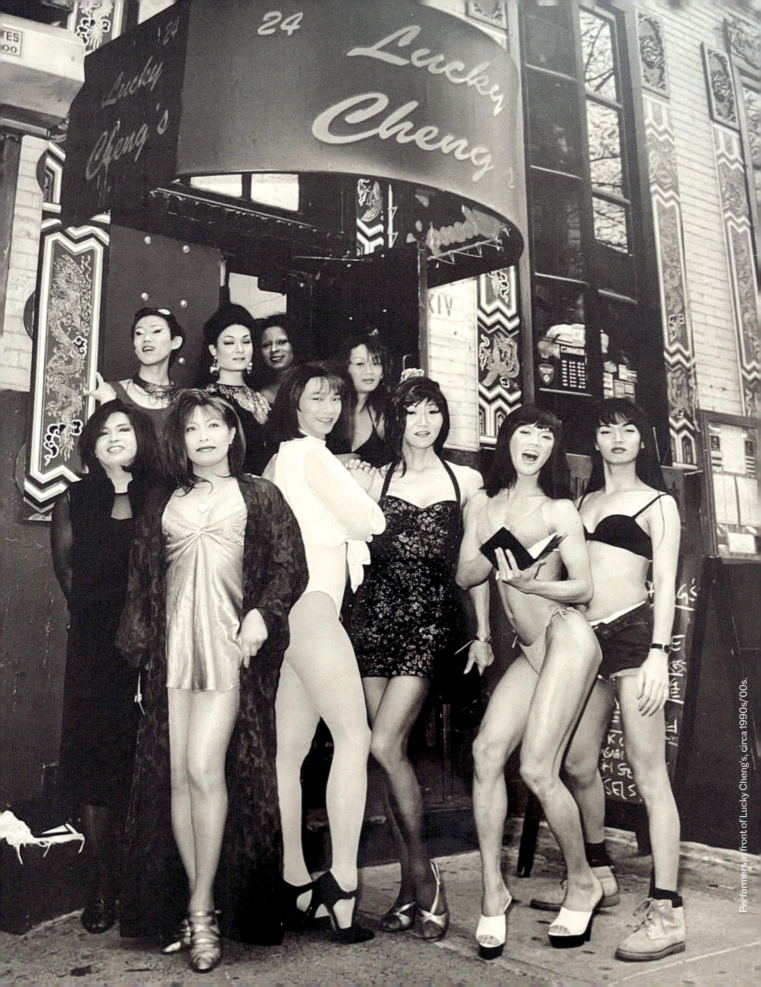

Performers in front of Lucky Cheng's, circa 1990s/'00s.

1990s

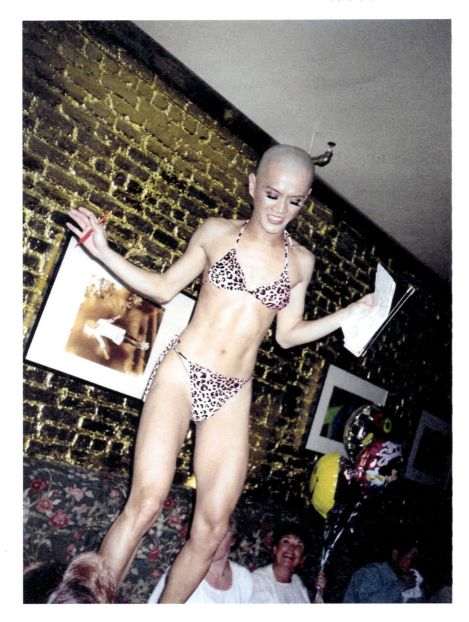

Daisy Ang performing tabletop, circa 1990s/'00s.

Lucky Cheng's flyer with photo by Linda Simpson and design by Meddle, circa 1990s/'00s.

Lucky Cheng's

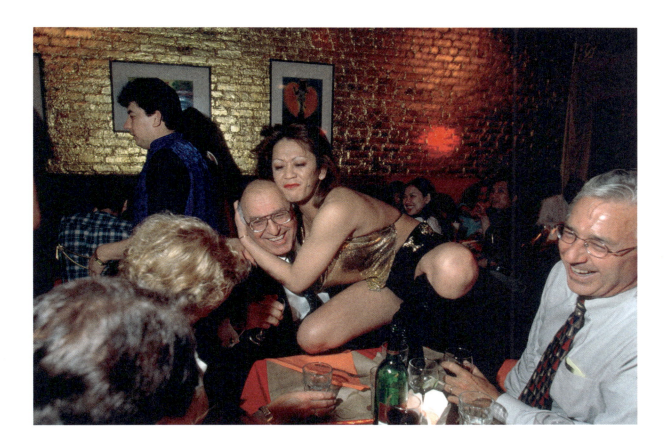

Tabletop performer, 1999.

"Other places during that time—Uncle Charlie's, Splash—oftentimes I would get pushed away, like they were not into skinny, effeminate Asians. At Cheng's I could feel comfortable."

Lucky Cheng's eventually loosened its policy on Asian-only queens, with many new performers getting their start there, including Laverne Cox, prior to her big break on Netflix's *Orange is the New Black*, and Kitten Withawhip, who would later change her drag name to Bob the Drag Queen and win the eighth season of *RuPaul's Drag Race*.

Early clientele consisted of artsy, East Village bohemians, but by 1995 the restaurant had received significant media attention and attracted celebrities like Prince Albert of Monaco, Bernadette Peters, and even Robert De Niro and Barbra Streisand, who famously arrived together, couldn't get a table, and were forced to move on.

In 1998, the eatery gained even more global prominence when it appeared on the debut episode of *Sex and the City* as the spot where Miranda celebrated her birthday. By the end of the 2000s, Cheng's had outgrown its East Village home, and relocated to Times Square in 2012. The opening of the much larger space at 240 West 52nd Street broadened its customer base further, bringing in many passersby off the street who would experience drag for the very first time.

Also in 2012, tragedy struck when Suthon was diagnosed with stage four breast cancer. Two years later, she passed away, and Lucky Cheng's shut down shortly thereafter. It later resurfaced as a pop-up nightclub, and since then has bounced around to various venues. The original building was demolished in 2019 to make way for a luxury condo.

SOUND FACTORY & SOUND FACTORY BAR

1990s

530 WEST 27TH STREET /
12 WEST 21ST STREET
NEW YORK, NY 10001 / 10010

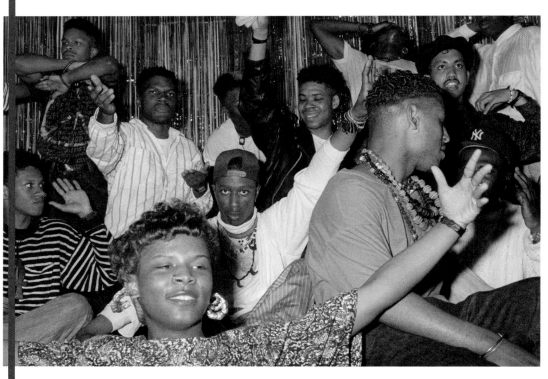

Voguers at Sound Factory, 1990.

In 1989, Christina Visca, Richard Grant, and Phil Smith created the Sound Factory. Previously, Visca and Grant had owned a club called Bassline, while Smith had been a former co-owner of Paradise Garage. Sound Factory quickly became known for its state-of-the-art sound system as well as for Junior Vasquez, its legendary resident DJ, whose association with the Houses of Xtravaganza and Aviance helped inject the Harlem ballroom scene into the downtown club scene.

Sound Factory's original location was in a converted warehouse at 530 West 27th Street between Tenth and Eleventh Avenues, with a first floor sporting a giant disco ball and a second floor that pumped house and disco music. The club packed in a widespread mixture of tribes, including Chelsea boys, chic lesbians, graceful Harlem voguers, as well as straight people and suburbanites.

Though it was not exclusively queer, Sound Factory always presented as LGBTQ+-friendly, and reserved Saturday nights for its monumental gay party. By not serving alcohol, it was able to extend its events into the late afternoons, skirting the mandatory Sunday closing time and meshing the underground vibe of an after-hours club with a megaclub's size and attendance. Sound Factory was also made popular thanks to Junior Vasquez's innovative DJing, as he took advantage of the club's booming bass and experimented with unique sampling, radical mashups, and ambient sounds.

In 1992, co-owner Smith shifted his attention to the newly opened

Sound Factory & Sound Factory Bar

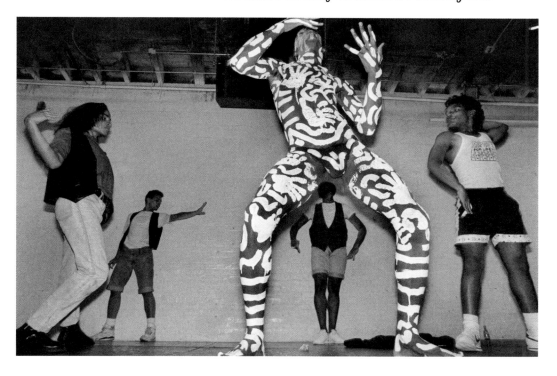

Top: Voguing performance at Keith Haring Party for Act Up at Sound Factory, 1989.

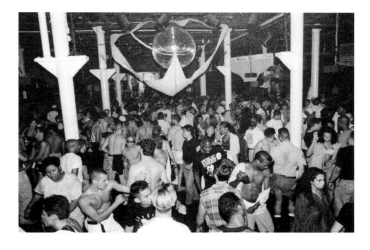

Middle Right: Sound Factory dancefloor, 1992.

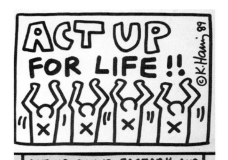

Middle Left: Act Up flyer, circa 1990.

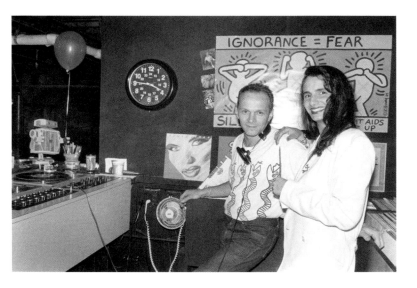

Bottom: Junior Vasquez and Christina Visca in the Sound Factory DJ booth, 1989.

1990s

Sound Factory Bar at 12 West 21st Street, a smaller venue and principally gay offshoot of the club. The Sound Factory Bar, or SFB for short, took over the space which previously housed the gay club Private Eyes, a popular nightspot during the late '80s and early '90s. Though everyone was welcome, SFB catered largely to gay men of color, with parties like Factoria 21, a tribal house gay night on Thursdays. Wednesdays, meanwhile, were home to the Underground Network parties, with Grammy winner Little Louie Vega as the resident DJ. Fridays were usually the night to catch legendary "Godfather of House" Frankie Knuckles spinning, while Sunday daytime was often reserved for the Body Positive Tea Dance, a social gathering for HIV-positive men.

After a six-year run, Sound Factory suddenly closed in 1995, still peaking in popularity. Reasons for its closure were never clear, but with Smith focused more on SFB and Visca having departed the year prior, ending Sound Factory was a preemptive move, according to Grant. "Contrary to rumor, we did not lose our cabaret license," he informed *Billboard* magazine at the time, "but we knew that was a danger, so we decided to close." That same year, Sound Factory was replaced by Twilo, a more trance-oriented club that featured several gay nights as well.

Grant later reopened Sound Factory at 618 West 46th Street, where it ran for several more years before running into narcotics-related problems and being shut down in 2004. The original 27th Street space is now occupied by the McKittrick Hotel, a performance venue and dining complex. SFB, meanwhile, lasted until 1997, when it closed and reopened as a new club called Cheetah, which would hold its own gay events such as Phab, a hip-hop party, before shuttering in 1999.

Left: Voguer Jose Xtravaganza at the War Ball at Sound Factory, 1991.

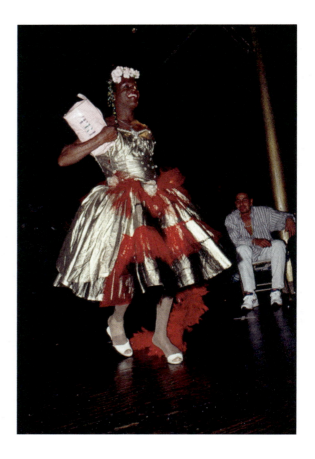

Right: Marsha P. Johnson walking the War Ball at Sound Factory, 1991.

Sound Factory & Sound Factory Bar

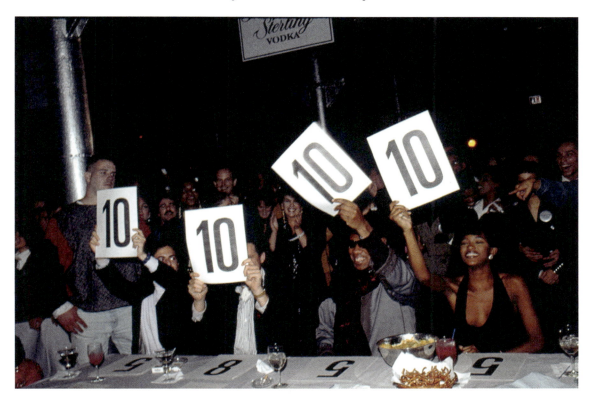

Marc Jacobs, Isaac Mizrahi, André Leon Talley, and Naomi Campbell giving tens across the board at the Tanqueray Ball AIDS Benefit at Sound Factory, 1989.

Troy Lambert, patron: "The SFB crowd was predominantly Black and Latino, so it had more of a banjee vibe. Most of the guys there were trying to give you a trade kind of look—very butch, very masculine, Timbs, basketball sneakers. And everything then was oversized—baggy jeans, shirt, and usually some kind of bucket hat...It was a wonderful place to dance all night long to great music."

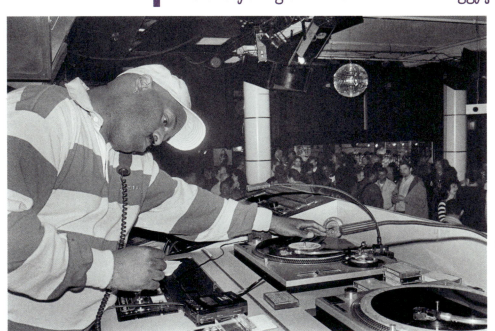

Frankie Knuckles DJing at Sound Factory Bar, 1994.

1990s

NO DAY LIKE SUNDAY @ CAFÉ TABAC

**232 EAST 9TH STREET
NEW YORK, NY 10003**

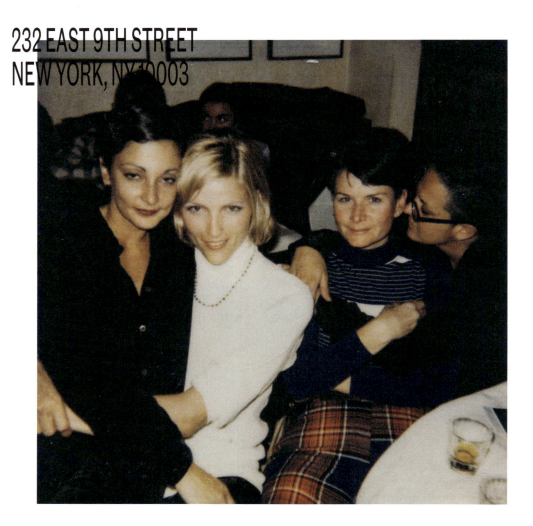

Wanda Acosta, Gigi Stoll, Frankie Foye, and Bettina at Café Tabac, circa 1990s.

Located at 232 East 9th Street in the East Village, Café Tabac was a posh restaurant and bar that opened in 1992. Though only open for five years, it managed to draw an incredibly diverse cross-section of hip East Village '90s New York, most notably during its No Day Like Sunday parties, thrown by Wanda Acosta and Sharee Nash beginning in 1993.

Deemed "the chicest lesbian party at the hottest of restaurant-bars in the East Village" by *Paper* magazine, No Day Like Sunday was closely tied with the birth of the term "lesbian chic" as it drew in fierce, beautiful women from the queer community for an elegant, salon-style soiree. The party began as a word-of-mouth and invite-only affair—which was initially part of its appeal—as some of its closeted attendees appreciated the secrecy. Eventually, queer and curious celebrities and New York It-girls began showing up, including Jenny Shimizu, Sandra Bernhard, Queen Latifah, and even Madonna.

Acosta recalled that the impetus for starting No Day was borne out of a personal desire for an elevated women's party space. "I wanted to feel like I didn't have to be kind of hidden somewhere to express my sexuality and I hadn't really found that," she said. "Most of the spaces at the time for women were dark bars, or the back of a restaurant, or the basement of a space." Acosta also remarked that Café Tabac at the time was constantly featured in gossip columns as a regular celebrity hangout.

Nash recalled loving the Café Tabac space: "Upstairs had a sexy red pool table with banquettes all around.

No Day Like Sunday @ Café Tabac

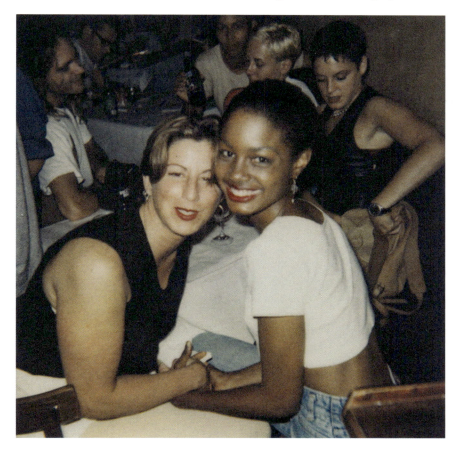

Top: Two friends, circa 1990s.

Bottom Right: Edris Nicholls, Mfon Essien, Laura Sheridan, and Rhonda Patillo, circa 1990s.

Bottom Left: Jenny Shimizu and Maria Luisa, circa 1990s.

Pierra Lordie and friend, circa 1990s.

And the lighting was just like amber, it would throb. You could fit like twenty people in there, so women would go and sit there and just watch women play pool. You'd have some dolled-up blonde and she'd bend over the pool table, and everybody would just be ogling. So it was kind of like a sex room in that sense, in a whole different way."

When Acosta and Nash pitched Tabac to host the party, the owner would let them try it only on Sundays, the restaurant's slowest night, and asked them to throw the first event on the coming weekend, allowing only four days to prepare. They called friends and handed out flyers to promote the party, while Nash served as the de-facto DJ. The turnout far exceeded expectations and was a smashing success. No Day continued for the next three years, reeling in a crowd that swirled with models, artists, activists, trendsetters, power dykes, and celebrities alike.

Though still exceedingly popular at the time, the event abruptly ended in 1996 when the owners decided to close down Tabac. Both Acosta and Nash knew they could never recapture the perfect ambience of No Day at another venue. By then, they were also involved with other parties and clubs, including their wildly successful Monday night women's parties at Bar d'O, which attracted more women of color and ran for nine years.

No Day Like Sunday @ Café Tabac

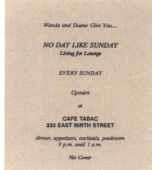

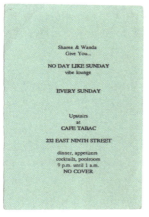
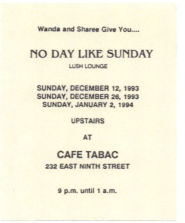
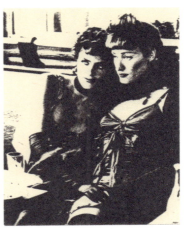

No Day Like Sunday flyers, circa 1993–1994.

Wanda Acosta, No Day Like Sunday founder: "What was great about Tabac that hadn't happened in other lesbian spaces was that you could arrive at five or six and have dinner. It was a full-on menu, you could come with friends, have dinner, and then segue into this night. It became this communal thing where you'd end up making friends with strangers."

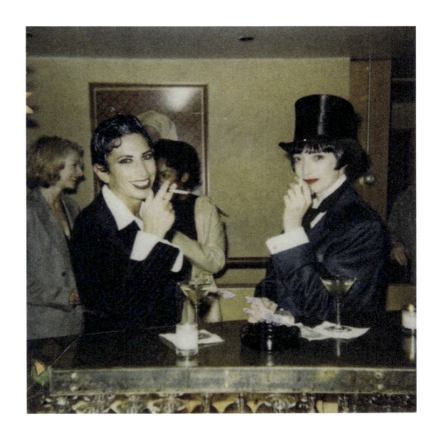

Carole Ramer and Azy Schecter, circa 1990s.

1990s

EDELWEISS

578 ELEVENTH AVENUE
NEW YORK, NY 10011

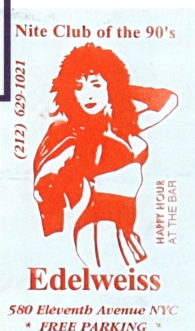

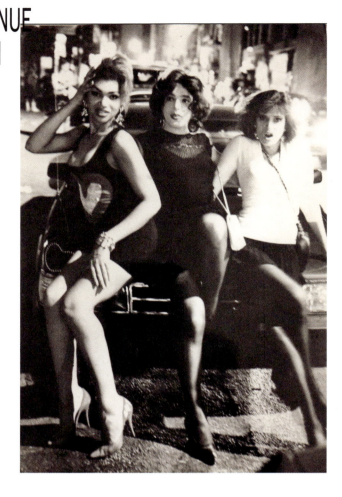

Left: Edelweiss business card, circa 1990s.

Right: Cynthia, Logi, and Georgina outside Edelweiss, circa 1990s.

First opened in 1994, Edelweiss was a Hell's Kitchen nightclub that served as an integral hangout for gender-non-conforming people of all kinds, as well as their admirers. Throughout the '90s, the club, whose name may have referred to the Edelweiss flower (which grows in rough terrain and overcomes adversity) endured frequent raids, shutdowns, and neighborhood complaints. It consequently closed and reopened several times throughout the decade, bouncing around various addresses, though its longest run was at 578 Eleventh Avenue between 43rd and 44th Streets.

Edelweiss was owned and operated by Constantine Eliopoulos, who was eventually charged for promoting and permitting prostitution at the venue. While there certainly were sex workers working at Edelweiss, it was still an important haven for people exploring their gender identity and was often filled with curious men who appeared to have dressed in their wives' clothing. Wanda Stephens, who visited Edelweiss several times, described the club's relationship with the trans community: "For people like me who wanted a place to go and express ourselves in a feminine manner, it was a comfortable place, but we weren't always understood. I think if they had recognized that there were a lot of us who were just in the spectrum of trans, instead of playing to the prostitution, there would still be a Club Edelweiss today."

Like many trans havens at the time, Edelweiss was particularly targeted by Mayor Giuliani's "Quality of Life" campaign. Midtown

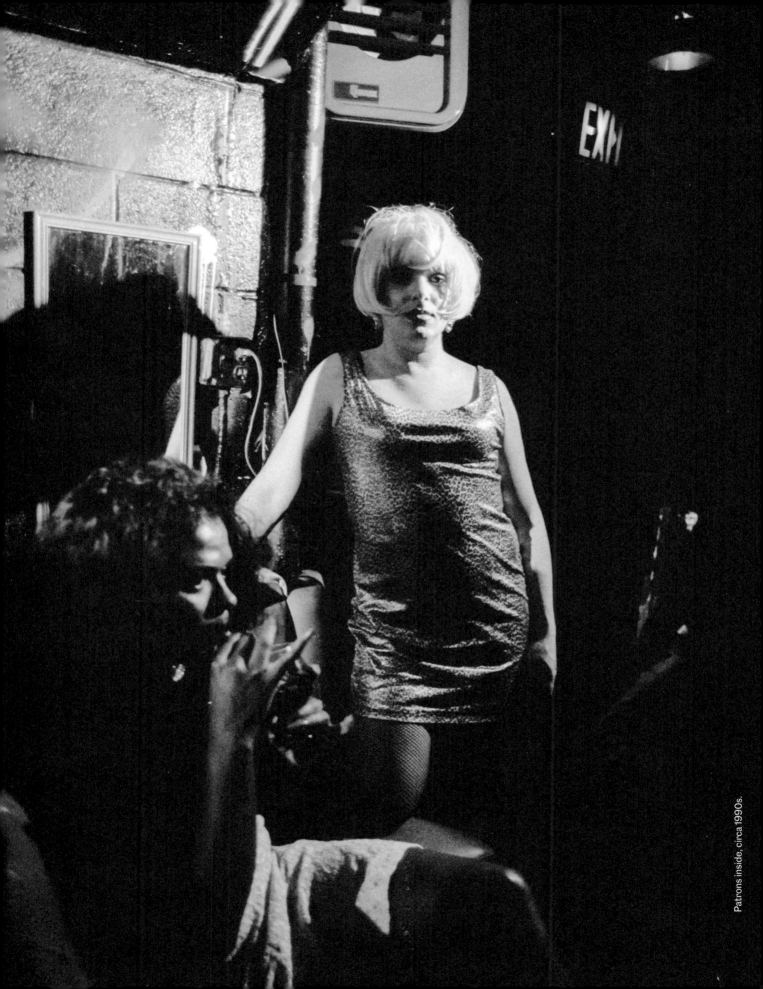
Patrons inside, circa 1990s.

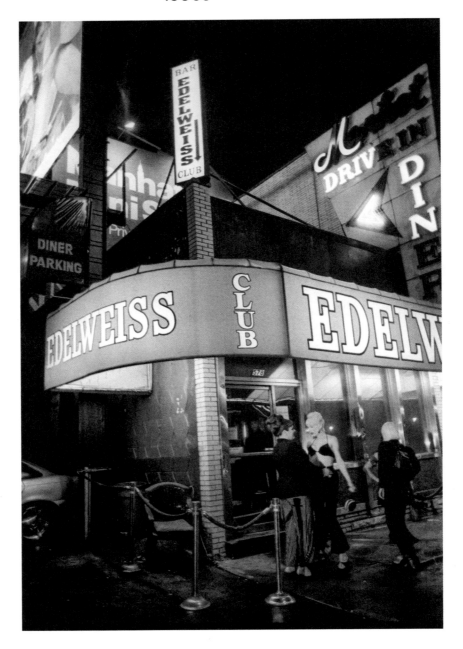

Edelweiss exterior, circa 1990s.

Enforcement, responsible for cleaning up Times Square, often raided the club and arrested many of its patrons. In one raid, there were 18 busts for drug-dealing and 25 for prostitution. In 1999, Midtown Enforcement went so far as to send Detective Gerard McMahon as an undercover drag queen named "Cindy" into Edelweiss, one of the first documented cases of a police department using a male officer in drag. This particular bust led to the club being padlocked for a year and its demise shortly thereafter.

Eliopoulos' defense lawyer, Hal Weiner, tried fighting back, suing the city on Civil Rights grounds. Weiner noted in *New York* magazine: "Transvestites and transgendered people are probably the most despised people in the city…You can probably find the same number of drug dealers and prostitutes at the Waldorf-Astoria bar, if you put the kind of effort the NYPD put into this. All the drug arrests were stings; the sex was agreed to; and if lap-dancing is all they saw, they might as well raid fraternity houses."

Edelweiss

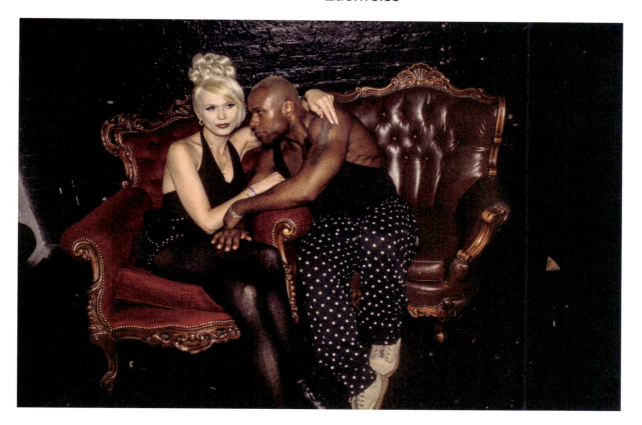

Eva and friend at Edelweiss, circa 1990s.

Brandy Wine and Brenda A. Go-Go, drag performers: "We always had a great time at Edelweiss. It was certainly an ego boost going there, as it was probably the only club other than the Vault where we were hit on. We remember being there once with a drag friend named Twisteena, whose breasts were created with water balloons. This hot man asked her to dance, and one of the balloons burst while they were on the dancefloor."

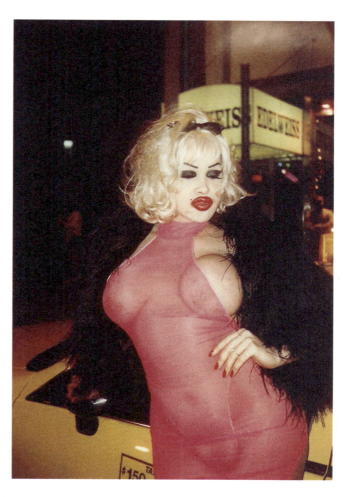

Monica Mugler in front of Edelweiss, 1994.

THE LURE

409 WEST 13TH STREET
NEW YORK, NY 10014

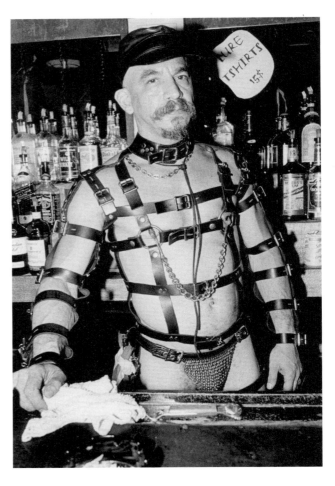

Burt Kuijpers bartending at the LURE, 1999.

Located at 409 West 13th Street in Manhattan's Meatpacking District, the LURE (an acronym for "Leather, Rubber, Uniforms, Etc.") first opened in January 1994 and was one of New York City's most popular leather bars. In part the brainchild of Wally Wallace, former longtime manager of the Mineshaft (see p. 128) during the '70s and early '80s, the LURE was bankrolled by investors from within the leather community and reportedly had 26 owners. Throughout the decade, it became particularly known for its mega-popular Wednesday night party called Pork, which showcased a wide variety of live S&M acts and erotic performances.

Michael Mitchell, who worked as an artist doing erotic figure drawings at the club, recalled: "Pork attracted the leather crowd as well as the Lower East Side tattoo-my-neck, pierce-my-tongue crowd, and its promoters hired a handful of artists, a barber, and a body painter to be regular features there. Then there was a big stage where they'd have musical acts, or a scrim where all you saw were silhouettes who were fisting or fucking or whipping. I remember one great whipping scene of this couple who were into flogging. For the show, the top was in full leather and the bottom was dressed as Mickey Mouse, with big ears, four-fingered gloves, and the little diaper thing with the buttons. And every time the guy whipped him—and he hit him hard—instead of saying 'Ow!' he'd go, 'Oh boy!' in a little Mickey Mouse voice."

Following in the footsteps of places like the Mineshaft, the LURE also enforced a strict dress code.

The LURE

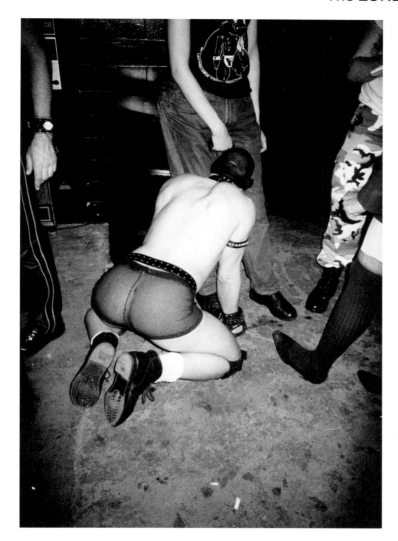

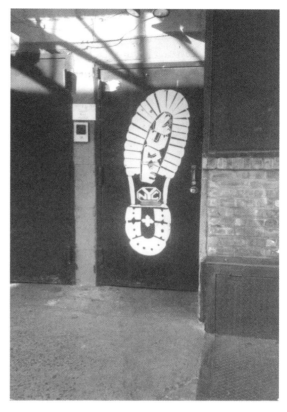

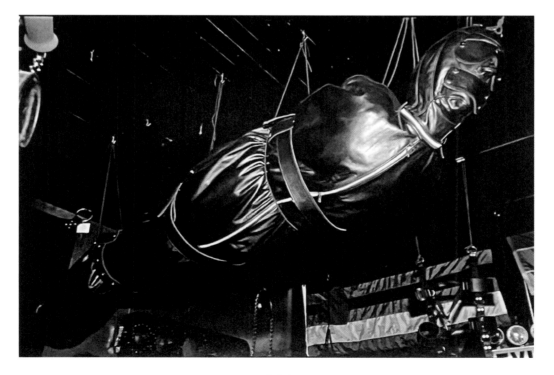

Top Left: Pup on leash, 1999.

Top Right: LURE entrance, 1980s.

Bottom: Hanging bondage suit, 1999.

A brief writeup in *New York* magazine carefully listed what was off-limits: "No cologne, including odors or scents of soaps or fabric softeners that prohibit one's manly scent; no dresses, female drag, or disco/designer drag; no suits, sports coats, tuxes, ties, knickers, loud-colored clothing, or shorts; no white sneakers, brightly colored footwear, or sandals of any kind; no 'Lacoste'-style shirts." The LURE was a place to strut one's stuff in fetish attire of all kinds—leather and tall boots, cop or firefighter gear, rubberwear or latex, and combat fatigues would all be smiled upon, living up to the bar's acronym.

At the LURE, one could cruise for a hot leather daddy, collar a slave, or get whipped by an expert flogger. It wasn't uncommon to see men there licking boots, torturing nipples, or even gulping down urine from beer bottles. The LURE also became a popular meeting place for numerous local fetish and sexual interest groups, such as the New York Renegades, known for their dungeon parties. When the nearby club Manhole closed down, the LURE became the new home for GMSMA's (Gay Male S/M Activists) popular Dungeon Demos.

Beginning in the 2000s, the rise of internet use slowed down the LURE's business and attendance dwindled. Additionally, 2000 saw fellow leather bar and longtime neighbor the Eagle close down, only to relocate to West 28th Street, drawing yet more attention away from the LURE.

The LURE also popped up in 2000 on HBO's *Sex and the City*, when Samantha moves into an apartment on the block, foreshadowing what would become of the neighborhood. Real estate in the Meatpacking District rapidly shifted, and high-end nightclubs and restaurants began opening. When the LURE's ten-year lease came up for renewal, the landlord jacked up the rent, rendering its survival on West 13th Street no longer viable. While there was talk of perhaps relocating, it closed permanently in April 2003.

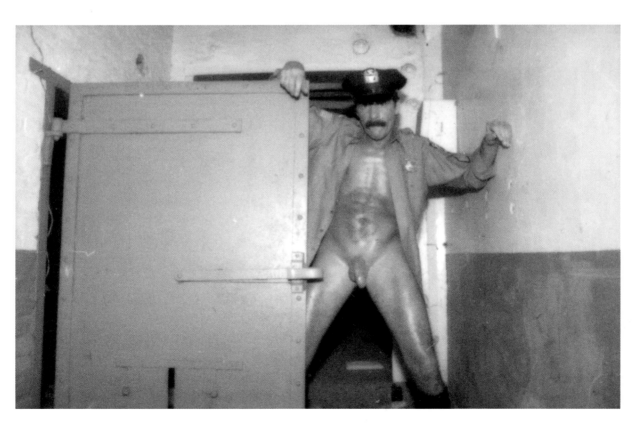

Formerly occupied by a bakery, the basement of the LURE contained walk-in ovens, 1992.

The LURE

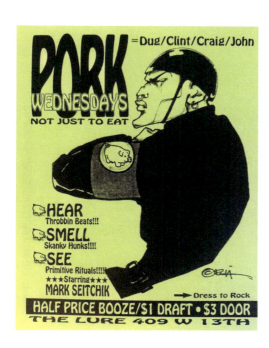

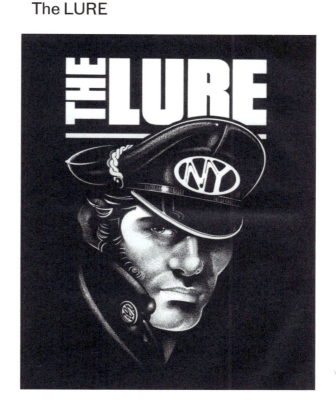

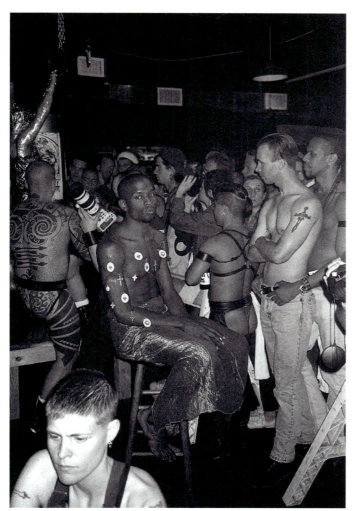

Peter Boruchowitz, patron: "I worked for a bondage magazine producing videos, including one called *Bound & Gagged 2: A Night At The LURE*, which we shot on location. I got to go down to the basement—I didn't even know there was one—but the LURE had previously been an old bakery, and down there were three massive bread ovens, each one nothing more than a brick space with a heavy metal door. These, of course, made for perfect little jail cells, so I wrote a story about people being kidnapped at the LURE and we used those ovens in the film."

Top Left: PORK Wednesdays flyer, circa 1990s.

Top Right: LURE poster by artist Rex, 1994.

Bottom: Piercing art at the LURE, 1995.

CLUB CASANOVA @ CAKE

99 AVENUE B
NEW YORK, NY 10009

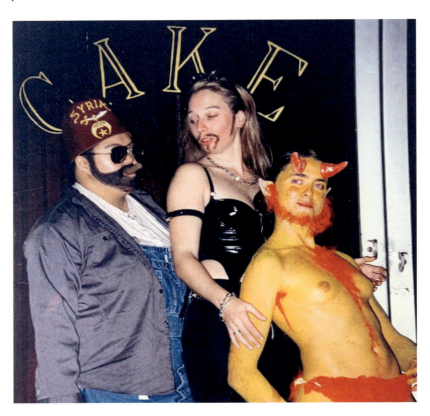

Club Casanova performers Uncle Louie, Labio, and Evil Caveboy in front of Cake, 1996.

With its tagline "Where Everyone is Always Treated Like a King," Club Casanova was the world's first weekly drag king party, founded in 1996 and hosted by the legendary Mo B. Dick. Dick enlisted several close friends, including drag queen Misstress Formika, nightclub promoter Mario Diaz, and graphic designer David Morrow to help launch the first party on a Sunday night at the Pyramid Club. It featured drag kings Justin Kase, Len E. Dykstra, Daddy Carl, and Budd performing as the Beatles and go-go dancing on the bar top. The party remained at Pyramid for two additional weekends, but because it was held on Sunday night and began at one o'clock in the morning, it never gained traction. Club Casanova then moved to the bar Coney Island High on St. Marks Place for a month, which was a bigger venue and even harder to fill, before finally finding its long-term home at Cake, located at 99 Avenue B in Alphabet City, whose size and layout meshed better with the Casanova vibe.

Mo Fischer first began performing as Mo B. Dick in the East Village in 1995. In forming Club Casanova just one year later, Dick hoped to foster a community and prove naysayers wrong who insisted that drag kings could not be entertaining or draw crowds. Once landing at Cake, however, Club Casanova quickly became successful and garnered significant media attention.

There had never been a drag king show which packed in crowds so regularly. During its run, Club Casanova employed drag king staff and showcased performances by some of

Club Casanova @ Cake

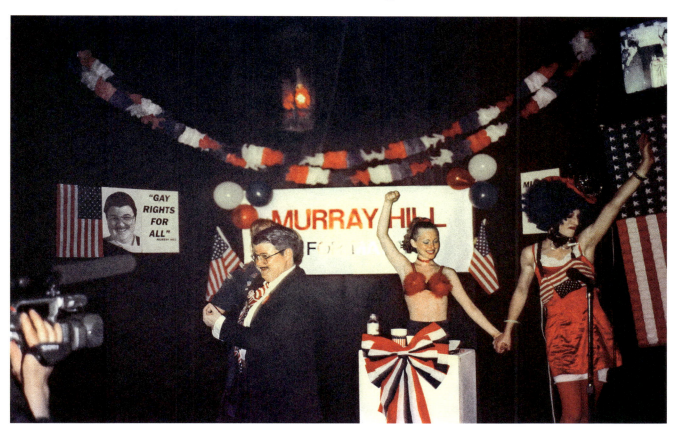

Murray Hill runs for mayor at Club Casanova, 1997.

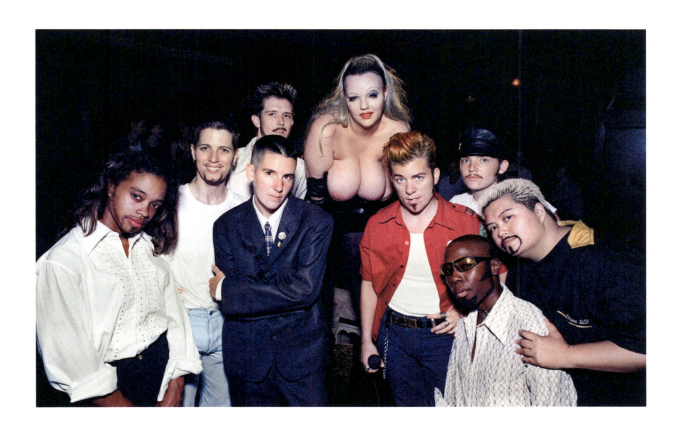

Drag king contest at Club Casanova, including Krishna, Willy Ryder, World Famous *BOB*, Mo B. Dick, Sam, Uncle Louie, and Dred, 1997.

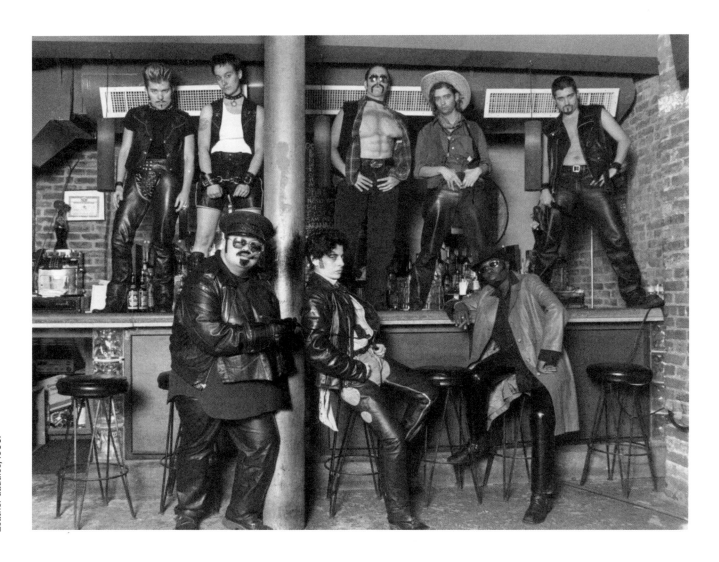

Leather daddies, 1996.

the leading kings at the time, including Dred, Lizerace, Evil Cave Boy, and even Murray Hill, who made his debut there and who is now one of the most famous drag kings working today.

Sadly, Club Casanova lasted for only 21 months, but nevertheless managed to make a substantial impact on the emergence of the drag king movement worldwide. According to Dick, Mayor Giuliani's increased enforcement of the antiquated Cabaret Law led to the club's demise, with fire marshals dropping in regularly for unannounced check-ins and discouraging people from coming back.

Following Cake's closing, Dick took the show on the road and produced a national tour of Club Casanova. Dick and other Casanova kings also began appearing in films and on television, including in the influential drag king documentary *Venus Boyz*. Dick still performs and produces today, and painstakingly documents the history of male impersonators and drag kings at DragKingHistory.com.

Club Casanova @ Cake

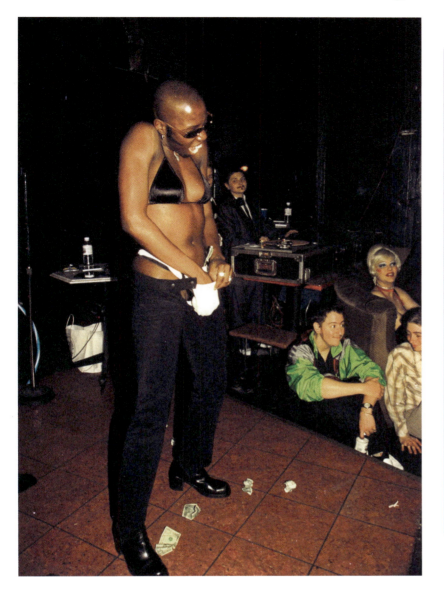

Dred performing at Club Casanova, circa 1996-1998.

Mo B. Dick, drag king/Club Casanova founder: "The premise of Casanova was strength in numbers. You'd show up and there's a drag king collecting money at the door. You walk in and see drag kings go-go dancing on the stage. You look over, there's a drag king DJ. And then I was the drag king host, and there'd be a drag king show, and just all these drag kings milling about. So you'd just be immersed in this drag king scene that was absolutely fabulous."

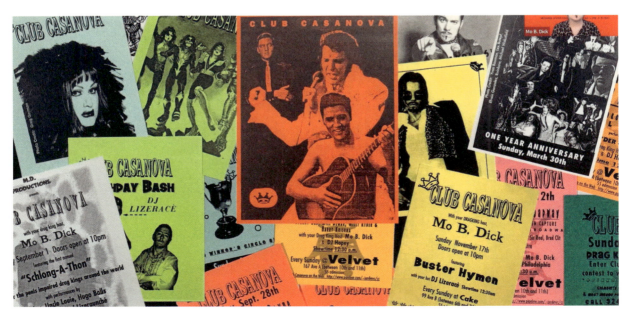

Club Casanova flyer collage, circa 1996-1998.

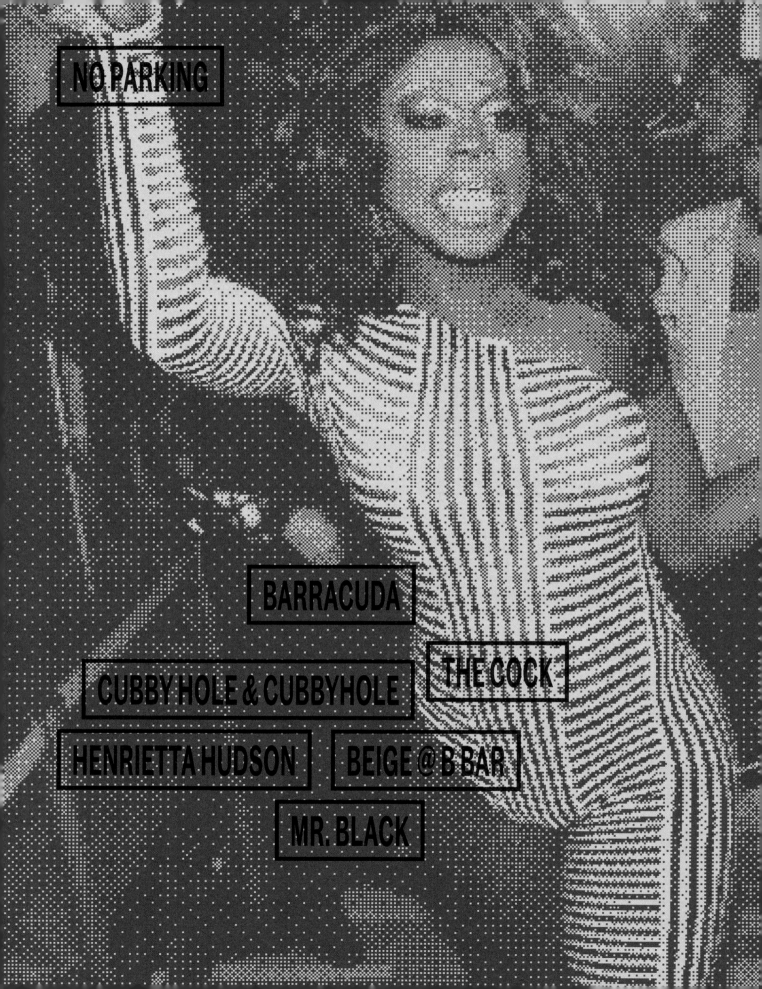

2000s

THE RISE OF THE INTERNET, LOUNGE BARS, AND HOMO HELL'S KITCHEN

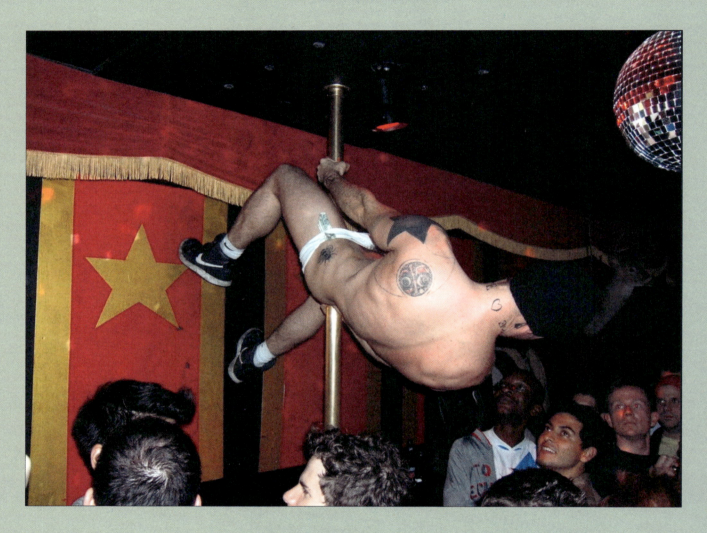

A pole dancer at Easternbloc, a Soviet-themed gay dive bar in the East Village that first opened in 2005.

As their internal clocks changed from 1999 to 2000, computers continued operating without any of the major disruptions or failures that many feared—the Y2K scare was over. Internet use skyrocketed in the new millennium, and LGBTQ+ people continued finding each other from the comfort of their own homes (or in internet cafés) through websites that launched during the decade. In addition to AOL chat rooms, there was Craigslist (which added the Personals section in 2000), Manhunt,

Adam4Adam, Lesbian.org, Gay.com, and countless others. Newly launched social media platforms like Friendster, Myspace, and Facebook arrived in the early 2000s, and grew to become important forums for queer people to flaunt their identities and connect with one another.

While meeting online became easier, the importance of connecting in person was reinforced by several historical and political events that heavily shaped the entire decade. The tragic events of September 11, 2001, hit the country hard, and as one of the primary attack sites, New York City was perhaps hit hardest. For weeks after the Twin Towers fell, much of NYC remained shuttered, including bars, clubs, and other spaces where LGBTQ+ folks usually found solace. When venues reopened, many hosted memorials and fundraisers, while numerous queer people, including drag performers and artists, fueled their internal fires by protesting the multiple wars that the US would subsequently embark on (Afghanistan in 2001 and Iraq in 2003) as a result of the attacks.

The 2000s also saw much of the LGBTQ+ community get involved in the fight to legalize same-sex marriage. In 2002, the *New York Times* changed the name of its popular "Weddings" pages to "Weddings/Celebrations," and started featuring same-sex unions for the first time. Hundreds of other newspapers followed suit.

In 2003, the Supreme Court struck down all remaining laws regarding sodomy in the country in the case of *Lawrence v. Texas*. Journalist Linda Greenhouse commented on this landmark decision in the *Times*, observing that "a conservative Supreme Court has now identified the gay rights cause as a basic Civil Rights issue." This statement would prove prescient, as one year later, Massachusetts became the first state to legalize same-sex marriage, while Connecticut, Iowa, Vermont, and New Hampshire would do so in 2008 and 2009. But not all states felt the same way. In 2008, California passed Proposition 8 to ban same-sex marriage, sparking a nationally seen silent protest called the NoH8 Campaign, featuring photographs of celebrities like Ricky Martin, Jane Lynch, and George Takei with duct tape over their mouths. California eventually overturned Prop-8 in 2010. New York wouldn't legalize same-sex marriage until 2011.

In New York City specifically, the general landscape of LGBTQ+ neighborhoods saw major shifts during the 2000s, following Mayor Giuliani's cleanups. Perhaps no region gentrified faster than the Meatpacking District,

which went from a haven for gritty, underground parties and sex clubs to a squeaky-clean tourist destination filled with high-end boutiques and chic restaurants. While downtown on both the east and west sides continued housing many notable LGBTQ+ venues, they too saw intense gentrification. Chelsea queens started getting priced out and moved north to Hell's Kitchen, forging a new gayborhood, while gay clubs like Posh, Therapy, and Bar-Tini soon began popping up there to cater to the new demographics. Simultaneously, LGBTQ+ creatives who typically resided in the East Village or Lower East Side were being squeezed out of the borough entirely. Many flocked to Williamsburg, Brooklyn, or Astoria, Queens, forging new queer enclaves around bars like Sugarland, Metropolitan, and True Colors.

Following in the wake of 1998's runaway success *Will & Grace*, LGBTQ+ representation in mass media steadily grew in the 2000s. The American version of *Queer as Folk*—based on the British series of the same name—debuted in 2000, and for the first time treated TV viewers to raunchier and more realistic sex scenes between same-sex couples. It became Showtime's biggest hit and paved the way for the premiere of *The L Word* in 2004, which revolutionized the depiction of queer women on TV. HBO's *Six Feet Under* (2001), meanwhile, introduced much of America to its first long-term committed gay relationship, while 2003's *Queer Eye for the Straight Guy* on Bravo made celebrities out of its lifestyle experts, the "Fab Five."

In 2007, Candis Cayne, known for performing at many of New York's bars throughout the '90s and '00s, became the first transgender actress with a recurring role on a primetime TV series when she debuted on ABC's *Dirty Sexy Money*. That same year, social media star (which was only a burgeoning career option at the time) Tila Tequila put bisexuality front and center when her dating show *A Shot at Love* debuted on MTV. By the end of the decade, LGBTQ+ shows and characters were seemingly everywhere. There was Ryan Murphy's *Glee* on Fox, ABC's *Modern Family*, and *RuPaul's Drag Race*, which debuted on Logo and would completely transform the landscape of drag.

On the big screen, perhaps no film made a bigger splash in the 2000s than Ang Lee's *Brokeback Mountain* (2005), which depicted a complex same-sex relationship between two American cowboys, received critical acclaim, and won several Academy Awards. Numerous other notable LGBTQ+ films helped break down barriers further, including *The Hours*

(2002), *Far From Heaven* (2002), *Transamerica* (2005), *Milk* (2008), and *A Single Man* (2009). On the music scene, numerous young queer artists born out of New York clubs made big splashes while being loud and proud, including the Scissor Sisters, Lady Gaga, and Le Tigre.

Increased acceptance and visibility in the media helped many celebrities come out of the closet in the 2000s, including Rosie O'Donnell (2002), Neil Patrick Harris (2006), Lance Bass (2006), and Wanda Sykes (2008). Meanwhile, Ellen DeGeneres, one of the first celebs to break down the closet door in 1997 only to have her show canceled, returned to the small screen in 2003, with an immensely popular daytime talk show that allowed her—a visibly queer woman—to dance her way into the hearts of millions.

Another significant individual who made his way into Americans' hearts was Barack Obama, who in 2008 was elected the first Black president in US history. Obama was heavily backed by the LGBTQ+ community, and during his first year in office, signed into law the Matthew Shepard and James Byrd Jr. Hate Crimes Prevention Act, expanding the 1969 US federal hate crime law to include crimes motivated by a victim's sexual orientation, gender identity, or disability. While many great strides were certainly made in the 2000s, Obama's presidency would help usher in numerous additional landmark decisions in favor of LGBTQ+ rights in the decade to come.

CUBBY HOLE & CUBBYHOLE

**438 HUDSON STREET /
281 WEST 12TH STREET
NEW YORK, NY 10014**

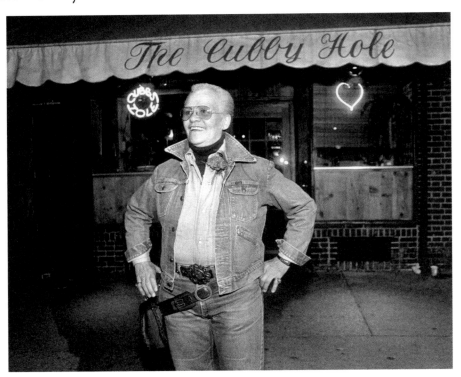

Stormé DeLarverie working as a bouncer, 1986.

In a confusing twist of lesbian bar lineage, New York City has been home to two different venues at two different addresses that have shared the Cubby name. The first was Cubby Hole—two words—located at 438 Hudson Street in the West Village, which operated from 1983 to 1990. When it closed, the space reopened as the lesbian bar Henrietta Hudson one year later, which still operates there today. In 1994, a different lesbian bar in the West Village called DT's Fat Cat, located at 281 West 12th Street, renamed itself after the previous Cubby Hole, this time combining the words to make Cubbyhole, which is open now as one of the last two lesbian bars in Manhattan.

Elaine Romagnoli opened the first Cubby Hole in 1983 after her previous lesbian bar venture, Bonnie & Clyde, closed in 1981. Cubby Hole got its name from its diminutive dimensions, totaling a mere 360-square-feet [110-meters], was generally dark and without much decor, and consisted of a bar and a standing/mingling area where women danced (albeit barely). Notable employees included its security guard, Stormé DeLarverie, a biracial singer and activist with a long career as a male impersonator in the Jewel Box Revue (see p. 50), and Lisa Cannistraci, a bartender who would eventually open Henrietta Hudson in 1991. Romagnoli would ultimately close Cubby Hole to focus on her next venture, a lesbian bar called Crazy Nanny's.

The history of the second Cubbyhole began in 1987 when Tanya Saunders and Debbie Fierro opened DT's Fat Cat on West 12th Street. This bar was also small, and in 1994,

Cubby Hole & Cubbyhole

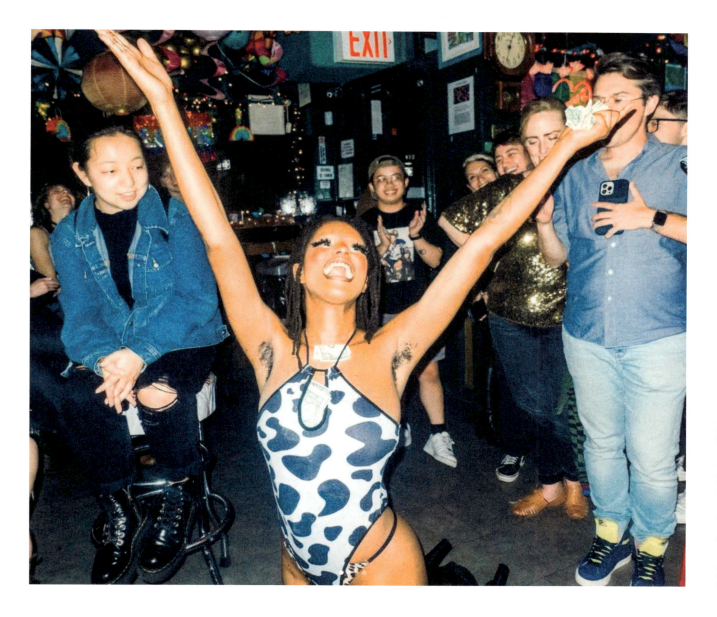

Bri Joy performing at Cubbyhole, 2023.

2000s

Saunders requested permission from Romagnoli to change DT's name to Cubbyhole. Since then, Cubbyhole has steadfastly remained one of New York's most beloved queer spaces, packing people wall-to-wall under its perpetually festive piñata and ornament-festooned ceiling.

The iconic ceiling at Cubbyhole is, in fact, its most memorable feature. What first began with a meager couple of souvenirs that patrons brought back from vacations, Cubbyhole's ceiling decor evolved into what *New York* magazine described as looking like Saunders "raided a thrift shop the day after Mardi Gras."

In 1993, Fierro left Cubbyhole to open Rubyfruit, a lesbian restaurant at 531 Hudson Street. Saunders, meanwhile, ran Cubbyhole solo until her death in 2018, leaving the bar to Lisa Menichino, who has tended bar there for over twenty years and is now its owner. In an interview for Krista Burton's book *Moby Dyke*, Menichino noted, "Cubbyhole's the kind of place that feels friendly, like a small town dumped into a crowded city. We're open 365 days a year because Cubbyhole is special to this community. We stayed open through 9/11, through Hurricane Sandy, through blizzards, blackouts…even if we could

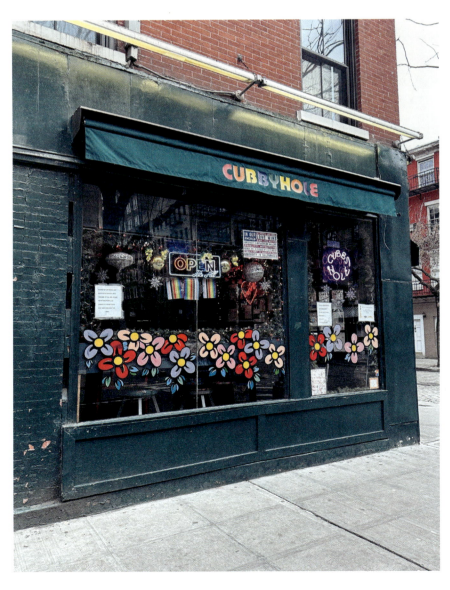

Cubbyhole exterior, 2023.

only be open a few hours a day, we wanted to be a beacon for people."

For many years, Cubbyhole was one of only three remaining bars in all of New York City specifically catering to queer women (the others being Henrietta Hudson, alongside Ginger's in Brooklyn). By 2023, new spots began to pop up again in the outer boroughs, offering additional options for people who would roll up to West 12th Street and realize they wouldn't be able to squeeze into their beloved Cubbyhole.

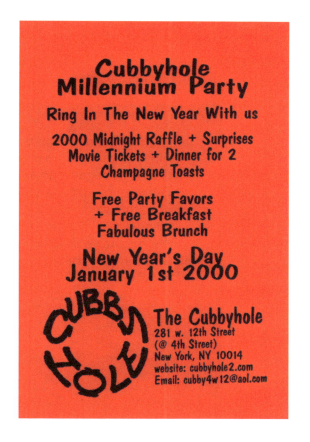

Cubbyhole Millennium party flyer, circa 1999–2000.

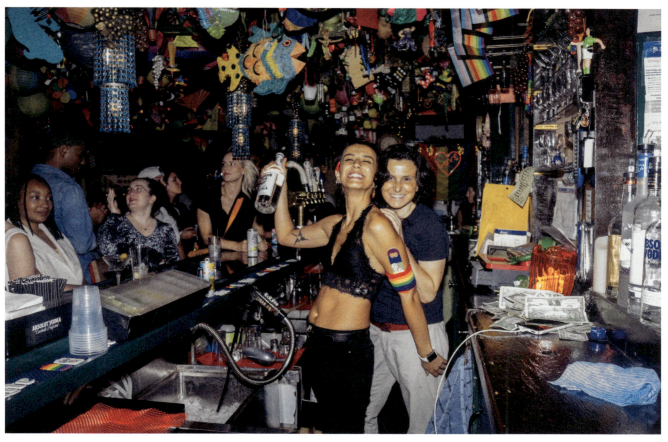

Kass Laines and Lisa Menichino behind the bar, 1990s.

BEIGE @ B BAR

**40 EAST 4TH STREET
NEW YORK, NY 10003**

2000s

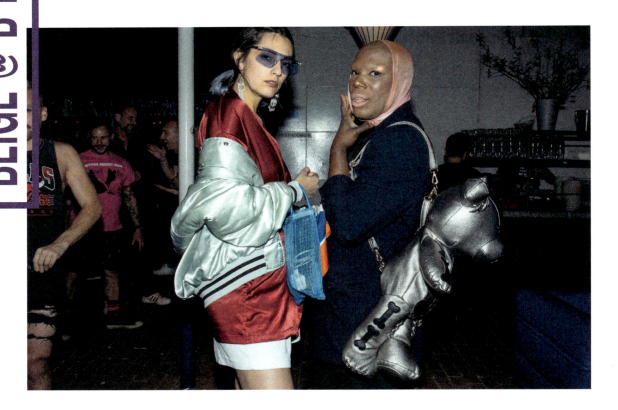

Fashionable duo at Beige, circa 2000s.

Located at 40 East 4th Street in the East Village, Bowery Bar and Grill, eventually shortened simply to B Bar, began hosting a legendary Tuesday night party called Beige in 1994. Founded by Erich Conrad, Beige attracted a highly fashionable and predominantly LGBTQ+ crowd, including many hip queer celebs like Alexander McQueen, Amanda Lepore, and Zachary Quinto. For the next 17 years, it ruled Tuesday nights, becoming one of downtown's longest-running parties and assembling a concoction of models, designers, Page-Six habitués, and handsome young up-and-comers looking to both see and be seen.

B Bar opened in the early '90s as a large restaurant and bar in a one-level structure that was formerly a gas station. Its unique layout was beloved for its expansive outdoor patio, where customers could smoke with abandon. In the *New York Times*, actress Parker Posey recalled when Conrad first told her the idea for the party, saying it was like "the color of '70s Halston, off-kilter strange glamor." Conrad himself added that "Beige was everyone's least favorite color during the early '90s, so it was tongue-in-cheek. I wanted to have a fun clubhouse, a canteen with a mix of all kinds of people, after the heaviness of AIDS in the '80s."

Conrad followed through on his eccentric idea, and Posey was one of the countless celebrities and nightlife fixtures drawn in by the lure of Beige. Many of the big names in frequent attendance were well-known LGBTQ+ folks like Andy Cohen, Lance Bass, Boy George, and Calvin Klein, as well as queer icons like Dolly Parton, Britney Spears, and Naomi Campbell.

Beige @ B Bar

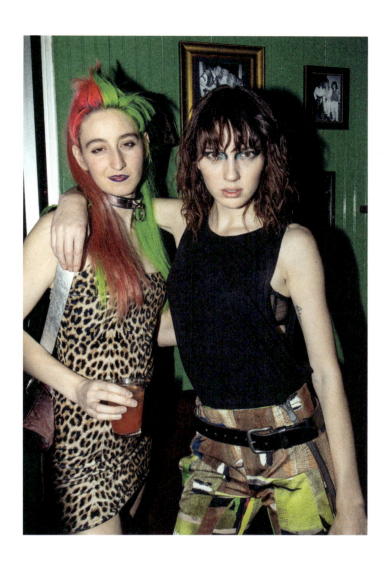

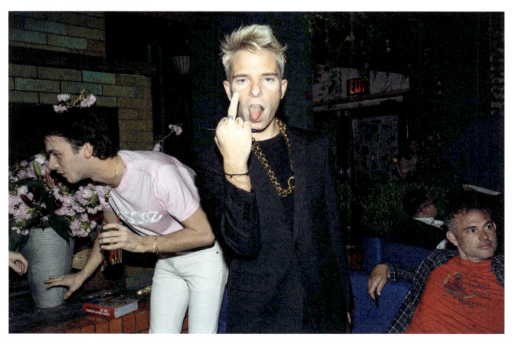

Top Left: Friends at Beige, circa 2000s.

Top Right: B Bar logo, circa 2000s.

Bottom: Middle finger, circa 2000s.

2000s

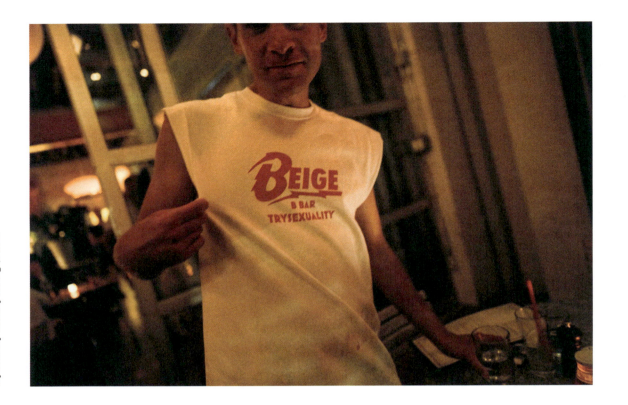

Trysexuality Tuesday at Beige, 2018.

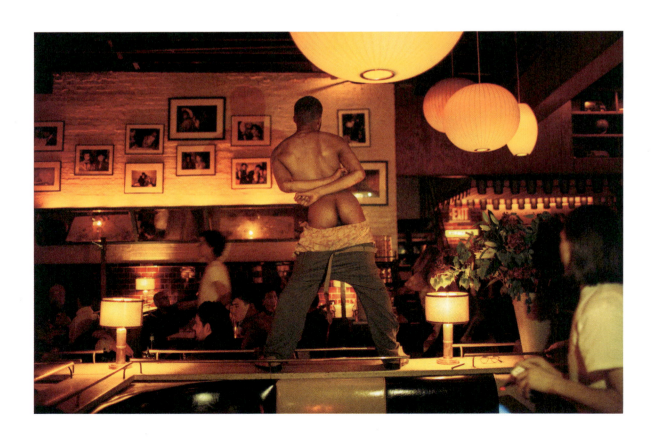

Butt at Beige, circa 2000s.

248

Beige @ B Bar

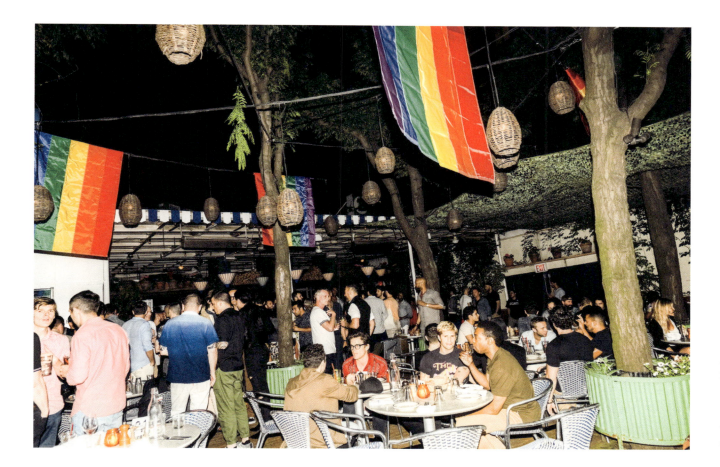

Outdoor scene, 2018.

According to nightlife vet Michael Musto in *New York* magazine's *The Intelligencer*, the success of Beige was all about the people: "It was free admission, pretty much anyone who came, got in, and there were no invitations, and yet it got a fantastic crowd because the right people knew about it."

Beige's run ended abruptly in May of 2011, with Conrad blaming noise complaints filed by residents of a new luxury apartment building across the street. At the time, he told the *Times* he was sad to say farewell but was hoping to make it work elsewhere. In 2018, after being asked repeatedly to bring back Beige, he revived the party at B Bar as a monthly event. This time around, the festivities would not last, as the building was demolished in 2022 to make way for a 21-story office tower.

> Michael Alicea, patron: "Beige was the promise of an absolutely perfect New York City evening: you'd meet someone new…and eventually find yourself mingling with their entire group. The night would unfold, leading you to some trendy Lower East Side apartment, surrounded by a bunch of lively Club Kids. The only drawback? It was all happening on a Tuesday night."

2000s

BARRACUDA

275 WEST 22ND STREET
NEW YORK, NY 10011

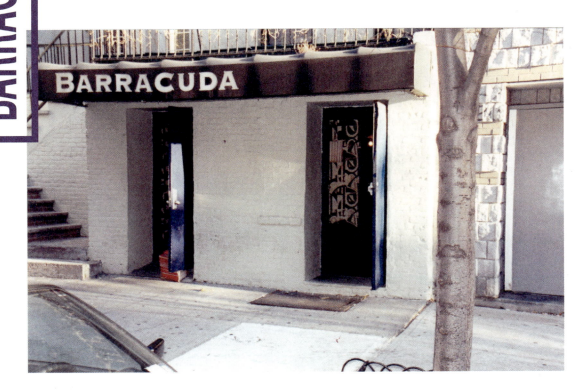

Barracuda exterior, circa 2000s.

Barracuda is a gay lounge bar located at 275 West 22nd Street in Chelsea that was opened in 1995 by partners Bob Pontarelli and Stephen Heighton, the duo behind other gay establishments Crowbar, Industry, and Elmo. From its inception, Barracuda was seen as innovative for putting drag entertainment front and center. It quickly became known for its nightly shows with many now-legendary performers, some of whom launched their careers there, including Jackie Beat, Candis Cayne, Sherry Vine, Hedda Lettuce, Peppermint, and Miz Cracker. Most notably, Barracuda has hosted Star Search—a drag competition begun by Mona Foot at Crowbar in 1991—since 1995, making it the longest-running bar show in New York City.

When Pontarelli and Heighton first opened Barracuda, Chelsea was in the midst of growing into a prominent gayborhood, as many LGBTQ+ folks moved northwards from Greenwich Village in pursuit of lower rents. The pair were big fans of drag and wanted to showcase the art form. In an interview in *The Advocate*, drag queen Jackie Beat noted, "Chelsea was the West Hollywood of New York City. If you were an East Village girl, it was a little uncool. With Barracuda, it became a little cool."

Barracuda also became known for its frequent interior decor overhauls, which Pontarelli and Heighton would do every six months. According to Pontarelli: "One of our tricks to success was to maintain who you are but give people something to talk about... One time, we turned the whole place into a log cabin...Then it became a Tiki hut, then it became Austin Powers'

Barracuda

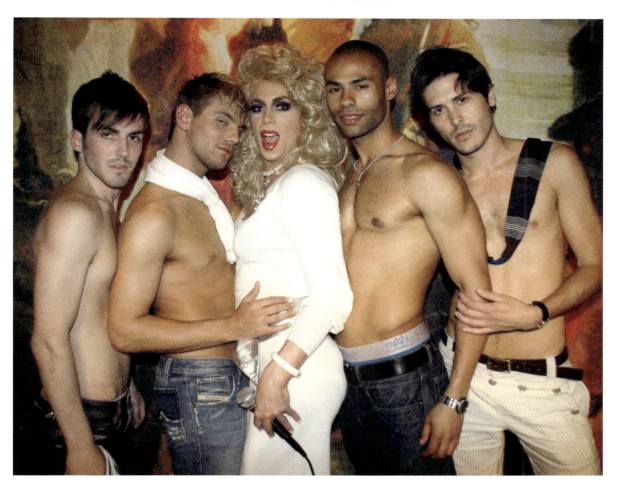

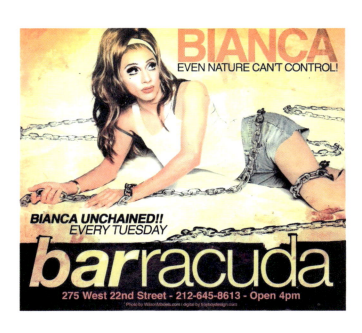

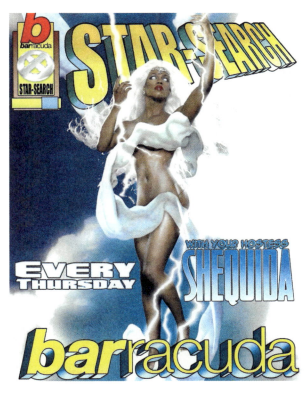

Top: Sherry Vine with Gavin, Don, Rob, and Kevin, 2007.

Bottom Left: Bianca Del Rio flyer, circa 2000s.

Bottom Right: Star Search with Shequida flyer, circa 2000s.

2000s

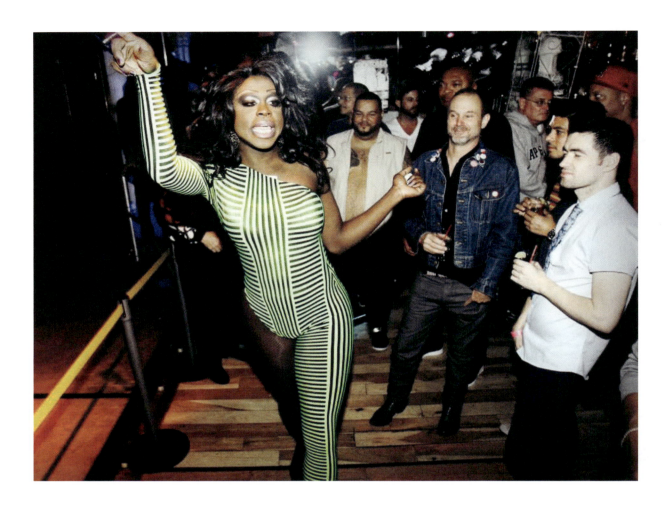

Bob the Drag Queen performing at Barracuda, 2014.

bachelor pad. I can't even remember them all, there were so many." One *HX Magazine* ad cheekily depicted this phenomenon: "Barracuda changes its look more than some boys change their socks."

Throughout the 2000s, Barracuda became a destination for celebrities like Nathan Lane and Graham Norton, and the venue began featuring high-profile performers onstage, including Eartha Kitt, Rue McClanahan, and Jennifer Coolidge. It also became a popular spot where Broadway promoters would build exposure for new shows and where record companies promoted new music.

In 2011, Heighton passed away, leaving Pontarelli to run Barracuda on his own. When it was closed during the Covid-19 pandemic, Pontarelli did a major renovation once again. Mona Foot, meanwhile, passed away unexpectedly in 2020, and when the revitalized Barracuda reopened in 2021, it held an epic memorial in her honor. Despite such significant losses over the years, Barracuda remains a seminal queer destination in New York City for tourists, locals, and performers.

252

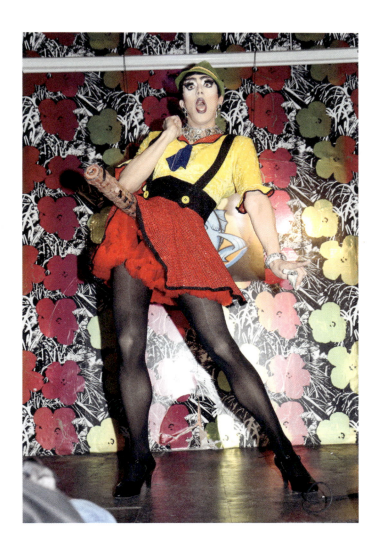
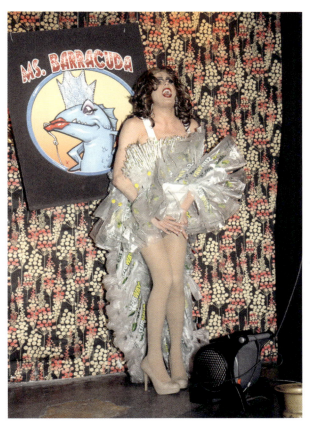

Left: Drag performer, 2017.

Right: Tina Burner, 2015.

Bob Pontarelli, Barracuda owner: "When we first opened Barracuda, we fashioned it as a 1950s roadhouse. And I thought to myself, 'What says 1950s?' Then I remembered there was a car called the Barracuda—so that's how the name came about. Later, the bar got a fish tank, which was legendary because everything died in it. It was terrible. We got this giant tank which immediately was a topic of conversation, because it was a fish tank at a gay bar. And then it became a topic of conversation because everything would constantly croak in it. Back then, you could still smoke in gay bars, so the smoke would get in the water and kill everything."

THE COCK

93 SECOND AVENUE
NEW YORK, NY 10003

2000s

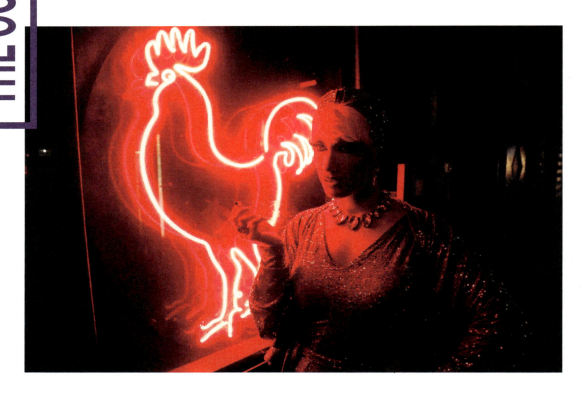

Neon Cock sign, 2019.

Now in its third iteration at 93 Second Avenue, the Cock is a raunchy gay dive bar in Manhattan's East Village known as one of the city's few remaining venues with what *New York* magazine once referred to as a "rollicking backroom sex scene," where both cruising and exhibitionism are highly encouraged. Situated on two floors, the main room typically features go-go dancers and hosts provocatively named parties like King-Size Fridays and Diet Cock. Photography inside is technically forbidden, while the bar's street exterior is famously minimal, promoted only by a neon sign shaped like a red rooster, evoking a red-light district's aesthetic.

The Cock first emerged in 1998 when a young gay party promoter named Mario Diaz approached Allan Mannarelli, a straight man who owned a nameless venue at 188 Avenue A, and asked if he could use the space to host Foxy, one of his bawdy parties. Mannarelli agreed, and Diaz revamped the space and decided to name the venue the Cock. He recalled in *Interview* magazine: "I knew I wanted to have a red neon rooster. I didn't want to write the Cock on the front. I thought the mystery of just having the red neon would be impactful...From day one, we promoted seven nights a week. It was always a disaster, which was part of the charm of the Cock; it was falling apart. That was the seedy beauty of it." The Foxy party set the bar high for the venue, melding creativity and debauchery with its Foxiest Person Alive contests.

Not long after the opening, *New York* magazine reported that this atmosphere attracted "not only horny young men but also plenty of

The Cock

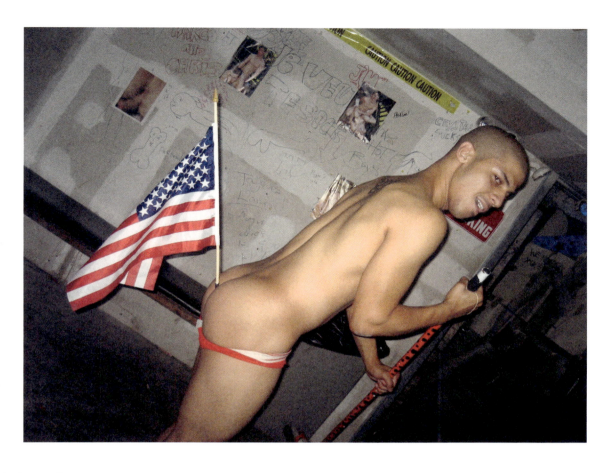

Kelvin and flag at the Cock, circa 2006–8.

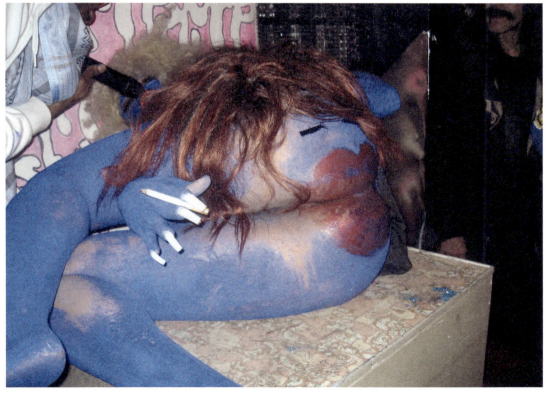

Shaquanda Coca Mulatta and her blue butt act, 2006.

spectacle-seeking celebrities," which included Christina Aguilera, David LaChapelle, and George Michael. The Cock's sleaze-fueled popularity, however, also attracted the cops, who, under the reign of Mayor Giuliani, began inspecting it as often as twice a week, ticketing for anything they could find. In 2000, it was temporarily forced to shutter—deemed a public nuisance—and many thought that the too-good-to-be-true era of the Cock had ended. Instead, Mannarelli hired a lawyer to fight his many citations, and won. The bar lived on but continued to incur legal troubles.

In 2005, Mannarelli moved the Cock to its second location at 29 Second Avenue and tried relocating again to Avenue B in 2014, but the community board rejected the application due to the venue's reputation. In 2015, after significant opposition and a "Block the Cock" campaign by locals, the bar settled at its present site at 93 Second Avenue.

Despite its notoriety and long-term collection of critics, the venue continues to live on as what Alexander Cheves in the online magazine *Them* called "the last filthy gay bar in New York...There is—alarmingly—no other bar like it in the city and very few bars like it left in the country."

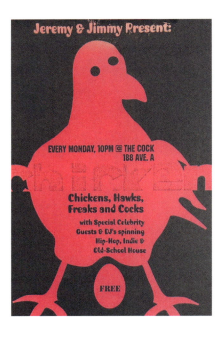

Chicken at the Cock flyer, circa 2000s.

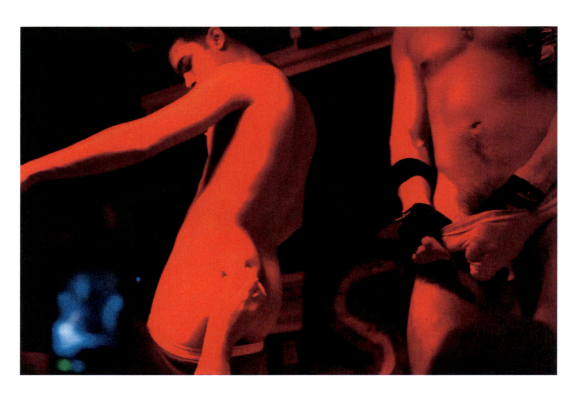

Man Parrish's SPERM party, 2008.

The Cock

Mario Diaz, the Cock founder: "At the Cock's Foxy parties, people just came in and did the most outrageous, shocking stuff, like Krylon Superstar, who put everything in her ass. Once she stuck a corn cob up her butt and popcorn came out. Another time she douched with milk, squirted it in a bowl, and then ate cereal out of it. A different night, she put batteries in her butt and a light bulb in her mouth lit up. Then [performer] Justin Vivian Bond said, 'Krylon's had everything in her ass but the bathroom sink.' That same night, Krylon disconnected the Cock's bathroom sink from the wall, brought it onstage, and stuck the pipe in her ass."

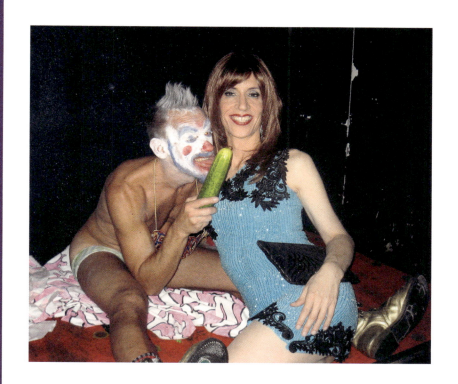

Paul Wirhun as Blinky the Clown and Linda Simpson, 2006.

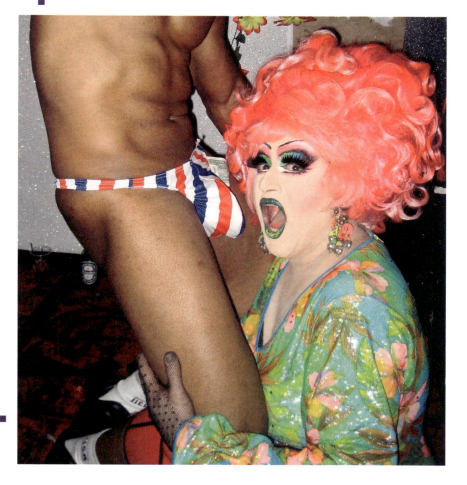

Miss Understood and friend, circa 2006–2008.

MR. BLACK

643 BROADWAY
NEW YORK, NY 10012

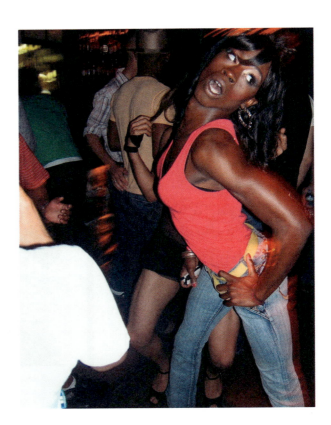

Right: Dancing at Mr. Black, circa 2000s.

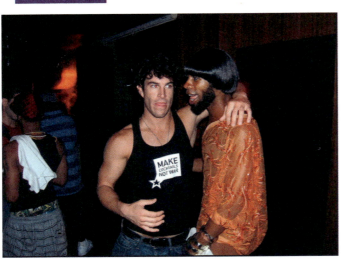

Left: Make cocktails not war, circa 2000s.

Located at 643 Broadway on the corner of Bleecker Street, Mr. Black was a rambunctious gay dance club open from 2006 to 2009, often credited with revitalizing the downtown bar scene by bringing a substantial young crowd to the NoHo neighborhood. Stuart Armando (also known as Stuart Black) opened the venue in what was formerly a basement bar that housed the hip-hop-centric club Table 50.

New York magazine noted at the time that the "spare yet sexy decor" of Table 50 was maintained, to which the *New York Times* added: "Patrons participate in nocturnal rituals of a more underground nature. A dim staircase descends into a brick-vaulted basement, which over the past 150 years has been a subway tunnel, a Black Panther haunt, an S&M dungeon, and now, a gay bar. Weekends are predictably gay, with bare-chested—and sometimes bare-bottomed—waiters serving rum-and-Diet Cokes to stylists and publicists who come to cruise, preen, and gossip."

During its three-year run, Mr. Black was host to a variety of recurring and one-off popular parties, such as Actor Turned Hustler Thursdays with DJ Spencer Sweeney, and Jonny McGovern's (aka the Gay Pimp) Boys Gone Wild Saturdays, described as a fun frat boy go-go affair. Other notable DJs who spun at Mr. Black included Gant Johnson, Peter Rauhofer, Johnny Dynell, Sammy Jo (of Scissor Sisters fame), and Honey Dijon.

The sheer debauchery downstairs at Mr. Black often got the club in trouble. In 2007, *Gothamist* reported that 32 people were arrested during a 5 a.m. narcotics raid, though it was

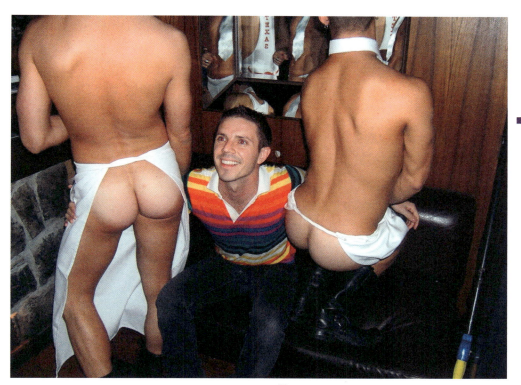

Jake Shears of Scissor Sisters and butts, circa 2000s.

Johnny Dynell, Mr. Black DJ: "Sammy Jo, Peter Rauhofer, and I put turntables in one of the bathroom stalls, and we DJed on the toilet in the men's room. The whole bathroom could hold maybe twenty people or something. But we were DJing on the toilet, in the stall, spraying Glade air freshener, while Jake Shears from the Scissor Sisters would go-go dance on the sink in his underwear."

noted that regulars—like nightlife legend Ladyfag (who worked at Mr. Black) and Armando—managed to escape, while "The Ass" (Luke Nero), a bottomless cocktail waiter and notable club mascot, and "Mini-Ass" (Chase Hostler), a go-go boy, were detained.

Inevitably, the troubles caught up to Mr. Black, which would close and reopen twice, eventually moving to 251 West 30th Street (then called Mr. Black 3) before shuttering for good in 2009. While it may have had a short existence, the club had a big impact. As frequent patron Chris Sommerfeld lamented: "Mr. Black was *the* spot for meeting paramours right before the internet became the default."

Arm's length at Mr. Black, circa 2000s.

HENRIETTA HUDSON

438-444 HUDSON STREET
NEW YORK, NY 10014

2000s

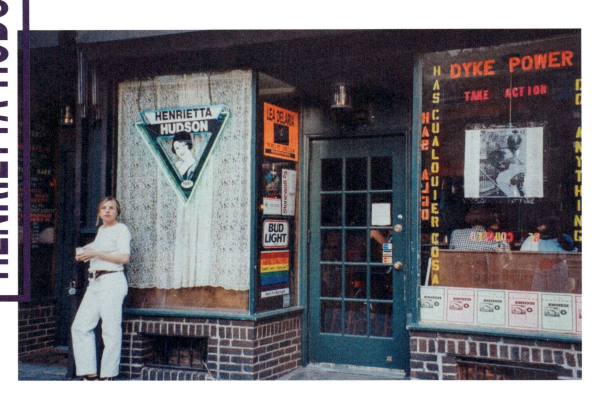

Henrietta Hudson exterior, circa 1990s.

438–444 Hudson Street in Manhattan's West Village is currently home to Henrietta Hudson, one of New York City's few remaining and longest-lasting bars catering to lesbians. Originally named Henrietta Hudson Bar & Girl—employing some queer-tinged play on the word "Grill"—it first identified as a lesbian bar from 1991 to 2014, before rebranding itself in the hopes of being more inclusive. In 2021, it again rebranded, coining the phrase "a queer human bar built by dykes."

In 1991, Lisa Cannistraci, a former bartender at the venue when it was the Cubby Hole (see p. 242), and her business partner Minnie Rivera, established Henrietta Hudson. It was quite literally built by a community of lesbians, who donated boom-boxes, labor, and construction materials. The bar's name came from a feminization of the famous Henry Hudson river that lies three blocks west.

Throughout its over 30 years in operation, Henrietta Hudson has served as an important space for queer women, reinventing itself along the way to remain popular and relevant. One mainstay, however, was Stormé DeLarverie, who previously worked the door at Cubby Hole and remained a bouncer at Henrietta's well into her eighties, before passing away in 2014.

According to Cannistraci, one of the venue's greatest challenges was the arrival of marriage equality: "Lesbians can now go make out at an Applebee's and stay local, so you have to give them a reason to come into the West Village and go to Henrietta Hudson."

When it was forced to close in March 2020 due to Covid-19,

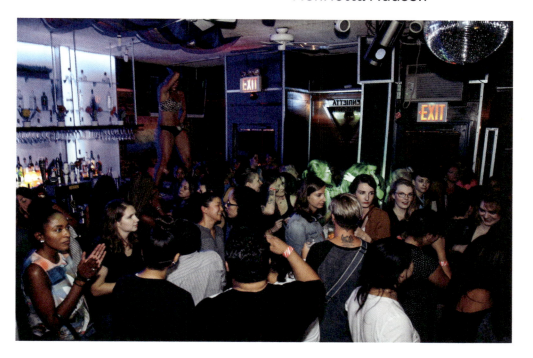

Packed crowd and go-go girl at Henrietta Hudson, circa 2000s.

Cannistraci revamped Henrietta Hudson yet again, with a complete redesign featuring a bright, mid-century look and Palm Springs-like decor. Across its many rebrandings and redecorations, it has stood the test of time, especially when compared to the lifespan of most lesbian bars (it's now the longest-running one in America). As Cannistraci told *New York* magazine's blog *Grub Street*, "We used to be known as the Madonna of lesbian bars because we were constantly reinventing ourselves. Now we're Cher—the lesbian bar that wouldn't die."

> Sharee Nash, patron, DJ, party promoter: "The first lesbian bar I went to was Henrietta's... These two girls had started a fight and one of them had just sprayed mace around her and I happened to walk right into it. So yeah, I got maced my very first time at a lesbian bar, and for a little while after that I tried to just be like, 'I don't think I'm gay, this isn't the life for me.'"

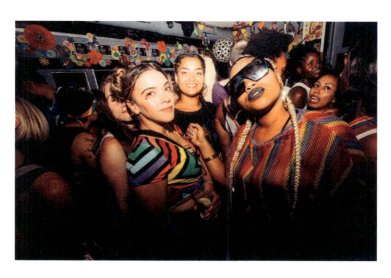

Pride at Henrietta Hudson, circa 2000s.

NO PARKING

4168 BROADWAY
NEW YORK, NY 10033

2000s

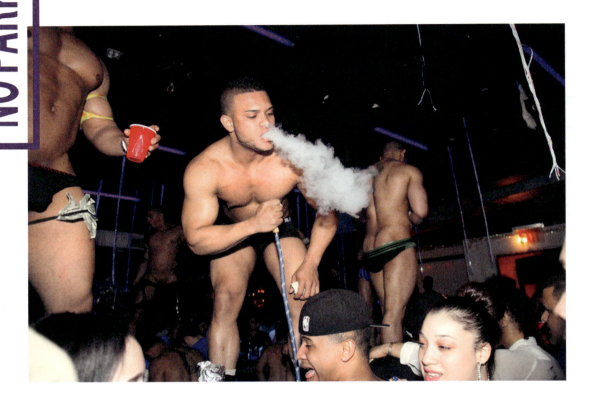

Dancers and hookah at No Parking, 2014.

Located at 4168 Broadway between West 176th and 177th Streets, No Parking was a 2,000-square-foot [610-meter] LGBTQ+ bar that operated in Washington Heights from 2006 to 2014. Named for being in a parking garage, the bar drew predominantly gay male crowds from both Harlem and the Heights, serving as a popular spot for people of color.

When owner Brian Washington-Palmer opened No Parking it was deemed a pioneering venture as one of the only gay bars to open officially in upper Manhattan, and the only one specifically in Washington Heights. According to patron Juan Rosa in the *New York Daily News*: "No Parking really broke new ground. For the first time, the LGBT community of color had a place of their own in their own neighborhood."

Located just two blocks away from the George Washington Bridge bus terminal, the bar also attracted patrons from New Jersey, Connecticut, and the Bronx, quickly establishing itself as a necessary venue filling a much-needed void. "There were lines down the block. Everyone had to wait in line for an hour," Washington-Palmer told the *New York Daily News* in 2015, adding, "There's not a lot of options for [gay] people of color." He also noted that his bar was largely filled with Black and Latino customers who came from closeted communities and saw it as a refuge. No Parking's popularity within the community led to the subsequent openings of other uptown queer hangouts such as El Morocco in 2008 and Castro in 2014.

No Parking's space featured a circular bar on which go-go boys in

No Parking

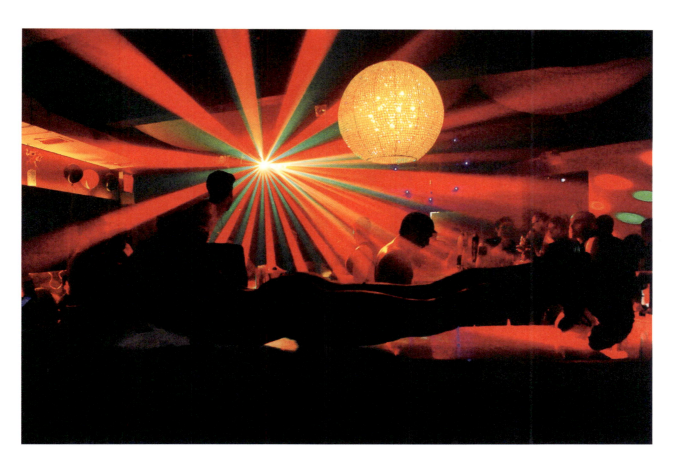

Backlit dancer on bar top, 2012.

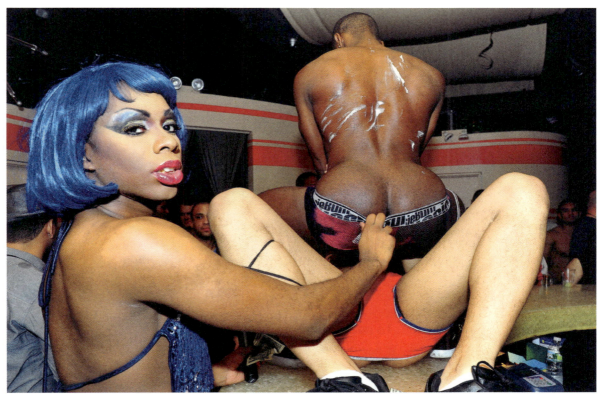

Honey Davenport with dancers, 2011.

2000s

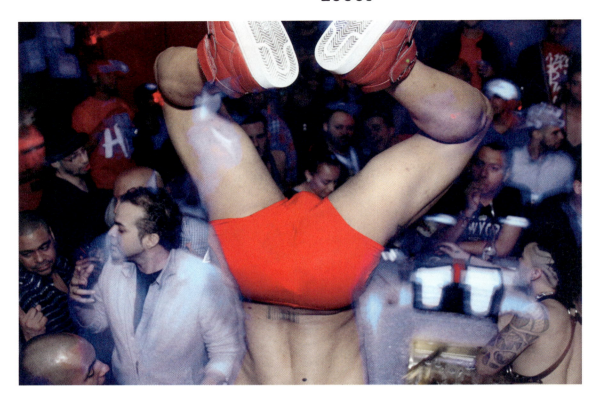

Tramp stamp, 2013.

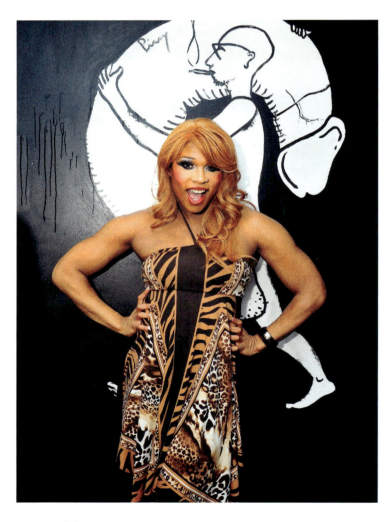

Peppermint in front of penis mural, 2012.

high-tops and baseball caps would sway to the beats of the venue's trio of regular DJs, Nesto, MK, and Matt GoodBar. The business was managed by Manny Fiero, who started working there in 2007, and stated that the chiseled dancers, many of whom were not publicly out, were the club's highlight, particularly on Cockfight Wednesdays, boasting up to fifteen go-go's at a time. Other recurring events included Sugar Daddy Sundays, a party bent on "Bringing Boys and Daddies Together," and As Usual Wednesdays, which miraculously offered free shots all night long.

No Parking shuttered in 2014 after its landlord orchestrated a deal for a Planet Fitness to move in instead. Washington-Palmer fielded several requests to reopen the club elsewhere but was doubtful he could ever recreate the original's energy: "It couldn't be the same thing. The Heights is really expensive now."

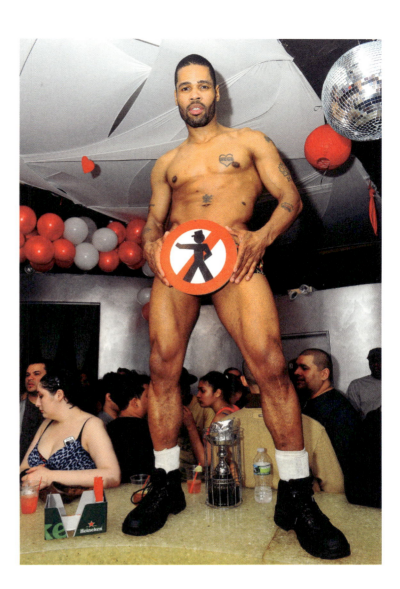

Dancer with No Parking menu, 2012.

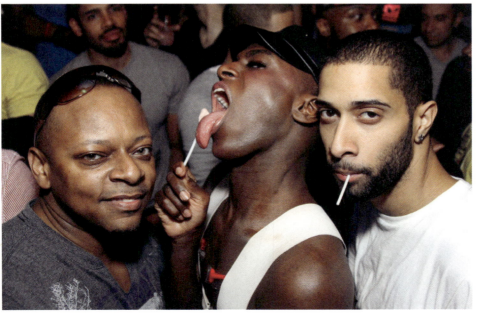

Laniel Xtravaganza, Jonte Moaning, and friend, 2013.

FLAMING SADDLES

XL

BOOM BOOM ROOM & LE BAIN

CLUB CUMMING

WESTGAY @ WESTWAY

NO BAR

CHINA CHALET

2010s APP-ILY EVER AFTER

2010s
AGE OF THE APPS, CONCEPT CLUBS, AND THE QUEER TAKEOVER

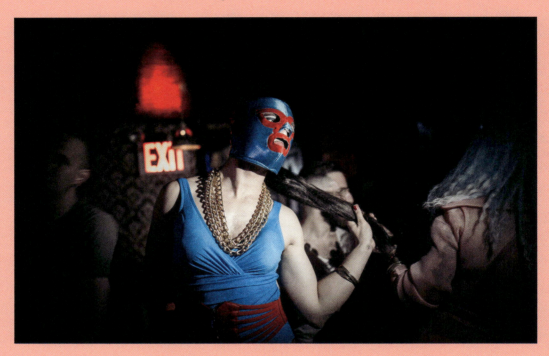

Sementha Alexander in a luchador mask at Nowhere in 2018. A sign outside the East Village dive—which first opened in 2003—describes it as the "Best Fabulously Unfabulous Gay Bar" in New York City.

As the 2010s commenced, the progression of LGBTQ+ rights seemed to be moving at warp speed. On December 22, 2010, President Obama signed into law the Don't Ask, Don't Tell Repeal Act, finally banning the discriminatory regulation that for seventeen years prevented military service members from being openly queer. Around the same time, Secretary of State Hilary Clinton addressed the United Nations: "Gay rights are human rights, and human rights are gay rights." Just six months later, New York became the largest state to legalize same-sex marriage on June 24, 2011. In response, thousands congregated outside the historic Stonewall Inn to celebrate the milestone victory.

More political advancements soon followed. In 2012, Tammy Baldwin became the first out lesbian elected to the US Senate, while Kyrsten Sinema became the first openly bisexual senator. That same year, Vice President Joe Biden appeared on NBC News announcing he was "absolutely comfortable" with same-sex marriage, a declaration which would push Obama to follow suit. On November 6, 2012, the duo were re-elected.

In his inaugural address, Obama declared: "Our journey is not complete until our gay brothers and sisters are treated like anyone else under the law—for if we are truly created equal, then surely the love we commit to one another must be equal as well." With that proclamation, the fight for marriage equality received a massive boost, and in 2013 the Supreme Court overturned the Defense of Marriage Act.

Though the entire process would take another two years to complete, on June 26, 2015, same-sex marriage became officially legalized in all of the US. Two days later, two million people attended the NYC Pride March, celebrating the major achievement which for so long had seemed unfathomable.

While same-sex marriage's legalization was certainly a defining moment for LGBTQ+ rights in the 2010s, the decade also saw improvement in the advancement of transgender and nonbinary rights and visibility. In 2014, Obama signed an executive order expanding employment protections to include gender identity. That same year, *Orange is the New Black* star Laverne Cox became the first out trans person nominated for a Primetime Emmy, as well as the first to appear on the cover of *TIME* magazine in an article announcing the arrival of "The Transgender Tipping Point."

In 2015, Caitlyn Jenner came out as trans in a high-profile interview, and publicly documented her transition for much of America to see. Trans visibility was also furthered by the reality TV show *I Am Jazz*, the TV series *Transparent*, *Pose* (which told the history of New York's ballroom scene), and *A Fantastic Woman*, which became the first trans-themed movie to win the Academy Award for Best Foreign Language Film. Meanwhile, in 2017, *Moonlight* became the first film with LGBTQ+ protagonists to win Best Picture.

Transgender progress wasn't just limited to the media, as several out trans individuals made history by being elected to government positions, including Danica Roem, Victoria Kolakowski, Phillipe Cunningham, and Andrea Jenkins. In 2015, Title IX, which prohibited sex-based discrimination in any school or education program since 1972, was extended to ban discrimination against transgender students. That same year, the Pentagon announced it would allow transgender personnel to serve openly in the military. Finally, in 2019 the World Health Organization announced that being trans would no longer be classified as a mental disorder, marking a significant step towards its destigmatization.

Not everything was coming up roses for the LGBTQ+ community, however, as many trans people continued to face oppression in the US, with hundreds murdered each year in acts of anti-trans violence. Then, in 2016, the queer community at large received a horrific reminder to stay vigilant when a devastating mass shooting at Pulse, a gay nightclub in Orlando, Florida, took the lives of 49 people; it was the deadliest mass shooting in modern US history at the time. The despicable act reignited discussion around LGBTQ+ hate crimes and reminded the queer community about the sanctity and importance of physical queer spaces.

This proved pivotal during a period in which LGBTQ+ people began questioning whether exclusively queer nightlife venues were even necessary. Between the passage of same-sex marriage and the wider acceptance of LGBTQ+ people in general, was a gay bar needed anymore? By the end of the decade, lesbian bars in particular were suffering, with only two dozen left in the entire country, three in NYC alone. While other factors contributing to the decline of gay and lesbian bars included gentrification and the rising cost of rent, perhaps none was more obvious than the introduction and growing popularity of "the apps."

Apple released the first iPhone in 2007, rapidly revolutionizing the smartphone industry and human social behavior. In March 2009, Grindr became one of the first geosocial apps to launch, and by 2010, gay and bisexual men quickly adopted it into their daily regimens to meet men for casual sex, dating, and friendship from the comfort of their handheld device. Now, guys could cruise one another from anywhere: the office, the train, even at the gay bar itself, where men could now be seen furtively glancing at their screens instead of at each other. The popularity of Grindr spawned several competitors, including Jack'd (2010), Scruff (2010), Her (2013), and Sniffies (2018), as well as more dating-centric apps like Tinder (2012), Hinge (2012), Bumble (2014), and Lex (2019). A myriad of academic articles, think pieces and social media rants ensued, debating whether LGBTQ+ sex and dating apps were the primary perpetrators responsible for the decline of queer spaces.

Perhaps in direct response to this shift, copious LGBTQ+ nightlife spaces like China Chalet, Flaming Saddles, and Club Cumming tried to find innovative ways or gimmicks to attract patrons, pushing boundaries by creating quirky, unique, or Instagrammable venues that would be worth the IRL

visit. Other new spots aimed to survive by latching onto larger institutions like hotels, such as XL (the Out NYC), No Bar (the Standard East Village), and Le Bain and the Boom Boom Room (the Standard Highline).

The 2010s inspired many nightlife spots to think outside the box and help redefine what a queer club could be. One of the biggest draws was the international success of the Emmy-winning *RuPaul's Drag Race* franchise, which became the community's favorite sport to watch and led most bars and clubs to add viewing parties to their weekly calendars. Another boost came from the repeal of the highly controversial Cabaret Law in 2017, which had plagued LGBTQ+ venues for nearly a century.

Yet another major event that forever altered behavior in the queer community came in 2012, when the FDA approved Truvada (PrEP) for use as pre-exposure prophylaxis. Now, HIV-negative people could be prescribed the drug to protect them from acquiring the virus to begin with, a stunning revolution in HIV prevention. Almost immediately, New York City recorded high rates of PrEP uptake as well as declining HIV infection rates. While not erased entirely, the virus that wiped out nearly an entire generation of gay men and haunted the generations that followed was at last being curtailed.

In 2016, President Obama designated the Stonewall Inn a national monument. Three years later, New York City hosted World Pride in honor of the 50th anniversary of the Stonewall Uprising, which brought approximately five million people to town and was the largest LGBTQ+ gathering recorded in history. But for all the strides made throughout the 2010s, the decade also came with reminders that the fight doesn't just stop with marriage equality or any other singular gain.

Perhaps no reminder of this fact was greater than the shocking results of the 2016 presidential election, when the heavily favored progressive Democratic candidate Hillary Clinton was beaten by Republican Donald Trump in a bitter upset. A wave of conservative backlash followed, and the decade came to a close with multiple attacks on LGBTQ+ rights, particularly aimed at drag performers and trans individuals. The queer community was spurred back into action, and in 2018 an unparalleled number of openly LGBTQ+ candidates ran for political office, with a record-breaking 244 elected in what came to be called the Rainbow Wave. Once again, the LGBTQ+ community was reminded to never be complacent and prove its resiliency. The fight continues.

WESTGAY @ WESTWAY

**75 CLARKSON STREET
NEW YORK, NY 10014**

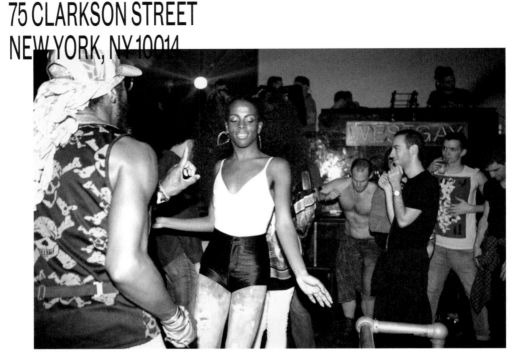

Artist and DJ Juliana Huxtable at Westgay, 2013.

Billed by many as NYC's "It Club" during its brief run, Westway was a strip-club-turned-nightclub located at 75 Clarkson Street in the West Village. Owned by Carlos Quirarte and Matt Kleigman, the club opened in June 2011 and *Eater* deemed it "New York's newest hot spot." Early on, it hosted an assortment of high-end events including glitzy fashion parties and underground hip-hop performances, but the venue particularly exploded in popularity as a result of its Westgay at Westway parties, which DJ and celebrated party promoter Frankie Sharp started throwing there on Tuesday nights beginning in February 2012.

As a venue, Westway retained its former runway stage setup and stripper poles, but also boasted a vast dancefloor and an array of couches situated behind the DJ booth for more casual lounging. Notable décor included a disco ball in the shape of a female torso, and a neon-pink sign that read "Westgay" casting an ambient glow over the space.

According to the *New York Times*, Westgay was "a filled-to-capacity nexus for all strata of gay society" where, according to frequent patron Stevie Huynh, "social hierarchy is left at the door. It feels like the authentic New York of the '70s and '80s." The *Times* went so far as to declare that the party had "echoes of Studio 54," attracting the likes of fashion designers such as Nicola Formichetti and Prabal Gurung.

In addition to both mingling with chic New Yorkers and dancing to the sets of stellar DJs, Westgay parties offered weekly performances from a variety of artists, ranging from *Drag Race* alum Willam to 2000s pop darling Natalia Kills to underground rappers like Mykki Blanco and Rye Rye. More well-known artists like Azealia Banks, Charli XCX, and even Lil' Kim also showed up to grace the Westway stage.

The club's debauchery ended abruptly when Quirarte and Kleigman announced it would be closing in 2015 to make way for luxury condos. While Westway and Westgay went out with a bang, many people still mourn their demise, like journalist Stephanie Maida, who decried on the high society website *Guest of a Guest*, "Is this how people felt when Studio 54 closed?"

Westgay @ Westway

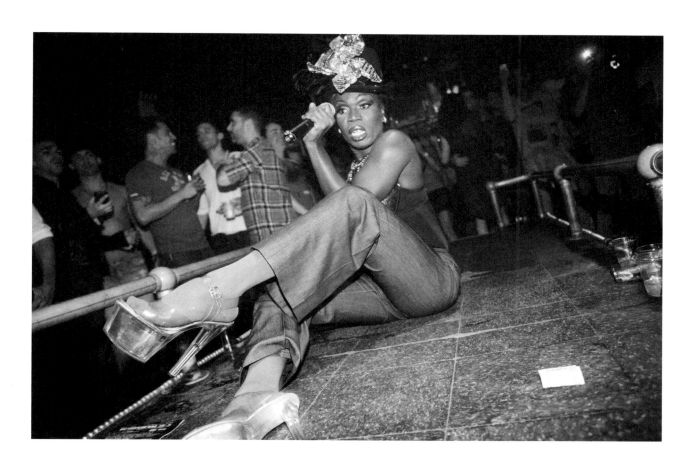

Working the runway ramp at Westgay, 2013.

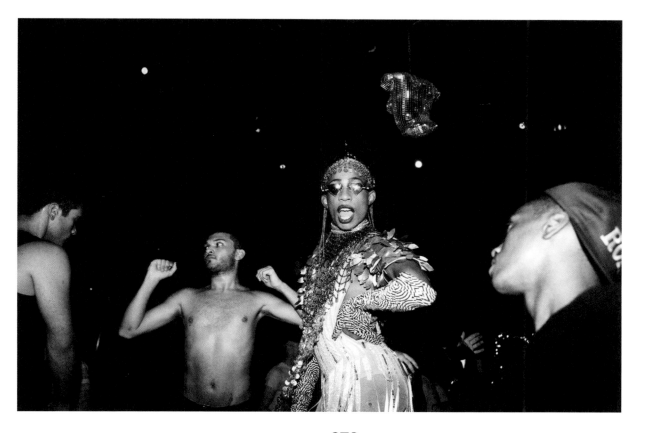

Leo Gugu, 2013.

2010s

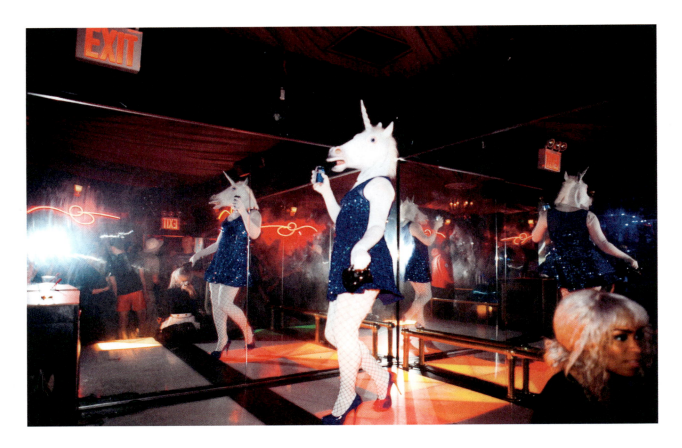

Unicorn dancer, 2013.

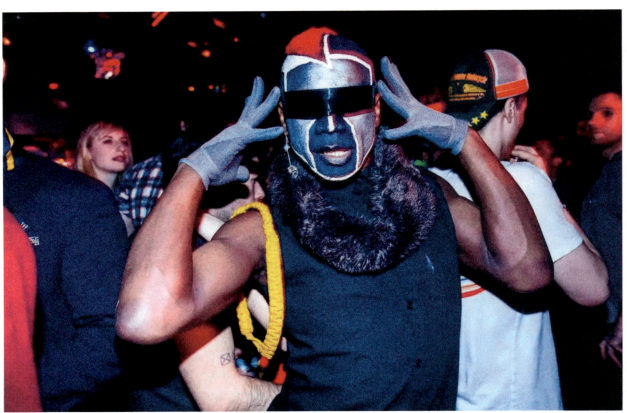

Serving face, circa 2010s.

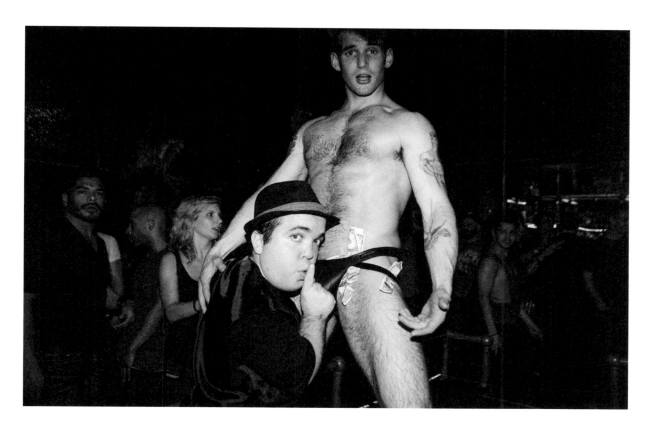

Chris Harder and friend, 2013.

Kyle Supley, patron: "One guy at Westgay that always stood out to me would show up decked out in a full suit and a giant light-up orb on his head. It had a face painted on it, but he couldn't see out of the headpiece, so he would just kind of walk around the club, being guided around by others the whole night."

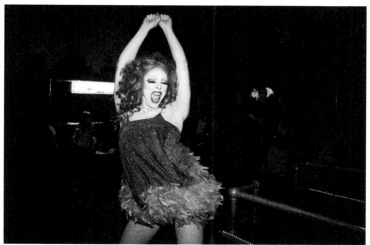

Feather dress, 2013.

2010s

512 WEST 42ND STREET
NEW YORK, NY 10036

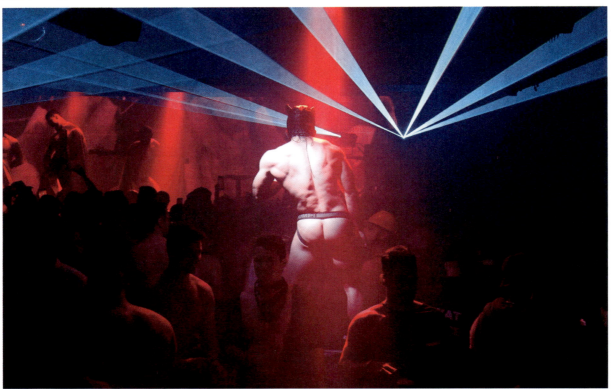

Masked go-go dancer in jockstrap at XL, 2016.

New York City's first XL Bar & Lounge operated from 2001 to 2006 in a two-level, sleekly designed storefront location at 357 West 16th Street in Chelsea. The venue featured a stylishly unique layout and decor, including ceilings with projected virtual blue skies, and bathrooms where urinals and sinks faced each other, with a large glowing fish tank in between. The club's lush look was featured on *Sex and the City*, while *HX Magazine* at the time remarked that, "XL is to most other bars what Disney World is to a country fair."

In 2012, a trio of gay nightlife mavens—John Blair, Beto Sutter, and Brandon Voss—reinvigorated XL, but this time as a megaclub situated inside New York City's first officially gay hotel, the Out NYC, at 512 West 42nd Street in Hell's Kitchen. Striving to live up to its name, the new XL was a 14,000-square-foot [4,300-meter] venue that billed itself as the city's largest gay nightclub and entertainment complex. Its jet-black interior featured a long stage backlit by a massive L.E.D. screen, an expansive sunken dancefloor, and a lounge area with tables that could be whisked away when late-night dancing got too crowded. Early on, Blair anticipated that XL was bound to succeed, explaining that the entire surrounding neighborhood was "very, very gay."

XL began hosting a different flavor of party and DJ each night of the week. Fridays tended to attract young, clean-cut professionals with danceable pop music, Saturdays catered to an older, more muscular crowd looking for circuit party house tunes, Sunday nights were billed as

Latino Nights, while Mondays hosted Vogue Knights, complete with beats by DJ MikeQ. In addition to its diverse cast of DJs, XL also used its vast stage to please cabaret fans with a variety of shows, hosting performances by pop idols like Ariana Grande and Lady Gaga, as well as drag acts from the likes of Peppermint, Derrick Barry, and Amanda Lepore.

In 2015, the Out NYC became the target of boycotts after news broke that its gay owners, developers Ian Reisner and Mati Weiderpass, had hosted a dinner for then-Republican presidential hopeful Ted Cruz at their home. The pair had also donated to Cruz, who was widely known for his vehemently anti-LGBTQ+ policies. Numerous organizations began canceling their events and programming at the hotel, and in 2016, Reisner and Weiderpass closed the business and sold it to Merchants Hospitality, who rebranded it as the Cachet and ended its run as a gay hotel. With the Out NYC meeting its unfortunate demise, so too did XL, defying Blair's early prediction for long-term success and reaffirming that NYC's nightlife scene can sometimes feel like the wild, wild west.

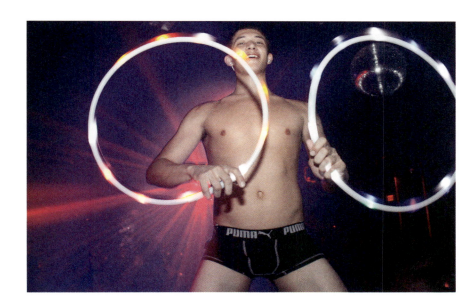

Hoops at XL, 2013.

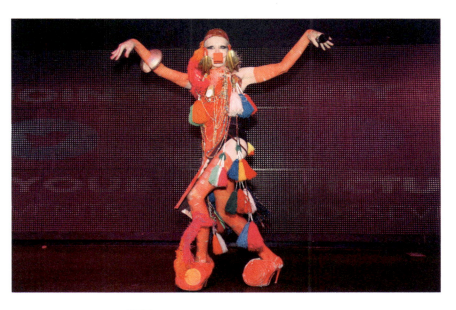

Performer onstage in over-the-top tasseled look, 2015.

CHINA CHALET

47 BROADWAY
NEW YORK, NY 10006

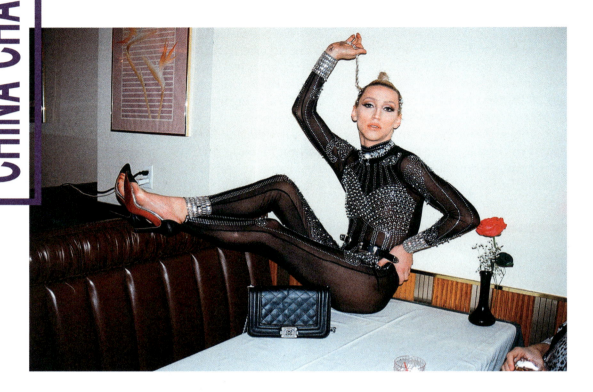

Linux at Ty Sunderland Presents Heaven on Earth: Ariana Grande vs. Nicki Minaj party, 2019.

Located at 47 Broadway between Rector and Morris Streets in the Financial District, China Chalet was a queer anomaly: from the hours of 11 a.m. to 9:30 p.m. it was an unassuming dim sum restaurant, but from 10 p.m. onwards, the space's second floor transformed into a music venue and late-night club that attracted a predominantly LGBTQ+ crowd. A *New York Times* article described the hip parties there "as if New York's art world had been transported to a Holiday Inn in the Midwest," while *WWD* called it the "Studio 54 of the Instagram era."

Owned by Keith Ng, China Chalet first opened in 1975 as a Chinese restaurant with a banquet hall setting, catering primarily to a business clientele. In the mid-2000s, it began concurrently operating as a rental space for nightlife events. The first was an afterparty in 2005 for an exhibition by queer photographer Glynnis McDaris, who soon started hosting regular parties at the restaurant with her partner, Gemma Ingalls.

These events tended to draw a predominantly artsy and downtown-chic LGBTQ+ crowd, which starkly contrasted with the restaurant's traditional daytime clientele. According to journalist Whitney Bauck in *Fashionista*, the people you would see at China Chalet on a given night "would almost certainly be the tastemakers helping define what 'cool' looks like in this decade of New York history."

Parties at the venue were organized and attended by many certifiably hip LGBTQ+ starlets, including musician Kim Petras, fashion designer

China Chalet

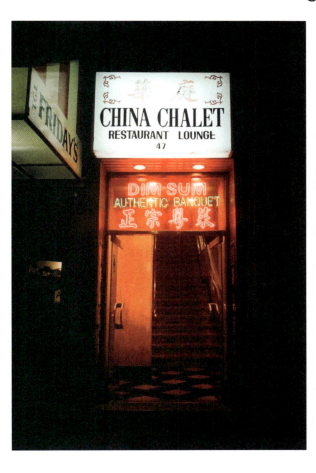

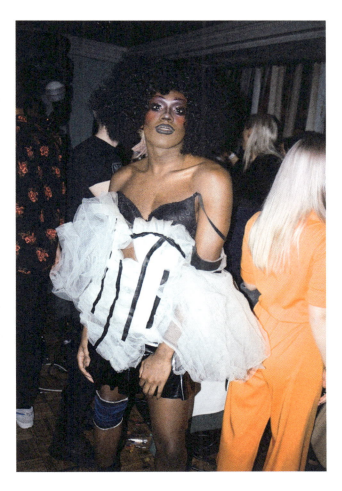

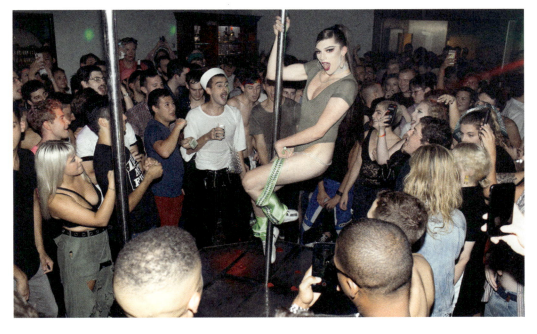

Top Left: China Chalet exterior, 2017.

Top Right: Ruby Fox at Ty Sunderland Presents Heaven on Earth: Lady Marmalade, 2019.

Bottom: Temporary stripper poles at Heaven on Earth, circa 2010s.

Humberto Leon, and visual artist/DJ Juliana Huxtable. One of the most epic party series thrown at Chalet was Club Glam, which began in 2016 and was organized by Dese Escobar, Kyle Luu, and Fiffany Luu, each of whom came from fashion backgrounds. Escobar informed the *New York Times* that the party was meant to be "post-identity, meaning that it's not strictly queer or straight, young or old."

Another popular queer bash at Chalet was the recurring Heaven on Earth, hosted by DJ Ty Sunderland. Sunderland recalled in *VICE* that he had wanted to throw a party featuring stripper poles, but that no strip club in New York City would let a gay promoter take over a Friday night. He then asked if he could install temporary stripper poles at China Chalet, and thus Heaven on Earth began.

In the summer of 2020, the parties came to a halt when the venue announced it would permanently close, ending its run as one of the longest-operating Chinese banquet halls in Manhattan. No specific reason was given, but many journalists, such as *VICE*'s Dan Q. Dao and *Eater*'s Robert Sietsema, speculated the economic downturn prompted by Covid-19 was a probable cause. In addition to the 47 Broadway location, there were two additional China Chalets: one in Staten Island, which closed in 2020, and another on Manhattan's Upper East Side, which met its demise in 2021. But it was the 47 Broadway location's closure that hit the queer community hardest. Addis Fouche, a frequent patron of the venue, eulogized the loss: "I thank China Chalet for being one of the only spaces where I, a sober woman, felt comfortable going. I thank it for being a safe space for queer people and POC. I thank it for changing my perspective on New York City nightlife."

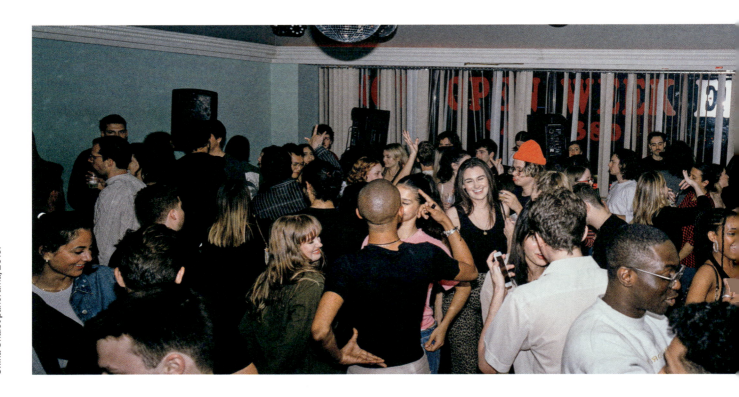

China Chalet panorama, 2019.

China Chalet

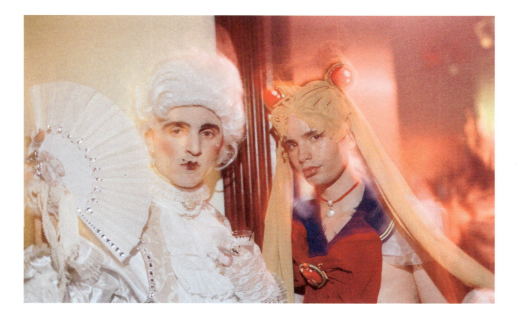

Raveyard at China Chalet, 2018.

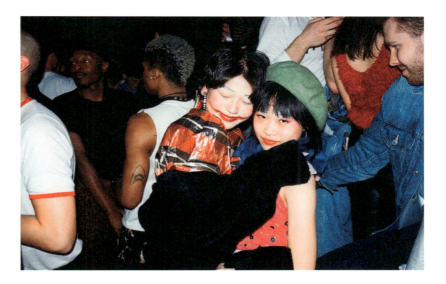

Ty Sunderland Presents Heaven on Earth: NYFW, 2019.

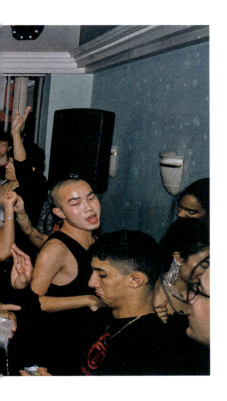

Anya Schulman, patron: "China Chalet was a rare queer haven of sorts, and going there meant a sense of possibility—it was always so hard to find a party with queer women. I escaped there, shared it with family, met a future roommate in line, and felt my most beautiful there. It truly felt like a rare constant that was kind of a cliché but also a comfort and a joy."

BOOM BOOM ROOM & LE BAIN

848 WASHINGTON STREET
NEW YORK, NY 10014

2010s

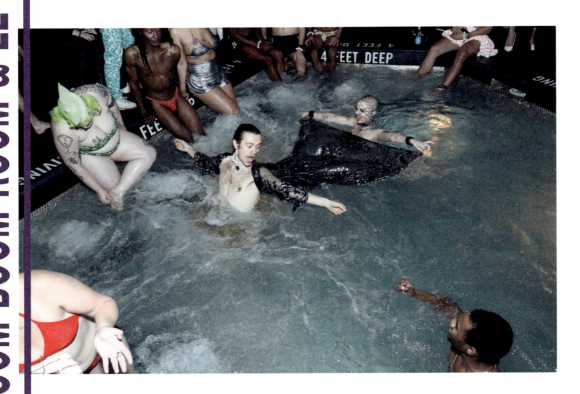

Pool cape at Le Bain, 2022.

In 2010, two adjacent nightlife venues opened atop the newly constructed Standard Hotel, the iconic building straddling New York City's High Line at 848 Washington Street in the spruced-up Meatpacking District. The first venue, initially called the Boom Boom Room and now simply Boom or the Top of the Standard, is an upscale, glittering cocktail lounge with dramatic views of both the Hudson River and the High Line. Boom tends to attract well-dressed, well-connected crowds and frequently hosts luxurious private events, many of which are LGBTQ+-related.

Across the hall, the darker, clubbier, and even more queer-oriented discotheque Le Bain opened, known for the highly photographed miniature swimming pool at its center, in which party patrons often strip down for an added layer of debauchery. In addition, the space is sheathed in black and charcoal tiling, and features vending machines dispensing lavishly priced swimsuits. During the warmer seasons, party goers can also hang out on the outdoor faux-grass rooftop to take in incredible views.

Throughout the 2010s and beyond, both Boom and Le Bain have reigned as some of the top venues for scenesters to be seen, and have been notoriously hard to get into, known for long lines, velvet ropes, and guest lists.

For over a decade, one of Le Bain's most popular recurring events has been Susanne Bartsch's On Top, which attracts androgynous neo-Club Kids, model-esque drag queens, chiseled gay men, and a slew of fashionistas. It frequently reels in a cavalcade of outlandishly dressed

Boom Boom Room & Le Bain

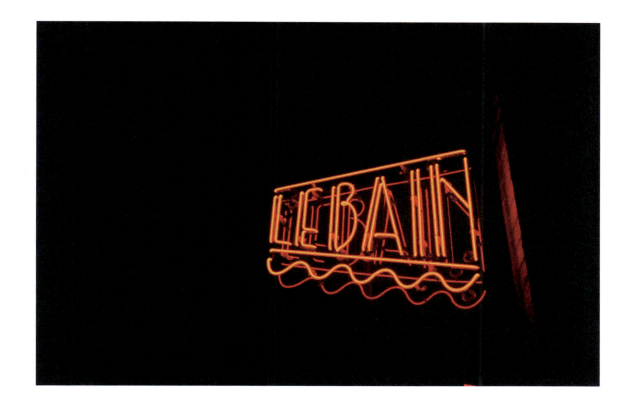

Le Bain neon signage, circa 2010s.

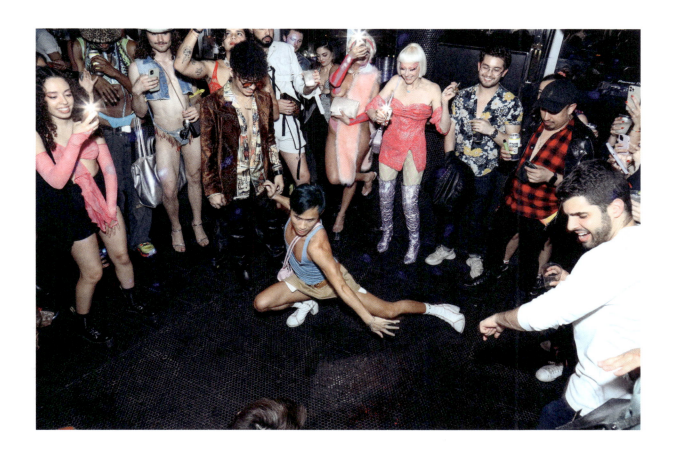

Susanne Bartsch, center, watches dance circle at Le Bain, 2022.

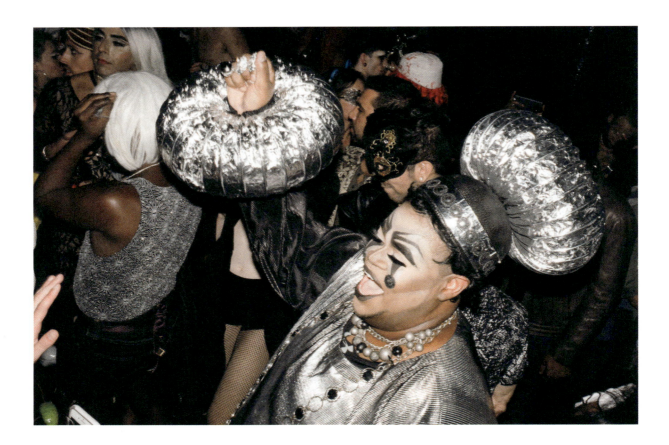

Silver look at Le Bain, 2018.

nightlife icons, celebrities, and influencers, including Amanda Lepore, Rify Royalty, and Carmen D'Alessio. The *New York Times* noted that most On Top revelers "adhered to Ms. Bartsch's dress code—anything goes. Nothing is too much. Show me some skin—and turn out in elaborate get-ups. Full body paint, a beekeeping suit and a Shakespearean fencing ensemble were recently spotted."

Alongside its iconic patrons, On Top has also been known for its impressive roster of DJs, including Amber Valentine, Will Automagic, Ty Sunderland, and Eli Escobar. Meanwhile, Le Bain has often hosted several other popular recurring queer-centric parties, including Escobar's Dance Dance Dance, Christina Visca's Birdcage, and Occupy The Disco's Paradisco.

Depending on the night, patrons can occasionally bounce between Le Bain and the classier Boom Boom Room, hailed as one of Manhattan's most distinguished cocktail venues. Boom has been described as the type of space where Jay Gatsby would have likely hosted a party, boasting elegant fireplaces, sparkling constellation-like light fixtures, and plush, sleekly designed leather couches usually filled with habitués dressed-to-the-nines, sipping top-shelf cocktails. The space's interior is designed around its grandiose circular bar, enveloped in fluted-wood columns that curve up from floor to ceiling.

Boom tends to get busy for happy hour and offers live jazz performances, but by 10 p.m. turns into one of the city's most exclusive spots. While technically open to anyone,

Boom Boom Room & Le Bain

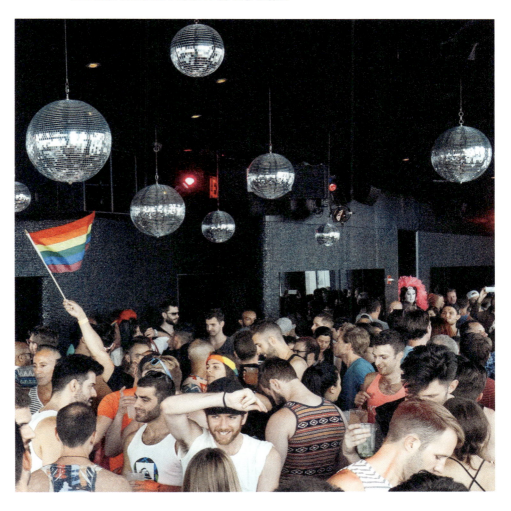

Pride at Le Bain, 2018.

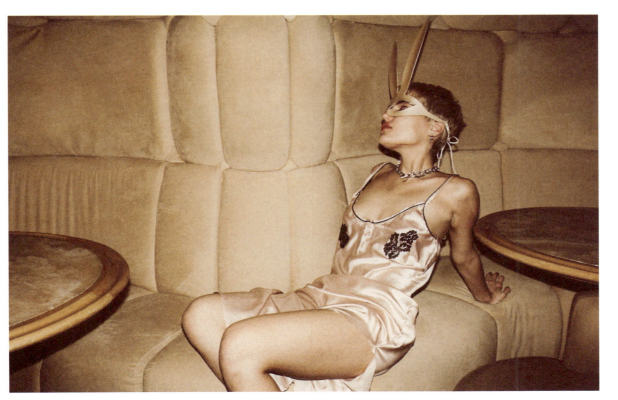

Lingerie and bunny mask at Boom Boom Room, 2018.

Boom heavily attracts many LGBTQ+ folks, and over the years has hosted countless queer-centric private parties. One year, Madonna performed at Pride x Boom, singing atop the venue's iconic golden bar, while legendary DJ Honey Dijon spun for the crowd beforehand, which included Andy Cohen, Indya Moore, and Anderson Cooper. Another year, fashion duo David and Phillipe Blond threw a bash at Boom celebrating the LGBTQ+ community's resilience, which featured singer Tinashe performing, Susanne Bartsch emceeing, and DJ Mazurbate spinning.

Whether it's skinny dipping at Le Bain or sipping on a martini at Boom, both venues atop the Standard have proven themselves coveted queer nightlife spots since their inception, while On Top remains one of Manhattan's chicest parties. On one particular night there, performer Joey Arias, while looking out across the city skyline, shouted, "Here we are, on top of the world!" and the queer crowd proudly erupted in cheers.

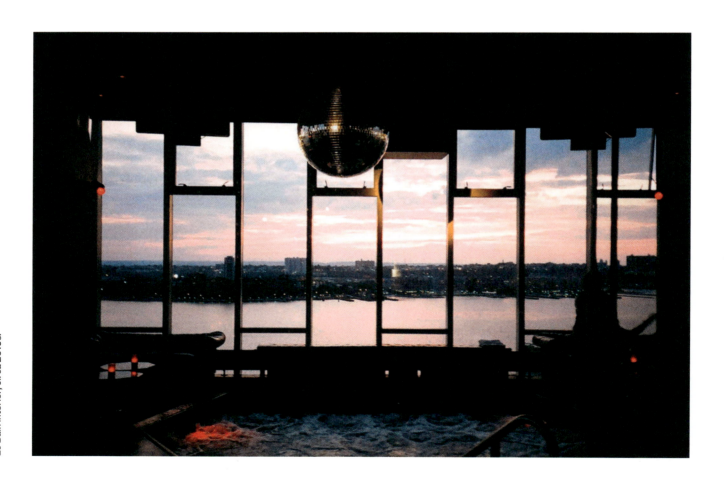

Le Bain interior, circa 2010s.

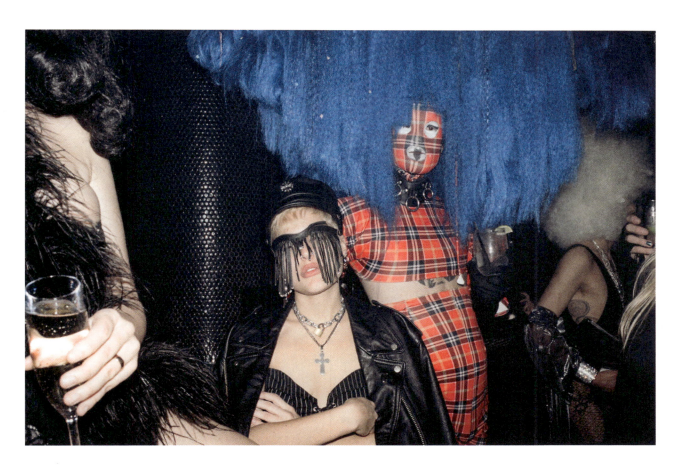

Eye fringe and blue hair, 2017.

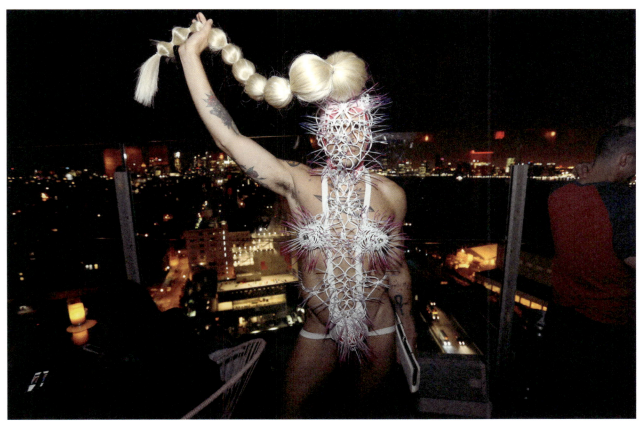

Braid and spikes at Le Bain rooftop, 2015.

FLAMING SADDLES

793 NINTH AVENUE
NEW YORK, NY 10019

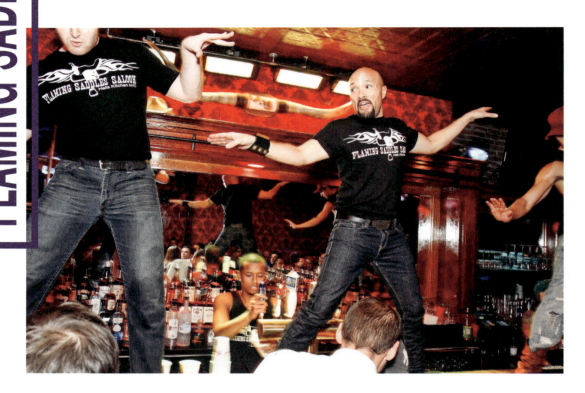

Opening night at Flaming Saddles, 2011.

In October 2011, a country and western gay saloon named Flaming Saddles arrived in Hell's Kitchen at 793 Ninth Avenue. Though many now-defunct gay bars in New York had adopted a cowboy theme in the past (Boots & Saddle, Chaps, and Hayloft, to name a few), Flaming Saddles committed to the bit even more, becoming best known for its hunky bartenders—decked in denim, big-buckled belts, and cowboy boots—strutting to coordinated line-dance numbers both behind and on top of the bar.

During a time when many LGBTQ+ spaces were being opened and operated by queer people, Flaming Saddles was the brainchild of a straight couple, owners Jacqui Squatriglia and Chris Barnes. The *New York Times* described the unlikely proprietors thus: "She favors off-the-shoulder tops and stiletto heels; he wears leather jackets and rides a Harley."

Upon its debut, Flaming Saddles was immediately called the Coyote Ugly for queer folks, which proved to be on target, as Squatriglia had previously choreographed the dance routines at Coyote and now does the same at Flaming Saddles.

The bar's interior pays homage to a frontier-town saloon, with bordello-red drapes, velvety patterned wallpaper, wide-plank floors, and a pressed-metal ceiling. Meanwhile, Squatriglia insisted that Flaming Saddles have a jukebox rather than a DJ, and at any given hour, country tracks by the likes of the Chicks, Shania Twain, and of course, Dolly Parton, can be heard playing. But the main draw is always the Flaming

Saddles Bandits, the name of the line-dancing staff known for dipping, splitting, cartwheeling, and pounding their cowboy heels across the 32-inch-wide [81 cm] bar top. The deliberately non-stripping shows put on by the Bandits are immensely popular but have also attracted more rowdy bachelorette parties over the years, leading to the venue's iconic sign "Straight Women No WooHooing" hanging above the bar.

Flaming Saddles estimates that many of its patrons grew up in states like Oklahoma, Texas, or Tennessee. "There was not a gay bar in Hell's Kitchen for me," Brianne Demmler told the *Times*, a regular visitor who went to Flaming Saddles with her girlfriend the day they got engaged. Squatriglia, meanwhile, added that Southern mothers will oftentimes come in and tell her: "Jacqui, thank you. My son doesn't tell me where he goes, but I know he's here and he's safe because you're here."

In November of 2014, the success of Flaming Saddles led Barnes and Squatriglia to open a second location in West Hollywood. That location sadly closed in 2020, one of the many casualties of the Covid-19 pandemic, but the cowboy boots in Hell's Kitchen are certainly still walking.

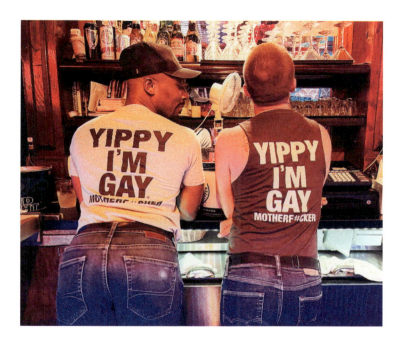

Two Flaming Saddles bartenders, circa 2010s.

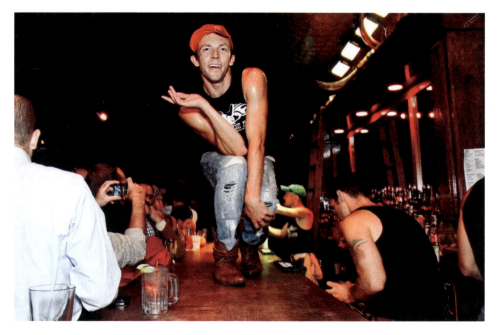

Performing on the bar on opening night, 2011.

NO BAR

25 COOPER SQUARE
NEW YORK, NY 10003

2010s

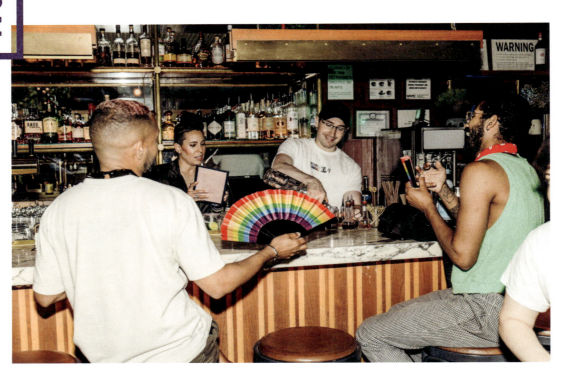

Patrons at No Bar, 2023.

Located at 25 Cooper Square, No Bar first opened in 2019 inside the East Village's Standard Hotel, intending to cater specifically to a queer crowd. Originally created by Angel Dimayuga, the Standard's former creative director of food and culture, it is one of the first LGBTQ+ bars to open inside of a major hotel chain, taking over the space that formerly housed the short-lived Narcbar.

Situated on the hotel's ground floor, No Bar is part of a mini-campus that includes a high-end restaurant, a café, and a garden. Its interior design is intentionally quirky, decorated with cow-print booths, an installation of artistically decorated mirrors, a large disco ball, and plenty of neon signage. Round lighting fixtures hang from the ceiling like water droplets, aqua-blue-hued tables are scattered around the front of the space, and an L-shaped marble bar sits on one side of the venue while semicircular banquettes line the other.

Prior to opening No Bar, Dimayuga had been an executive chef at the hip restaurant Mission Chinese Food and had been a fixture in New York's underground LGBTQ+ nightlife scene, running the monthly party Gush that drew a diverse crowd of predominantly queer women.

In addition to being a casual hangout spot serving craft cocktails and fancy bar snacks, Dimayuga also strove to ensure that No Bar would run like a mini queer nightclub, curating a variety of recurring events including a *RuPaul's Drag Race* viewing party, a drag bingo night, queer speed dating, and a Wednesday night lesbian party called Slather!. They told *Bon Appétit*

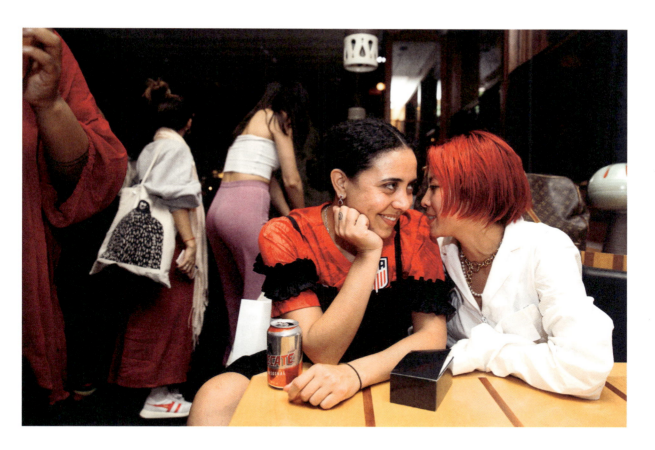

Keenan MacWilliam and Angel Dimayuga at Womxn's Night at No Bar, 2019.

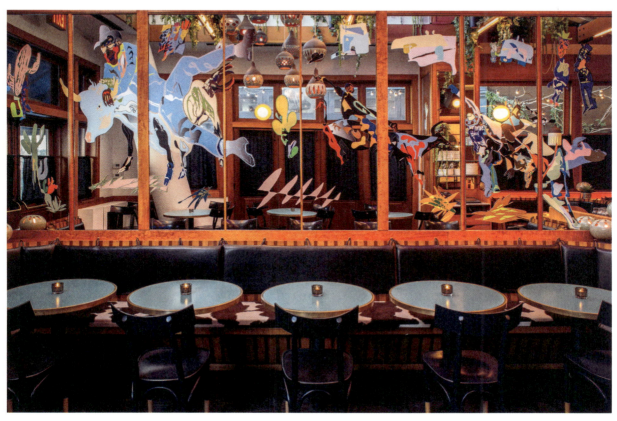

No Bar interior, 2019.

that, when they moved to New York in 2006, they felt they did not quite fit in at any of the lesbian bars they encountered. "I think people refer to *The L Word* a lot, but *The L Word* isn't really my scene or my people," they said, noting that the groundbreaking show's original cast was predominantly white and upper-class. With No Bar, they realized they could recreate the vibe of Gush in a fixed, permanent space that just happened to have incredible visibility, thanks to the Standard Hotel's global recognition.

That visibility has indeed been a boon for No Bar. While some of its patrons travel from all over to visit the space, others simply descend from their hotel rooms, proving that the venue can exist as both a hotel bar and a queer bar. "I really considered the history of the area, what the neighborhood needs, and the future," Dimayuga told the *New York Times*. "We're reimagining what a New York City gay bar is."

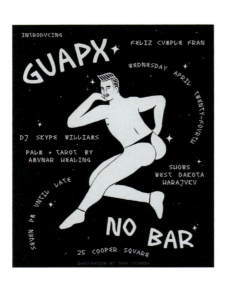

Left: Guapx at No Bar flyer, 2010s.

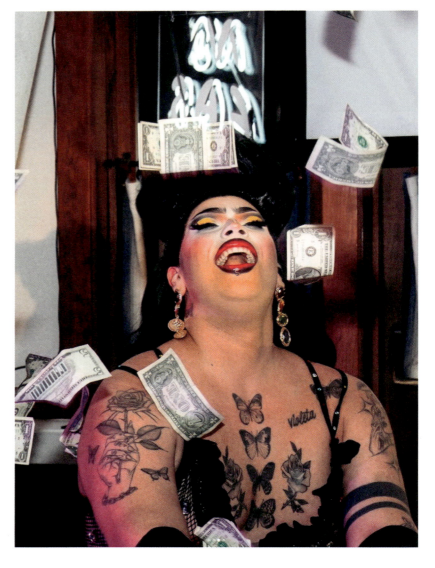

Right: Essa Noche performing, 2023.

Angel Dimayuga, No Bar founder: "No Bar allowed me to bring in marginalized folks that normally wouldn't get the stage at these boutique luxurious hotels. Non-traditional designers created the logo, an artist showed off her work by illustrating Black cowboys on the back mirror, and I was really inspired at the time by Doja Cat's 'MOOO!' video, which is how I got into this sort of campy cow print aesthetic. The identity politics felt a little trite at this time in the late 2010s, but on the backend we knew that we were basically making a lesbian-run, Black-run mezcal bar."

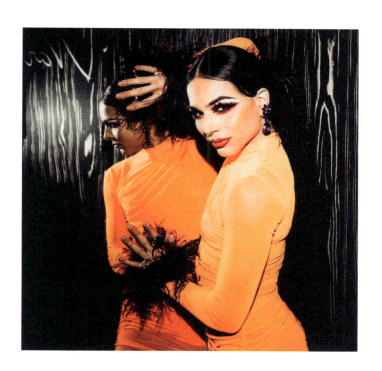

April Carrion at No Bar, 2010s.

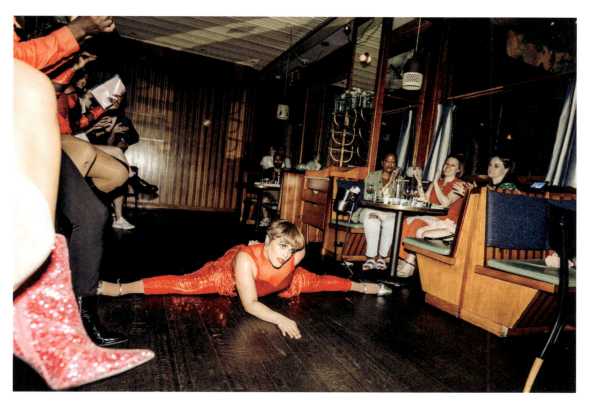

Drag performer at Pride brunch, 2023.

2010s

CLUB CUMMING

**505 EAST 6TH STREET
NEW YORK, NY 10009**

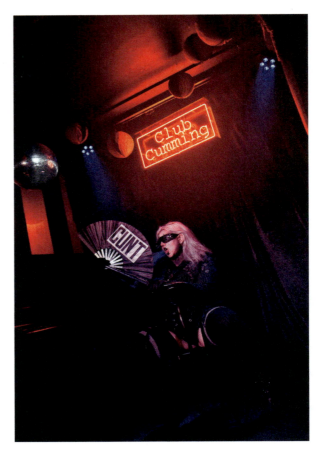

Vynx performing at Club Cumming, 2023.

2017 saw a new type of queer space open at 505 East 6th Street in the East Village, an address already associated with several beloved LGBTQ+ bars (including Wonderbar from 1990 to 2002 and Easternbloc from 2002 until 2007). When Easternbloc announced it would be closing, award-winning actor Alan Cumming swooped in to salvage the space, teaming up with owners Benjamin Maisani and Darren Dryden and party promoter Daniel Nardicio to reinvent the storied club into a Weimar-themed, performance-centric queer venue, cunningly called Club Cumming.

The concept first emerged in 2014 while the actor was performing in the Broadway musical *Cabaret,* whose story is set in 1920s Berlin. After his nightly performances, he would often host impromptu gatherings in his dressing room, eventually calling it Club Cumming and even having a neon red sign made of the name, which now hangs above the actual Club Cumming's stage.

His makeover of the former Soviet-themed Easternbloc space included adding chandeliers, tasseled velvet drapes, and a large-scale black-and-white wall mural painted by his husband, Grant Shaffer. One of the figures featured on the mural is Nashom Wooden, who, as drag performer Mona Foot, was a beloved staple of New York nightlife before his untimely passing in 2020.

Club Cumming's interior is anchored by its compact stage up front, which serves as the venue's main draw, hosting a wide variety of entertainment on a nightly basis that ranges from burlesque performances to drag

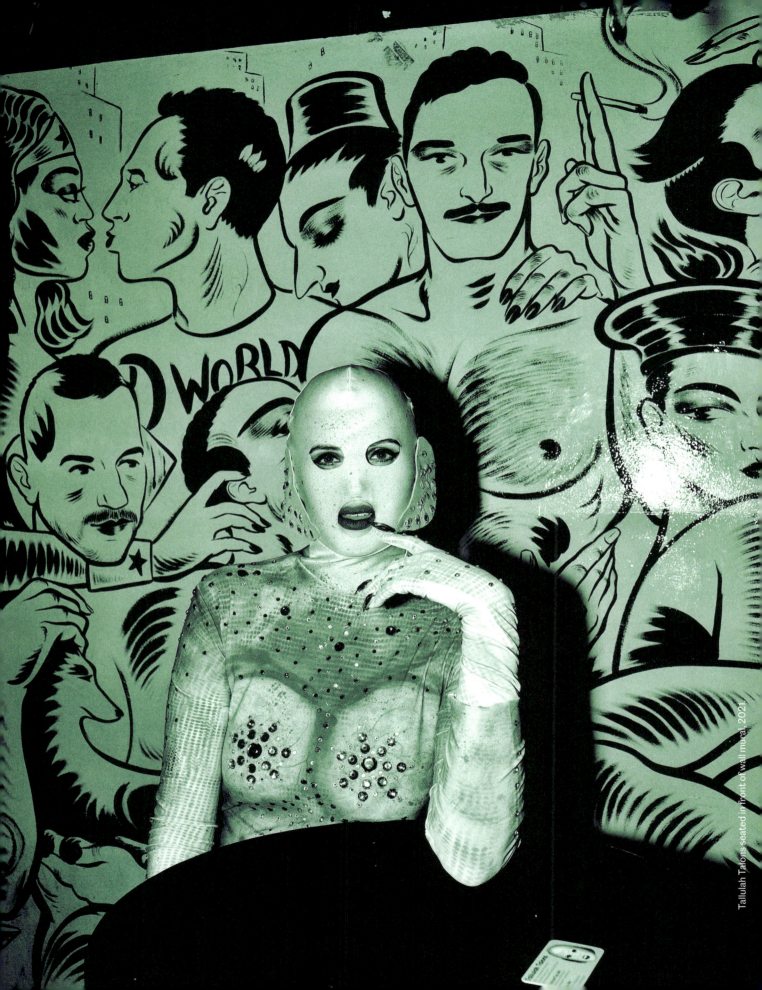

Tallulah Talons seated in front of wall mural, 2021.

shows, film screenings to DJ sets, and even "raunchy readings." The venue also puts on jazz and classical music performances as well as Broadway acts, and occasionally full productions of off-off-Broadway musicals. It has also been known to host a plethora of other quirky events, including a weekly knitting circle called Stitch & Bitch, a Romy and Michele-themed tea dance, and a weekly drink-and-draw event called Anatomy Lessons featuring deliciously near-nude models. According to a writeup in *Page Six*, Cumming wanted his conceptual club to highlight a "mixture of performance, DJs and theme nights as eclectic and unexpected as Alan himself."

In 2017, the *New Yorker* praised Club Cumming, stating that "the tiny space welcomes a far broader spectrum of the queer community… and overflows with a sense of inclusive camaraderie." These days, it's still going strong, making regular appearances on countless "Best Gay Bars in New York" lists. Nardicio parted ways with the club in 2020 to open his own venue called Red Eye, but Alan Cumming himself can still often be spotted at the bar, sometimes performing, socializing, and even bartending.

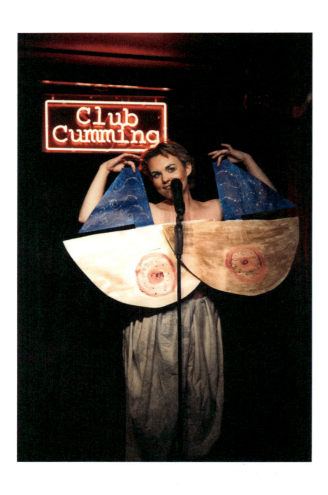

Left: Peach Fuzz performing for Thezbians, 2023.

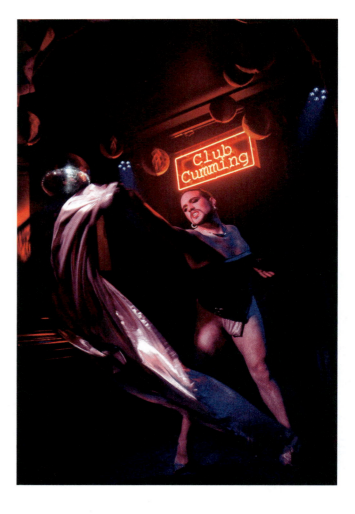

Right: Mizzaddy performing, 2023.

Club Cumming

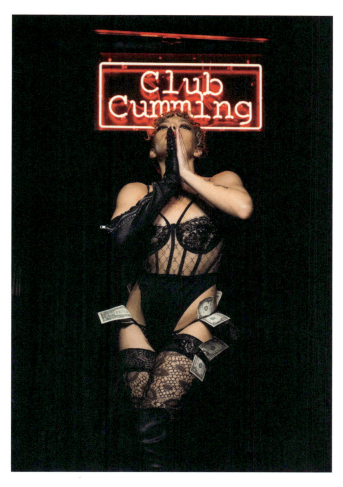

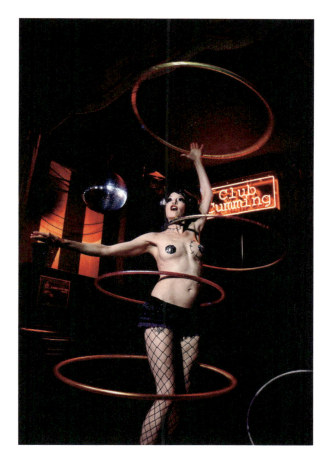

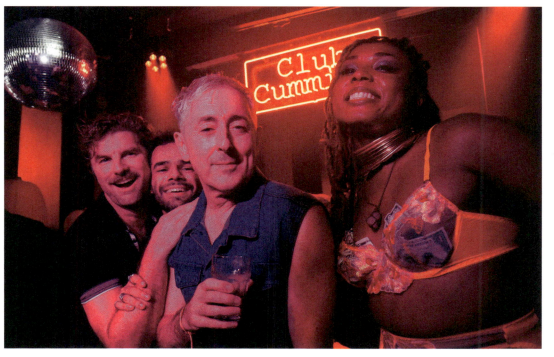

Top Left: Nirah performing for Thezbians, 2023.
Top Right: Pinkie Special performing, 2021.
Bottom: Alan Cumming and friends at Club Cumming, 2023.

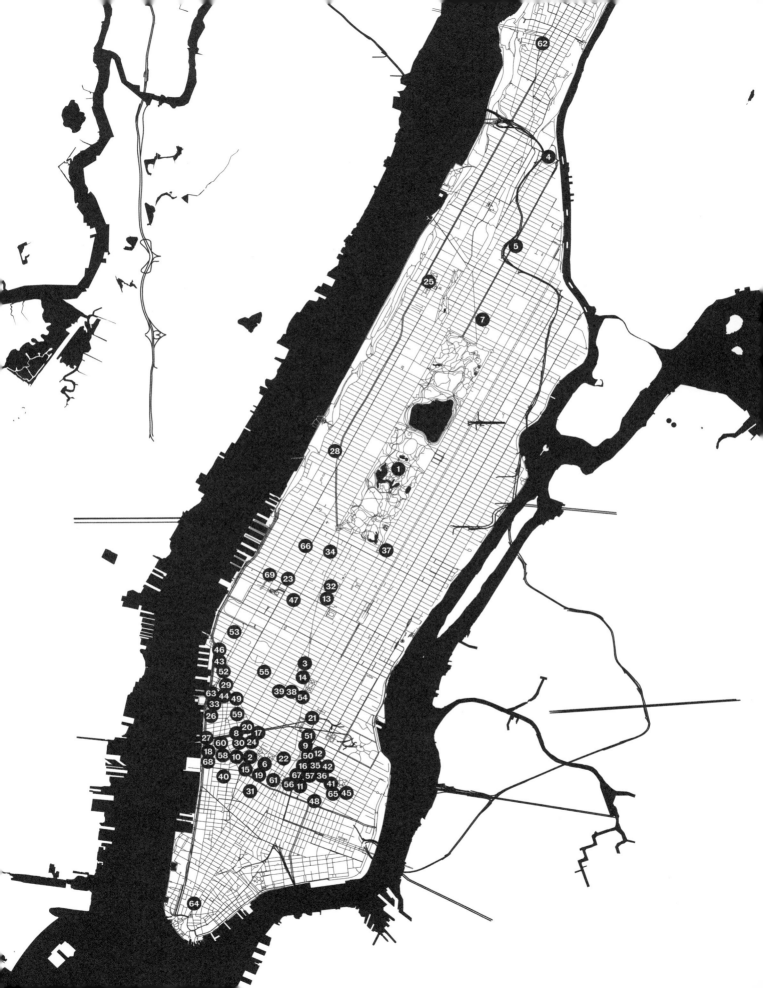

1920s–1930s

1. Central Park
p. 26
2. Eve's Hangout
p. 24
3. Everard Baths
p. 20
4. Hamilton Lodge Ball @ Rockland Palace
p. 30
5. Harry Hansberry's Clam House
p. 22
6. Howdy Club
p. 34
7. Jimmie Daniels' Nightclub
p. 36
8. Stewart's Cafeteria
p. 32
9. Webster Hall
p. 18

1940s–1950s

10. Caffe Cino
p. 58
11. Club 82
p. 62
12. Club 181
p. 60
13. Jewel Box Revue (Headquarters)
p. 50
14. The Mattachine Society & Daughters of Bilitis Offices
p. 66
15. San Remo Café
p. 44
16. St. Marks Baths
p. 54
17. Women's House of Detention
p. 46

1960s

18. Christopher's End
p. 84
19. Crazy Horse Café
p. 76
20. Julius'
p. 74
21. Max's Kansas City
p. 86
22. Oscar Wilde Memorial Bookshop
p. 80
23. The Sanctuary
p. 90
24. The Stonewall Inn
p. 92
25. Student Homophile League @ Earl Hall
p. 82

1970s

26. 12 West
p. 122
27. Christopher Street Piers
p. 116
28. The Continental Baths
p. 108
29. Crisco Disco
p. 114
30. First Pride March
p. 102
31. GAA Firehouse
p. 110
32. GG's Barnum Room
p. 124
33. The Mineshaft
p. 128
34. Studio 54
p. 132

1980s

35. Boybar
p. 174
36. Club 57
p. 150
37. The Copacabana
p. 182
38. Danceteria
p. 154
39. Limelight
p. 168
40. Paradise Garage
p. 144
41. Pyramid Cocktail Lounge
p. 162
42. The Saint
p. 158
43. Tracks
p. 178

1990s

44. Clit Club @ Bar Room 432
p. 204
45. Club Casanova @ Cake
p. 232
46. Edelweiss
p. 224
47. Escuelita
p. 194
48. Lucky Cheng's
p. 212
49. The LURE
p. 228
50. No Day Like Sunday @ Café Tabac
p. 220
51. Palladium
p. 198
52. The Roxy
p. 208
53. Sound Factory
p. 216
54. Sound Factory Bar
p. 216

2000s

55. Barracuda
p. 250
56. Beige @ B Bar
p. 246
57. The Cock
p. 254
58. Cubby Hole
p. 242
59. Cubbyhole
p. 242
60. Henrietta Hudson
p. 260
61. Mr. Black
p. 258
62. No Parking
p. 262

2010s

63. Boom Boom Room & Le Bain
p. 282
64. China Chalet
p. 278
65. Club Cumming
p. 294
66. Flaming Saddles
p. 288
67. No Bar
p. 290
68. Westgay @ Westway
p. 272
69. XL
p. 276

BIBLIOGRAPHY AND RESOURCES

BOOKS

Albrecht, Donald and Stephen Vider. *Gay Gotham: Art and Underground Culture in New York.* New York: Skira Rizzoli Publications, Inc., 2016.

Bérubé, Allan. *Coming Out Under Fire: The History of Gay Men and Women in World War II.* North Carolina: The University of North Carolina Press, 1990.

Brewster, Bill and Frank Broughton. *Last Night a DJ Saved My Life: The History of the Disc Jockey.* New York: Grove Atlantic, 2014.

Burton, Krista. *Moby Dyke: An Obsessive Quest To Track Down The Last Remaining Lesbian Bars In America.* New York: Simon & Schuster, 2023.

Calhoun, Ada. *St. Marks is Dead: The Many Lives of America's Hippest Street.* New York: W.W. Norton & Company, 2016.

Carter, David. *Stonewall: The Riots That Sparked the Gay Revolution.* New York: St. Martin's Griffin, 2004.

Chauncey, George. *Gay New York: Gender, Urban Culture, and the Making of the Gay Male World, 1890–1940.* New York: Basic Books, 1994.

D'Emilio, John. *Sexual Politics, Sexual Communities: The Making of a Homosexual Minority in the United States, 1940–1970.* Chicago: The University of Chicago Press, 1983.

Downs, Jim. *Stand By Me: The Forgotten History of Gay Liberation.* Athens: The University of Georgia Press, 2020.

Echols, Alice. *Hot Stuff: Disco and the Remaking of American Culture.* New York: W.W. Norton & Company, 2010.

Engelbrecht, Barbara. "Swinging at the Savoy." *Dance Research Journal Volume 15, Issue 2.* Spring 1983.

Faderman, Lillian. *The Gay Revolution: The Story of the Struggle.* New York: Simon & Schuster, 2015.

Gieseking, Jen Jack. *A Queer New York: Geographies of Lesbians, Dykes, and Queers.* New York: New York University Press, 2020.

Gillen, John Leo. *Temporary Pleasure: Nightclub Architecture, Design and Culture from the 1960s to Today.* Munich: Prestel, 2023.

Goodman, Elyssa Maxx. *Glitter and Concrete: A Cultural History of Drag in New York City.* Toronto: Hanover Square Press, 2023.

Hankin, Noel. *After Dark: Birth of the Disco Dance Party.* East Hampton: Leon Niknah Publishing Company, 2021.

Hurewitz, Daniel. *Stepping Out: Nine Walks Through New York City's Gay and Lesbian Past.* New York: Henry Holt and Company, Inc., 1997.

Jay, Karla and Allen Young, ed. *Lavender Culture.* New York: New York University Press, 1994.

John, Elton. *Me: Elton John.* New York: St. Martin's Griffin, 2019.

Kaiser, Charles. *The Gay Metropolis: The Landmark History of Gay Life in America.* New York: Grove Press, 2019.

Katz, Jonathan Ned. *The Daring Life and Dangerous Times of Eve Adams.* Chicago: Chicago Review Press, 2021.

Kennerley, David. *Getting In: NYC Club Flyers from the Gay 1990s.* New York: Daken Press, 2023.

Kerouac, Jack. *The Subterraneans.* New York: Grove Press, 1958.

Kin, David George. *Women Without Men: True Stories of Lesbian Love in Greenwich Village.* New York: Brookwood, 1958.

Kries, Mateo, Jochen Eisenbrand and Catharine Rossi, ed. *Night Fever: Designing Club Culture 1960–Today.* Weil am Rhein: Vitra Design Museum, 2018.

Lait, Jack and Lee Mortimer. *U.S.A. Confidential.* New York: Crown Publishers, 1952.

Lawrence, Tim. *Life and Death on the New York Dance Floor, 1980–1983.* Durham: Duke University Press, 2016.

Lawrence, Tim. *Love Saves the Day: A History of American Dance Music Culture, 1970–1979.* Durham: Duke University Press, 2003.

Leap, William L., ed. *Public Sex/Gay Space.* New York: Columbia University Press, 1999.

Levine, Martin P. *Gay Macho: The Life and Death of the Homosexual Clone.* New York: New York University Press, 1998.

Marcus, Eric. *Making Gay History: The Half-Century Fight for Lesbian and Gay Equal Rights.* New York: HarperCollins, 2002.

Mcleod, Kembrew. *The Downtown Pop Underground: New York City and the Literary Punks, Renegade Artists, DIY Filmmakers, Mad Playwrights and Rock 'N' Roll Glitter Queens Who Revolutionized Culture.* New York: Abrams Press, 2018.

Miller, Neil. *Out of the Past: Gay and Lesbian History from 1869 to the Present.* New York: Vintage Books, 1995.

Moore, Patrick. *Beyond Shame: Reclaiming the Abandoned History of Radical Gay Sexuality.* Boston: Beacon Press, 2004.

Ostrow, Steve. *Saturday Night at the Baths: Books 1 and 2.* USA: Xlibris Corporation, 2010.

Ryan, Hugh. *The Women's House of Detention: A Queer History of a Forgotten Prison.* New York: Bold Type Books, 2022.

Sewall-Ruskin, Yvonne. *High on Rebellion: Inside the Underground at Max's Kansas City.* United States: Open Road Media, 2016.

Shapiro, Peter. *Turn the Beat Around: The Secret History of Disco.* New York: Farrar, Straus and Giroux, 2015.

Stegall, Gwendolyn. *A Spatial History of Lesbian Bars in New York City.* New York: Master's Thesis, Columbia University, May 2019.

Strychacki, Stanley. *Life as Art: The Club 57 Story.* Bloomington: iUniverse, Inc., 2012.

Stryker, Susan. *Transgender History: The Roots of Today's Revolution.* New York: Seal Press, 2017.

Tucker, Ricky. *And the Category is...Inside New York's Vogue, House, and Ballroom Community.* Boston: Beacon Press, 2021.

Wilson, James F. *Bulldaggers, Pansies, and Chocolate Babies: Performance, Race, and Sexuality in the Harlem Renaissance.* Ann Arbor: University of Michigan Press, 2010.

ONLINE RESOURCES

A Gender Variance Who's Who
zagria.blogspot.com

Addresses Project
addressesproject.com

Back 2 Stonewall
facebook.com/back2stonewall

Bedford + Bowery
bedfordandbowery.com

Bowery Boys History
boweryboyshistory.com

Daytonian In Manhattan
daytoninmanhattan.blogspot.com

Digital Transgender Archive
digitaltransgenderarchive.net

Disco-Disco
disco-disco.com

Drag King History
dragkinghistory.com

Dressing Dykes
dressingdykes.com

Ephemeral New York
ephemeralnewyork.wordpress.com

EV Grieve
evgrieve.com

Fire Island Pines Historical Preservation Society
pineshistory.org

Harlem World Magazine
harlemworldmagazine.com

Jahsonic
jahsonic.com/music.html

Jeremiah's Vanishing New York
vanishingnewyork.blogspot.com

Kenneth in the (212)
kennethinthe212.com

The Last Bohemians
lastbohemians.blogspot.com

Lesbians of New York City
lesbiansofnewyorkcity.com

Lost Womyn's Space
lostwomynsspace.blogspot.com

Messy Nessy Chic
messynessychic.com

New York Songlines
nysonglines.com

NYC LGBT Historic Sites Project
nyclgbtsites.org

OUTgoing NYC
jferzo.co/outgoing-the-hidden-geography-of-nycs-gay-nightlife

OutHistory
outhistory.org

Queer Music Heritage
queermusicheritage.com

Stonewall Revival
stonewallrevival.com

Village Preservation: The Greenwich Village Society for Historical Preservation
villagepreservation.org

Zeitgayst
thestarryeye.typepad.com/gay

PICTURE CREDITS

Every effort has been made to contact the copyright holders. Any copyright holders we have been unable to reach or to whom inaccurate acknowledgement has been made, please contact Prestel, and full adjustments will be made to subsequent printings.

Front cover: © Diana Davies, courtesy of Manuscripts and Archives Division, the New York Public Library. Back cover: © Efrain Gonzalez.

pp. 4–5 © Lesbian Herstory Archives, Bettye Lane Collection; p. 8 © Brian Landeche and Max Rodriguez.

1920s–1930s: pp. 14–15, 30 © Johnson Publishing Company Archive, courtesy J. Paul Getty Trust and Smithsonian National Museum of African American History and Culture, made possible by the Ford Foundation, J. Paul Getty Trust, John D. and Catherine T. MacArthur Foundation, The Andrew W. Mellon Foundation, and Smithsonian Institution; p. 16 © Robby Virus; p. 18 © Mary Evans / Jazz Age Club Collection; p. 19 top left © Plattsburgh State Art Museum, State University of New York, Rockwell Kent Collection, Bequest of Sally Kent Gorton; p. 19 top right © John Sloan, 2024 Delaware Art Museum / Artists Rights Society (ARS), New York; p. 19 bottom © Jessie Tarbox Beals/Schlesinger Library, Harvard Radcliffe Institute; p. 20 top © George P. Hall & Son Photograph Collection, New-York Historical Society; p. 21 top © agefotostock/Alamy Stock Photo; p. 22 © J.D. Doyle Archives, Queer Music Heritage; p. 23 © E. Simms Campbell, Library of Congress, Geography and Map Division; p. 24 © Nina Alvarez; p. 25 top © New York City Municipal Archives, Department of Records & Information Services; p. 25 bottom © the Eran Zahavy Collection; p. 26 © the Detroit Publishing Company photograph collection (Library of Congress); p. 27 © Theatrical Cabinet Photographs of Women circa 1866–1929, (1866), Harvard Theatre Collection, Houghton Library, Harvard University; p. 28 top © Robert Young Collection; p. 28 middle and bottom © the LGBT Community Center National Archive, Richard Peckinpaugh Collection; p. 29 © Frank Thompson Collection, courtesy of Manuscripts and Archives Division, the New York Public Library; p. 31 top © James Van Der Zee Archive, the Metropolitan Museum of Art; pp. 32, 33 top © the Estate of Paul Cadmus; p. 33 bottom © Photographic Views of New York City, the New York Public Library; p. 34 © Drag King History; p. 35 top and bottom left © the Lesbian Herstory Archives, Buddy Kent Collection; p. 36 © NYC Municipal Archives, Department of Taxes; p. 37 © Federal Theatre Project/Library of Congress.

1940s–1950s: pp. 38–39, 53 bottom © Raymond Jacobs, courtesy of Susan Jacobs and Laura Jacobs Pavlick; p. 40 © John Barrington Bayley, courtesy of the NYC Landmarks Preservation Commission; pp. 44, 45 bottom © the Greenwich Village Society for Historic Preservation, San Remo Collection; p. 45 top right © Fred W. McDarrah/MUUS Collection via Getty Images; p. 46 © Irving Haberman/IH Images/Getty Images; p. 47 top © Anna Moscowitz Kross papers, Sophia Smith Collection, SSC-MS-00087, Smith College Special Collections, Northampton, Massachusetts; p. 47 bottom right © court press photo, original source unknown, digital image captured from Burnside Rare Books sale by Hugh Ryan; p. 47 bottom left © Bettmann Archive/Getty Images; p. 48 © the Lesbian Herstory Archives; p. 49 right © Nan Lurie, courtesy of the Schomburg Center for Research in Black Culture, Art and Artifacts Division, the New York Public Library; pp. 50, 52, 53 top left and right, 60 right, 62–65 (all) © J.D. Doyle Archives, Queer Music Heritage; p. 51 © the Schomburg Center for Research in Black Culture, Photographs and Prints Division, the New York Public Library; p. 54 bottom © the William D. Hassler photograph collection, New-York Historical Society Digital Collections; p. 55 top © Mikkel Aaland (photo from Sweat); p. 56 left © AP Photo/Rene Perez; p. 56 right © Boris Vallejo; p. 57 © Ira Tattelman; p. 58 top © James D. Gossage, Collection of Robert Patrick; p. 58 bottom © Brian Merlis, courtesy of Magie Dominic; p. 59 top © Ben Martin, *TIME* magazine; p. 59 bottom © Michael Townsend Smith and Magie Dominic; p. 60 left © Lisa E. Davis; p. 61 top and bottom © Lesbian Herstory Archives, Buddy Kent Collection; p. 66 top © Cheryl Williams; pp. 66 bottom, 67 top © Manuscripts and Archives Division, the New York Public Library; p. 67 bottom © Lilli Vincenz Collection, Manuscript Division, Library of Congress (054.00.00), photo by Kay Tobin.

1960s: pp. 68–69, 86 bottom, 87, 88 bottom, 89 top and bottom © Anton Perich; p. 70 © Randy Wicker; p. 74 top © Dave Kotinsky/Getty Images for Paramount+; p. 74 bottom © Fred W. McDarrah/MUUS Collection via Getty Images; pp. 76–79 © Digital Transgender Archive, *Female Mimics Magazine*; p. 80 © Kay Tobin, courtesy of Manuscripts and Archives Division, the New York Public Library; pp. 81 bottom, 84, 85 top, 85 bottom right, 94 © Diana Davies, courtesy of Manuscripts and Archives Division, the New York Public Library; p. 82 left © the Estate of Robert Giard; pp. 82 right, 83 top left, 83 bottom © University Archives, Rare Book & Manuscript Library, Columbia University Libraries; p. 83 top right © Library of Congress Prints and Photographs Division; p. 86 top © Bob Gruen; p. 91 © John Dominis, *LIFE* magazine; p. 92 © *NY Daily News*

Archive via Getty Images; p. 93 © Fred W. McDarrah/MUUS Collection via Getty Images; p. 95 top © Tom Bernardin; p. 95 bottom © 2017 Stonewall Revival.

1970s: pp. 96–97, 114, 115 right, 123 right, 124, 125 bottom, 126 bottom, 127, 133 bottom, 134 top and bottom, 136 bottom, 137 © Bill Bernstein (Last Dance Archives); p. 98 © Chase Connery Collection; p. 102 © Manuscripts and Archives Division, the New York Public Library; pp. 103–7 all, 112 top and bottom, 113 top © Diana Davies, courtesy of Manuscripts and Archives Division, the New York Public Library; p. 108 left and right © Pierre Venant; p. 109 top © Ron Larson, *Mandate* magazine, 1975; p. 109 bottom *Queen Quarterly*, 1970; pp. 110, 113 bottom © Lesbian Herstory Archives, Bettye Lane Collection; pp. 111, 116, 118–21 all © Leonard Fink, courtesy of the LGBT Community Center National Archive; p. 117 © Stanley Stellar; p. 122 © Ebet Roberts/Getty Images; p. 123 left © Larry Blagg Collection, Division of Rare and Manuscript Collections, Cornell University Library; pp. 125 top, 126 top, 133 top, 135, 136 top © Meryl Meisler; pp. 128 top, 129 right, 130, 131 © Leather Archives, Wally Wallace Collection; p. 128 bottom left © Leather Archives/M Sussholtz for GMSMA; p. 128 bottom right © 2024 Tom of Finland Foundation / Artists Rights Society (ARS), New York; p. 129 left © Swann Auction Galleries; p. 132 © John Kelly/Ebet Roberts/Getty Images.

1980s: pp. 138–39, 178–81 all, 185, 186 right © Chantal Regnault; pp. 144, 146 top © Bill Bernstein (Last Dance Archives); pp. 145 top, 146 bottom © Meryl Meisler; pp. 145 bottom, 147 © Michele Saunders; pp. 148 top and bottom, 149, 187 top © Tina Paul; pp. 150, 151 bottom, 152, 153 top and bottom © Harvey Wang; p. 151 top left and right © Club 57 St. Marks Place Archive by Stanley Strychacki; pp. 154, 183 top and bottom, 187 bottom © Mariette Pathy Allen; p. 155 © David Wojnarowicz Archives at NYU Fales; p. 156 left and right © Daniel Falgerho; p. 157 top left and right © April Palmieri; pp. 157 bottom, 177 top © Scott Ewalt; pp. 158–61 all © Tim Smith; pp. 162, 164 © Joost Heinsius; pp. 163 top and bottom, 165 top and bottom, 166 © Ande Whyland; pp. 167 top, 170 bottom © Gallery 98 Collection; pp. 167 bottom, 169 bottom © Linda Simpson; pp. 168, 169 top right, 170 top, 172 top, 173 © Steve Eichner; pp. 169 top left, 171, 172 bottom © Efrain Gonzalez; pp. 174, 175 bottom © Juanita MORE! Collection; p. 175 top © Steven Perfidia Kirkham; pp. 176, 177 bottom © Jillian Jonas, Collection of Village Preservation; pp. 184, 186 left © John Simone.

1990s: pp. 188–89, 204, 205 bottom, 206 right © Alice O'Malley; pp. 190, 195 top and bottom, 205 top, 229 top left, 230, 232, 234, 235 top © Efrain Gonzalez; pp. 194, 218 left and right, 219 top © Chantal Regnault; pp. 196 top, 197 © Mark Avers Collection; p. 196 bottom © Steven Perfidia Kirkham; pp. 198, 199, 202 © Tim Hursley; pp. 200, 201 top, 209 top left, 227 bottom © Linda Simpson; pp. 201 bottom, 208, 209 bottom, 210, 211 top right © Steve Eichner; pp. 203 bottom, 225, 226, 227 top © Mariette Pathy Allen; p. 206 left © Gallery 98 Collection; p. 207 bottom left © Clit Club Archives; pp. 209 top right, 231 top left © David Kennerley Collection; pp. 211 top left, 224 left © Brandy Wine and Brenda A. Go-Go Archive; pp. 211 bottom, 217 top and bottom, 219 bottom © Tina Paul; pp. 212–14 all © Daisy Ang Collection; p. 215 © Michel Setboun/Corbis via Getty Images; pp. 216, 217 middle right © Alice Arnold; p. 217 middle left © Mark Tusk Collection; pp. 220–223 © Wanda Acosta Collection; p. 224 right © Georgina Quiñones; pp. 228, 229 bottom © Nina Kaarina Roberts; p. 229 top right © Leather Archives, Wally Wallace Collection; p. 231 top right © Leather Archives, Alistair Leigh Collection; p. 231 bottom © Stanley Stellar; p. 233 top and bottom © Lucien Samaha; p. 235 bottom © Mo Fischer/Mo B. Dick.

2000s: pp. 236–37, 250, 251 all, 252 © Bob Pontarelli; pp. 238, 258–59 all © Mark Tusk; p. 242 © JEB (Joan E. Biren) from the book *Making a Way: Lesbians Out Front*, Anthology Editions; p. 243 © Marissa Fortugno; p. 244 © Marc Zinaman; p. 245 top and bottom © Lisa Menichino; pp. 246, 247 top left, 247 bottom, 248 bottom © Serichai Traipoom; pp. 248 top, 249 © Dolly Faibyshev/Redux; pp. 253 left and right, 254 © Wilsonmodels; p. 255 top and bottom, 257 top and bottom © Linda Simpson; p. 256 top © Jeremy Wade; p. 256 bottom © Eva Mueller; p. 260 © Lisa Cannistraci; p. 261 top © Grace Chu; p. 261 bottom © Molly Adams; p. 262 © Michael Luongo; pp. 263 top and bottom, 264 bottom, 265 top © L. Mollicone/@chulofiasco; pp. 264 top, 265 bottom © Jonathan Saldana.

2010s: pp. 266–67, 276–77 all, 282, 283 bottom, 287 bottom © Wilsonmodels; p. 268 © Daniel Albanese; pp. 272, 273 top and bottom, 274 top, 275 top and bottom © Cyle Suesz; p. 274 bottom © Krista Schlueter; pp. 278, 279 top right, 281 bottom © Megan Walschlager/@leggomymeggoz; p. 279 top left © Michael Greene; p. 279 bottom © Serichai Traipoom; pp. 280, 281 top © Bing Guan; pp. 283 top, 286 © Sebastian Puga; pp. 284, 285 top and bottom, 287 top © Neil Aline; pp. 288, 289 bottom © Jena Cumbo; p. 289 top © Ozzy Orozco; pp. 290, 293 bottom © Wes Kloefkorn; p. 291 top © Jackie Molloy; p. 291 bottom © Markus Marty; p. 293 top © Leandro Justen; pp. 294, 295, 296 right, 297 top right and bottom © Kevin "Action" Jackson Jr.; pp. 296 left, 297 top left © Mckenna Poe.

AUTHOR BIOGRAPHY

Marc Zinaman is a New York City-based writer and historian with a passion for preserving LGBTQ+ history. Since 2021, he has been running the social media account @Queer_Happened_Here, which maps the forgotten queer history of New York and has served as the inspiration for this book. He has also written a newsletter under the same name, and has been a contributing writer to the NYC LGBT Historic Sites Project and Making Queer History. He was the contributing editor of the book *Getting In: NYC Club Flyers From the Gay 1990s* and currently serves on the planning committee for the forthcoming American LGBTQ+ Museum.

ACKNOWLEDGMENTS

Thank you to Ali Gitlow, who believed in this book from the start and helped guide it along every step of the way. Also major thanks to the incredible team who helped put it together, copyeditor/proofreader Lauren Humphries-Brooks and designers John Philip Sage and Asad Pervaiz.

Special thank you to my husband Greg for his tireless support and for being my number one cheerleader every single day. This could not have happened without your continuous encouragement.

Thank you to David Kennerley for being my second pair of eyes on this project and for consistently insightful feedback. Thank you as well to the rest of my friends and family for helping see me through this journey.

I also want to thank the many LGBTQ+ historians and projects out there whose incredible work and efforts came before me and who provided support along the way, including: the NYC LGBT Historic Sites Project, the Addresses Project, OutGoing NYC, Adam Baran, Amanda Davis, Lisa E. Davis, Andrew S. Dolkart, Jeff Ferzoco, Elyssa Maxx Goodman, Jonathan Ned Katz, Beau Lancaster, Ken Lustbader, Hugh Ryan, Michael Ryan, Gwen Shockey, Jay Shockley, and Kyle Supley. Thank you as well to all the photographers, image suppliers, and archivists who contributed the visuals to this book. I am forever grateful to you for documenting and preserving this history and for allowing me to share it.

Thank you to every single person who spoke with me and shared their stories, including: Brenda A-Go-Go, Wanda Acosta, Michael Alicea, Daisy Ang, Jim Aronow, Alan Barrows, Susanne Bartsch, Martin Belk, Tom Bernardin, Bill Bernstein, Jay Blotcher, Peter Boruchowitz, Robert Bryan, Helen Buford, Nora Burns, Renée Cafiero, Lisa Cannistraci, Cornelius Conboy, Angel Dimayuga, Lisa E. Davis, Mo B. Dick, Mario Diaz, Johnny Dynell, Tyler Evertsen, Gene Fedorko, Addis Fouche, Norell Gardner, Thomas Gargiulo, Susan Hannaford, Hewley Helstone, Darryl Hobson, Mark Horn, Kate Huh, Jesse Hultberg, Aaron Elvis James, Justine Keefe, Dan Ken, Nina Kennedy, David Kennerley, Alphonso King, Jr., Steven Perfidia Kirkham, Troy Lambert, Robbie Leslie, Paul H. Lewis, Peter McGough, Mark McKenney, Lisa Menichino, Joshua Meyers, Abraham Mitchell, Jr., Michael Mitchell, Susan Morabito, Hope Moran, Sharee Nash, Justin Nuttall, Teddy Pecora, Bob Pontarelli, Basil Reyes, Danny Rodriguez, Max Rodriguez, Pat Rogers, Tim Rush, Michael Ryan, Michele Saunders, Anya Schulman, Linda Simpson, Camilla Slattery-Eidenberg, Chris Sommerfeld, Wanda Stephens, Marsha Stern, Ken Stewart, Thor Stockman, Harmonica Sunbeam, Kyle Supley, Ira Tattelman, Thomas Von Foerster, Kathy Wakeham, Matthew Waldman, Karin Ward, Randy Wicker, Antonin Williams, Brandy Wine, Gregg Woolard, Branden Wuensch.

Lastly, I am indebted to all the LGBTQ+ pioneers who danced, marched, loved, cried, died, and fought tirelessly to carve out spaces for themselves in this world. This book would not exist without their efforts.

© Prestel Verlag, Munich · London · New York, 2025
A member of Penguin Random House Verlagsgruppe GmbH
Neumarkter Strasse 28 · 81673 Munich
© for the text by Marc Zinaman and Peppermint, 2025
© for the images see Picture Credits, p. 302, 2025

produktsicherheit@penguinrandomhouse.de

Library of Congress Control Number: 2024942680
A CIP catalogue record for this book is available from the British Library.

The publisher expressly reserves the right to exploit the copyrighted content of this work for the purposes of text and data mining in accordance with Section 44b of the German Copyright Act (UrhG), based on the European Digital Single Market Directive. Any unauthorized use is an infringement of copyright and is hereby prohibited.

Editorial direction: Ali Gitlow
Copyediting and proofreading: Lauren Humphries-Brooks
Design and layout: John Philip Sage and Asad Pervaiz
Production management: Luisa Klose
Separations: Schnieber Graphik, Munich
Printing and Binding: TBB, a.s., Banská Bystrica

Penguin Random House Verlagsgruppe FSC® N001967
Printed in Slovakia
ISBN 978-3-7913-8041-4
www.prestel.com